Pots, Prin
Ceramics
Agenda, f....4..
to the 20th Century

Edited by Patricia F. Ferguson

The British
Museum

This publication has been generously supported by Ceramica-Stiftung Basel

Publishers
The British Museum
Great Russell Street
London WC1B 3DG

Series editor
Sarah Faulks

Pots, Prints and Politics:
Ceramics with an Agenda, from the 14th to the 20th Century
Edited by Patricia F. Ferguson

ISBN 9780861592296
ISSN 1747 3640

Front cover: Teapot with Tian'anmen Gate, undated, Jingdezhen, China, porcelain, metal, h. 23cm. British Museum, London, 2013,3007.240, donated by Alfreda Murck

Pg. iv: details of a selection of images reproduced in the book (clockwise from top left, see **Figs 64, 163, 149, 106**)

Pg. vi: details of a selection of images reproduced in the book (clockwise from top left, see **Figs 80, 173, 26, 161**)

Printed and bound in the UK by 4edge Ltd, Hockley

Papers used by the British Museum are recyclable products made from wood grown in well-managed forests and other controlled sources. The manufacturing processes conform to the environmental regulations of the country of origin.

Further information about the Museum and its collection can be found at britishmuseum.org

Contents

Remember them that are in Bonds

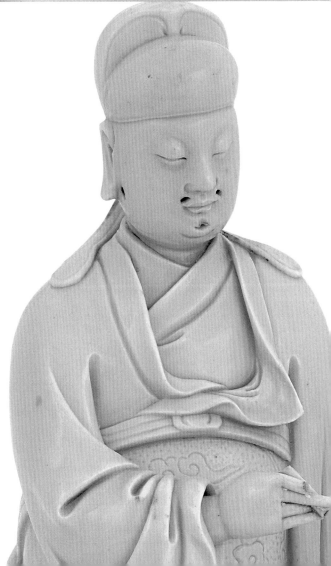

Introduction

Patricia F. Ferguson

The diverse papers in this publication share a common theme: the long-standing interrelationship between ceramics, prints and politics. Today, contemporary ceramic artists are frequently celebrated for using clay as a driving force for social change; indeed, throughout history potters have tackled serious social issues and challenged conventions, both blatantly and surreptitiously.[1] Jars, dishes, mugs and teapots, traditionally associated with domestic spaces but embellished with political imagery, have charted evolutions in public opinion, while documenting the histories of hate, fear, prejudice and social injustice. Their delicate, fragile bodies and pristine glazes, so non-threatening, enticing and familiar, have seduced audiences with their subversive messages. The source of much of this imagery is typically found in the graphic arts, specifically the print medium. As potters mastered painting on vessels, and moved from geometric and abstract designs to portraying figures with narratives, they turned to prints for inspiration; from the 1750s, entrepreneurs even developed techniques to print on ceramics, which, like prints, were also widely disseminated through multiples. The authors in this publication have challenged and interrogated a variety of ceramic objects to understand why a particular print source was selected and to identify its agenda; the answers are equally relevant and relatable to our own complex world. The papers raise issues of class, race, piety, propaganda, self-promotion and gender, as well as national and regional identities, asking questions of ourselves and of our collective pasts.

The publication began as a study day with the title, *Pots, Prints and Politics: Ceramics with an Agenda*, held at the British Museum on 16 February 2018, which accompanied a display in Room 90a at the Museum, entitled 'Pots with Attitude: British Satire on Ceramics, 1760–1830', supported by the Monument Trust. It focused on transfer-printed pottery – creamware, porcelain, bone china and earthenware – which mapped the progression of public opinion on a variety of social issues that included the passions, politics and prejudices of the British. This 'potted history' began in the 1760s, when its voice was elite white men in periwigs, and by the 1830s had evolved to include working-class men and women calling for reform, encouraged by revolutions in America and France. The study day also recognised a milestone of the British Museum's Department of Prints and Drawings: the contribution of one million images to the Museum's Collection Online database. This unparalleled resource began under former Keeper Antony Griffiths in 1990, with images first included in 2002–3. When it was launched in 2007, it was groundbreaking for making the collection accessible to the entire world through images searchable using words.

Printing is a relatively recent invention when compared to ceramic art with its origins in the Palaeolithic period. Woodblocks were used to print on paper in China by the 8th century; the technology reached Europe first as a method of decorating textiles, and by the late 14th century was being employed for printing religious images on paper. But although Johannes Gutenberg's invention of movable type in the 1440s dramatically increased the demand for printed images (usually combined with type in books), it was engraving, which spread from a method of decorating

metalwork to a method of printing on paper in Europe in the first half of the 15th century, that was to have the greatest influence on ceramic design. As these papers illustrate, some potters had access to the latest engravings from the leading print shops, others utilised antiquated images perhaps found on a market stall or purchased as a job lot at auction, and the rest commissioned designs from in-house engravers. Ceramic historians have much to learn about print culture and vice versa.

The study day initially attempted to reflect the many cultures with a significant print tradition represented in the collections of the British Museum, moving beyond 18th-century Europe to Ming China and Renaissance Italy. Not all enjoy a symbiotic relationship. The potters of Japan with its important tradition of woodblock production (*ukiyo-e*), from the 1670s through to the early 20th century, have rarely been directly influenced by political prints until recently.[2] Some countries were late to adopt these technologies: for example, in Iran, European-style commercial printing was only introduced in the mid-19th century, and its impact on Qajar ceramic design has yet to be established. Another avenue for investigating political agendas in order to widen the remit is the depiction of ceramics in graphic art, or 'pots in prints' (see Redfern, Chapter 13). Few nations enjoyed the freedom of the press found in Britain, restricting what could be expressed by potters. These are just some of the limitations to our subject.

Academically broad, the essays survey not only Asian and European material, but also cross-cultural interactions, specifically the employment of European print sources in Asian porcelain design and construction, although not the direct impact of Asian print sources on European ceramics, which is a more recent phenomenon. The papers are presented chronologically, beginning in China in the 14th century and concluding in China under Chairman Mao in the mid-20th century, oscillating in the middle between Asia, Europe and America. Each introduces the constantly evolving messages and meanings that have had an impact on their relevant societies, raising issues that are equally pertinent today. The varied backgrounds of the authors, from widely published authorities to early-career researchers and academics, bring unique perspectives to their source material and expose specialist subjects to the scrutiny of audiences outside their usual coterie.

The publication begins in Asia in the 14th century with Luk Yu-ping questioning whether Chinese potters took advantage of China's long and celebrated history of printmaking to communicate political messages of power or dissent before the 20th century. In order to demonstrate their imperial legitimacy and right to rule, the courts of the Southern Song and Ming dynasties ordered ceramic ritual vessels modelled after printed images of long-lost archaic bronzes recorded in illustrated antiquarian catalogues. In addition to these examples, Luk explores rare painted narrative scenes after woodblock print sources found on Yuan and Ming porcelain made during a period when anti-Mongol sentiment was rife among the elite ethnic Han Chinese and finds evidence of 'discreet remonstrance and criticism', which included female patronage, although it was subtly expressed for fear of censorship.

Building on the influence of prints on Yuan-period ceramics, Elaine Buck interrogates a single 14th-century celadon-glazed Longquan wine jar carved with four narrative scenes. The depictions have links with a *zaju* drama – a type of play associated with deliverance or conversion, entitled *Yueyang Lou* (Yueyang Tower) – performative landscapes and increasing competition from potters in Jingdezhen. These performances are frequently associated with Daoism through characters such as Lü Dongbin, one of the Eight Immortals, but immortality-themed ceramics also appealed to Buddhists, which expanded the market for such wares, despite religious hostility. While illustrated *pinghua* ('historical narratives') of popular dramas are extant from the late 13th century and resemble the carving on the jar in format and conventions, such survivors are extremely rare and no exact print source has been identified.

Wenyuan Xin considers the booming book trade in Ming China and particularly pictorial hagiographies that inspired potters and ivory carvers in Fujian province during the 16th and 17th centuries. Encyclopaedic hagiographies provided a comprehensive guide to the biographies of deities and immortals from Buddhist, Daoist and Confucianist traditions, and by the late Ming period were increasingly commercial in their employment of woodblock illustrations. With the growth of popular religions among the populace, ivory and porcelain idols became ubiquitous in the domestic sphere, worshipped for their promises of good fortune and long life. Xin presents a group of patron deities executed in ivory or porcelain and connects them with the social and religious factors that contributed to this phenomenon through woodblock prints.

Moving away from Asia and its discreet critical references, the following two papers offer insight into more overt political encounters on European ceramics. Dora Thornton begins by examining a group of Italian maiolica objects painted by Francesco Xanto Avelli of Rovigo and others, employing sexual imagery to comment on the corruption of the papal city and the papacy resulting in the Sack of Rome in 1527, aimed at an elite, but unidentified, audience. *Istoriato*, pottery painted with a complex narrative, offered a new visual language for potters, inspired by the expanded range of graphic sources that artists could exploit, adapting and editing details to suit their objectives. The group includes banned pornographic images used to construct an anti-Medici allegory and Thornton concludes by contrasting Xanto's indiscreet commentary with the overt messages of dissent in the work of Grayson Perry.

The masterful Xanto also features in the paper by Elisa Paola Sani who contextualises a maiolica *istoriato* dish in the Wallace Collection, London, depicting the Battle of Mühlberg of 1547 on the River Elbe in Saxony, one of the greatest victories of the Holy Roman Emperor Charles V. Although Renaissance patrons preferred battle subjects from antiquity, this rare subject, a contemporary military encounter, appears on a small group of wares. Sani explains how Xanto and others used war imagery as imperial propaganda to glorify their patrons, elevating their heroic status to those of the Roman Caesars whom they emulated. This dish and its subject matter glorified Charles V and his

war against Protestantism to preserve the integrity of the Holy Roman Empire, equating his military enterprises with ancient history, such as the conversion of Emperor Constantine at the Battle of the Milvian Bridge in AD 312.

Staying in Europe but progressing a century, Claire Blakey and Rachel King question the role of print sources in understanding the problematic subject of lead-glazed relief-moulded ceramics attributed to the French potter Bernard Palissy and the body of post-Palissean wares, most often identified as copies. They argue that the three-dimensional designs were based on a variety of interdisciplinary materials and were only indirectly inspired by prints of the Fontainebleau School and others. Their methodology focuses on a dish in the Burrell Collection in Glasgow with the design of *Henri IV and Family*, an extremely popular model reproduced into the 19th century, which is after a print published in 1602. The design securely identifies it as post-Palissy ware. However, having observed that prints were recopied repeatedly in cheaper media, graphics allowed later potters more agency and creative autonomy, eschewing the usual labels of 'followers' or 'imitators' of Palissy.

Helen Glaister tackles cross-cultural interactions, specifically the employment of European print sources in the fabrication of Asian figural sculpture for commercial markets in Europe in the mid-18th century, and asks to what extent these figures represented the exoticised 'other' or perhaps a nostalgic 'self'. A shared fascination with foreignness may be observed in the contemporary visual and material culture of China, where Europeans featured alongside other nationalities and ethnicities then considered at the periphery of the Sino-centric world. A group of three models, probably part of one order, depicting a Frankfurt Jewess, a Polish Jew and a Turkish dancer, are defined through the reading of their ethnic costumes borrowed from the publication, *Neu-eröffnete Welt-Galleria* (1703). The figures elicit discussions about the movement of Jewish communities between London, Amsterdam and Vienna, as well as the Ottoman Empire, and about how costume and physiognomy, namely beards, contributed to the Jewish identity. Glaister concludes that understanding these figures depends entirely on the context in which they were originally seen.

The next five papers examine European prints and ceramics in the 18th century, when the use of graphic sources was extremely widespread. Catrin Jones deconstructs an ormolu-mounted Meissen porcelain *bourdaloue*, or chamber pot, in the Holburne Museum in Bath, in order to explore the layered sexual narratives of its original decorative scheme, and considers the representation of women as the subject matter depicted on, and as consumers of, desirable porcelain. Traditionally, gilt-metal embellishments reflected changing tastes and were employed to integrate disparate objects into coherent visual stories in the fashionable interior. Here, however, as Jones reveals, the addition of an assemblage of mounts is more about disguise and conceit, transforming and repurposing the *bourdaloue* in its afterlife and for its last patron.

European prints were not only used by Chinese potters for shapes and figures, but they also provided design sources for painters. In my own paper I looked at one of the most celebrated Chinese porcelain armorial table services made for the Anson family. Its central image is painted with a romanticised landscape incorporating the life-giving breadfruit tree discovered during Admiral George Anson's famous voyage round the world in 1740–4. The depiction is based on an illustration in his luxurious publication of 1748. Little known until the 1950s, the service took on a life of its own when a family anecdote was exploited to validate the achievements of the Admiral. Here, I revise the popular myth using evidence from the engraver's accounts and other documents to adjust the timeline for this important Chinese armorial ware, and in the process challenge 75 years of accepted dogma.

While the British are usually acknowledged as the inventors of transfer printing on ceramics, Alessandro Biancalana refutes this, demonstrating that the Italians were the first innovators. Reflecting on iconographic print sources employed at the forefront of ceramic design, Biancalana considers those associated with the Italian porcelain factory founded at Doccia, near Florence, by Marchese Carlo Ginori. His experimental transfer printing on porcelain was executed under the glaze in cobalt blue between 1748/9 and 1752/3. With access to the factory's archives, Biancalana explores the importance of print culture at the manufactory, and the potential impact of this new invention on Florentine culture and the city's economic growth. Using primary sources and gathering transfer-printed examples of all the known sources adapted by the potters at Doccia, a fuller understanding of the factory's agenda is elucidated.

Sheila O'Connell examines the celebrated, but enigmatic, Irish-born porcelain painter and artist, Jefferyes Hamett O'Neale, who was active in the second half of the 18th century. Building on her study of his oeuvre, the paper introduces ceramic historians to O'Neale's satirical and political anti-government prints, and print historians to his work on imported Chinese and English porcelain. O'Neale's distinctive hand is immediately recognisable in both mediums. O'Connell then clarifies the problematic dating of the various editions of his well-known series of ornamental prints published in *The Ladies Amusement*. She concludes by resolving the mystery of O'Neale's working life post-1770, when he is no longer employed to paint on ceramics.

A utilitarian creamware ale mug transfer-printed with a poignant scene of Louis XVI's final meeting with his family before his execution, known as *La dernière entrevue* or *The Last Interview*, is investigated by Caroline McCaffrey-Howarth. The ideologically charged mug can be understood as an object of pro-imperialist rhetoric located within wider political visual strategies seeking to celebrate monarchical hegemony. However, given the rising Republican sentiments within regional Britain in the 18th century, especially in cities such as Liverpool, where the object was most likely produced, McCaffrey-Howarth has argued the mug also possessed the agency to act as a political tool confirming that monarchical and aristocratic power structures could be challenged in England, as well as in France.

Historic Japanese ceramics are rarely imbued with political messages, and, consequently, Mary Redfern has looked at ceramics depicted in graphic still-life compositions created within Japan's popular poetry clubs (*kyōka*). In the

late 18th century such clubs bridged social divisions. While the objects portrayed within these *surimono* – privately printed woodblock prints for special occasions – may only be imagined, the prints offer a unique glimpse of ceramics from the perspective of this literary sphere. Their commissioning was restricted to the heyday of *kyōka* circles. Redfern explores Katsushika Hokusai's series, *Everything Concerning Horses* (1822), to gain an understanding of the social networks from which they were drawn. Her analysis considers the playful puzzles of allusion crafted between poet, artist and recipient to discover the true place of ceramics, not just those represented in commercially published prints.

Examples of anti-slavery china made at the Minton factory in Staffordshire between 1829 and 1845 are the focus of a paper by Ronald W. Fuchs II and myself. They look beyond bone china's association with genteel and feminine activities, to its intended use by abolitionists to domesticate and normalise the idea of abolition. The choice of images and text transfer-printed on plates, jugs and teawares, as well as needle-books, bags and pincushions, particularly the kneeling enslaved woman holding a Bible, also made abolition less threatening. A group of unmarked wares appears to have been produced by Thomas Minton for the Female Society for Birmingham; these were sold to raise money, awareness and questions in people's minds about what they should do to end slavery.

In the final paper Mary Ginsberg discusses the use of propaganda symbols on mid-20th-century domestic teapots in Revolutionary China, from the founding of the People's Republic of China in 1949 through the Cultural Revolution and the death of Chairman Mao in 1976. These symbols were borrowed from popular print culture aimed at promoting revolutionary goals among the proletariat. The new visual language was typically appropriated from familiar motifs and legends to introduce innovative ideas and radical concepts, which were repeated across media. Examples include the work of Lu Xun, who founded the Modern Woodcut Movement, employing prints as an agent for social change. Ginsberg concludes with a discussion of how these symbols were used in propaganda campaigns delivering different messages, officially and unofficially.

Ceramics with agendas, painted or printed, surround us; although often hidden in plain sight they require an enquiring mind to discover and interpret a maker's original motive or intention. Graphic sources frequently hold the key to understanding their meanings and, ultimately, the reason these objects were created. Individually, each paper herein contributes to ongoing research within their distinct cultural sphere, but collectively the publication builds on a less-studied theme addressing print culture and its impact on commercial and social networks, design, production and significance within ceramic studies, and, even more profoundly, on society as a whole. The constantly changing political climate that nurtured these agendas, many a response to toxic social attitudes, such as racism and discrimination, fuelled their creation. The role of prints in political communication, the rise of public opinion and national identities accelerated with the circulation of large quantities of images, whether in the form of cheap mass-produced popular prints or deluxe fine art. Like printers, potters followed these developments primarily for commercial gain, but in some instances at personal cost or as forced propaganda. This timely volume with its 15 essays makes a valuable contribution to the field of ceramics, prints and politics with the aspiration that it will inspire future research, exhibitions and publications.

Acknowledgements

This publication would not have been possible without the support of the Monument Trust, which funded my position at the British Museum in 2017–18, as Project Curator, 18th-century Prints and Ceramics, an interdepartmental post between Prints and Drawings, and Britain, Europe and Prehistory. I am immensely grateful to Hugo Chapman, Jill Cook, Judy Rudoe and Jonathan Williams for the opportunity to work with the British Museum's amazing collections. In addition to the speakers at the study day and the authors in this publication, I would also like to thank the following for their generous assistance and thoughtful advice, especially Aileen Dawson, Lloyd de Beer, Jessica Harrison-Hall, J.D. Hill, Edward Hulme, Nicole Coolidge Rousmaniere, Naomi Speakman, Clarissa von Spee, Victoria Stopar and Dora Thornton, as well as the following in planning and organising the study day: Gaetano Ardito, Joseph Borges, Isabella Coraça Vajano, Adrienne Johnson and Jan Peters. I am indebted to the following who enlightened this publication with their specialist knowledge on the miscellaneous subjects covered within it: Rose Kerr, Stacey Pierson, Antony Griffiths, John Mallet, Connie Wan, Derek and Diana Davis, Sharon Liberman-Mintz, Sophie Heath, Laura Crook Woodward, Alfred Haft, Nicola Scott, Melissa Atkinson, Vanessa Salter, Bridget Guest, Liz Street, Carrie Blough and Terese Austin. I am especially honoured for the publication to have received funding from the Ceramica-Stiftung Basel. Most importantly, I am indebted to Sarah Faulks, Senior Editorial Manager: Research Publications at the British Museum, for all her advice, support and encouragement.

Notes

1 For example, Paul Scott has used traditional blue-printed ceramic art to comment on environmental issues, see Scott 2012 and Scott 2015.

2 See the work of Hisono Hitomi, *Food Heaven: Seven Sister's Road*, 2018 (British Museum, 2018,3018.9), created especially for the *Manga* exhibition in 2019, at the British Museum, curated by Nicole Coolidge Rousmaniere, who also commissioned the work.

Chapter 1
Pots, Prints and Politics in China? Some Examples from the 14th to the 17th Centuries

Luk Yu-ping

'Pots with Attitude: British Satires on Ceramics, 1760–1830', a display curated by Patricia Ferguson in Room 90a at the British Museum, showcased the ceramic objects that were the result of English potters adopting the new technique of transfer printing from copper plates and the development of satirical prints with political agendas in London. The display and one-day workshop on the theme prompted the question of whether a similar phenomenon appeared in other cultures and periods in history. China, for instance, has long and celebrated histories in printmaking and the production of high-fired ceramics. Did these major areas of visual and material culture in China interact to communicate political messages prior to the 20th century?

China began producing translucent white porcelain by the late 6th century, but it had the ability to produce high-fired ceramic vessels long before then.[1] Jingdezhen 景德鎮 in Jiangxi province, south-east China, emerged as the porcelain capital of the world by the 17th century, and the material of porcelain, also known as 'china', would become synonymous with the country. The history of printing on paper in China had developed by around AD 700.[2] The *Diamond Sutra*, produced in China in AD 868, is the world's earliest dated complete printed book.[3] Woodblock printing in China reached a new level of sophistication around the 17th century, when the multi-block polychrome printing technique was mastered. Other techniques, such as copper engraving, were introduced from Europe to China from the beginning of the 18th century.[4] Transfer printing, the technological innovation that facilitated the appearance of British satires on ceramics, was adopted during the late 19th or early 20th century.[5]

Traditionally, images on Chinese ceramics were hand-painted under or over the glaze, incised, or made through sculpting and moulding. Compared to transfer printing, these techniques have a less direct relationship with printed images. Furthermore, the link between printmaking and ceramic cannot be taken for granted since the decorators of Chinese ceramics probably relied more on model drawings than illustrations from printed books.[6] It has thus been necessary to explore and establish the connection between printed images and images found on Chinese ceramics.[7] In addition, there has been interest in exploring the links between 'pots and politics' and 'prints and politics'.[8] But addressing the three 'Ps' together – where images on ceramics are based on prints and show engagement with political power and dissent prior to the 20th century – presents a specific challenge. This chapter studies three examples that date from the 14th to the 17th centuries, and examines the basis for political readings of these works.

The role of prints in the creation of imperial vessels

Politics, narrowly defined, concerns the state and its governance. This brings the discussion to the imperial court in China. Codified ritual (*li* 禮) was a key part of imperial rulership.[9] A ritual system that utilised appropriate ritual vessels was necessary for the performance of state and local ceremonies devoted to the worship of heaven, earth and other focal points of veneration.[10] A ruler who established correct practices modelled on those of the ancient past demonstrated imperial legitimacy and his inheritance of the

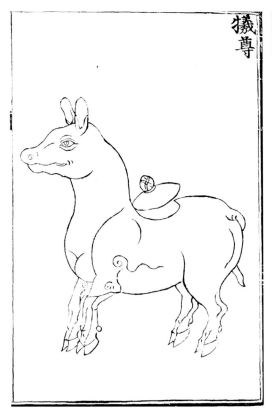

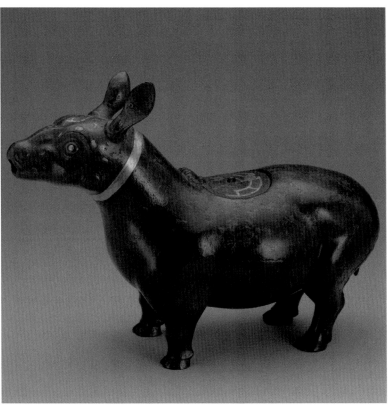

Figure 1 Image of the animal-shaped vessel *xizun* in the *Collected Rites of the Great Ming (Da Ming jili* 大明集禮), preface dated 1530. Fu Sinian Library, Academia Sinica, Taipei. Courtesy of the Institute of History and Philology, Academia Sinica

Figure 2 Animal-shaped wine vessel, 375–276 BC, China, bronze inlaid with malachite and turquoise, h. 28.6cm. Collection of the National Palace Museum, Taipei

mandate to rule. Classic texts such as *Zhouli* 周禮 (Rituals of Zhou), a late Warring States (*c*. 480–221 BC) or Qin dynasty (221–206 BC) text on the government of Western Zhou (*c*. 1046–771 BC), formed the basis of imperial ritual systems of successive dynasties.[11]

The ritual vessels of the Shang (*c*. 1600–1046 BC) and Zhou (*c*. 1046–256 BC) in ancient China were made of bronze. During the Northern Song dynasty (960–1127), bronze vessels of these early dynasties became the subject of antiquarian study and printed illustrated catalogues. This includes the *Illustrated Antiquities from the Xuanhe Hall, Revised (Chongxiu Xuanhe bogutu* 重修宣和博古圖, completed after 1123), which was commissioned by Emperor Huizong 徽宗 (r. 1100–26).[12] This catalogue recorded and classified bronzes in the Song imperial collection. The printed images of the catalogue also served as models for making replicas that were used in ritual.[13] In addition, Huizong used the *Illustrated Antiquities* as a political tool to demonstrate his power and to control those who opposed him by criticising them in the catalogue.[14]

Printed books with illustrations became particularly important at times when access to ancient bronzes was lost. When the Northern Song dynasty fell to the Jurchens from the north in 1127, many of the ancient ritual bronzes in the imperial collection were destroyed.[15] The Southern Song (1127–1279) Emperor Gaozong 高宗 (r. 1127–62), who had retreated to the south to establish the court in Hangzhou, had to rely on printed books to cast new vessels and restore the imperial ritual system.[16] Similarly, later in the Ming dynasty (1368–1644) when the Xuande 宣德 emperor (r. 1425–35) wanted to have ritual vessels made in an antique

bronze style, his officials had to consult printed books such as Huizong's *Illustrated Antiquities* noted above as well as vessels made of ceramic to fulfil the command.[17] Printed illustrated texts became a necessary source for determining the design of imperial ritual vessels. These records, however, were not always consistent in their illustrations of ancient vessels. For instance, a vessel for sacrifices known as *xizun* 犧尊 appears in Song-dynasty printed books as either an animal-shaped vessel with an opening on its back or a jar-shaped vessel with an animal motif on its body.[18]

During the Ming dynasty there were attempts to reconcile different records of ancient ritual vessels, as discussed below. It was also during this time that a significant transformation in ritual vessels took place: porcelain replaced bronze as their primary material.[19] While some examples of this existed from the Song dynasty, it was in the Ming dynasty that porcelain was specified by imperial decree to be the material of ritual vessels in a wide range of contexts.[20] One of the main reasons given for this change is the need for frugality at the beginning of the dynasty, since porcelain objects were cheaper to produce than those in bronze.[21] There was also an increasing tendency from the Song dynasty onwards to have ritual vessels look like daily utensils.[22]

The development of the jar-shaped *xizun* shows the coming together of 'pots, prints and politics', as well as the experimentation with different designs during the Ming dynasty. An image of the *xizun* as a vessel in the shape of an animal made of bronze is included in the official *Collected Rites of the Great Ming (Da Ming jili* 大明集禮), published in

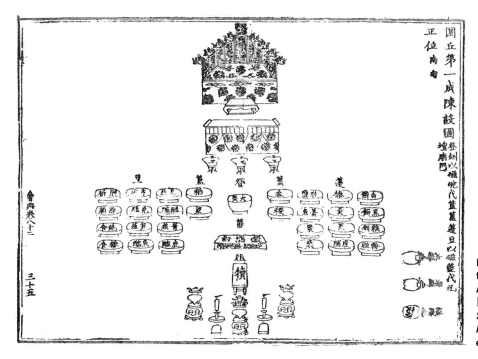

Figure 3 Illustration of the display on the first level of the Circular Mound Altar (*Huanqiu diyicheng chenshe tu* 圜丘第一成陳設圖), *Collected Statutes of the Great Ming* (*Da Ming huidian* 大明會典), reprint of the 1587 edition (Taipei, 1963), *juan* 82, 1298–1

1530 and based on an edition sanctioned by the founder of the dynasty, completed in 1370 (**Fig. 1**). According to the accompanying textual description, this *xizun* vessel is in the shape of cattle (*niu* 牛). This image can be compared to a surviving example of this vessel from the 4th to 3rd centuries BC (**Fig. 2**). However, the official interpretation of the *xizun* would change over time. In the later *Collected Statutes of the Great Ming* (*Da Ming huidian* 大明會典), completed in 1587, the *xizun* is clearly understood as a vessel with an animal motif as seen in the bottom right corner of an illustration showing the layout of ritual vessels for an imperial altar (**Fig. 3**).[23]

Judging by extant Ming objects, the imperial court by the middle of the dynasty had accepted the idea of the *xizun* as a porcelain vessel with an animal motif. Two examples of this design survive from the Hongzhi 弘治 period (1487–1505), both with a dark blue glaze and a pair of handles on the shoulder (**Figs 4–5**). The blue glaze indicates they were made for use at the altar to Heaven in the capital Beijing.[24] According to the image in the *Collected Statutes*, the vessels probably once had a cover. The images painted in gold show more naturalistic-looking animals, one with horns in the form of an ox and the other without horns and probably female.[25] A third example is in the Baur Foundation, Geneva, and is from the later Jiajing 嘉靖 reign (1521–67) (**Fig. 6**).[26] It has the same shape and blue glaze as the Hongzhi vessels, but it carries a more stylised image of the hornless animal. These

Figure 4 Jar, Hongzhi period, 1487–1505, Jingdezhen, China, blue-glazed porcelain with animal design painted in gold, h. 32.2cm. Palace Museum, Beijing. Image provided by the Palace Museum, Beijing. Photo Feng Hui

Figure 5 Jar, Hongzhi period, 1487–1505, Jingdezhen, China, blue-glazed porcelain with animal design painted in gold, h. 32cm. Palace Museum, Beijing. Image provided by the Palace Museum, Beijing. Photo Wang Jin

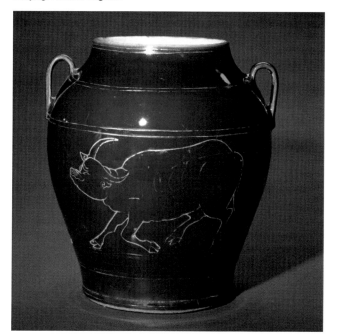

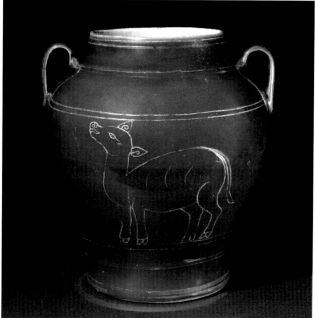

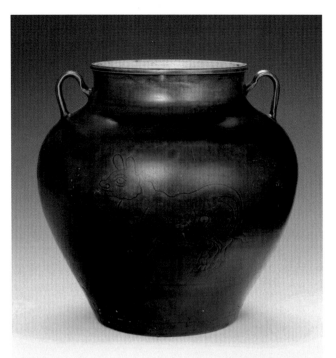

Figure 6 Jar, Jiajing mark and period, 1521–67, Jingdezhen, China, blue-glazed porcelain with incised design, h. 25.8cm. Baur Foundation, Geneva. Photo Marian Gérard

Figure 7 Jar, Yuan dynasty (1271–1368), Jingdezhen, China, porcelain, painted in underglaze blue, h. 27.5cm. Acquired by Eskenazi Limited. Photo © Christie's Images/Bridgeman Images

few surviving examples show there was exploration not only in terms of the form of the *xizun* but also in the motif that should be drawn on the vessel once its form was decided.

Shih Ching-fei notes that the motif on the Baur Foundation vessel looks very similar to the woodblock-printed image of the *xizun* in the *Collected Rites*.[27] The overall appearance and particularly the lines above and below the eye as well as the curled line on the rear leg correspond to the print. However, the two are not identical, which suggests the maker of the image on the porcelain was basing the drawing on an impression of the print rather than directly copying from it. The impression shown is that of a static object rather than the outlines of a lively animal in motion as implied in the Hongzhi examples. In other words, the motif incised on the Baur Foundation vessel evokes the appearance of an archaic bronze vessel based on the image in the *Collected Rites*. Yet, one notable difference is that the covered opening depicted in the printed image, which identifies the object as a vessel, has been omitted from the image on the porcelain.[28] The result is an image that is both an archaic bronze mediated by woodblock printing, and an animal. It seems there was a compromise between the idea of the *xizun* as an animal-shaped vessel and a vessel with an animal motif. It is an innovative solution to two different understandings of the *xizun* design, both of which existed in the Song records. It also points to a ruler – the Jiajing emperor – who was prepared to reinterpret or 'improve' upon the past. The Jiajing reign was a period when the imperial ritual system was widely reformed.[29] This was connected to the emperor's power struggle as an indirect heir to the throne and a descendant of a side branch of the imperial family.[30] The change to the *xizun* design can be viewed as a part of these reforms.

For the current discussion, it is notable that the woodblock-printed image stood in place of an archaic

bronze vessel as the basis for the image on the Jiajing porcelain *xizun*. Moreover, this image is incised rather than painted, which is another point of difference with the Hongzhi examples. The technique of incising on the leather-hard ceramic bears some resemblance to the act of carving on woodblock. It may be speculated that the printed image on which the porcelain motif is based expressed legitimacy primarily because of its ties to a printed edition compiled by the founder of the Ming dynasty rather than its links to an actual archaic bronze. It is a sense of a printed lineage that seems to be referred to in the design of the motif and the act of adding it to the surface of the Jiajing porcelain vessel.

Dissent in Yuan-dynasty blue-and-white wares

The Jiajing ritual vessel discussed above is a rare example where an incised decoration has been linked to a printed image. Instead, hand-painted images over or under the glaze, with their potential for a variety of figural and narrative depictions, present the most likely connections between ceramic decoration and printed images in China. Such links have been suggested for underglaze blue (blue-and-white) porcelain made in Jingdezhen, Jiangxi province, from as early as the 14th century during the Yuan dynasty (1271–1368) and perhaps even earlier in Cizhou 磁州 stoneware from the Song and Jin dynasties (1115–1234) painted with overglaze iron-oxide decoration.[31]

Blue-and-white porcelains made in the 14th century are usually decorated with flora and fauna (both real and mythical), as well as other patterns. In addition, there is a special category of Yuan blue-and-white wares of around 20 known examples that depict narrative scenes with figures.[32] Most of the subject matter of these images has been identified and linked to a form of drama known as *zaju* 雜劇 (variety play) that flourished during the Yuan dynasty.[33] Specifically, around half of them represent famous historical

characters who were loyal subjects and cultural or military heroes.³⁴ They include:

• Jar depicting Guiguzi 鬼谷子 (Master of the Ghost Valley), a military strategist of the Warring States period, coming out of seclusion from the mountains (Eskenazi Limited) (**Fig. 7**);
• Vase depicting General Meng Tian 蒙恬 (d. 210 BC) of the Qin dynasty (Hunan Provincial Museum);
• Jar depicting General Zhou Yafu 周亞夫 (d. 143 BC) of the Han dynasty (Museum of Oriental Ceramics, Osaka);
• Jar depicting 'Xiao He 蕭何 pursues Han Xin 韓信 under the moon', which tells the story of Han Xin (231–196 BC), who was recommended to the future founder of the Han dynasty, Liu Bang 劉邦 (r. 202–195 BC), by a high-ranking official, Xiao He (d. 193 BC). Initially Han Xin was not held in esteem so he decided to leave in disappointment. The scene shows Xiao He chasing after Han Xin on horseback to persuade him to return (Nanjing Municipal Museum);
• Vase with cover depicting 'Three visits to the thatched cottage', which tells of the future ruler of the Shu Kingdom, Liu Bei 劉備 (AD 161–223), visiting the military strategist Zhuge Liang 諸葛亮 (AD 181–234) thrice to persuade him to serve (Museum of Fine Arts, Boston);
• Two jars depicting 'Yuchi Gong 尉遲恭 saves his master', where General Yuchi Gong (AD 585–658 BC) saves the Tang Emperor Taizong 太宗 (r. 626–49) from an ambush (Nanning Museum and Museum of Fine Arts, Boston);
• Jar depicting 'Zhaojun 昭君 leaving the pass behind', which tells the story of Lady Wang Zhaojun 王昭君 (c. 54–19 BC), who was sent by the Han-dynasty (206 BC–AD 220) emperor to the frontier in a marriage alliance with the nomadic Xiongnu 匈奴 of the Steppe (Idemitsu Museum of Arts, Japan) (**Fig. 8**).

Notably, the large jar depicting the story of Guiguzi has been convincingly linked to a woodblock-printed illustration of this scene in one of the titles included in the *Five Completely Illustrated Plain Tales* (*Quanxiang pinghua wuzhong* 全相平話五種), published in 1321–3, a single copy of which survives in the Naikaku Bunko (Cabinet Library), Japan (**Fig. 9**).³⁵ These

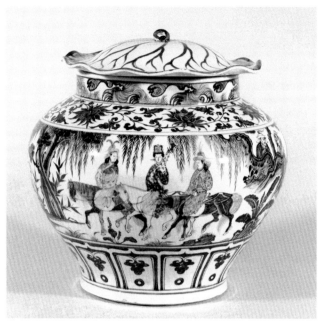

Figure 8 Jar and cover, Yuan dynasty (1271–1368), Jingdezhen, China, porcelain, painted in underglaze blue, h. 28.4cm. Idemitsu Museum of Arts, Tokyo, Japan

plain tales were popular reading material, printed with illustrations on the upper section of the page above the relevant text. The scene shows Guiguzi coming out of seclusion in the mountains in order to save his disciple who had been captured at war. He is portrayed as a monk or a supernatural being, sitting in a carriage pulled by tigers. The messenger who had travelled to the mountains to alert him of the news is depicted to the right. There are some differences between the compositions on the porcelain jar and the print, such as the presence of another military figure on horseback behind Guiguzi that is not found on the print, but they are sufficiently alike in the overall layout and iconographic features of the figures to suggest that this or another printed version of the story could have been the basis for the painted scene on the porcelain jar.

Some of the other subject matter in the above list also appears in printed book illustrations, although none matches

Figure 9 Pages from the *Five Completely Illustrated Plain Tales* (*Quanxiang pinghua wuzhong* 全相平話五種) showing 'Guiguzi coming down from the mountain', 1321–3, woodblock-printed book Jian'an (present-day Jian'ou), China. Naikaku Bunko (Cabinet Library), Tokyo, Japan. Courtesy of National Archives of Japan Digital Archive

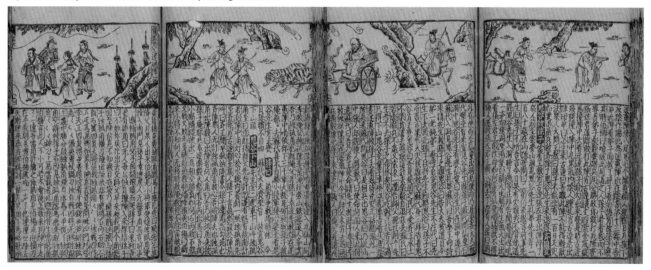

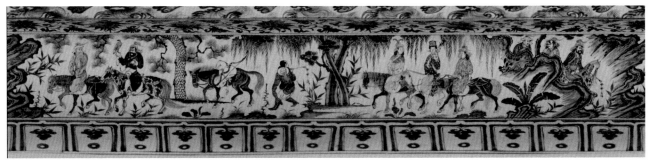

Figure 10 Complete scene from Figure 8

as closely as Guiguzi.³⁶ On the other hand, the rare survival of two single-sheet woodblock prints dated to the Jin dynasty, found at Kharakhoto (Ch. Heishuicheng 黑水城), Inner Mongolia, provides evidence that connects printing and theatre culture.³⁷ One of the two prints portrays the 'Four Beauties', which include Wang Zhaojun, who is depicted on the jar in the Idemitsu Museum of Arts, Japan. The second print shows General Guan Yu 關羽 (d. 220), who served Liu Bei, also mentioned in the list above. Probably made for decorative purposes, these two prints were produced by commercial print shops in Pingyang 平陽 (modern Linfen 臨汾, Shanxi province), which was a printing and theatrical centre in northern China during the 13th and 14th centuries.³⁸ Taken as a whole, these examples suggest the circulation of visual imagery and narratives that moved across ceramic decoration, print and theatre during the Jin–Yuan periods.

The subject matter of the blue-and-white porcelains listed above is notable for its celebration of military and cultural heroes who were loyal to Han Chinese rulership. This is significant since China during the Yuan dynasty was under the rulership of the Mongols, who were originally nomadic pastoralists from the north. It has been suggested that the appearance of such narratives on these decorated vessels, and their popularity in Yuan drama, is related to the social tensions between the Han Chinese and their Mongol rulers, and may even express anti-Mongol sentiment.³⁹ The abolishment of the civil service examinations during this period led to the loss of status of the literati and, for many, the opportunity to serve in government. Some scholars turned to playwriting for their livelihood, which is a factor in the rapid development of this art form.

Unfortunately, there is no information about the early owners of these blue-and-white vessels that can provide some clue to their reception. One exception is the jar depicting 'Xiao He pursues Han Xin under the moon', which was excavated from the tomb of the early Ming General Mu Ying 沐英 (1345–92) located in Nanjing.⁴⁰ Mu Ying was pivotal in expelling the Mongols from China for the subsequent Ming rulers. The story of a talented military official seeking an appreciative master would have resonated with him. However, if this jar was indeed made in the Yuan dynasty as many believe, rather than in the early Ming, then it would have had an earlier provenance that is no longer known. Furthermore, the Mongol court also patronised *zaju* especially in the early part of the dynasty.⁴¹ The theme of unwavering loyalty to the ruler is equally applicable to those serving under the Mongol rulers as in previous dynasties. As

such, caution needs to be exercised when applying a political reading to these narrative decorations.

Of the examples identified above, there is reason to believe that the jar depicting the story of 'Zhaojun leaving the pass behind' carried subversive meaning. This historical tale from the Han dynasty was transformed in the Yuan as a play entitled *Autumn in the Han Palace* (*Han gong qiu* 漢宮秋).⁴² As Hongchu Fu notes, there were two major points in the play that diverged from historical records: instead of going ahead with the marriage alliance, Lady Wang Zhaojun commits suicide by throwing herself into a river on the way to the frontier.⁴³ Moreover, the power dynamics between the nomadic Xiongnu and the Han dynasty were reversed in the play so that the Xiongnu could force the emperor to give up his concubine. As Fu observes, this 'was a potentially subversive force' in the context of the Mongol rule of China.⁴⁴ Wang Zhaojun's suicide and her rejection of Han China's enemy heighten the sense of patriotism in the play, while the portrayal of the weakness of the Han dynasty could easily be associated with the fall of the Song dynasty that led to the Mongols conquering China. An abrupt U-turn in the narrative whereby the Xiongnu were so moved by Wang Zhaojun's suicide that they continued to pursue an alliance with the Han dynasty may be read as the playwright's effort not to offend the Mongol censors.⁴⁵ Kanazawa Yo links the narrative decoration of the jar from the Idemitsu Museum of Arts with scenes from *Autumn in the Han Palace*. The jar is depicted with a procession of Xiongnu flanking Wang Zhaojun as they travel to the frontier. But the direction of the procession suddenly reverses when the Xiongnu leader who would marry Wang is shown facing the opposite direction and looking downwards in a dramatic rocky scene, which according to Kanazawa Yo suggests Wang's suicide (**Fig. 10**).⁴⁶ If we take this interpretation one step further, then the decoration on the jar, which may be based on a lost print or a well-known scene in a performance, can be read as expressing subversive, anti-Mongol sentiment in the same way that the play *Autumn in the Han Palace* transformed the story of Wang Zhaojun in the Yuan dynasty.

Censorship and reception of blue-and-white wares in the late Ming dynasty

The issue of censorship also becomes a factor in relation to images on later, 17th-century blue-and-white porcelain. This is discussed by Stephen Little in his publication on porcelain produced in the late Ming and early Qing dynasties (1644–1912) – a so-called 'transitional' period when the imperial

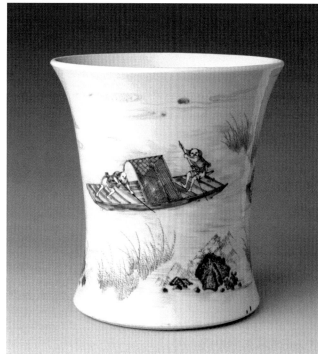

Figure 11a–b Brush pot (front and back), 1636, Jingdezhen, China, porcelain, painted in underglaze blue, h. 23.5cm. The Metropolitan Museum of Art, New York, 2020.73.5. Gift of Julia and John Curtis, in celebration of the Museum's 150th Anniversary, 2020

kilns temporarily ceased operation in Jingdezhen.[47] As a result, potters and their workshops could cater to the market more freely, which led to greater variety in production. This period also saw the development of vibrant book publishing and printmaking cultures in urban centres. Stories from dramas, novels and histories that were printed and circulated provided potters with rich sources of inspiration. Narrative content that was still rare on Yuan-dynasty wares would become a feature of 17th-century ceramics from Jingdezhen.

One of the examples that Little discusses is a concave brush pot with an incised inscription dated 1636 showing two scenes of fishermen on boats, now in the Metropolitan Museum of Art, New York (**Fig. 11a–b**).[48] Little finds that this composition closely resembles a woodblock-printed illustration in an edition of the novel *Water Margin* (*Shuihu zhuan* 水滸傳) printed around 1610 to 1640 (**Fig. 12**).[49] *Water Margin* is a classic novel written in the 14th century that tells the stories of a group of outlaws from the Song dynasty, many of whom had been forced to join gangs due to corrupt officials. The particular image in question depicts a rebel leader Wang Qing 王慶 beckoning fishermen to help him cross a river to evade capture.[50] Wang Qing is shown waiting at the shore for a boat to reach him, while another group of fishermen enjoys drinking and merrymaking in the upper part of the composition. Little argues that the same pictorial elements can be identified on the two sides of the 1636 brush pot, with one notable difference: Wang Qing is not represented in the image.

According to Little, the omission of the key figure of Wang Qing may have been an act of self-censorship as 'the depiction of a popular historical rebel in this period of widespread peasant rebellions was considered dangerous'.[51] Indeed, by 1642, the Chongzhen 崇禎 emperor (r. 1627–44) would try to ban the publication of *Water Margin* because of its seditious content.[52] However, it should be clarified that the character of

Figure 12 Page from a version of the novel *Water Margin* (*Shuihu zhuan* 水滸傳), c. 1610–40, China, woodblock-printed book, ink on paper, 25.8 x 15.9cm. Private collection

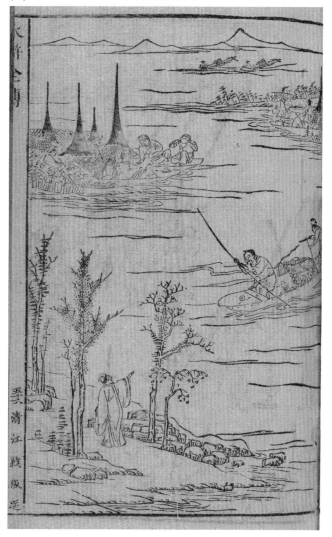

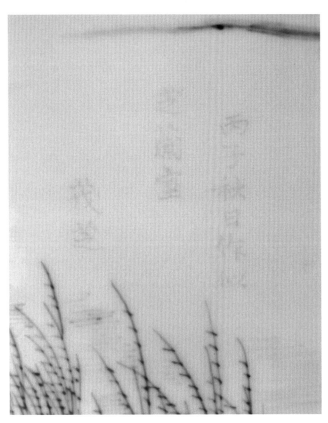

Figure 13 Detail of Figure 11a–b showing the incised inscription on the brush pot

Wang Qing appears in some versions of *Water Margin* as a rebel leader whom the outlaw heroes have to defeat after they were granted amnesty by the Song emperor.[53] The title of the woodblock illustration, seen in the bottom left, reads 'Killing the rebel at the Qing River' (*Qingjiang sha panni* 清江殺叛逆). It shows the dramatic moment before the rebel Wang Qing is tricked onto the boat and captured by one of the former outlaws Li Jun 李俊 pretending to be a fisherman. The hero of this episode is not Wang Qing, the figure on the shore, but Li Jun, the fisherman on the boat, who is shown facing forward, larger in scale and in the middle section of the composition. Nevertheless, if we followed Little's overall argument, audiences who had read this illustrated version of *Water Margin* may have recognised the story and interpreted the figures not as fishermen but heroes of the novel in disguise. At the same time, without Wang Qing, the image on the brush pot can be understood as an innocent scene of fishermen enjoying themselves, which was a popular subject in painting, thus avoiding the association with fictional rebel leaders or outlaw heroes.[54] The incised inscription on the brush pot offers tantalising information about its production (**Fig. 13**):

> Made on an autumn day in the year *bingzi* similar to the Iris and Orchid Chamber, [by] Maozhi.
>
> 丙子秋日作似 芝蘭室 茂芝

The cyclical date *bingzi* should refer to the year 1636 of the 'transitional' period. The rest of this inscription is unusually ambiguous as it does not include words explicitly stating 'made by', 'made for' or 'made at'. However, the order and spacing of the text suggests the painter of the brush pot is Maozhi. Previously, the character *si* 似 ('similar to') was transcribed as *ci* 此 ('this'), which led to the inscription being read as 'made by Maozhi… presented to' the Iris and Orchid Chamber, the assumed recipient of this brush pot.[55] However, the character is unmistakably *si* 似, which means the inscription is comparing the brush pot to something related to the Iris and Orchid Chamber, a person or place that was held in regard by the maker given the raised position of the characters of the name above the rest of the inscription. Could this ambiguity be related to the hidden political meaning of the brush pot that Little suggests?

There is a comparable blue-and-white brush pot from the 17th century in the Palace Museum, Beijing. Notably, this second brush pot also depicts two similar groups of fishermen and carries an incised inscription mentioning the studio name the Iris and Orchid Chamber (**Fig. 14a–b**):

> Made for the Iris and Orchid Chamber on a winter's day in the year *yihai*
>
> 乙亥冬日為芝蘭室製

In this case, the inscription clearly states that the brush pot was made for the Iris and Orchid Chamber. The cyclical year *yihai* most likely refers to 1635, which is only one year earlier than the previous example.[56] The closeness of the dating, the comparable inscription, painting content and style of the two brush pots have led to speculation that they were made by the same person Maozhi.[57] While this second brush pot also depicts two groups of fishermen, the larger group on one side is shown drinking on the shore under a prominent tree. On the other side, fishermen are busy catching fish rather than crossing the river with their poles in their boat. These differences make the image clearly about fishermen busying and enjoying themselves, rather than being a possible reference to the printed illustration of *Water Margin* that carried politically sensitive meaning in the late Ming. It is tempting to postulate that the inscription of the 1636 brush pot is referring to this earlier example, emphasising that they are 'similar' in order to further obfuscate any political reading of the painted image and any clear link to its recipient.

Although it is not possible to prove with certainty that late Ming viewers of the 1636 brush pot connected it to a woodblock printed illustration of *Water Margin*, the potential audience for such a work is worth exploring further. There is no recorded information about Maozhi, the painter of possibly both brush pots, but the Iris and Orchid Chamber is a studio name that is appropriate for a person with a Confucian education or a high level of cultivation. The phrase 'a chamber of irises and orchids' (*zhilan zhi shi* 芝蘭之室) appears in the *Family Sayings of Confucius* (*Kongzi jiayu* 孔子家語) compiled in the 3rd century AD to describe a pleasant environment that has a positive effect on a person.[58] The Yuan-dynasty painter Wang Meng 王蒙 (c. 1308–85) famously painted a handscroll titled *Iris and Orchid Chamber* (*Zhilan shi tu* 芝蘭室圖), which depicts the elegant dwelling of a reclusive monk in Hangzhou.[59] In addition, given that the brush pots depict groups of fishermen, it seems reasonable to assume that their intended audience was a man. Yet, interestingly, in the *Index to the Studio and Alternative Names of Persons from the Ming Dynasty* (*Mingren shiming biecheng zihao suoyin* 明人室名別稱字號索引), there is only one person

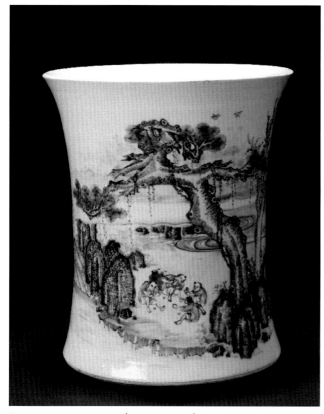
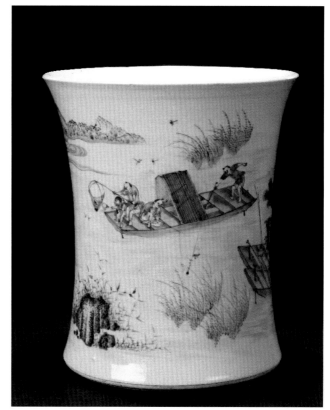

Figures 14a–b Brush pot (front and back), 1635, Jingdezhen, China, porcelain, painted in underglaze blue, h. 24cm. Palace Museum, Beijing. Image provided by the Palace Museum, Beijing. Photo Li Fan

with the studio name 'Iris and Orchid Chamber' whose biography fits the late Ming time period. That person is Xing Cijing 邢慈靜 (b. 1573), a woman poet, calligrapher and painter.[60]

A native of Linyi 臨邑 in present-day Shandong province, Xing Cijing was relatively well known in her own time alongside her brother Xing Tong 邢侗 (1551–1612), who was a metropolitan graduate of 1574.[61] She published her writings and poems, and some of her calligraphy and paintings can be found in museum collections today.[62] She was apparently still alive in the early Chongzhen period, perhaps as late as 1640, and as such, hypothetically speaking, she could have been the owner of the 1635 and 1636 brush pots.[63] It may be difficult to entertain the possibility that a brush pot potentially referencing *Water Margin* had any connections to a woman since this novel is very 'macho': out of the 108 fictional rebel heroes only three of them are women and they are all minor characters. The most famous is probably Pan Jinlian 潘金蓮, the sister-in-law of Wu Song 武松, one of the heroes. Pan was involved in an extramarital affair and the murder of her husband, and she was ultimately killed in the novel. Although there is no record of Xing Cijing's interest in *Water Margin*, there is evidence she appreciated the *Records of the Three Kingdoms* (*Sanguo zhi* 三國志), which is also very much focused on male action and relationships. One of Xing's surviving poems is entitled 'Reading the *Records of the Three Kingdoms*' (*Du Sanguo zhi* 讀三國志),[64] in which she reflects on the fate of the brilliant military strategist Zhuge Liang (AD 181–234), summarising his career and lamenting his final demise in four lines.[65] While the *Records of the Three Kingdoms* is the title of the historical accounts of the Three Kingdoms period (220–80), it was also the basis for the novel

now commonly known as the *Romance of the Three Kingdoms* (*Sanguo yanyi* 三國演義), which was titled *Popular Elaborations of the Records of the Three Kingdoms* (*Sanguo zhi tongsu yanyi* 三國志通俗演義) in the 1522 edition.[66]

There is in fact a third known blue-and-white brush pot from the 17th century that carries an inscription referring to the Iris and Orchid Chamber (**Fig. 15**).[67] It happens to

Figure 15 Brush pot, 1626, Jingdezhen, China, porcelain, painted in underglaze blue, h. 21.2cm. Private collection. Reprinted with permission from Michael Leung Hiu Sun (ed.) 2017. *Commissioned Landscapes: Blue & White and Enamelled Porcelain of the Seventeenth Century*, exh. cat., China Guardian Auctions, Beijing, cat. 69

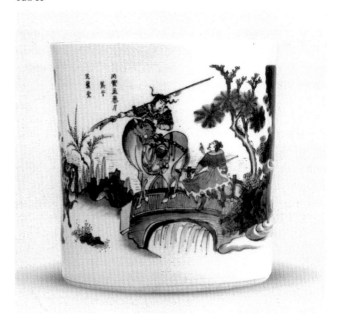

depict a narrative scene from the *Records of the Three Kingdoms* showing Cao Cao 曹操 AD 155–220), lord of one of the Three Kingdoms, bestowing a robe on the military hero Guan Yu 關羽 (d. AD 220), who was loyal to another ruler. The inscription reads:

> Written at the Iris and Orchid Chamber in the first month of spring in the year *bingyin*
>
> 丙寅孟春月寫於芝蘭室

The cyclical year *binyin* 丙寅 most likely refers to 1626, making this the earliest of the three brush pots. It would be remarkable if this brush pot could be connected to Xing Cijing. However, it is impossible that the Iris and Orchid Chamber here refers to her since it was 'made at' this place. As far as it is known, Xing returned to her native place in Shandong after her husband who was an official passed away in 1616.[68] Porcelain objects with underglaze blue decoration like this brush pot were produced in Jingdezhen, Jiangxi province, far away from Linyi in Shandong province, so in this case the name should refer to a different location or person.

Nevertheless, Xing Cijing's poem 'Reading *Records of the Three Kingdoms*' complicates expectations about the gender of the audience for such stories and images in the late Ming period. In prosperous urban centres of China during the 17th century, women who came from literary families or were trained as courtesans had access to education and took part in literary circles and the publishing world.[69] It is not inconceivable that they could have had access to popular novels like *Water Margin* just as male audiences did, and appreciated porcelains painted with scenes from these stories, including ones that potentially expressed political and critical points of view.

Conclusion

The example of imperial ritual vessels discussed in this chapter shows the importance of printed images as records and models of production that could also be used to express political meaning. However, political views that were critical of those in power tend to be subtly expressed, most likely because of censorship or fear of repercussions. There is a long tradition among the educated elite in China of using painting and literary compositions for 'discreet remonstrance and criticism'.[70] Thus, the satire shared in 18th-century English print media and ceramics was not a cultural phenomenon that can be observed in China in the earlier period addressed in this chapter. From the 19th century onwards, new forms of political press and satirical cartoons emerged in China and many more examples of everyday ceramics with political messages would also appear.[71]

Notes

1 For an introduction to Chinese ceramics, see Krahl and Harrison-Hall 2009.

2 von Spee 2010, 15.

3 This was found in Cave 17 ('Library Cave'), Mogao Caves, Dunhuang, at the beginning of the 20th century and is now kept in the British Library.

4 For an introduction to the history of printed images in China, see von Spee 2010.

5 Liu 2008, 216. Liu suggests that transfer printing was introduced after lithography, which was not widely used until 1876. On lithography in China, see Pang 2007, 40.

6 Clunas 1981–2, 75.

7 Clunas 1981–2; Hsü 1986; Little 1990; Zhou 2015; and others mentioned in this chapter.

8 Imperial porcelain production and collecting in China are major areas of study in which politics and imperial power are discussed directly or indirectly. For instance, Harrison-Hall 2001 surveys Ming ceramics by reigns and highlights how emperors' decisions affected porcelain production. On printmaking and politics see, for instance, essays in Chia and De Weerdt 2011 and in Jang 2008; the latter studies printmaking at the Ming court.

9 On the state and ritual in China see, for instance, McDermott 1999.

10 See Lau 1993.

11 On *Zhouli* and its significance see, for instance, Elman and Kern 2010.

12 See, for instance, Wang Tao 2018.

13 Ibid. 2018, 93.

14 Ibid.

15 Ibid., 94.

16 Ibid.

17 Lü *et al.* 1428, 'Preface', *juan* 1.

18 See examples of printed images reproduced in Shih 2016.

19 See, for instance, Wang 2011; Shih 2016.

20 Wang 2011, 75.

21 Wang 2011, 79; Shih 2016, 117.

22 Wang 2011, 77–9.

23 *Da Ming huidian*, *juan* 82, 1298–1.

24 Lau 1993, 99.

25 Both vessels are in the Palace Museum, Beijing. See Lü 2017a, fig. 5; Lü 2017b, fig. 5.

26 Published in Ayers 1969, vol. 2, A168, no. 638; Lam, Crick and Schwartz-Arenales 2018, no. 36, 128.

27 Shih 2016, 115.

28 Ibid.

29 Zhao *et al.* 2010, 56.

30 On the Jiajing emperor, see Fisher 1990.

31 Little 1990, 21.

32 Zhou 2015, 120; Zhang and Huo 2015, 52.

33 See, for instance, Saito 1967; Kanazawa 2015; Zhou 2015.

34 Zhou 2015, 120.

35 See Rosemary Scott's text in Christie's 2005, 66–9. For an explanation of 'plain tales' and the surviving titles, see Idema and West 2016, xvii–xxii. The illustration is found in *Yue Yi's Attack on Qi – The Final Collection of the Springs and Autumns of the Seven States* (*Yue Yi tu Qi qiguo chunqiu houji* 樂毅圖齊七國春秋後集).

36 Zhou 2015, 125–9.

37 Zhang 2014. Also discussed in Zhou 2015.

38 Zhang 2014.

39 See, for instance, Huang 2015; Li 2011.

40 Yu 2005, 20.

41 Mackerras 1988, 34.

42 Fu 1995, 125–35.

43 Ibid., 126–8.

44 Ibid., 129.

45 Ibid., 134–5.

46 Kanazawa 2015, 230.

47 Little 1990. On transitional wares see, for instance, Kilburn 1981.

48 Little 1990, 25–6, fig. 4. Also see Curtis and Little 1995, cat. no. 56.

My thanks to Joseph Scheier-Dolberg, Curator at the Metropolitan Museum of Art, New York, and his colleagues Alison Clark (Collections Manager) and Oi-Cheong Lee (Photographer) for their assistance with the images of this object and the related woodblock print.

49 Ibid., 26. For the woodblock print, see Little 1990, fig. 3; Curtis and Little 1995, cat. no. 57. The dating of the print follows Curtis and Little 1995.

50 Ibid.

51 Ibid.

52 Hegel 1981, 77.

53 Some late Ming writers criticised the version of *Water Margin* that added tales of Wang Qing and another character Tian Hu 田虎. See McLaren 2005, 160, 167.

54 Little 1990, 26.

55 See Little 1981, 66, Little 1990, 31 footnote 12 and Curtis and Little 1995, cat. no. 57.

56 Chen 2005, 332–3, no. 216. The brush pot is dated to 1695 in this catalogue, but Wang Yinong has re-dated it to 1635 given its 'transitional' style and similarities to the brush pot dated 1636. See Wang Yinong 2018, 108.

57 Wang Yinong 2018, 108.

58 Wang 1991, *liuben* 六本, 77.

59 A version of this painting is in the National Palace Museum, Taipei.

60 Yang and Yang 2002, vol. 1, 213. The poet Zhang Shixian 張師賢 is also listed with the studio name Zhilan shi. However, he is included among early Ming poets, and so does not fit with the 17th-century dating of the brush pots. See Qian 1991, 011–064 *jia qian ji* 甲前集. This reference provided in Yang and Yang 2002. The name is listed as Zhang Xixian 張希賢 but it has the same style name (*zi*) and native place.

61 Fong 2008, 91–9.

62 For instance, a painting of Guanyin by her is in the National Palace Museum, Taipei, reproduced in Weidner *et al.* 1988, 22.

63 Wu 2009, 4; Guo and Lu 1997, 43.

64 Fong 2008, 93.

65 The poem is recorded in Qian 1910, *gui si* 閏四, 42.

66 On the various editions of this novel, see Plaks 1987.

67 Wang Yinong 2018, 104–5, figs 6, 7. My thanks to Hui Tang for her assistance with the images of this object.

68 Wu 2009, 5.

69 On women and publishing in 17th-century China, see Ko 1994.

70 Murck 2000, 1.

71 On the development of press and politics in China, see Judge 1996. The British Museum has a large collection of teapots from 20th-century China donated by Alfreda Murck that carry political images and messages (see Ginsberg in this volume, Chapter 15).

Chapter 2
A 14th-Century Longquan Pot with a Dual Purpose

Elaine Buck

Sitting on the highest shelf in the British Museum's Enlightenment Gallery is a large 14th-century thickly potted wine jar (*guan*), covered with a pale green, jade-like celadon glaze, that was made at the Longquan kilns, in Zhejiang province (**Fig. 16**). The jar depicts scenes from the play *Lü Dongbin Gets Drunk Three Times in the Yueyang Tower* (呂洞賓三醉岳陽樓), written by the Yuan-dynasty (1271–1368) playwright Ma Zhiyuan (馬致遠) (*c.* 1250–1321) around 1280.[1] The pot has sat silently on that shelf for a number of years, overlooked by most of those who pass by. But when the pot was created almost 700 years ago, it made a powerful statement that was impossible to ignore.

During the Yuan period, theatre was a celebrated part of daily life. Performances attracted people from every level of society. One of the most popular dramatic spectacles was the *zaju* (雜劇), or variety play. The *zaju* was an early form of Chinese opera, typically in four acts with poetic dialogue alternating with songs and arias, as well as dancing and music. *Zaju* were performed in the entertainment districts of cities and towns at commercial fee-charging theatres, while in more rural areas, travelling troupes of actors performed plays on permanent and temporary stages, frequently at temples, with no charge to the public. Lyrics and dialogue were written in the vernacular, in the robust and colourful language of everyday usage, so everyone could understand. Temples, buildings and tombs were often decorated with scenes from *zaju* plays; the leading characters and actors appeared in murals, as reliefs and sculptural figures with excerpts from celebrated arias.

Many plays were well crafted. Some of the playwrights were highly educated and erudite men – often unemployed scholars – and their plays easily qualify as literary masterpieces replete with literary, historical and popular references. The demand for good material was so great that stories and legends were frequently reworked and converted into plays, sometimes more than once. Among the most popular musical dramas of the period, and a thematic subgenre of the *zaju*, were deliverance or conversion plays. The majority of these plays were Daoist in character and involved an immortal, usually Lü Dongbin or Zhongli Quan, both members of the Eight Immortals group, a legendary group of human beings all of whom had achieved immortality during their lifetimes. In deliverance plays the immortal was sent down to earth to show a human being or a tree spirit the way to enlightenment and immortality.

The future disciple initially resists because he is generally content with his life. The immortal, however, persists and using his magical powers, which frequently involve resorting to violence, ultimately persuades the individual of the impermanence of life and the futility of the pursuit of fame and fortune. The play ends with the disciple being introduced to the Eight Immortals and accompanying them to a peach party held by the Queen Mother of the West (*Xiwangmu*) at her paradise on Mt Kunlun where everyone feasts on her longevity peaches.

Deliverance plays were popular because they were entertaining. There was action with exciting twists and turns in the plot, comedy and good music, all of which, along with their message – the idea of the pursuit of fame and fortune being futile and the promise of a free and easy future

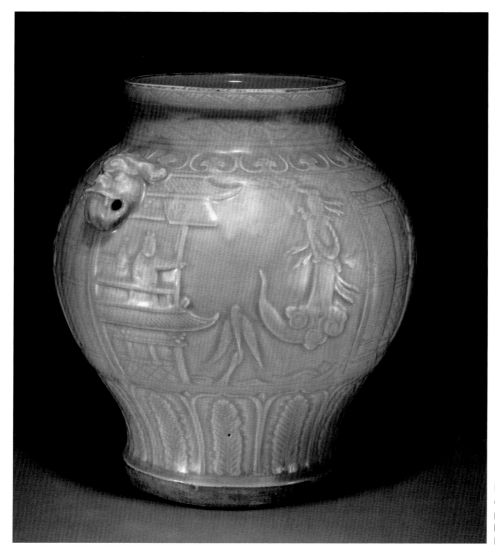

Figure 16 *Guan* wine jar,
c. 1320–68, Longquan, Zhejiang
province, China, porcelain,
h. 33.7cm. British Museum,
London, 1936,1012.38

– resonated with the population, many of whom felt
excluded and oppressed by their Mongol rulers. Although
there is no evidence to suggest that deliverance plays were
actually used to promote Daoism, given the subject matter
and the fact that stages were built at temples, it is possible
that religious activities contributed to their popularity.

In *Lü Dongbin Gets Drunk Three Times in the Yueyang Tower*,
hereinafter *Yueyang Lou* (岳陽樓) or *Yueyang Pavilion*, the
immortal Lü Dongbin is sent to deliver the spirits of a willow

and plum tree that haunt the tower.[2] The Yueyang Tower
was a famous tower located in the city of Yueyang (a cultic
centre for Lü Dongbin) at a scenic spot on the banks of Lake
Dongting (洞庭湖) in southern Hunan where the lake
converges with the River Yangzi (揚子江). In the 11th
century a number of texts were written that documented
encounters by highly respected officials with Lü Dongbin at
the tower's wine shop.[3] There were also some poems Lü
Dongbin allegedly wrote on the tower walls, the most

Figure 17 The four scenes from the Longquan *guan* (Fig. 16), left to right: Lü Dongbin descending on a cloud outside the Yueyang Tower
wine shop; a woman speaking to a maid; a woman burning incense and another by a scholar's rock; a man writing '*sheng xian*' on a banner
over a bridge watched by a woman holding a possible inkstone. British Museum, London, 1936,1012.38

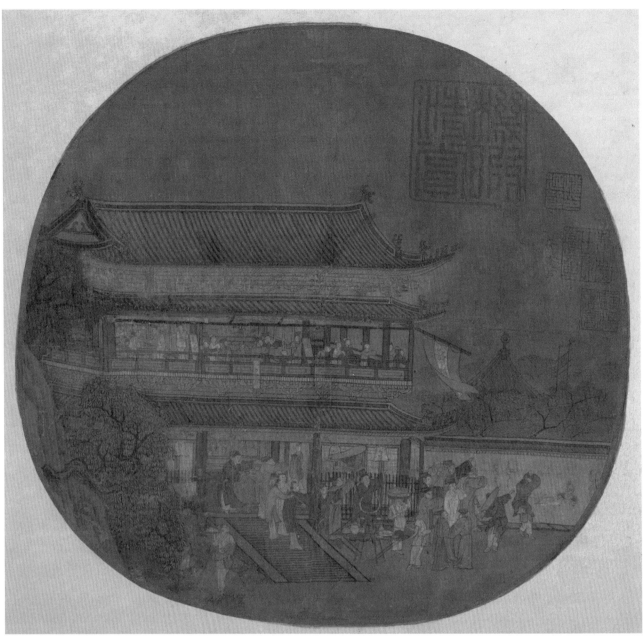

Figure 18 *The Immortal Lü Dongbin Appearing Over the Yueyang Pavilion*, 呂洞賓過岳陽樓, anonymous artist, late 13th century, China, fan mounted as an album leaf; ink and colour on silk, image 23.8 x 25.1cm. Metropolitan Museum of Art, New York, Rogers Fund, 1917, 17.170.2

famous of which ended with the words 'Three times I entered Yueyang but no one was aware . . .'.[4] Wine is closely associated with the joys of immortality and, like all immortals, Lü Dongbin loved good wine and frequented wine establishments.

Act 1 of the play opens with the clerk of a tavern at the tower hanging out a sign to attract customers, inscribed *Yueyang* (岳陽).[5] It is at this moment that Lü Dongbin descends on a cloud. This is followed by an encounter between the willow spirit and Lü Dongbin. Before a tree spirit can become immortal it must first be reborn as a human. This is explained by the willow spirit. Lü Dongbin leaves stating that he will return.

Act 2 takes place 30 years later. The willow spirit has been reborn as Guo Ma'er (郭馬兒) and the plum spirit as He Lamei (賀臘梅). The two have married. Guo Ma'er appears and explains that he and his wife operate a teahouse at the Yueyang Tower. Despite the fact that they have been

married for several years, regrettably they have no children. This is their one great sorrow. At this point, Lü Dongbin returns to the tower. He Lamei recognises Lü Dongbin, which is a sign that she is ready to accept Daoist teachings. Guo Ma'er, on the other hand, dismisses Lü Dongbin as a crazy drunken Daoist. He flatly refuses to accompany Lü Dongbin on the grounds that he cannot leave his wife He Lamei. Lü Dongbin gives Guo Ma'er a sword and tells him to kill He Lamei. Guo accepts the sword to humour Lü Dongbin and returns home. The next morning when he wakes up, he discovers that his wife has been beheaded. When he examines the sword given to him by Lü Dongbin, he finds a poem on it signed by Lü Dongbin.

In Act 3 Guo Ma'er goes to the authorities and accuses Lü Dongbin of murdering his wife He Lamei. When Lü Dongbin is apprehended in Act 4, the poem is no longer on the sword. Lü Dongbin assures the authorities that Guo's wife is very much alive and indeed, using his magic powers,

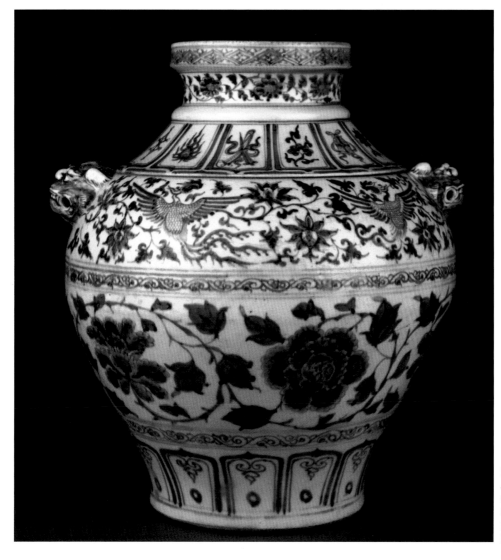

Figure 19 *Guan* wine jar, 1320–50, Jingdezhen, Jiangsu province, China, porcelain, painted in underglaze blue, h. 39.4cm. British Museum, London, Percival David Foundation, PDF.620

he produces her. The magistrate orders Guo to be put to death for wrongly accusing Lü Dongbin of murder. Not knowing what to do, Guo begs Lü Dongbin to intercede and save him. At this moment the magistrate and his clerks are transformed into the Eight Immortals.

Consistent with the approach used in illustrated *pinghua* (評話 or 平話) ('historical narratives'), the jar depicts a number of discrete moments (**Fig. 17**). Thus the first scene shows a man in the tower's tavern pointing to Lü Dongbin who is descending on a cloud. Next to the tower is a tree. The man is obviously the clerk in the tavern, surrounded by small bowls and a pear-shaped wine flask of *yuhuchunping* (玉壶春瓶) form, while the tree is the willow spirit, who features in Act 1.

The popularity of the encounter theme may have been a factor in its representation on the British Museum jar. A very similar scene complete with the tower, banner and figures pointing to an aerial Lü Dongbin is depicted on a fan painting in the Metropolitan Museum of Art, New York, dated to the late 13th century and entitled *The Immortal Lü Dongbin Appearing Over the Yueyang Pavilion* (**Fig. 18**).[6] Likewise, the motif of Lü Dongbin on a cloud hovering over a building is a recurrent motif in the Chunyang Hall (纯陽殿) at Yongle Gong (永乐宫) in Shanxi province.[7] The mural in the hall, which is dedicated to Lü Dongbin in his role as a patriarch of the Complete Realisation School of Daoism, depicts 52

scenes from his life. Produced by the workshop of the Yuan-dynasty mural painter Zhu Haogu (朱好古), the mural dates from roughly the same period (*c.* 1358) as the British Museum jar.

In the second scene a woman, accompanied by a maid carrying a towel, points to a tree. The woman is He Lamei and the tree can be interpreted as a reference to her prior existence as a tree spirit. When Lü Dongbin appears 30 years later it is only He Lamei who recognises him and remembers that she was formerly a tree spirit.[8] In the third scene on the jar two figures, a man and a woman, presumably Guo and his wife, stand in front of a censer burning incense. This is perhaps a reference to their prayers for a dearly wanted child.

The fourth and last scene shows a man and a woman facing a bridge. The man points a brush at a sign on the bridge that reads '*sheng xian*' 升仙, translated as 'ascending to the realm of immortals', which he has just painted, while the woman holds what is possibly an inkstone. The man and woman are undoubtedly Guo Ma'er and He Lamei and this would appear to be a reference to their conversion. The motif of a bridge and the idea of crossing over is a pun on the Chinese word *du* 兑, 'to convert'.

One of the issues raised by the decoration on this jar is its relationship to woodblock prints. A number of scholars have suggested a link between narrative illustrations on Yuan

Figure 20 Vase with the Eight Immortals omitting Lü Dongbin and repeating an unidentified immortal, 1300–68, Longquan, Zhejiang province, China, stoneware, celadon glaze, h. 23cm. British Museum, London, 1936,1012.83

Figure 21 Vase with two of the Eight Immortals, Zhongli Quan and Li Tieguai, 1300–68, Longquan, Zhejiang province, China, stoneware, celadon glaze, h. 24.3cm. British Museum, London, Percival David Foundation, PDF.203

blue-and-white porcelain and contemporary woodblock illustrations.[9]

There are illustrated *pinghua* (histories) from the period. These generally follow the 'picture above, text below' (*shangtu/xiawen*) format, with the illustration at the top of the page and the related text printed below.[10] We also know that play scripts were printed during the Yuan and that some of these were illustrated. This has been confirmed by the 1983 discovery of an illustration and a fragment of an illustration from the well-known play *Xixiang ji* or *Romance of the Western Chamber* (西厢记) by Wang Shifu (王实甫) (1250–1327).[11] How common this was and what other plays were illustrated is unknown.

But the probability that *Yueyang Lou* was published with illustrations during the Yuan period is good. The play had all the ingredients for a popular play: a famous location, a protagonist who in the form of Lü Dongbin was a scholar and powerful (an anomaly during the Yuan) with a sword that cut through evil, clever dialogue, twists and turns in the plot, comedic exchanges and a happy ending. In the late Yuan/early Ming the playwright Gu Zijing 谷子敬 (c. 1368–1392) took the same story set in the same location, made some minor changes, substituted a peach for the plum tree and called his version *The Willow South of the City* (呂洞賓三度城南柳). This in and of itself suggests that the story enjoyed widespread popularity.

The story also continued to be popular well into the 16th century long after such plays were regularly performed. This is indicated by the publication of both plays with illustrations.[12] The choice of the moments illustrated in the extant Ming editions is different from those found on the British Museum jar, as are the format and style. Instead of the 'picture above, text below' format of the Yuan period, in the Ming editions the illustrations follow the full-page format and a style that is characteristic of the Ming period (1368–1644) (see Luk, Chapter 1, **Figs 9, 12**).

Of course, pending the discovery of additional material, it is impossible to unequivocally link the British Museum's Longquan jar with a set of illustrations. Nevertheless, Longquan, where the jar was produced, was within easy access to publishing centres in Jianyang (northern Fujian) and Hangzhou. The scenes on the jar also exhibit characteristics that we associate with *pinghua* illustrations and which are consistent with the idea of a play. For example, buildings are cropped. This is a common device used in woodblock illustrations of the period. Fine lines are employed to suggest texture just as they would in a woodblock illustration. Two of the scenes recreate moments of high drama (that is, the descent of Lü Dongbin on a cloud, and the ascension of Guo Ma'er and his spouse to immortality). The focus is on the figures/actors, who are large, gesture dramatically and are set in a shallow stage-like ground. The limited depth is indicated by furnishings (for example, latticed doors) placed at an angle. The setting is economical and limited to props that provide clues to the plot (for example, the tower, trees that refer to the tree spirits, a censer that signifies prayers, and a bridge that symbolises conversion and the crossing over to immortality). Possibly more significant is that there is no prototype for the depiction of a series of narrative scenes on a Longquan jar. Although obviously not impossible, this does make it difficult to believe that the inspiration for the jar came from the Longquan potters themselves.

So what was the function of this jar? In his treatise on Northern Song (960–1127) landscape painting, *Lofty Record of*

Forests and Streams, the 11th-century artist Guo Xi linked such paintings with the real experience of wandering in a landscape. The idea was that the viewer, presumably a scholar official with little time for leisure, could by contemplating the painting relive or live the actual experience; in Guo Xi's words, 'Without leaving your room you may sit to your heart's content among streams and valleys'.[13] There is no reason why this idea should not extend to ceramics: a jar decorated with scenes from a play might function as a visual extension of, or a substitute for, a live performance.

However, the question that springs to mind is not why the play is depicted here at all, but rather why the deliverance play *Yueyang Lou* appears on a Longquan ware jar at this point in time. The Longquan glaze does not lend itself to surface decoration. It is a thick, semi-opaque glaze, which when applied tends to obscure decoration. In recognition of this fact the pieces that have surface decoration usually reflect one of two approaches: either the decoration is bold and carved in high relief or alternatively the decoration is left in the biscuit.

Why are narrative scenes from a deliverance play depicted on a 14th-century Longquan jar in this manner? There were undoubtedly many factors, but two stand out.

The first had to do with the need to remain commercially viable. The 14th century witnessed the rise in popularity of porcelain decorated with cobalt-blue pigment.[14] The Longquan potters were not complacent. They realised they had to develop products that could compete with the wares being produced at Jingdezhen or go out of business, which was obviously undesirable. The design of the British Museum jar with its bands in varying widths and its emphasis on the centre, the animal mask handles, and the loop of plantain leaves around the foot is a clear case of pilfering from blue-and-white ceramics (**Fig. 19**). But while the Longquan potters could duplicate the composition and some of the motifs, they could not mimic the painting effects so skilfully and successfully achieved at Jingdezhen with cobalt-blue pigment. However, they could and did find other ways to compensate. This included producing clever and unusual wares, of which this jar is a good example. Here the combination of the jade-like glaze, the shape designed as a container for wine and the decoration together operate to create a brilliant conceit of immortality.

The second reason for the jar's appearance at Longquan during the 14th century has to do with the relationship between the Buddhists and Daoists and the religious character of the area. The two religions had a history of rivalry that went back centuries. During the early Yuan it had been particularly vicious, resulting in the destruction of Daoist scriptures and the confiscation of Daoist monasteries and temples.

Most of the area that is modern-day Zhejiang was part of Jiangzhe, which was a major economic, cultural and religious centre. There were four important religious sites in the area, including Mt Tiantai to which both groups laid claim. Since the 10th century Mt Tiantai had been a centre for the Buddhist lohan cult. Lohans and immortals share similar functions and powers as well as some visual characteristics. Indeed, as Richard Kent has recognised, the cult of lohans probably benefited 'immeasurably' from indigenous beliefs about immortals.[15] This is a fact that probably did not go unnoticed by the Daoists.

While there are numerous ceramics from the Song (960–1279) and Yuan periods, there are very few surviving examples that depict immortals, and it would appear that the only ones that include a few figures belong to a small group of octagonal meiping (a plum bottle or vase, often used to store wine), two of which are in the British Museum and come from the Longquan kilns (**Figs 20–1**). This suggests the existence or at least a recognition by the Longquan potters of a possible opportunity to expand or strengthen their market by creating ceramics featuring immortals.

So what agendas does this jar (**Fig. 16**) reveal? For the potters who made it, it was part of an effort to remain competitive in a changing market. For the consumer who purchased it, it offered the opportunity to live or relive a theatrical experience that not only entertained but also celebrated contemporary culture, conveyed religious teachings, shared moral values, and commented on political and social issues.

Notes

1 Harrison-Hall 2001, cat. 16:17, 468–9.
2 The idea for the play may have originated in a legend about Lü Dongbin's encounter with a pine spirit in Yueyang inscribed on a stele at the tower, see Baldrian-Hussein 1986, 155–9. As of the writing of this case study, the jar has been appropriately displayed in the British Museum's Enlightenment Gallery.
3 For a discussion of these, see Katz 1999, 67–8.
4 Baldrian-Hussein 1986, 151. The same poem is included in Act 3 of Ma Zhiyuan's play.
5 Translated in Yang 1972, 48–96.
6 https://www.metmuseum.org/art/collection/search/40093?searchField=All&sortBy=relevance&ft=the+immortal+lu+dongbin&offset=0&rpp=20&pos=1 (accessed 3 December 2018).
7 See, for example, the episode of the pregnant Buddhist nun depicted on the west wall of the hall reproduced in *Yongle Gong bihuaxuanji* 1958, cat. 88.
8 Editor's note: for an alternate reading of this and the following two scenes, see Xin 2017, 62–3.
9 Editor's note: there are also links between print sources and Cizhou-type stoneware painted with iron-brown slip made in North China, primarily in Hebei and Shanxi province, which increasingly included figurative subjects; for a discussion see Xin 2017.
10 For examples of illustrated *pinghua* in the *shangtu/xiawen* format, see a page from the *Brief Accounts of the Three Kingdoms*, printed by the Li Family, Jiangyang, 1294, in Chen and Ma 2000, 4, 77.
11 These are reproduced in West and Idema, 1991, fig. 31.
12 See Zang 1966, 3.
13 As translated in Bush and Shih 1985, 151.
14 See editor's note in note 9 above regarding Cizhou-style painted wares.
15 Kent 1994, 185.

Chapter 3
Illustrated Hagiographies and Figure Production in Late Ming Fujian

Wenyuan Xin

The publishing industry in China, after nearly two centuries of decline, eventually recovered from the disruption caused by the turmoil of the Yuan–Ming transition and flourished from the early 16th century onwards, when arguably for the first time printed books supplanted manuscripts and became widely available.[1] One notable trend in Ming publishing was the growing use of illustrations in an unprecedented variety of books.[2] These illustrations, although not intended to be appreciated primarily for their artistic value, became an important source of inspiration for artisans of the time. Fictional scenes derived from woodblock prints were commonly copied onto the blue-and-white porcelain produced in Jingdezhen, as well as other objects made from lacquer, ivory and carved bamboo. The relationship between prints and porcelain has drawn much attention from Chinese and Western scholars. These studies, by and large, focus on prints as design sources for the decoration on painted porcelain; however, this does not tell the full story. Skilful craftsmen not only transferred images from one two-dimensional surface to another, but were also inspired by prints when creating three-dimensional objects: figure models. This chapter looks in detail at the relationship between the figure models produced in Fujian province during the 16th and 17th centuries and contemporary prints, and explores the social and religious factors that contributed to this phenomenon.

Illustrated hagiographies in the late Ming book market

The boom in the book trade during the Ming dynasty (1368–1644) was characterised by the increase in both the size and diversity of the reading public. Commercial publishers and editors from the major printing centres – Nanjing, Suzhou and Hangzhou in the Jiangnan area, and Jianyang in the Northern Fujian province – competed fiercely with one another and produced ever more varied forms of books to fulfil every conceivable need of new readers.

In the bustling book market there was a penchant for illustrated hagiographies as evidenced by the considerable number of such works that survive. Hagiographies were created to describe the lives and deeds of deities and immortals, often with illustrations portraying a set of significant events and moments, through which various religious figures became well established and widely known. Pictorial hagiographies reached their climax during the reign of Wanli (r. 1573–1620) and it was at this time that many of the best works were published. They were produced in the album format, with a short biography for each individual, mostly accompanied by a full-page illustration (**Fig. 22**). Fortunately, copies of some of them still exist, such as *Youxiang liexian quanzhuan* 有象列仙全傳 (*Complete Collection of Biographies of Immortals with Illustrations*, hereinafter referred to as *LXQZ*) and *Xian fo qi zong* 仙佛奇蹤 (*Sacred Traces of Immortals and Buddhas*, hereinafter referred to as *XFQZ*). The most important encyclopaedia – *Sancai tuhui* 三才圖會 (*Collected Illustrations of the Three Realms*) (1609) – which aimed to give a detailed representation of all knowledge about the world, included a chapter in the same format devoted to the biographies of deities and immortals, providing evidence that this type of work was highly important during the late Ming period.

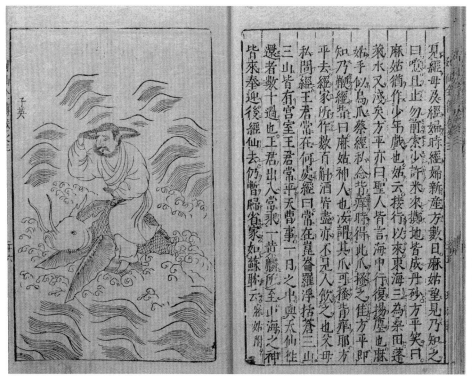

見經母及經婦晡經晡新產方數日麻姑望見乃知之曰噫且止勿前却率來米擲地皆成丹砂方平笑曰姑猶作少年戲也吾老矣了不喜復作此狡獪變化也麻姑手似烏爪蔡經心念背大癢時得此爪以搔背當佳也方平已知經心中所念即使人牽經鞭之曰麻姑神人也汝何忽謂其爪可以搔背耶見鞭著經背亦不見有人持鞭者麻姑自說云接待以來已見東海三為桑田向到蓬萊

皆來奉迎後經仙去彷彿臘雀家如蘇頰云麻姑附還者數十過也王君出入常乘三山皆有宮室王君常在崑崙羅浮括蒼三私問經王君常平天曹事一日之中與天仙從平去經家所作數百肺酒皆盡亦不見人飲之也父毋知乃命以來方平亦言此神人也

Figure 22 Pages from *Complete Collection of Biographies of Immortals with Illustrations* (有象列仙全傳 *Youxiang liexian quanzhuan*) showing the 'Immortal Ziying riding a carp', 1573–1620, woodblock printed, ink on paper, Wanli edition, 26 x 16.6cm. Yonezawa City Library, Yamagata, Japan

Hagiographical fictions narrating the life stories of a single protagonist were also produced in large quantity, especially in the Jianyang prefecture in Northern Fujian province. Unlike hagiographical albums, the fictions in Jianyang continued the 'illustration-above-text' format from the Song (960–1279) and Yuan periods (1271–1368) with illustrations occupying only the top register (see **Fig. 29**). Yu Xiangdou (act. 1588–1609), one of the most eminent publishers in Jianyang, in his preface to *Tales of the Eight Immortals* complained bitterly about a competitor shamelessly pirating his work and tapping the lucrative market, which provides a glimpse into the popularity of hagiographical works at this time.

The tradition of pictorial hagiography in China was deeply indebted to depictions of *jataka* stories in Buddhism, which were used to establish and spread the religion abroad. Vivid and powerful visual representations were later adopted by the Daoists, probably to compete with the Buddhists for support from the state and the populace.[3]

Late Ming hagiographical works, however, were not crafted or patronised by temples but rather by commercial publishers who were usually well educated but had failed their national examinations. The authors decided the content of the books, which were primarily meant to be sold on the market for profit. The commercial nature of the book industry is evident in the colophons or prefaces of some works, which often blatantly explain why the work was produced and extol the merits of the edition while denigrating those of the publisher's competitors.[4] For example, in *LXQZ*, published in 1600 in Jiangsu, the colophon proudly notes that the publication was 'a valuable book rarely seen or heard' due to the involvement of renowned scholars in its editing and the large number of immortals and illustrations included. *XFQZ*, published two years later, which features not only Daoist deities and immortals but also figures from Buddhist tradition, such as

Guanyin and Bodhidharma, expresses more explicitly that the purpose of the publication is 'for pleasure in the [reader's] spare time'.

The protagonists in these books were not new to the Ming public. Their legends were already known through storytelling, theatre performance and writings. During the late Ming period, commercial authors and publishers combined fragments from various sources and reconstructed them to appeal to a wider audience. The most important source was probably the Daoist canon, which was commissioned by the Yongle emperor (r. 1402–24) in 1403 to preserve and recover the Daoist texts that had been threatened or damaged at the end of the Yuan period and was eventually completed in 1445 during the reign of Zhengtong (r. 1435–49). The Daoist canon includes not only a considerable number of individual hagiographies, some of which were accompanied by illustrations, but also entire compendia, such as the monumental hagiographical tome *Lishi zhenxian tidao tongjian* 歷世真仙體道通鑒 (*Comprehensive Mirror of Perfected Immortals and Those Who Embodied the Dao through the Ages*), compiled by Zhao Daoyi in the 13th century. Zhao's work features nearly 900 biographies of immortals, deities and eminent Daoist masters, many of whom were adopted in later works such as *LXQZ*, albeit with some interesting changes deliberately made by publishers. The language was made more accessible to readers of limited education. Religious elements, such as cult lineage, self-cultivation and religious status, were weakened or even removed. Plots about supernatural powers were strongly emphasised. It is clear that the religious context of pictorial hagiographies had gradually faded by the time of the Ming period and that their role as a form of entertainment had become more prominent.

Despite this, hagiographical works were not produced or consumed completely out of their religious contexts. They were often accompanied by materials providing information on worship manuals and the words of protagonists. In this

Figure 23 Wenchang with potter's mark of He Chaozong, early 17th century, Dehua kilns, Fujian province, China, porcelain, h. 34cm. Asian Civilisations Museum, Singapore

respect, it is more accurate to argue that they were encyclopaedic sourcebooks that amalgamated all knowledge about their protagonists for didactic, practical and also entertainment purposes.

The rising interest in hagiographical works indicates that the subject gained a new importance during the Ming period. It is therefore necessary to consider the broader context in which they were produced and consumed.

One of the most remarkable features in the development of Daoism in the later period was the gradual absorption of deities from other Chinese religions into the Daoist pantheon. The phenomenon had already become widespread during the Song dynasty and continued in the Ming era. Ming emperors and members of the wider imperial family were very generous supporters of popular religions, which peaked in the late period when Jiajing (r. 1522–66) and Wanli, the two longest-reigning emperors of the Ming dynasty, were both devout Daoists. Emperor

Wanli commissioned a Supplement to the Daoist canon in 1607, which not only contained a great number of scriptures concerning deities and immortals but also incorporated works by some of the most eminent rebel freethinkers of his time.[5] A few popular deities were even granted titles of nobility and attained imperial recognition.[6] The attitude at court undoubtedly encouraged the worship of popular gods at the local level and also stimulated the market for hagiographical publications.

Furthermore, the concept of the Three Teachings (San Jiao 三教) – Confucianism, Daoism and Buddhism – formed in the Song dynasty, was further developed and promoted in the Ming dynasty and led to the popular belief that the Three Teachings were merely different paths to the same spiritual goal.[7] Therefore, the boundary between Daosim and other religions became so fluid that the images of deities, immortals and saints from Buddhist, Daoist and Confucianist traditions could be combined into a single volume.

Figure 24 (far left) Portrait of Wenchang from *Sancai tuhui*, 1609, Nanjing, woodblock printed, ink on paper, printed area 20.6 x 13.6cm. National Central Library, Taipei

Figure 25 (left) Wenchang, 16th–17th century, Zhangzhou, Fujian province, China, ivory, h. 15cm. British Museum, London, 2018,3005.186, donated by The Sir Victor Sassoon Chinese Ivories Trust

Illustrations played an important role in the marketing of hagiographical works, as seen in their colophons or prefaces, which often emphasised the quality and number of illustrations included. Since illustrations were carved on woodblocks, figures were overwhelmingly rendered in simple black lines with very limited tonal gradations. Many figures were presented in an animated state, such as swinging their arms and sleeves, twisting their bodies and turning their heads in a dramatic fashion, most likely inspired by Chinese dance and theatre.[8] Although the book illustrations primarily served to clarify and comment on the main texts rather than being appreciated for their aesthetic qualities,[9] the simplicity and effective use of lines made them the perfect models for contemporary craftsmen. The connection between these hagiographical prints and crafts was nowhere more aptly expressed than in Fujian province in the 16th and 17th centuries.

Sitting on the south-east coastline of China, the Fujian province of the late Ming period stood apart from the empire in many ways. Among the most significant reasons for this were the flourishing overseas maritime trade in the south and west coastal region and the thriving printing activities inland to the north.

Figure production in Fujian

Fujian province had played an important role in Chinese overseas maritime trade during the Song and Yuan dynasties. The succeeding rulers of the Ming dynasty, however, held strongly cautious and negative attitudes towards Sino-foreign civilian trade. Strict bans were enforced for nearly two centuries until the opening of the port of Yuegang in 1567, which enabled a rapid expansion of such trade. Located within Zhangzhou prefecture in the western part of the Fujian coastline, it was the only port

throughout the Ming era where Chinese civilians were officially allowed to trade with foreigners. During the half-century from 1570 to 1620, Fujian merchants virtually monopolised foreign maritime trade, apart from trade through Macao, which had been controlled by the Portuguese since 1553.[10]

Fruitful overseas contacts not only brought considerable economic returns but also stimulated the growth of local craft-based industries. The ivory-carving industry in Zhangzhou was one of the most noticeable developments. In the 16th century, the Iberians started their adventures into the Asian waters searching for 'Christians and spices'.[11] Spanish missionaries, after occupying the Philippine islands in 1565, began to commission ivory votive figures in Fujian – the only accessible port for them – for newly established Christian churches. European carvings or prints featuring holy figures were sent to Zhangzhou for artisans to copy, which soon encouraged the production of Chinese deities in ivory for the domestic market. Because they were inspired by European works, it is not surprising that Gao Lian (*c.* 1573–1620), a late Ming scholar, in his book *Zun sheng bajian* 遵生八箋 (*Eight Discourses on the Art of Living*) (1591), wrote that 'ivory figurines carved in Fujian were executed with delicacy and exquisiteness, but due to the lack of solemnity of antiquity, they cannot be appreciated'.

Zhangzhou was not the only place that specialised in the manufacture of figures at this time, as white porcelain figures were being made at Dehua, a county about 40km north of Zhangzhou. While production at Dehua can be traced back to as early as the Northern Song dynasty (960–1127), it took the potters several centuries to perfect their techniques, and output eventually reached its golden age in the later years of the Ming dynasty. Mature Dehua porcelain is famous for its undecorated, lustrous white

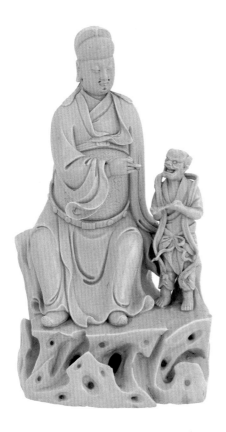
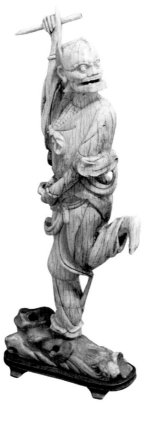

Figure 26 (far left) Wenchang and Kuixing, c. 1600–44, Dehua kilns, Fujian province, China, porcelain, h. 28cm. British Museum, London, 1980,0728.54, bequeathed by Patrick Donnelly

Figure 27 (left) Kuixing, 16th–17th century, Zhangzhou, Fujian province, China, ivory, h. 22cm. British Museum, London, 2018,3005.21, donated by The Sir Victor Sassoon Chinese Ivories Trust

surface and became known in the West as 'Blanc de Chine'.[12] The Dehua kilns probably started with domestic wares and then turned to figures, most likely due to the particular qualities of the local raw materials. Because of its very low plasticity, clay mined in Dehua is unsuitable for potters' wheels; however, its resistance to high temperature distortion means that it is an ideal material for making figures with complicated details using the piece-moulding method. The unusual sensibility and sculptural merits embodied in Dehua figures are still appreciated today.

Some connections between figures in carved ivory and moulded porcelain have already drawn scholarly attention, which leads to speculation that Dehua porcelains could have been used as cheaper versions of Zhangzhou ivories.[13] Rose Kerr notes that by employing the piece-moulding method Dehua potters were able to achieve a remarkable degree of delicacy and detail – features also attained in carved ivory.[14] In addition, the oxidising firing condition gives the finished products a warm ivory tone and the surface a gloss very similar to ivory.[15] Indeed, among Chinese connoisseurs Dehua porcelain is often referred to as 'ivory white'.

Apart from those mentioned by Kerr, there are other connections worth noting. Both Dehua porcelain and Zhangzhou carved ivories were considered unsuitable for scholarly tastes. Holding the same acerbic attitude as Gao Lian towards Zhangzhou ivory figures, Wen Zhenheng (1585–1645) wrote in *Zhang wu zhi* 長物志 (*Treaties on Superfluous Things*), published in the early 17th century, that 'for making cupboards or tables for [the worship of] the Buddhas, saints and deities, the recent eight-cornered tables with curved feet, and also those religious images from the Fujian [Dehua] kilns, are absolutely not to be used'.[16] Furthermore, both Gao Lian and Wen Zhenheng were

scholars active in the Jiangnan area – the wealthiest region and the cultural heartland of the empire. Their familiarity with Fujian crafts suggests that both porcelain and ivory figures must already have been distributed beyond the region and were sufficiently well known for scholars to feel the need to write about them.

Many factors contributed to the growth of the production of religious figurines in Fujian during the late Ming period, such as the influence of frequent overseas trade, the availability of models in other materials and increasing commercialisation. In addition to these factors, an examination of changes in local religions might also shed some light on the emergence of new art forms.

The terrain of Fujian province is largely mountainous. Arable land was therefore both scarce and extremely valuable. It was an important source for tax revenue, which the local government used to support maritime defence in the province. By the time of the Ming era, however, most of the fertile farmland in Fujian had for some time been in the possession of the Buddhist temples, which were exempt from paying taxes. This caused conflict between the temples and the government and led to local elites taking an ever-stronger anti-Buddhist stance and eventually to the decline of Buddhist temples.[17] The commoners therefore turned away from traditional monastic institutions to more personal and eclectic forms of worship in order to satisfy their emotional thirst for the unknown world. Also, with the growth of the popular religions as discussed above, various deities and immortals were 'invited' into the domestic sphere and revered for their ability to bring fortune, protect homes and families, secure long life or guarantee a successful career. Martín de Rada (1533–1578), a Spanish missionary, visited Fujian in 1575 and wrote in his *Relation*:

so great was the number of idols which we saw everywhere we went that they were beyond count, for each house has its own idols besides the multitudes which they have in temples and in special houses for them . . . through whom they pray to Heaven to grant them health, wealth, dignity, or a prosperous voyage.[18]

Figures made in Zhangzhou and Dehua were usually no more than 40cm in height, which made them a suitable size for domestic or private worship, or display at home for good luck. Therefore, figurine production in Fujian can be considered to be a response to the rise of eclectic patterns of worship and the growth of popular religions.

Prints as prototypes

The production of both ivory-carved and porcelain-moulded figures in Fujian reached its height in the 16th and 17th centuries, before which wood, bamboo, stone and metalwork had established their own modelling traditions. Fujian craftsmen often used such materials when modelling their works, and some of them employed a variety of media. Moreover, the artisans of the day would have been well aware that the large number of illustrated hagiographical publications was the most comprehensive source available to them for the study of religious figures.

Jianyang in the northern part of Fujian had been a major printing centre since the Song dynasty. By the Ming era it was playing an even more significant role in commercial publishing, with the largest share of this market. The abundant Jianyang woodblock prints of the period featured not only in the classics and literary collections but also in new kinds of works for commoners, especially medical texts, divination manuals, household encyclopaedias and illustrated fictions.[19] Hagiographical volumes enjoyed great popularity in Jianyang. Yu Xiangdou published and edited many hagiographical fictions as well as writing several important books dedicated to some of the most beloved popular gods, including *The Heavenly King Huaguang's Journey to the South* and *Journey to the North* (both published in the 16th century).

Many of the Jianyang prints came from the town of Shufang, where a book fair was held on the first six days of each month.[20] Merchants travelled from all over the country to make purchases and probably brought with them books produced in other regions. Popular volumes could be imitated quickly by Jianyang publishers, who deliberately used lower-quality paper and local softwood blocks to manufacture cheaper products in order to expand their market. Although criticised for their poor quality, Jianyang prints were considerably less expensive than those from the Jiangnan area, which helped them to reach a much wider audience. With a large quantity of books in circulation and at a lower price, it would make sense for artisans and their patrons to have ready access to the most up-to-date and richly illustrated hagiographical works and choose the models from these 'pattern books'.

While purely Daoist figures in carved ivory or porcelain are rare, patron deities form an important group, whose foremost member is Wenchang, the god of literature. Wenchang was first worshipped as a thunder god in the form of a snake in Sichuan in south-west China during the 5th and 6th centuries.[21] From the Song period onwards,

Figure 28 Portrait of Kuixing from *Sancai tuhui*, 1609, Nanjing, woodblock printed, ink on paper, printed area 20.6 x 13.6cm. National Central Library, Taipei

Wenchang was closely associated with literati and widely invoked by candidates hoping for success in the civil service examinations. He was therefore depicted as a typical Confucian scholar (**Fig. 23**). The figure by one of the most celebrated potters, He Chaozong, working in the 17th century, shows Wenchang seated on a pierced rock and holding a *ruyi* sceptre in his right hand, which rests on an outcrop. He is dressed in a loose robe secured by two belts around his chest and stomach and wears a scholar's hat with two ribbons hanging over his shoulders. The rank badges on both the back and front of the costume are incised with a pair of birds among *ruyi* clouds. These bird badges were exclusively used by civil officials in the Ming and Qing (1644–1912) dynasties, which in this case emphasised Wenchang's connection with the literati and symbolised his career success and material rewards. The holes on his upper lips, cheeks and chin would have had real hair inserted to render the carved figure more lifelike. His relaxed pose, serene expression, physical appearance and flowing robes greatly resemble the portrait of Wenchang in *Sancai tuhui*, although in the latter the *ruyi* sceptre is held by a young servant (**Fig. 24**). The rank badges on the porcelain figure are not shown in the illustration, probably because it was much more difficult to cut the elaborate pattern into a

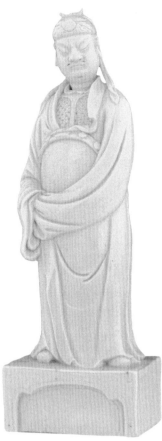

Figure 29 (far left) Page from *The Account of Guandi of Past Generations Manifesting his Holiness* (關帝歷代顯聖志), 1573–1644, woodblock printed, ink on paper, Wanli or Chongzhen edition. National Library of China, Beijing

Figure 30 (left) Guandi, *c.* 1600–20, Dehua kilns, Fujian province, China, porcelain, h. 29.6cm. British Museum, London, 1938,0524.27, bought with the help of public subscription from the George Eumorfopoulos Collection

woodblock than incise it on clay. Wenchang figures carved in ivory are often in a standing position in order to make the most efficient use of the natural curved shape of tusks, but the resemblance to the print is still visible (**Fig. 25**). His raised hand, which probably originally held a brush, is missing. The section between the two belts bears the trace of a stain, suggesting that the rank badge may have been painted rather than carved.

Wenchang is frequently portrayed in prints and paintings with an entourage consisting of an old man holding a scroll and two young servants, who seldom appear in sculptures.[22] In the latter Wenchang is instead often depicted with his acolyte, Kuixing, the god of examinations (**Fig. 26**). The combination makes perfect sense as this type of statue would be worshipped on a daily basis by people praying for success in their exams. Here, Kuixing resembles a demon; he has bulging eyes and an open mouth. He is holding an open book, and his smaller stature indicates his relatively lower importance. An ivory figure of Kuixing (**Fig. 27**) on his own shows him standing on the head of *ao*, a giant turtle in Chinese mythology, alluding to a traditional Chinese saying, '*du zhanaotou*': a good wish for the attainment of first place in an exam. He holds a brush in his raised right hand and probably a weight that is used to measure the worth of scholars; his left leg is kicking upwards aiming at, although not shown here, the Northern Star, as is evident in an illustration (**Fig. 28**).

Equally important is Guandi or Emperor Guan, the deified form of Guan Yu, who was a hero of the early 3rd century and famous for his loyalty and bravery. Guan Yu began to be worshipped in the early Tang dynasty (618–906) and received the imperial title of emperor (*di*) in 1615.[23] He

then came to be viewed as a protector against all threats to the empire and as the patron of the military. At the popular level, Guandi was appreciated as a symbol of trust, particularly as a sign of good faith in business transactions, and therefore became the protector of merchants. Portraits of Guandi were rarely included in hagiographical albums of the Ming dynasty, but his life stories were circulated widely in the format of fictions with rather inferior illustrations depicting the protagonists in various poses (**Fig. 29**). A Dehua figure shows Guandi standing with his hands hidden in his large sleeves and held to one side (**Fig. 30**). Although Dehua models must have often followed woodblock prints, in this case the folds of drapery seem to be a direct imitation of an ivory carving like the one mentioned previously (see **Fig. 25**). By adding the Y-shape chain-mail armour under the outer robe, his identity as a military figure is clearly revealed.

Also popular in Fujian were the Immortals, who were believed in the late Ming period to bring to fruition all the best things in life. Among the innumerable Daoist Immortals, the eight figures known as the Eight Immortals (*Bāxiān* 八仙) were most fervently worshipped by the Quanzhen (Complete Realisation) Daoist school from the 14th century onwards.[24] The composition of eight members was not fixed until the appearance of the fiction *Ba xian chu chu dong you ji* 八仙出處東遊記 (*Origin Tale of the Eight Immortals and their Journey to the East*) by Wu Yuantai (act. *c.* 1566) in the second half of the 16th century.[25]

The Eight Immortals are common in Zhangzhou carved ivories but are rarely found in contemporary Dehua porcelain figures; the reasons for this are not yet entirely clear.[26] Immortals were often portrayed as odd or

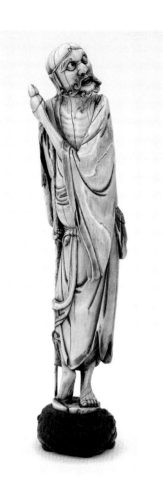

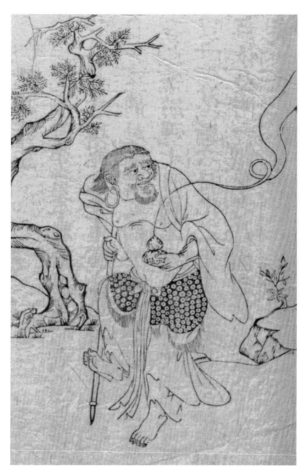

Figure 31 (far left) Li Tieguai, *c.* 1580–1644, Zhangzhou, Fujian province, China, ivory, h. 29cm. British Museum, London, 1952,1219.6, donated by Miss L.E.S. David

Figure 32 (left) Portrait of Li Tieguai from *Xian fo qi zong*, 1602, probably Nanjing, woodblock printed, ink on paper, 26.2 x 16cm. Yonezawa City Library, Yamagata, Japan

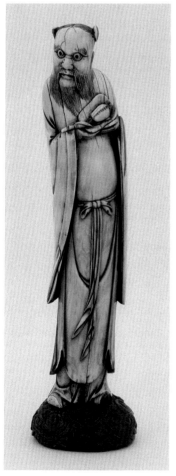

Figure 33 (far left) Zhongli Quan, *c.* 1580–1644, Zhangzhou, Fujian province, China, ivory, h. 29.8cm. British Museum, London, 1952,1219.8, donated by Miss L.E.S. David

Figure 34 (left) Portrait of Zhongli Quan from *Xian fo qi zong*, 1602, probably Nanjing, woodblock printed, ink on paper, 26.2 x 16cm. Yonezawa City Library, Yamagata, Japan

unconventional in their appearance, symbolising their rejection of established social norms or traditional ways of life. Each can be recognised by their highly individual features and stance, which were carefully imitated by Zhangzhou carvers from woodblock depictions.

Li Tieguai, or Iron-crutch Li, according to legend, almost always appears as a barefoot, dishevelled beggar with one lame leg, as shown vividly in a well-carved ivory figure (**Fig. 31**). He is depicted leaning on his iron crutch that would never rust or break and holding a medicine gourd that could cure any illness and would never be emptied, which is almost identical with the illustration in *XFQZ* (**Fig. 32**). His head is turned to the left, again consistent with the printed figure, although there is nothing for him to look at. Similarly, the iconic features of Zhongli Quan (**Fig. 33**) – his exposed pot belly, top-knotted hairstyle and big feather fan – carefully follow the woodblock print original (**Fig. 34**). From the Ming dynasty, the Eight Immortals were increasingly absorbed into popular culture and were quite often associated with Shoulao, the god of longevity. The Immortals were therefore reshaped into a group of wish-fulfilling figures closely linked with birthday celebrations, which explains why there is a tortoise, a symbol of longevity, on the fan of Zhongli Quan.[27]

This brief examination of the relationship between woodblock prints and figurines in Fujian during the 16th and 17th centuries demonstrates that the artistic adoption of such figures was in fact the result of the interplay between religions, printing culture and craftsmanship. Public interest in the life stories of deities and immortals was led by the growth of popular religions, which together with the prosperity of the printing industry stimulated the production of numerous illustrated hagiographical works, providing a comprehensive guide to the deities, immortals and saints in Chinese religious traditions, both Buddhist and Daoist, and from official and popular cults. These richly illustrated books, through the active book trade network in Jianyang, flowed into Zhangzhou and Dehua and then became important references for local craftsman or their patrons when making religious figurines to meet the increasing demands of domestic and eclectic worship.

Notes

1 Brokaw 2005.
2 Chia 2002, 206–7.
3 Murray 2000.
4 Chia 2002, 51.
5 Little and Eichman 2000.
6 For example, Guan Yu, a celestial guardian who was absorbed into the Daoist pantheon during the Song dynasty, was entitled as a *di* (emperor).
7 Little and Eichman 2000.
8 Gillman 1984.
9 Chia 2002.
10 Chang 1990.
11 Gillman 1984.
12 Other types of wares were also produced in Dehua kilns during the Ming and Qing dynasties, such as *qingbai* and blue-and-white wares.
13 Harrison-Hall 2001.
14 Kerr 2016.
15 Ibid.
16 Translation from Yuan 2002, 37–48.
17 Tien 1990.
18 Quoted from Gillman 1984, 46.
19 Chia 2002.
20 The book fair was noted in both the 1553 and 1601 Jianyang gazetteers.
21 Kleeman 1994.
22 A painting by Ding Yunpeng (1547–*c.* 1628), dated 1596, shows Wenchang descending on clouds with a similar entourage: British Museum, 1936,1009,0.129.
23 Duara 1988.
24 Jing 1996.
25 The members of the Eight Immortals are: Zhongli Quan, Lu Dongbin, Li Tieguai, Zhang Guolao, Han Xiangzi, Cao Guojiu, Lan Caihe and He Xian'gu.
26 A rare Wanli period porcelain figure identified as Zhongli Quan, painted in cobalt blue and made in Jingdezehn, is in the Hallwylska Museum, Stockholm, Sweden, acc. no. XLVIII:VII:C.b.b.01, see Kerr and Jansson 2015.
27 Jing 1996.

Chapter 4

'Take Note': The Construction of Political Allegories of the Sack of Rome (1527) on Italian Renaissance Maiolica in the British Museum

Dora Thornton

The British Museum's superb collection of Italian Renaissance ceramics includes a small group of pieces from the 1530s that comment on contemporary politics. This is a rare phenomenon on tin-glazed ceramics (maiolica) and all the items of this kind are the work of Francesco Xanto Avelli of Rovigo (c. 1487–c. 1542), active in Urbino, or his close circle of associates. The question of how they collaborated or influenced one another is complex. It is not clear who they were painting for, as the pieces do not feature the coats of arms of a patron. Nor is it clear as to whether anyone noticed, but the ambition to make a political point – one that would be understood within an elite audience – is there. These objects have a distinctive quality, even if their meaning resists precise interpretation and remains obscure, which places them at the beginning of the European tradition of politics on pots.

Narrative painting on pottery – often derived from contemporary developments in prints and printmaking – was a new phenomenon in 15th-century Italy. From around 1470 onwards, potters worked at the limits of available kiln technology to perfect a completely new kind of ceramic: maiolica. Commentators at the time remarked on the fine quality of the very best pieces as discussed here: its lightness in the hand, its shining, well-fired surface, its clean white tin-glaze that made a perfect ground for painting, and its brilliant pigments.[1]

It was the painting of the best pieces that raised the intellectual status of maiolica for elite patrons as a modern art form. And it could do distinctive and different things, such as displaying the use and successful firing of varied pigments and glossy glazes, and proving the painter's mastery of the art of *disegno*: a contemporary concept encompassing both drawing and graphic design.[2] Outline drawing in a restricted range of colours had long been practised on Italian ceramics, but this period saw the development of a wider range of pigments and expanding knowledge in how to fire them successfully.[3] The growing status of *disegno* among artists and patrons within increasingly wealthy urban elites led to a new visual language on pots, *istoriato*, pottery painted with complex narratives, which developed simultaneously in a number of pottery centres. It was always a small production at the top of the market. This is the expression of a highly evolved elite culture with a distinctive pattern of consumption and a new code of social behaviour expressed through art. The renowned art historian Giorgio Vasari (1511–1574) was familiar with ceramics: his surname derived from the trade of *vasaio*, or potter, as practised by his grandfather in Arezzo, and he was aware of what was distinctly modern about maiolica in his day.[4] He thought it a greater achievement than the pottery painting of the ancient Romans, with its restricted palette, which never equalled 'the brilliance of glaze nor the charm and variety of painting which has been seen in our day.'[5] *Disegno* was given new impetus by the revolution in printing and printmaking – both woodcuts and copperplate engraving – which extended the range of graphic sources that ceramic artists could exploit in their work, from meticulous copies to excerpted figures or complex narrative collages. A mid-16th-century treatise on the potter's art by Cipriano Piccolpasso (1524–1579) shows

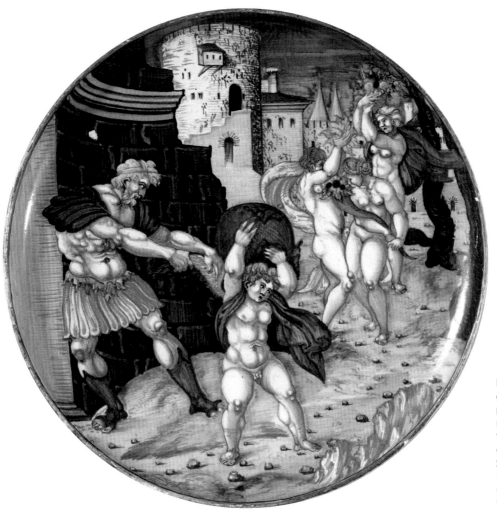

Figure 35 Lustred dish with a contemporary political allegory, probably the Sack of Rome, signed by Giulio da Urbino, 1534, Urbino, Italy, tin-glazed earthenware (maiolica), diam. 27.6cm. British Museum, London, acquired with a contribution from the Art Fund, 1997,0401.1

painters sitting in a workshop, holding wares in their lap as they paint, with graphic sources tacked to the walls – either prints or workshop drawings – giving a vivid sense of the visual world of the ceramic artists who produced high-class maiolica.[6] What we see is growing confidence on the part of painters in the use of graphic sources and the skill with

Figure 36 Detail of the inscription on the reverse of dish in Figure 35

which they edit them to circular forms or curved surfaces, adapting them to their own purposes and adding colour.

Great attention has been paid by maiolica scholars over the years to the way in which Italian Renaissance ceramic artists positioned themselves within the burgeoning print culture of their time.[7] Two of them are discussed here. Francesco Xanto Avelli of Rovigo and his close collaborator Giulio da Urbino used the latest print technology – including pornographic imagery banned by the Pope – to create complex political allegories of their own invention. Xanto went further in inscribing his pieces on the reverse with literary tags or moral comments to point up the meaning. He is one of the precursors of the European tradition of pots with attitude celebrated in this book.

In 1997 the British Museum purchased, with the help of the Art Fund, a very fine *istoriato* dish (**Fig. 35**).[8] The great scholar-curator, Sir Augustus Wollaston Franks (1826–1897), started a tradition from the mid-19th century of acquiring items for the British Museum that document the development of maiolica: pieces that are inscribed, dated, signed or marked in some way, which have become the lodestones for all scholarly study of the subject. The collection is small but select.[9] This dish appealed as it is signed on the back by one of the finest ceramic painters of the Renaissance, Giulio da Urbino, and dated 1534.[10] The scene on the front, which is evidently an allegorical presentation of a complex subject, calls for interpretation. Here, a semi-naked man in ancient Roman armour pulls on the wing of a

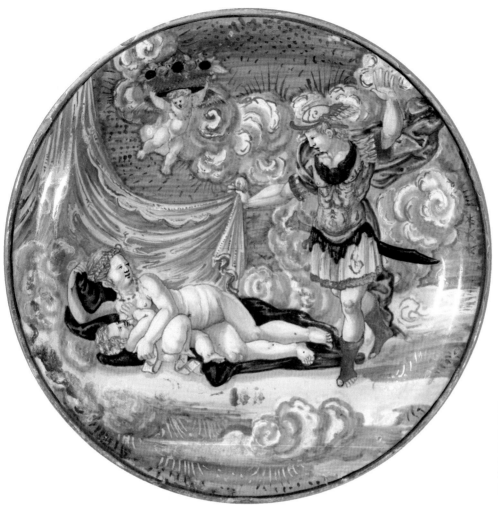

Figure 37 Lustred dish with Mars, Venus and Cupid, signed by Francesco Xanto Avelli, 1531, Urbino, Italy, tin-glazed earthenware (maiolica), diam. 26.2cm. British Museum, London, 1855,0313.12

putto, who bears on his shoulders a large spherical object. They stand before a ruined city with rock formations making a kind of stage. To the right are three naked women dancing, one with a cornucopia, the others with fruit and leaves. The scene is brilliantly painted in a range of pigments, with the figure drawing in cobalt, fixed in a second kiln firing at high temperature. The dish has been strikingly finished with metallic lustre, which lights up the details. This was something that required a third, low-temperature firing: a technique that was costly in raw materials, time and expertise. Even so it was difficult to achieve, with a high failure rate, as well as being dangerous in generating carbon monoxide as a by-product. It is perhaps no surprise that it was practised in specialised workshops, notably in Deruta and Gubbio, not necessarily the one in which the dish was first painted. Here, the lustre finish has been perfectly fired – probably in the workshop of Maestro Giorgio Andreoli in Gubbio – to produce a gleaming surface. These pieces were intended to be handled, displayed and discussed among their elite patrons in Renaissance Italy. As you turn the dish over, you see the inscription on the reverse that makes clear this is an allegory with layers of meaning and interpretation (**Fig. 36**): '1534. I encumber men's souls with thoughts of love'.[11] Giulio follows this with a flourish in place of a reference to a text, like that used by his mentor, Francesco Xanto Avelli, after many of his textual citations.[12]

Giulio da Urbino has not just copied this kind of signature from his mentor but also the way in which he uses literary sources to construct his own compositions. The inscription on the dish is derived from a poem by Petrarch (1304–1374), *Canzoniere*, number 10, lines 10–12: 'and the nightingale which nightly in the shade sweetly laments and weeps/encumbers the heart with amorous thoughts', but Giulio has transposed this into the first person, perhaps to be

Figure 38 Detail of the inscription on the reverse of dish in Figure 37

Figure 39 Nine fragments of the 'Loves of the Gods' (*I Modi* ['The Positions']), possibly by Agostino Veneziano after Giulio Romano's designs for Marcantonio Raimondi, c. 1510–20, Rome, Italy, engravings, mounted on a sheet, 24 x 27cm. British Museum, London, Ii,16.6.1-9

spoken by Cupid on the front of the dish. He has misremembered or intentionally altered the original sonnet.[13] When the dish was acquired it was assumed, because of the love poetry, that this was a love allegory, but the quotation derives from a sonnet about the political misfortunes of Rome and the corruption of the papal city. The allegory presented here is highly charged and topical. The key is Petrarch, and the way in which his poetry was used by Francesco Xanto.[14]

Xanto is a fascinating ceramic painter of great artistic ambition. An exhibition was dedicated to him at the Wallace Collection, London, in 2007, revealing him as a painter, poet and aspiring courtier under Francesco Maria I Della Rovere, Duke of Urbino (1490–1538).[15] He was born in Rovigo, in the Veneto, but spent most of his career in Urbino, seeking the support of the Duke as patron. He is well documented there from 1530, when he encouraged other workshop employees to bid for higher wages. Several workshop owners decided not to employ particular blacklisted workers, including Xanto, without prior agreement from each other.[16] His status was nevertheless high, as one notarial document from 1539 refers to him not as a potter but as an 'outstanding painter of pottery vessels', while another of 1542 calls him 'potter and painter of pottery'.[17] We know from his work that he collaborated with a series of assistants, of whom Giulio da Urbino was the best. The British Museum holds one of the most important pieces of Xanto's work, on which he describes himself as both painter and poet, which illustrates a scene from his obsequious sonnet sequence, *Il Ritratto*, or *The Portrait of the Most Illustrious and Indomitable Prince Francesco Maria Feltrio dalla Rovere Fourth Duke of Urbino* (**Fig. 37**).[18] A fine manuscript of the sonnets was kept by the Dukes of Urbino until the dynasty became extinct in 1658, after which it passed into the Vatican Library.[19] Xanto inscribed the back of the British Museum dish with *Mars, Venus and Cupid* with a

reference to his poem: '1532. Mars, having returned to Heaven, contemplates Venus, in the 25th Canto of the poem Rovere the Victorious by FXAR, painter, Francesco Xanto Avelli of Rovigo painted this in Urbino' (**Fig. 38**). The scene on the front exemplifies Xanto's way of working, using prints from the Raphael School, excerpting figures and rotating, reversing or transposing them in his own kind of collage technique to make new compositions and new meanings. Here he has employed three figures: Mars from an engraving by Giovanni Jacopo Caraglio (c. 1500–1565), *Mercury carrying Psyche to Olympus*, and Cupid from Marcantonio Raimondi (c. 1470/82–c. 1527/34) of c. 1515 after Raphael's *Parnassus*.[20] Venus is adapted from Position 9 of a series of prints illustrating sexual positions, *I Modi*, produced by Marcantonio after designs by Giulio Romano (1499–1546).[21] The prints were given additional life in a book edition in which they were accompanied by explicit sonnets by Pietro Aretino (1492–1556).[22] The prints were immediately suppressed by Pope Clement VII (1478–1534) in Rome in 1524 so that no complete set has survived, although the British Museum retains a set of prudish excerpts that include part of the figure used by Xanto for Venus; it is in the middle of the top row of cuttings (**Fig. 39**).[23] Otherwise, this Position 9 is known only from woodcut copies in reverse, showing that Xanto's source was the original Marcantonio print.[24]

Xanto's *Mars, Venus and Cupid* takes us closer to interpreting Giulio da Urbino's allegory. On another dish formerly in the Arthur M. Sackler Collection, Xanto employed the same female figure from *I Modi* to represent the languishing and voluptuous city of Rome, whose drapery is being tugged away by a figure representing the army of the Holy Roman Emperor Charles V (1500–1558), who in 1527 was responsible for the disastrous Sack of Rome (**Fig. 40**). The inscription on the back makes the meaning and political judgement explicit: 'Rome languishes in the presence of

Clement, take note', inscribed with the *y/phi* flourish. The sexual violence of the theme is underlined by Xanto's use of a figure from a print either by Marcantonio or Giulio Romano after *The Rape of Helen*.[25] Also, here is the putto with the inflatable ball on his shoulders: the inscription on Xanto's dish makes it clear that this figure is intended to be read as Pope Clement VII, a pope from the Medici family whose arms included six red spheres on their coat of arms. The Cupid is taken from an engraving by Marco Dente da Ravenna (1493–1527) of an ancient Roman sarcophagus that was admired by artists.[26]

How does Xanto's satirical plate allow us to interpret Giulio's? First it helps us understand how the allegory is put together, using the same Marco Dente engraving for the Cupid figure (**Fig. 41**), and adding another Marco Dente print after Baccio Bandinelli (1493–1560), *The Massacre of the Innocents*, for the violent soldier (**Fig. 42**), and a Caraglio print after Rosso Fiorentino (1494–1540) for the dancing women (**Fig. 43**).[27] But Giulio is allusive and perhaps less confident than Xanto in presenting this as a political allegory. It is not entirely clear that the violent soldier-hero represents Charles V or that the putto stands for Pope Clement, and the group of dancing women might be shorthand for the lascivious distractions of Rome, referring back to the amorous thoughts that corrupt the mind in the poem cited on the back. If this is right, then the dish shows the Medici Pope Clement being punished by Charles V, which is consistent not only with Xanto's interpretation of the Sack of Rome, but also with the imperial propaganda of the time, which saw the Sack not as licentious looting by

Figure 40 Dish with an Allegory of the Sack of Rome, attributed to Francesco Xanto Avelli, *c.* 1527–30, Urbino, Italy, tin-glazed earthenware (maiolica), diam. 26.3cm. Christie's, New York, 13 January 1993, lot 23. Photo © Christie's

mercenaries but as divine moral punishment of a sinful city and its debauched papal government.[28] Charles V's Latin Secretary, Alfonso de Valdés (*c.* 1490–1532), claimed that 'it was God's judgement which brought about the punishment of that city', but he held accountable the corrupt Roman clergy and evil advisers to Pope Clement rather than

Figures 41–3 (left, Figure 41) *Putto*, detail from Marco Dente, of an antique sarcophagus known as The Throne of Neptune, 1519–27, Rome, Italy, engraving, original 16.5 x 35cm. British Museum, London, 1860,0728.646, Bartsch XIV.194.242; (middle, Figure 42) *The Massacre of the Innocents*, detail from Marco Dente, after Baccio Bandinelli, *c.* 1520–30, Italy, engraving, 41 x 57.2cm. British Museum, London, V,2.132, Bartsch XIV.24.21; (right, Figure 43) *Hercules Defeating Achelous*, detail from Jacopo Caraglio, after Rosso Fiorentino, 1520–34, Rome, Italy, engraving, 21.2 x 17.8cm. British Museum, London, 1866,0623.16, Bartsch XV.86.48

Figure 44 *Clement VII and Charles V at the Congress of Bologna*, Sebastiano del Piombo, *c.* 1530, Italy, black and white chalk on grey prepared paper, 30.9 x 46.2cm. British Museum, London, donated by the Art Fund, 1955,0212.1

Clement himself, 'He just had the wrong people round him.'[29] Baldassare Castiglione (1478–1529), as papal nuncio, wrote to Valdés in August 1528 to denounce his judgement, claiming that he said 'the evils committed by the Pope and the Clergy in Rome were much greater than those committed by the soldiers. You also insist, in every possible manner, that those crimes [of the Sack] were the result of the Pope's own guilt and were divinely authorised.'[30] The satirist, Aretino, wrote the Pope a letter that apparently made him weep, placing the blame on his immoral clergy.[31] Even the 'talking' ancient Roman statue, Pasquino, had a note attached to him that stated the city's sufferings could be attributed to a heavenly vendetta against vice: 'Dunque, Pasquin, non ti stupir di ciò / che'l sacco, peste, fame, e'l Tever fé, / Ché per vendetta il ciel tutto mandò.' ('Don't be surprised, Pasquino, that the Sack, plague, famine and the Tiber flood / were all sent by Heaven in vendetta').[32] The *Pasquinade* implied that a person or defined group – the clergy – could be held to account for Rome's sufferings.

Other scholars have placed the dish in an Urbino context, as an allegory for the return of the Della Rovere to the Duchy of Urbino in 1521–2, which was confirmed on 12 December 1529.[33] The Congress of Bologna in 1530 between the Pope and the Emperor, at which Charles V was crowned as Holy Roman Emperor and acknowledged to be the arbiter of Italian affairs, is recorded in a drawing in the British Museum, made perhaps in preparation for a painting, by Sebastiano del Piombo (*c.* 1485–1547), who was in the papal retinue as a courtier in witnessing the event (**Fig. 44**). It is one of the very few images related to the aftermath of the Sack of Rome and has been described as being 'as much propagandist as documentary' in intention, as you can see by the portrayal of a wily Pope who appears to be in control of the situation.[34] Clement was in fact made to defer to the new Emperor, whose support for Francesco Della Rovere in his claim to the Duchy of Urbino was confirmed at the Congress.[35] In this context, might the warrior on Giulio's dish be regarded as Della Rovere rather than Charles V? The putto is still Pope Clement, and the

dancing women stand for the abundance that the renewed Duchy will bring to Urbino, seen in the ruined city. The loving thoughts of the poem are then directed by loving citizens to their Duke.[36] Whichever way you interpret Giulio's dish, it remains an important political statement about a contemporary event, an anti-Medicean allegory in the aftermath of the Sack of Rome. It must have been painted for someone in a small elite circle of patrons who would understand and agree with its message, in Urbino or beyond.[37]

But what was it about the Sack of Rome that unleashed these political satires on maiolica? One of Xanto's favourite authors, Ludovico Ariosto (1474–1533), wrote in *Orlando Furioso*, completed in 1532: 'Look at the carnage and plunder which afflicts the length and breadth of Rome. See there the arson and the rape – the sacred and profane fall victim equally.'[38] It was the most traumatic series of events of the 16th century in Italy: nine months of looting and rape by German mercenaries, accompanied by plague, which resulted in the deaths of thousands. Ten thousand more fled into the countryside, taking the plague with them.[39] Notarial acts document the damage to property and possessions in Rome itself, which fell particularly hard on the city's Jewish community.[40] All of Rome's citizens suffered, not least printmakers of the Raphael School whose work was so much used by maiolica painters. According to Vasari, Marcantonio's worn copper plates for engraving were taken by German soldiers, and Marco Dente was killed.[41] The shame of Italy at the hands of imperial troops was widely reported, as in the diaries of Marino Sanudo (1466–1536), in which he wrote that in the streets of Urbino – the great centre for *istoriato* maiolica of the kind we are considering – people wept at the atrocities being committed in Rome:

> here there is so much unhappiness about the situation in Rome
> that it is unbelievable; and let me say that with my own eyes I
> have seen when gentlemen have been speaking of it, as they are
> accustomed to do among themselves, some twenty-five of them
> weeping uncontrollably as if it had happened in their own
> houses.[42]

Figure 45 *Portrait of Pietro Aretino*, Giovanni Jacopo Caraglio, possibly after Titian, 1533–5, Italy, engraving, 19cm x 15.2cm. British Museum, London, 1871,1209.624 11

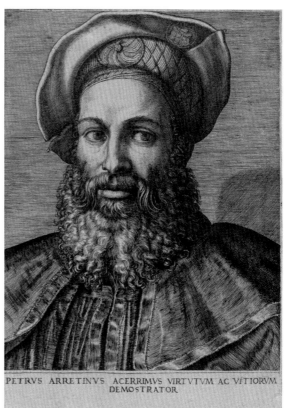

Figure 46 *Portrait of Pietro Aretino*, Marcantonio Raimondi, 1515–27, Italy, engraving, 17.4 x 15.5cm. British Museum, London, 1857,0711.32, Bartsch XIV.374.513

Clement VII hardly proved himself as defender of Rome. As John Mallet has noted, when he heard the approaching troops while at prayer in the Vatican, Clement promptly fled to safety in the Castel Sant'Angelo, as commented upon by Xanto on one of his plates: 'Clement shut up in the Castle and Rome suffers'.[43] He stayed there until he could buy his way out with gold melted down by the goldsmith Benvenuto Cellini (1500–1571) from the treasury of St Peter's Cathedral. He then escaped in disguise in December 1527 to the fortified papal towns of Viterbo and Orvieto; a fine allegorical dish by Xanto in the British Museum might refer to his flight.[44]

Cecil Clough has pointed out that Francesco Della Rovere was curiously inactive in the defence of Rome. He delayed and put his own interests in the Duchy of Urbino first, certainly before those of his old enemies, the Medici.[45] Charles V, back in Spain, was out of the action, and the death of his commander, Charles III, Duke of Bourbon (1490–1527), outside the city walls on 6 May 1527, after he had been unable to pay his German mercenaries, led to looting and destruction. Violence was accompanied by slavery for those who could not raise a ransom. All this was gruesomely described by Luigi Guicciardini (1478–1551) in his account of the Sack, which appears to have been written at the time.[46] Guicciardini argued that the destruction was 'the just wrath of God' against the papal Curia: 'My purpose is to show what sad and unlucky ends those governments come to which rule and maintain themselves in a culture of lust, greed and ambition.'[47] He had no doubt in blaming Pope Clement, voicing for his readers Clement's imagined thoughts as he was imprisoned in Castel Sant'Angelo:

And though he enjoyed great honours and sweet pleasures in the past, now he is paying for them with humiliation and pitiful distress. If he ever considered himself a wise and glorious prince, now he must acknowledge himself to be the most unfortunate and abject pontiff who ever lived. And since it is his fault that the Church, Rome and Italy all find themselves in such extreme danger, we can easily imagine that he often looks toward the sky with tears in his eyes and with the bitterest and deepest sighs he demands: 'Wherefore, then, hast thou brought me forth out of the womb? Oh, that I had died, and no eye had seen me!' Job 10.18].[48]

This deep sense of guilt and shame explains the strange lack of surviving visual representations of the Sack other than on maiolica made a few years after the event, once a consensus was possible. There must have been broadsheets – printed pages with satirical images and text – that were hawked in the streets by pedlars. A contemporary commentator suggests that such things were indeed available. Aretino wrote a play, *La Cortegiana*, in which a pedlar called *Furfante*, or Scoundrel, sells in Rome what are evidently illustrated broadsheets on a variety of topical subjects:

pretty stories, stories, stories, the war of the Turks in Hungary, the sermons of Father Martino, the Council, stories, stories, the facts of England, the festivities of the Pope and the Emperor, the circumcision of the Voivoda, the Sack of Rome, the Siege of Florence, the skirmish at Marseilles and its conclusion, stories, stories.

Published in the second edition of *La Cortegiana* in 1534, the same year in which Giulio painted his allegory of the Sack, Aretino gives us a sense of how relevant the topic was

Figure 47 Dish with a composite head made up of male genitalia, probably Francesco Urbini, 1536, Gubbio, Italy, tin-glazed earthenware (maiolica), diam. 23.2cm. Ashmolean Museum, University of Oxford. Purchased with the assistance of the Art Fund, the Resource/V&A Purchase Grant Fund, France, Madan, and Miller Funds, and numerous private donors, 2003, WA2003.136

even seven years later, in the year of Clement VII's death.[49] In fact, that interval of seven years may have allowed artists to begin exploring such a politically and morally sensitive subject, if only by complex allusion rather than direct statement. Aretino was well known as a satirist and was acquainted with the leading printmakers in contemporary Rome. He was the author of the pornographic sonnets that he wrote to accompany woodcuts after Giulio Romano, *I Modi*, which – as we have seen – were popular sources for

Figure 48 Detail of the inscription on the reverse of dish in Figure 47

Xanto. His portrait was engraved by Caraglio, inscribed in Latin on the frame 'D. Petrus Arretinus flagellum principum' or 'castigator of princes' (**Fig. 45**), while Marcantonio's strikingly beautiful portrait of around 1515–27, in a fine and rare first impression in the British Museum, presents Aretino as a fashionable courtier and commentator (**Fig. 46**).[50] It is labelled below in Latin: 'PETRVS ARRETINVS ACERRIMVS VIRTVTVM AC VITIORVM DEMOSTRATOR' or 'the man whose sharp tongue lays bare virtues and vices'. Closely involved in the printmaking and print-selling scene in Rome, Aretino's satirical success was one that other artists, even maiolica painters, may have wished to imitate. Might Xanto have been among them?

What did contemporaries make of Xanto as an artist, satirist and commentator? It has been suggested by Mallet that a maiolica dish by Xanto's colleague Francesco Urbini (act. 1530–1536), which is now in the Ashmolean Museum, Oxford, might offer a clue. Urbini worked in Gubbio for the workshop of Maestro Giorgio Andreoli from 1531 to 1536. This dish bears his mark on the back (a pair of scales), the initials FR and the date 1536 (**Figs 47–8**). The front is painted with a head composed entirely of penises, which makes fun of the long maiolica tradition of dishes with heads of beautiful women, and the inference of the imagery is underlined by the text: 'OGNI HOMO ME GUARDA COME FOSSE UNA TESTA DE CAZI' ('Every man looks at me as if I were a head of dicks'). This is written back to front as explained by the verse inscription on the reverse: 'El breve dentro voi legerite Come i giudei se intender el vorite' ('If you want to understand the meaning, you will be

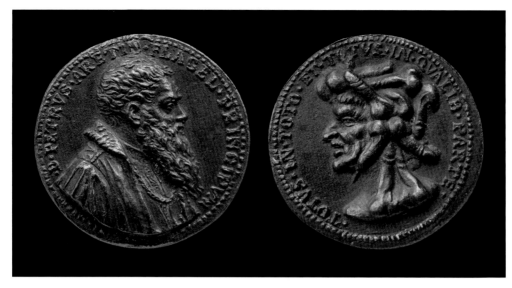

Figure 49 Medal, bust of Pietro Aretino, obverse, with a satyr's head formed of male genitalia, reverse, 16th century, Italy, cast bronze medal, diam. 4.6cm. British Museum, London, G3,IP.37

able to read the text like the Jews do'; that is, like Hebrew, right to left). Professor Timothy Wilson, who has recently catalogued the dish, thinks from the style of the painting that the artist must have been copying a print that, like *I Modi*, has not survived. He notes that something similar is listed in the print inventory of Ferdinand Columbus (1488–1539), son of the renowned explorer, in 1539, and Leonardo da Vinci (1452–1519) is said by Gian Paolo Lomazzo (1538–1592), the painter and art critic, to have drawn comparable profiles. The use of penises to build a portrait of a satyr is also seen on the famous portrait medal of Pietro Aretino, whose actual portrait appears on the obverse (**Fig. 49**).[51] Flipping the medal reveals Aretino as both satyr and satirist, and the

inscription repeats the legend on one of Aretino's print portraits, 'scourge of princes'.[52] Mallet at one point tentatively implied that the Ashmolean dish might be intended as a portrait of Xanto because of Urbini's close association with him, and because of the initials FR, which Xanto sometimes employed as a monogram in what are thought to be his early works. Speculating on unresolved issues about the relationship between the two painters in 1987, Mallet wrote in a review: 'It is odd . . . that in 1536 Francesco Urbini wrote the initials "F.R." under a dish on low foot painted with a peculiar phallic head, a piece also marked with Francesco's more usual sign resembling a pair of scales.'[53] Mallet wondered if the bowl might be a caricature of Xanto,

Figures 50–1 (left, Figure 50) *Taste and Democracy*, Grayson Perry, 2004, glazed ceramic, h. 41cm, diam. 26cm © Grayson Perry. Courtesy the artist and Victoria Miro, London/Venice; (right, Figure 51) Detail of Figure 50

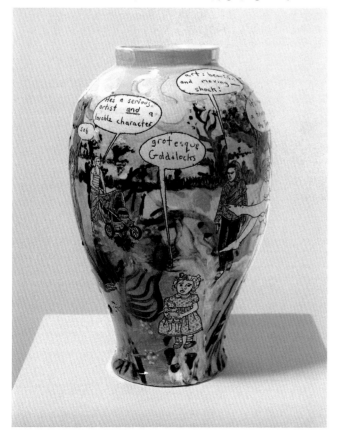

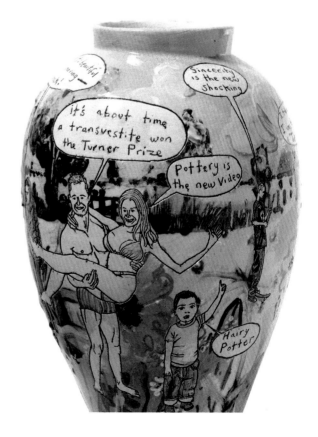

accompanied by a phrase that talks about his scurrilous reputation? Surely not, but the dish would seem to be a portrait; a piece made to commemorate someone or something within a small circle, as well as a playful joke. If so, it is intriguing that maiolica was the chosen medium. And it is interesting that what must be the same print has been used for a portrait of an emperor on a Frechen German stoneware jug dated 1595, in the Thomas Collection.[54] Perhaps the print source was German, not Italian?

And that is the curious thing: that a supposedly secondary and derivative art like maiolica should be used in this satirical way, especially as on the works by Xanto and Giulio to present a series of allegories with moral judgements on contemporary affairs. What is it about pots that makes this apparent contradiction possible? Grayson Perry, writing about his own pots as the first ceramic artist to win the Turner Prize in 2003, has intriguing insights. A pot (**Fig. 50**) that he made shortly after plays on his transvestite identity while proclaiming 'pottery is the new video' in a bid to be edgy and contemporary. It has an oddly *istoriato* look, perhaps in the scissors-and-paste manner of cut-outs, the layering and collage-like effect of what are clearly disparate transfer-printed sources to make a new whole. Like Xanto, Perry draws straight onto the surface as well. This is *istoriato* in the digital age. The text balloons add a series of exclamation marks around the figures, in amplifying or qualifying the imagery (**Fig. 51**), but that is not unlike Xanto's more savage inscriptions on the reverses of his pieces. As always with this kind of cross-cultural comparison, the differences in type and context are telling. On Perry's pots everything is on view all at once – there is something invitingly communal about them; they aim at mass communication – whereas Xanto's words are only revealed when you turn the object over, which implies a more personal and intimate relationship between a pot and a person within a socially restricted setting. Xanto was cultivating an elite and was proving his right to belong. We cannot be sure that his views were his own, or those of a patron or someone he was seeking to cultivate. But they certainly represent what one modern satirist has called 'a calculated dare'.[55] All the pieces discussed here are rare and distinctive within elite maiolica production in the 1530s. They stand out for their oddness.

Xanto is in some ways a precursor to Grayson Perry, in that, however different his style and classical allusions, he was making political statements through pornography (or sexually explicit imagery and comment) on pots.[56] Perry has commented that he 'still felt a lot of prejudice about my work, as I was being pigeonholed for using pottery'.[57] That is something that has certainly happened to Xanto historically; regardless of his message, ceramics have never been at the top of the European aesthetic hierarchy. Whatever the reason, Xanto's efforts at self-advertisement in his lifetime suggest he had to work hard to try to get his contemporaries to 'take note', as he put it on some of his pieces.[58] Of his own pots, especially the early lead-glazed ones in the tradition of Thomas Toft, Perry writes:

> it was never going to be a flashy, gay window-dressing art, it was always going to be humpy, heterosexual and earthy, however trite the images I put on the clay, the material would bring it,

literally, down to earth. One of the great things about ceramics is it is not shocking, so I thought 'I can be as outrageous as I like here because the vice squad is never going to raid a pottery exhibition'.[59]

Perry, of course, has brought his own transvestite twist to his pots, but perhaps Xanto felt much the same about censorship – after all, the Giulio Romano prints of *I Modi* he used had been banned and almost completely destroyed. With maiolica he was relatively safe to make his point. Surely no one would ever break a plate for its politics?

Acknowledgement

I would like to thank Grayson Perry for talking to me in his studio about his pots, their imagery, visual sources and making, and for his permission to illustrate his 2004 pot, *Taste and Democracy*.

Notes

1 Syson and Thornton 2001, 200; Wilson 2017, 12–20, for a recent account of the high status of the best maiolica.

2 Syson and Thornton 2001, 135–81, 211.

3 The literature is huge, but see especially Wilson 1987, 24–7; Wilson 2017, 47–63; Thornton and Wilson 2009, vol. 1, 37–51 for 14th- and 15th-century pieces in the Ashmolean Museum, Oxford, and the British Museum.

4 Rubin 1995, 61.

5 Vasari 1906, vol. 6, 581.

6 Piccolpasso 1980, Book 1, fol. 57 verso, and Book 2, xvii, 105–6.

7 This is a huge subject. Beyond the examples discussed here, for one artist and the impact of his prints and those by his copyists and imitators on maiolica, see Thornton 2004 and references.

8 British Museum, 1997,0401.1; Thornton 1999, 11–18; Cioci 2002, 110–21; Gresta 2002, 148–52; Mallet 2004, 37–54; Mallet 2007a, cat. 47; Thornton and Wilson 2009, vol. 1, cat. 171.

9 Dawson 1997; Wilson 1999, 203–18; Thornton and Wilson, vol. 1, 8–17.

10 Thornton 2007.

11 Thornton 1999, 12–13.

12 Mallet 2004, 38; Thornton and Wilson 2009, vol. 1, cat. 158 for an example.

13 For the poem, see Mallet 2007a, 189, Sonnet 10; and for commentary, see Cioci 2002, 110–12 and Gresta 2002, 151.

14 Holcroft 1988.

15 Mallet 2007a; Thornton and Wilson 2009, 256–89; Mallet 2007b.

16 Mallet 2007a, 13.

17 Triolo 1996, 394, doc. F; Mallet 2007a, 14; Wilson 2017, 147.

18 British Museum, 1855,0313.12; Thornton and Wilson 2009, vol. 1, cat. 164.

19 For text and translation, see Mallet 2007a, 15, 162–87.

20 Thornton and Wilson 2009, vol. 1, cat. 164.

21 Lawner 1984, 81; and for this figure and its source, see Talvacchia 1994, 121–53, 135, 137.

22 Talvacchia 1999, 12–13.

23 British Museum, Ii,16.6.1-9. In 2019 the original inventory numbers for the printed fragments acquired in 1837 were discovered, replacing the 1972, U.1306-1314 numbers. Talvacchia 1999, 14–15; Hislop and Hockenhull 2018, 176–7.

24 Mallet 2007a, 118.

25 Christie's, New York, 13 January 1993, Important Italian Maiolica from the Arthur M. Sackler Collection (Part 1), lot 23; Mallet 1988,

99, figs 13, 13R; Thornton 1999, fig. 10; Thornton and Wilson 2009, 292 n. 14.

26 Bartsch 1803–21, XIV.24.41.

27 British Museum, 1860,0728.646; Bartsch 1803–21, XIV.194.242 for the putto; British Museum, V,2.132, Bartsch 1803–21, XIV.24.21[or 41] for the soldier; British Museum, 1866,0623.16, Bartsch XV.86.48[1] for the dancing women; Thornton 1999, 14; Thornton and Wilson 2009, vol. 1, 290 and references for comments.

28 Thornton 1999.

29 De Valdés 1952, 25.

30 Ibid., 102.

31 Reynolds 2005, 160.

32 Marucci and Marzo 1983, vol. 1, *Pasquinade* 384, 377. Author's translation.

33 For this interpretation, see Clough 2005, 106; Cioci 2002; Gresta 2002.

34 Hirst 1981, 109; Mallet 2007a, 20, fig. 9.

35 Mallet 2007a, 21.

36 Cioci 2002; Gresta 2002; Thornton and Wilson 2009, vol. 1, cat. 171. For further comments, see Mallet 2007a, cat. 47.

37 Thornton and Wilson 2009, vol. 1, 292.

38 Ariosto 1983, Canto XXXIII, 55.

39 Brucker 2005, 79–81.

40 Esposito and Vaquero Pineiro 2005, 137.

41 Vasari 1906, vol. 5, 419.

42 Letter of 20 May 1527, see Sanudo 1879–1903, 45, 185–9; Hook 1972, 280.

43 Mallet 2007a, 19.

44 Thornton and Wilson 2009, vol. 1, cat. 157.

45 On Francesco, see Guicciardini 1993, 104; Clough 2005, 75–108.

46 Guiccardini 1993, 106–15; Gouwens 1998, xvii–xix.

47 Guicciardini 1993, 106.

48 Ibid., 116.

49 Landau and Parshall 1994, 359; Thornton 1999, 13.

50 British Museum, 1871,1209.624, Bartsch 1803–21, XV.98.64, and British Museum, 1857,0711.32, Bartsch 1803–21, XIV.374.513; Landau and Parshall 1994, 285.

51 British Museum, G3, IP.37; Wilson 2005; Wilson 2017, cat. 62.

52 Attwood 2003, 229, cat. 406.

53 Mallet 1987a.

54 Thomas 2003, cat. 15.

55 Hislop and Hockenhull 2018, 179.

56 Jones and Stephens 2020.

57 Klein 2009, 235.

58 Thornton and Wilson 2009, vol. 1, cat. 157.

59 Jones 2006, 192.

Chapter 5
War on a Plate: The Battle of Mühlberg on a Maiolica Dish at the Wallace Collection, London

Elisa Paola Sani

Looking at the majority of 16th-century Italian *istoriato* (story painting) maiolica, it might appear that the genre consisted of scenes of scantily clad figures, frolicking in bucolic settings. However, subjects featuring soldiers fighting were not infrequent. One of the most striking *istoriato* maiolica dishes picturing a famous battle is considered here: a large dish representing *The Battle of Mühlberg*, one of the Holy Roman Emperor Charles V's greatest victories, at the Wallace Collection, London (**Figs 52–3**).[1]

War and maiolica

First this chapter discusses why warlike subjects appeared on Italian Renaissance ceramics. Indeed, some of the largest and most elaborate services of *istoriato* maiolica known include depictions of military events, mostly from the classical period.

Wars were incessantly changing the political map of the country during the first part of the 16th century. There were constant battles, accompanied by devastation and the sacking of towns and cities, often followed by pestilence. The modern North-central Italian regions of Emilia Romagna, Marche, Tuscany and Umbria were among the territories that suffered most from the continuous political turmoil. This did not prevent them from being the leading producers of maiolica. Rulers and commanders were patrons of maiolica and commissioned (or, more often, received as gifts) table services depicting military subjects.

Istoriato, also called *figurato*, the most elaborate type of pottery painting, flourished particularly in the lands of the dukes of Urbino. The economy of the duchy depended on the duke hiring himself out as a military commander. As well as being at times commanders of the papal and Venetian armies, the Urbino dukes were also significant supporters of the Holy Roman Emperor Charles V (1500–1558) and his successors. Consequently, battle and heroic subjects were popular, while those glorifying the emperor were by far the most common among the contemporary military scenes depicted on maiolica from Urbino, as is discussed below.

Drawing battles

Unlike easel painters, potters relied heavily on graphic sources for their compositions, as painting on the powdery unfired tin glaze is unforgiving and does not allow for reworking. Woodcuts and engravings were key source material for potters when depicting the subject of war. Designs by Raphael (1483–1520) and his circle were the most widely used by Urbino potters. For example, the animated scene known as *Battle with a Cutlass* (1530–1), portraying the Romans and the Carthaginians, probably after Giulio Romano (1499–1546) and engraved by Agostino Veneziano (*c.* 1490–*c.* 1536), offered a multitude of artistically challenging active poses for *istoriato* painters.[2] An engraving from the famous cartoon of *The Battle of Cascina* made by Michelangelo in 1504 (1475–1564) was also employed as a source for maiolica, as seen on a dish at the British Museum made for the scholar and collector Pietro Bembo (1470–1547).[3]

Renaissance *condottieri* (mercenary captains) unsurprisingly enjoyed such warlike imagery. Maiolica, with

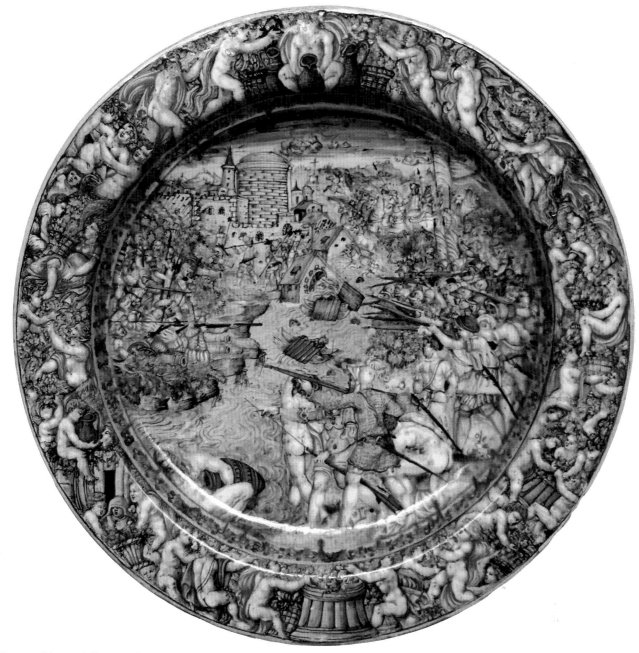

Figure 52 Plate with *Emperor Charles V Crossing the Elbe with his Army at the Battle of Mühlberg*, perhaps by Painter 'A.B.', in the workshop of Ludovico and Angelo Picchi, 1559, Castel Durante, Italy, tin-glazed earthenware (maiolica), diam. 43.3cm. The Wallace Collection, London, C146. Photo © author

its extensive and durable pictorial possibilities, was ideal for such decorations. In the mid-1530s, the pottery painter and poet, Francesco Xanto Avelli of Rovigo (*c.* 1487–*c.* 1542), painted with his assistants several series of ambitious maiolica panels, which are perhaps the earliest attempt at systematic treatment on maiolica of Classical subject matter.[4] One of these series deals with the First Persian Empire, describing the deeds of Cyrus the Great (600–530 BC), following the Latin historian Justin's *Epitome* of the *Universal History* by Trogus Pompeius.[5] Not being able to find suitable prints on the subject, he adopted a cut-and-paste technique, employing his usual stock of prints from Raphael's compositions. He put together some surprising imagery, and the plaques, which are numbered to form a sequence, were probably meant to be fitted in a *studiolo* of a prince, as has been suggested by Johanna Lessmann.[6] The famous *condottiero* Francesco Maria I Della Rovere (1490–

Figure 53 Reverse of Figure 52 inscribed in a square: 'd[e] lapresa d[e]/Sasonia/1559' ('of the taking of Saxony'). The Wallace Collection, London, C146. Photo © author

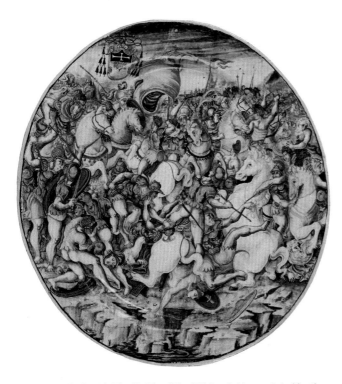

Figure 54 Dish with *The Battle of the Milvian Bridge*, painted by the 'Painter of the Coalmine Service', *c.* 1542, Urbino, Italy, tin-glazed earthenware (maiolica), h. 49cm, w. 46cm. Victoria and Albert Museum, London, V&A: 8925–1863. Photo © Victoria and Albert Museum, London

1538), Duke of Urbino and Commander of the Venetian army, to whose patronage Xanto aspired, would have appreciated an interior decorated with such a heroic topic.[7]

Prints were not the only source for dramatic military scenes on pottery. Sketches and drawings of monumental and relentless battles were also used. For example, the Battle of the Milvian Bridge in AD 312, between Emperors Constantine (*c.* 272–337) and Maxentius (*c.* 276–312), which was vital to the spread of Christianity across the Roman Empire, was represented in the south wall of the *Sala di Costantino*, one of the Vatican *Stanze* in an extraordinary fresco designed by Raphael and executed by Giulio Romano after Raphael's death in 1520. No print from the fresco existed in the first half of the 16th century, but preparatory cartoons were made and could have been seen by potters. The battle appears, for instance, on an armorial dish from a set known as the 'Della Rovere' dishes, which comprises pieces dated 1541–2, painted by an inventive *istoriato* artist named by John Mallet as the 'Painter of the Coalmine Service'.[8] The dish, which shows the left hand side section of the long battle, has a slightly oval shape that makes it look like a shield (**Fig. 54**).[9] The first owner of the dish is thought to have been a senior prelate. Religious figures were often involved in the political and military struggles of the time. The Vatican *Stanze* frescoes provided extremely prestigious subject matter for maiolica tablewares, which may have been recognised and appreciated by some of the patrons who were destined to receive them.

Classical literature was an influential source for heroic subjects depicted on maiolica. *The History of Rome* (29–27 BC), by Livy, was an important text during the Renaissance. With its simple woodcut illustrations, *The Deche di Tito Livio*

vulgare historiate, first published in Venice in 1493 and with many subsequent editions, provided subject matter as well as basic graphic guidelines for pottery painters wanting to represent Rome's ancient power. An Urbino *istoriato* service mostly painted by the 'Milan Marsyas Painter' with the arms of Francesco Sforza II (1495–1535), the last Duke of Milan, has violent subjects taken from the *Deche*, which reflected Francesco's contemporary rule of Milan.[10] A decade or so later, around 1545, Francesco Durantino (*c.* 1520–1597) made full use of the *Deche*'s text when he produced a series of most inventive battle scenes on *istoriato* dishes, representing the exploits of the great Roman general Scipio Africanus (236–*c.* 183 BC). The inscriptions on the reverse of the dishes, referring to chapters in the *Deche*, are the longest ever to appear on *istoriato* maiolica, symbolising clearly the importance given to the classical text (**Figs 55–6**).[11]

The degree to which classical battles were taken seriously by Renaissance patrons is shown by the fact that military subjects depicted on maiolica more often than not appear on large and artistically challenging services. The most ambitious of all war-themed *istoriato* maiolica series represents episodes from the life of renowned Carthaginian general, Hannibal Barca (*c.* 247–*c.* 183 BC), during the Second Punic War (219–217 BC). The scenes feature on at least 147 pieces of Urbino maiolica, many of which are numbered.[12] No graphic source is known to exist, but the complex descriptive rhyming verses on the reverse of the dishes must have been devised by a scholar. As Timothy Wilson has noted: 'The service is one of the most systematic attempts in all Renaissance art, in any medium, to portray in detail a substantial chapter of ancient Roman history'.[13] As befitting such a heroic and monumental topic, it was perhaps commissioned for a member of the ruling family of Florence, the Medici.[14]

Two of the most spectacular maiolica series ever created were executed from drawings especially made for them by important artists. Both depicted martial subjects and were diplomatic gifts from the Urbino dukes. The earlier series shows episodes of *The Fall of Troy* framed by inventive borders with putti, after beautiful designs by the Venetian artist Battista Franco (*c.* 1510–1561). It was produced at Urbino or Castel Durante, around 1545–50.[15] The other series comprises ambitious shapes including monumental wine coolers and elaborately moulded basins, decorated with stories of *The Campaigns of Caesar*, which follows drawings by the brothers Taddeo (1529–1566) and Federico Zuccaro (*c.* 1540/1–1609). These were painted on a refined background of inventive grotesque decoration, and probably made in the leading Urbino workshop of Orazio Fontana (*c.* 1510–1571) and of his collaborator Antonio Patanazzi (1515–1587), between 1565 and 1575.[16] Contemporary sources inform us that the Franco and Zuccaro series were in fact meant for key political allies of Guidobaldo II Della Rovere (1514–1574). Giorgio Vasari (1511–1574) recalls that sets with drawings by Franco were produced to be sent to Cardinal Alessandro Farnese (1520–1589) and to Emperor Charles V, while the 'Spanish Service', with Zuccaro's designs, was for Charles's son and heir, King Philip II of Spain (1527–1598) (**Fig. 57**).[17]

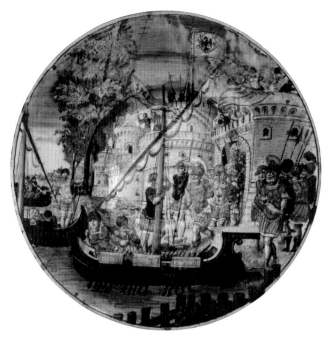

Figures 55–6 (left) Figure 55 Plate with *Scipio Sending Mago the Carthaginian to Rome to Announce his Victory*, painted by Francesco Durantino, probably in the workshop of Guido di Merlino, 1543–5, Urbino, Italy, tin-glazed earthenware (maiolica), diam. 29cm. Fondazione Banco di Sicilia, Palermo; (right) Figure 56 Detail of the reverse of plate in Figure 55. Images © Fondazione Banco di Sicilia

Glorifying the Holy Roman Emperor

All these ambitious maiolica war series represented events from the classical era. Renaissance princes identified with the Caesars and would have responded to the depictions of the heroic gestures of the Greek and Roman warriors and statesmen they sought to emulate. Contemporary battles, however, although often glorified in other media, were seldom represented on maiolica. This is perhaps because prints of contemporary events were scarce, and those that existed may not have had the prestige and aura of classical battle scenes.

Most of the contemporary military episodes represented on Urbino maiolica refer to the glorification of the Holy Roman Emperor and King of Spain, Charles V, and, in consequence, of his supporters, which included the Urbino dukes. While the emperor was ultimately responsible for much destruction in Italy, including the horrific Sack of Rome of 1527, he was also vital in re-establishing the legitimacy of the Urbino dukes, officially sanctioned during the Congress of Bologna, which followed the formal crowning of Charles. He was crowned Holy Roman Emperor at Bologna on 24 February 1530, by Pope Clement VII (1478–1534), who had previously been his enemy. This key historical moment marked the end of the wars in Italy and was depicted on maiolica;[18] many artists were present on this important day.[19] The episode was particularly meaningful for the Duke of Urbino, Francesco Maria I Della Rovere, who was summoned directly by the Pope to be part of the triumphal procession at the emperor's coronation.[20] The event was almost instantly represented in a fresco in the Villa Imperiale at Pesaro. Its entire decoration was dedicated to the glorification and legitimation of Francesco Maria's rule over the Urbino lands after his exile.[21]

While the emperor himself was portrayed on a maiolica bowl made in 1531, one year after his election,[22] most of the contemporary events represented by Xanto, who worked for the Urbino duke and sought his patronage, also depicted the emperor as a hero. In 1534 Xanto painted a dish with an allegory of the crucial Battle of Pavia of 1525, relying on various prints, even transforming a prostrate naked woman from an erotic print from *I Modi* into an armoured man.[23] The battle was a significant victory for Charles V, who defeated and captured the French King, François I (1494–1547).

Xanto's allegories of the Sack of Rome (see Thornton, Chapter 4), which he regarded as a just punishment for the

Figure 57 Plate with *Caesar Breaking the Bridge at Geneva*, c. 1560, Urbino, Italy, painted in the workshop of Orazio Fontana and/or Antonio Patanazzi, tin-glazed earthenware (maiolica), diam. 44cm. Victoria and Albert Museum, London, V&A: 7159–1860. Photo © Victoria and Albert Museum, London

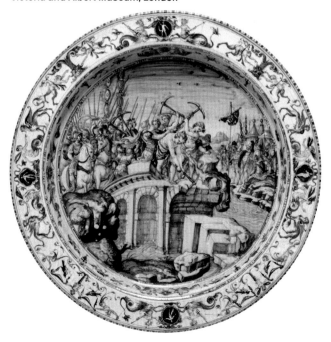

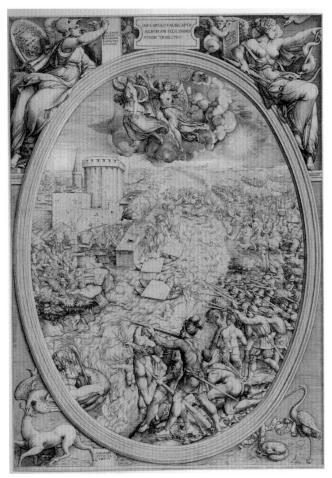

Figure 58 *Imp Caroli V Albis apud Milburgum felicissimo numine traiectio* ('The crossing of the River Elbe at Mühlberg by the Emperor Charles V under most fortunate auspices') with allegorical figures at four corners of a rectangular plate, enclosing an oval frame, 1551, Enea Vico, engraving, 53.6 x 37.9cm. British Museum, London, 1874,0808.278

during the battle. The Schmalkaldic War between Charles V and the Protestant princes of Germany in 1546–7 was much celebrated in the arts and literature of the time.

One of the earliest works to appear was a monumental print by Virgil Solis the Elder (1514–1562), which has printed below it a song by poet Hans Sachs (1494–1576), issued in the same year of the battle in 1547. It shows the dramatic defeat of the Elector Johann Frederick based on eyewitness accounts.[26] Among the many laudatory literary works was *Los Comentarios de la Guerra de Alemania* by Don Luis de Ávila y Zúñiga (c. 1490–c. 1560), the emperor's companion in arms. It was published in Venice in 1548, a year after the battle. Later chronicles included Alfonso de Ulloa's (c. 1529–c. 1570), La *Vita dell'invittissimo Imperator Carlo V* (1560) and a poem by Antonio Francesco Oliviero (1520–1580), *La Alamanna* (1567). All were key in the imperial propaganda of this important conflict, along with pictorial cycles executed in Spain.[27] The heroic image of the emperor, who participated directly in the wars, was established by the famous painting by Titian (1489/90–1576), *Charles V at Mühlberg* (1548), which was painted at the Augsburg court.[28] Engraved scenes of the battle based on designs by Maarten van Heemskerck (1498–1574) appeared on different media, such as grand parade shields.[29]

The earliest of the two prints by the Italian engraver Enea Vico of Parma (1523–1567), based on another portrait by Titian, shows a bust portrait of the emperor in armour within a classical temple, surrounded by allegorical figures evocative of his military successes and personal qualities. It was issued in 1550 with a commentary by Anton Francesco Doni (1513–1574) and was presented personally by Vico to the emperor in Augsburg in 1550.[30]

The other engraving by Vico, the outstanding printmaker of his generation, was made in 1551.[31] It is a spectacular oval composition framed by allegorical figures and emblems, depicting the defining moment of the Battle of Mühlberg and is the imagery that was frequently used by maiolica painters (**Fig. 58**). It shows the army of Charles V crossing the Elbe. In the words of A.V.B. 'Nick' Norman: 'the cavalry on the far wing of the army to the right crosses under covering fire from the harquebusiers of the centre. The opposite bank, on which stand a town and a number of water-mills, is defended by an army with field-guns. The remains of a pontoon bridge float down the river'.[32] In the foreground, men from the emperor's army undress, getting ready to swim across the river; some are in the water and steer boats. In the background, knights cross the river to reach the town.

Rosemarie Mulcahy has argued that the imposing engraving was intended to be part of a series with the triumphs of Charles V that never came to fruition. In 1549 Enea Vico sought the patronage of Cosimo de' Medici (1519–1574), Duke of Florence, and from 1569 Grand Duke of Tuscany, for this project.[33] Vico received a positive response from Cosimo, which is not surprising, as the Medici dukedom was a creation of the emperor. Vico also asked Cosimo for a recommendation to seek the direct patronage of the emperor. Cosimo suggested he contact Don Luis de Ávila y Zúñiga, the above-mentioned writer of the chronicle of the battle and personal adviser to Charles, who might

sins of the city and the papacy, have been seen as reflecting Xanto's support for the Urbino duke, who chose not to engage in battle with the imperial forces.[24] Towards the end of his career, in 1541, Xanto painted one of his most ambitious dishes. Unsurprisingly, it represents a battle of the Emperor Charles V, *The Taking of Goletta*. The pottery-painter based the composition on a print of *The Taking of Carthage* by Marco Dente da Ravenna (1493–1527) after a design by Giulio Romano. The ancient parallel provided prestige to contemporary undertakings. The dish, the largest known by Xanto, was meant for Ferrante Gonzaga-Guastalla (1507–1557), a general in the service of Charles V and brother of Federico II Gonzaga, Duke of Mantua (1500–1540).[25] A couple of decades after Xanto's allegories, the glorification of the Spanish Hapsburgs was still a major subject on Urbino maiolica.

The Battle of Mühlberg

Illustrations of military victories were an ideal subject for political propaganda. The contemporary event that was most often represented on Urbino *istoriato* maiolica was the Battle of Mühlberg. The battle took place on the River Elbe in Saxony on 24 April 1547, when Emperor Charles V and the Duke of Alba (1507–1582) were victorious over the Protestant league under its captain, Prince-Elector Johann Frederick of Saxony (1503–1554), who was taken prisoner

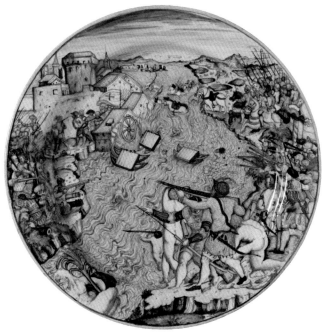

Figure 59 Plate with *Emperor Charles V Crossing the Elbe with his Army at the Battle of Mühlberg*, c. 1580–90, Urbino, Italy, tin-glazed earthenware (maiolica), diam. 43.5cm. Victoria and Albert Museum, London, V&A, 8926–1863. Photo © Victoria and Albert Museum, London

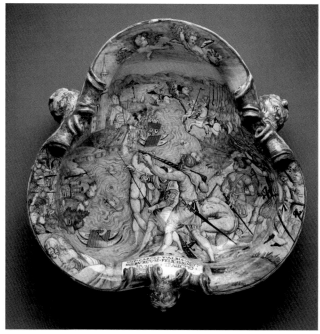

Figure 60 Wine cooler with *Emperor Charles V Crossing the Elbe with his Army at the Battle of Mühlberg*, c. 1560–90, Urbino, Italy, tin-glaze earthenware (maiolica), max. width 49.5 cm, diam. 14.9 cm. Metropolitan Museum of Art, New York, Gift of Julia A. Berwind, 1953, 53.225.90. Photo © Metropolitan Museum of Art, New York

have offered suggestions for the composition as well as securing a visit to Augsburg for Vico. In one of the letters to Duke Cosimo, Vico specified that the series was going to include episodes such as *The Coronation by Pope Clement, The Taking of Tunis, The Success in Algiers, The Triumphs in Germany* and so forth 'all to be set out in the order in which they occurred in a manner that will ensure their enduring memory. I will thus produce engravings based on drawings by skilled men on sheets of *foglio reale* size.'[34] Although Vico did not mention the name of the draughtsman, it has been argued that the design for the battle print was by Battista Franco.[35]

There are six known maiolica pieces illustrating the print by Vico.[36] They were all executed within the Urbino district and are all of grand proportions and fine workmanship (**Fig. 59**). While three are large dishes, three more are monumental wine coolers, the most impressive of all maiolica tablewares (**Fig. 60**).

We have evidence of at least one of the patrons connected with such impressive pieces. A wine cooler depicting the battle, now at the State Hermitage Museum, St Petersburg, has the arms of the Urbino duke, Guidobaldo II.[37] The presence of the Golden Fleece around the arms reveals the strong bond between the Urbino dukes and the Spanish rulers. In 1559 Guidobaldo had received the prestigious Order of the Golden Fleece from Philip II, therefore the theme of the *Battle of Mühlberg*, while celebrating the Hapsburgs, also reflected honour on the Urbino dukes. In 1565 Guidobaldo's son and heir, Francesco Maria II (1549–1631), was sent at 16 to the Spanish court of Philip II for three years. Philip II remained a lifelong model for Francesco Maria, the last Urbino duke.[38]

The only dated example of the known maiolica versions is a large plate in the Wallace Collection, inscribed on the reverse 'd[e] lapresa d[e]/Sasonia/1559' ('of the taking of Saxony') (**Figs 52–3**). This dish also fits well within the reign of Guidobaldo II. In 1558 he had been made General of the Kingdom of Naples by Charles's son and heir, King Philip II, and in 1559 had received from him the Golden Fleece.

Unlike all other representations of this battle on maiolica, the Wallace Collection dish is not in the style of Urbino potters, but rather shows similarities with the '*istoriato* house style' of the nearby potteries of Castel Durante from the middle of the 16th century. Johanna Lessmann was the first to study *istoriato* maiolica attributed stylistically to an unknown but prolific workshop of Castel Durante, which she named 'Workshop of Andrea da Negroponte', after the name appearing on a moulded bowl with Apollo at the Museo di Arte Medievale e Moderna, at Arezzo.[39] The workshop's sketchy and lively *istoriato* style features on a very large number of wares, especially moulded bowls. Wilson has attributed the Negroponte Style wares to the most widely documented family workshop in Castel Durante, that of the Picchi family, the brothers Ludovico and Angelo (d. *c.* 1573, 1583).[40] Recently, a dish from the same workshop bearing the initials 'A.B' has surfaced, reinforcing Lessmann's opinion on the painter's name, as 'A' might stand for 'Andrea', who was probably, but not certainly, a painter in the Picchi workshop.[41] The latter plate shares stylistic similarities with the Wallace Collection *Battle of Mühlberg* dish; however, the draughtsmanship of the Wallace dish is noticeably more elaborate.

Despite the obvious closeness to the image of the Vico print, the maiolica painter of the Wallace dish has added plenty of detailing to the central scene with the unfolding of the battle, offering a sketchy but realistic rendering of the dramatic scene. He shows particular attention to the different textures of the uniforms and armour of the

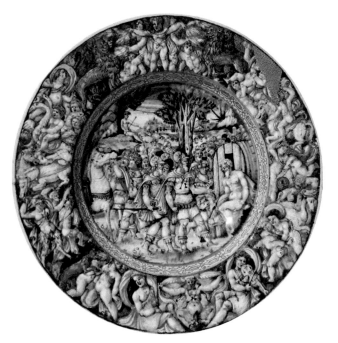

Figures 61–2 (left) Figure 61 Dish with *Alexander and Diogenes*, perhaps Painter 'A.B.', probably working in the Ludovico and Angelo Picchi workshop, 1559, Castel Durante, Italy, tin-glazed earthenware (maiolica), diam. 28cm. Museo delle Ceramiche, Pesaro; (right) Figure 62 Reverse of Figure 61 inscribed within two leafy branches: 'quando alesan/dro magnio ando/ innanze aquello/ diogine 1559' ('when Alexander the Great went in front of Diogenes'). Museo delle Ceramiche, Pesaro. Images © Comune di Pesaro/ Servizio Relazioni di governance e politiche culturali

characters, as well as of the weapons and the landscape, with well-defined architectural details. The painter has a lively but somewhat naïve painting style with figures with round faces and curly hair, depicted in tightly knitted groups. The colouring is rich, dominated by orange, blue and green with white highlights illuminating the flesh.

There is a group of ambitious dishes attributable to the Picchi workshop that can be related closely stylistically, as well as in terms of shape, to the Wallace Collection dish. All have inscriptions on their reverses within an ornamental frame, comparable to the Wallace piece. Included in this group are the following very large dishes: *Marcus Curtius Leaping into the Gulf*, dated 1558, at the Herzog Anton Ulrich Museum, Braunschweig;[42] *Apollo and Pan*, within a putti border a dish at the Walters Art Gallery, Baltimore;[43] *Samson* at the Museo Correr, Venice.[44] The closest of all maiolica to

the Wallace Collection example is, however, a 1559 dish of smaller size with an inventive border decoration similarly conceived, framing an *istoriato* scene of *Alexander and Diogenes*, at the Museo delle Ceramiche, Pesaro (**Figs 61–2**).[45] The same painter was also responsible for an armorial service comprising large and very elaborate *istoriato* dishes, which can also be dated to around 1559.[46]

The Wallace Collection *Battle of Mühlberg* dish has superb, very detailed motifs with a bacchanal of putti: little cupids harvesting grapes, with satyrs and women on the border (**Fig. 63a–b**). As with the dish at Pesaro – which has putti playing with different animals – the subject on the border seems to be unrelated to that at the centre. Putti engaged in similar poses often frame dishes taken from designs by Battista Franco, and these were obviously imitated by Castel Durante potters.[47] Vasari, in his second edition of his *Lives of*

Figure 63a–b Views of Figure 52 showing details of the border

the *Artists* (1568), recalls that maiolica with Franco designs was indeed made in Castel Durante.[48] However, Franco's drawings are mostly specular – that is, with the same design being drawn only on one side, then copied using a pounce technique on the other side – while the inventive border around our dish is symmetrical, it is drawn freehand in the round, a characteristic of all of the above-mentioned maiolica dishes close to the Wallace Collection piece. The seemingly unrelated decoration around the Battle dish, with a lively putti bacchanal, might represent instead a celebration of the Peace of Cateau-Cambresis, which ended the wars in Italy and sealed the predominance of Spain over France in the peninsula, which took place in 1559, the year in which the dish was made. This dish celebrating the triumph of Charles V is the most ambitious example of *istoriato* maiolica that can be attributed to the Picchi workshop of Castel Durante.

All the maiolica pieces known with the *Battle of Mühlberg* were made after the emperor's abdication in 1556. His reign, however, had an enduring legacy across the visual arts, from Titian portraits to Leone Leoni (1509–1590) and Giambologna (1529–1608) sculptures. Only a few years after his death in 1558, *The Life of the Emperor* was published by Ludovico Dolce (1508–1568).[49]

In his *Trattato dell'arte della pittura, scoltura et architettura* (1585), the painter and art historian Gian Paolo Lomazzo (1538–1592) commented that in the decoration of royal palaces, princes' houses and other splendid places 'he recommended to use the heroic events of the life of Charles V'.[50] The representations of the battle on Urbino maiolica can be seen in this light, celebrating the emperor and the war for Christianity, but also as an example for all rulers, elevating the military enterprises of Charles, one of the greatest and most powerful figures of the 16th century, to the status of those of ancient history.

Notes

1 This short paper is dedicated, without permission, to Suzanne Higgott, a marvellous scholar and mentor on the arts of the fire. I would like to thank Francesca Banini and Erika Terenzi at Pesaro Ceramics Museum, Reino Liefkes, John Mallet, the late A.V.B. 'Nick' Norman, Claudio Paolinelli, Justin Raccanello and Timothy Wilson. Patricia Ferguson has provided excellent advice and Sarah Faulks editing help. For the Wallace Collection dish (**Figs 52–3**), see Norman 1976, C146.

2 *Battle with a Cutlass*, Bartsch XIV.171.211. As we see, for instance, on an action-packed bowl by *The In Castel Durante Painter* made during the early 1520s at the Victoria and Albert Museum, London, C.200–1937: see Sani 2019, 75, fig. 14.

3 The British Museum dish is 1888,0215.1, along with the print, 1890,0415.6; see Thornton and Wilson 2009, I, cat. 188.

4 See Wilson 1996, 203.

5 See Wilson 1996, 205.

6 See Lessmann 2004. Another series of panels by Xanto depicts the fall of Troy; see one panel from this series at the British Museum, 1906,12-10,I, see Thornton and Wilson 2009, I, cat. 159.

7 On the topic of heroic and classical subjects on maiolica for the Duke of Urbino, see Cioci 2009 and Sani 2019.

8 On the painter, see Mallet 2003.

9 See Rackham 1940, cat. 869. A 1542 dish with same arms is at the

British Museum, see Thornton and Wilson 2009, I, cat. 187. It is known that the talented pottery painter Francesco Durantino represented the same battle on the exterior of a wine cooler dated 1553. The wine cooler is at the Chicago Art Institute, see Scheidemantel 1968. On the subject of Durantino, see Wilson 2004.

10 See Wilson 2018, cat. 90.

11 See Wilson 2004, 125–6, for a discussion about the series and a listing of the pieces known, to which can be added a dish at Palermo Museum: see Sani 2010, cat. 49, here illustrated.

12 See Drey 1991. One dish from the series is in the British Museum, 1878.12-30.445; see Thornton and Wilson 2009, cat. 192, for an extensive discussion of this series.

13 Wilson 2016, 208, cat. 67.

14 An inventory of 1774 shows that numerous pieces from the series were in the Medici collection, many of which were eventually sold, see Spallanzani 2009.

15 See Lessmann 1976; Clifford and Mallet 1976.

16 There is a vast literature on *The Spanish Service*, see Gere 1963; Clifford 1991; Clifford 2012; see also Thornton and Wilson 2009, cat. 239, for a comprehensive summary of the studies on the subject.

17 See Clifford and Mallet 1976, 388.

18 On a dish at Bologna, see Ravanelli Guidotti 1985, cat. 42, and for one in the Musée due Louvre, Paris, see Giacomotti 1974, cat. 920.

19 Many years after the events Giorgio Vasari painted *The Crowning of Charles V* in Palazzo della Signoria in Florence, 1556–62. Taddeo Zuccaro also painted the scene in the frescoes of the Villa Farnese at Caprarola; see Bodart 2003.

20 A most impressive work on paper representing the election of Charles V as Holy Roman Emperor is the 5-metre-long etching by Nicolas Hogenberg (c.1500–1539) which shows the Duke of Urbino, Francesco Maria, in the procession, wearing ceremonial dress and holding up his sword. See Paoli and Spike 2019, 121–9.

21 See Cioci 2009.

22 On a bowl at the State Hermitage Museum, St Petersburg, see Ivanova 2003, cat. 102. Paolinelli 2019, 92–3.

23 On a dish at the British Museum, 1855,0313.11, see Mallet 2007a, cat. 46; Thornton and Wilson 2009, cat. 167.

24 See Mallet 2007a, 16–22.

25 The 1541 dish is discussed and illustrated in Mallet 2007a, 37, figs 26–8.

26 See Geisberg 1974, vol. 4, 1278 (G1330).

27 See Checa Cremades 1999.

28 Prado Museum, Madrid, inv. no. 410.

29 For example, a scene with the surrender of the Elector of Saxony, deriving from one of 12 scenes of the *Victories of Charles V* published in 1556 by Hieronymus Cock (c. 1517/18–1570). On the designs, see Rosier 1990–1; on the shields, see Godoy and Leydi 2003, cat. 56, a shield at the Metropolitan Museum – the authors also mention another shield representing the same image, among 12 other scenes of the life of Charles V, at the Wallace Collection, London (inv. no. A334), as well as another one, belonging to Charles V, at the Real Armeria, Madrid.

30 Doni 1550. Facsimile edition, Sir William Stirling Maxwell, London 1868.

31 Bartsch, XV, 289, 18, I–II.

32 Norman 1976, 288–9, C146. The author of the Wallace Collection catalogue of Italian maiolica, A.V.B. 'Nick' Norman, was a leading expert of European arms and armour.

33 See Mulcahy 2002.

34 Mulcahy 2002, 331. Quoting letters from Archivio di Stato, Florence.

35 See Wilson 2016, 280, stating that the attribution to Franco is in Lauder 2004, vol. 1, p. 103 and vol. 3, p. 991.

36 See Wilson 2016, cat. 99, which lists all the six known pieces. See also Blanchegorge and Lécuyer 2011, cat. 22.

37 See Kube 1976, cat. 84. Despite the lack of inscriptions, the ducal arms on the wine cooler are very similar to those depicted on an *istoriato* service that the duke donated to the Augustinian Friar Andrea Ghetti da Volterra (*c.* 1510–1578). However, the friar was known for his Lutheran sympathies, and therefore it is unlikely that the wine cooler was part of the same service. On this set, see Wilson 2002. One of Ghetti's books was dedicated to Vittoria Farnese, Duchess of Urbino (1521–1602) and wife of Guidobaldo.

38 On the subject of the Urbino duchy and Spain, see Calegari 2001, 307–22, with further references.

39 See Lessmann 1979, 148–57. The dish at Arezzo is in Fuchs 1993, cat. 217.

40 Wilson 2002, 131–8. Leonardi and Moretti 2002.

41 See the discussion in Wilson 2016, 22–4, where the 'AB' dish is published at figs 27–8. I thank here Justin Raccanello, who discovered the dish.

42 See Lessmann 1979, cat. 102.

43 See Prentice Von Erdberg and Ross 1952, cat. 64, not dated but inscribed, in the same manner as the rest of the group, within a frame.

44 For the dish at Venice, Museo Correr, inv. no., Cl. IV, n. 112, see Mazzotti 2019, fig. 17. Another large plate with a scene from *The Story of Troy* is at Modena, see Liverani 1979, cat. 21.

45 See Giardini 1996, cat. 233. On the reverse: 'quando alesan/dro magnio ando/innanze aquello/diogine 1559' ('when Alexander visited that Diogene 1559').

46 For this set see Wilson 1996, no. 125.

47 See a dish at Galleria Estense, Modena, with putti and satyrs on the border, and warriors fighting in the middle, perhaps dated 1559 or 1669. Clifford and Mallet 1976, fig. 59; Liverani 1979, cat. 28.

48 See Clifford and Mallet 1976, 388.

49 See, for instance, Fantoni 2000.

50 Lomazzo 1585, II.

Chapter 6
Prints and Post-Palissian Ceramics

Claire Blakey and Rachel King

The potter Bernard Palissy (1510–1590) needs very little introduction to scholars and students of the French Renaissance.[1] Works by, or once believed to be by, Palissy are present in many British public collections, the vast majority acquired in the later 19th century as the art and culture of Renaissance France reached peak popularity in the anglophone world.[2] To acquire 'a Palissy' was to buy a relic of genius – the master became a focus of French pride in the early 1800s and there have been many studies since.[3] This chapter does not focus on Palissian ceramics, but rather on those which were once attributed to him. In the last decade, calls have grown for lead-glazed moulded ceramics made in France after Palissy's death to emerge from the master's shadow. Like Françoise Barbe, Anne Bouquillion and Aurélie Gerbier, we argue that embracing these ceramics as related to Palissian production whilst looking beyond the master is important if we are to return agency to these largely anonymous works and gain new insights into them and their makers.[4]

Before outlining the structure of this chapter, it is necessary to clarify terminology. Barbe, Bouquillion and Gerbier have recently reiterated the need to refine the language used when distinguishing between objects made by Palissy and objects in the manner of Palissy.[5] Following their precedent, we only use the term Palissian to refer to those ceramics made by Bernard Palissy and his workshop. It is now agreed that these amount to no more than nine examples of the *rustiques figulines* (rusticware) genre in addition to the fragments excavated from his atelier.[6] Traditionally, all other historiated or low-relief ornamental pieces made in the 17th century and later have been referred to as *suite(s) de Palissy* in the mistaken belief that these were made by *suiveurs* (followers) or *continuateurs* (continuers) from moulds created by the master potter.[7] Confusingly the phrase *suite(s) de Palissy* also encompasses many 19th-century ceramics made in imitation of works erroneously attributed to Palissy which continued to pass as 'original'. The most recent French scholarship suggests embracing the term 'post-Palissian' to refer to pieces which not only display the technical and stylistic influence of Palissy but also depart significantly – for example, historiated wares – from the master's known repertoire. We use post-Palissian in this chapter and do so in acknowledgement of the argument made by French colleagues that the term prevents the full appreciation of French lead-glazed moulded ceramics as it defines them by what they are not.[8] Barbe, Coulon and Denis-Depuis cite the continued 'severe lack of knowledge' as hindering the development of a better alternative.[9]

An opportunity for significant insight is afforded by the study of the relationship of printed matter to moulded ceramics. Exploring such issues as inspiration, dissemination of motifs and considering the processes underlying the production of these items has the potential to illuminate the works of now anonymous makers who have been eclipsed by Palissy's fame. The relationship between Palissy and print culture has been explored on a number of occasions, not least his awareness of the popular romance *Hypnerotomachia Poliphili* (1499),[10] and his production of his own treatises.[11] Though it has been noted that prints are

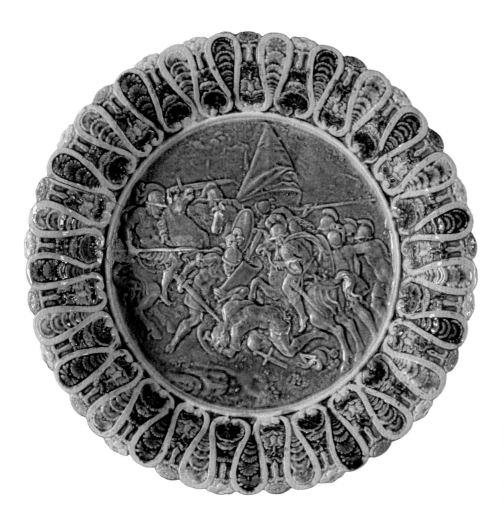

Figure 64 Dish with battle scene, *Combat of the Cavaliers and the Foot-Soldiers*, late 16th or 17th century, France, lead-glazed earthenware, diam. 27.5cm. British Museum, London, 1884,0616.1

particularly relevant to the discussion of post-Palissian lead-glazed moulded ceramics, and it is clear that printed matter was a significant source of imagery, motifs and ornament, it remains surprisingly difficult to identify specific and clear links. This chapter begins with a historiography of the study of objects today described as post-Palissian with a focus on the acquisition of select examples in major British public collections. This is followed by a brief outline of research into post-Palissian wares and prints. It then closes with a case study of a single subject which highlights the significance not only of early modern prints but also of 19th-century chromolithography.

In post-Revolutionary post-Napoleonic France, the potter Bernard Palissy was celebrated as the new Nation's creative darling. A man who sacrificed his sleep, his health and family comfort to the pursuit of mastering beauty and nature through experiment and innovation. Information about his life was gleaned from Palissy's own writings. These had re-emerged in the 1770s, reawakening interest in the artist.[12] In them, he stated that he had begun his career as a painter (of portraits and glass) before being inspired to explore ceramics, particularly the creation of novel bodies and glazes, and later, most famously, the moulding of flora and fauna to produce what he coined *rustiques figulines* (rusticware).[13] Impressive results brought him renown and commissions, first from Anne, Duc de Montmorency (1493–1567) and later Catherine de Medici (1519–1589), Queen of France. These patrons afforded Palissy, who was a Protestant, significant protection for most of his career, although he fell from favour at the end of his life, was exiled

in the 1570s, and ultimately died in the Bastille prison at the age of nearly 80 in 1590.

Palissy's renewed fame and insufficient evidence of what the master had actually produced led to hundreds of works becoming associated with him. Picking up on his claim to have 'rediscovered the way of making vessels decorated with diverse mixed glazes in the manner of jasper',[14] moulded objects bearing this type of decoration were attributed to him.[15] This inclusive attitude culminated in an especially large corpus of Palissy pieces, many of which had historiated subjects despite no evidence from Palissy's lifetime or writings that he produced ceramics moulded with mythical, historical or biblical scenes. In 1855 the discovery of an isolated fragment of an oval platter, showing *The Baptism of Christ*, during an archaeological excavation of the Jardin des Tuileries, site of Palissy's workshop, gave credence to such attributions.[16]

The British Museum in London established its 'Palissy' collection as interest in the artist was reaching its climax. The first items were acquired in the 1850s and a second group entered around the time of the 1884 Fountaine Sale (e.g. **Fig. 64**).[17] The same sale was the source of a historiated 'Palissy' piece in the Edinburgh Museum of Science and Art, now National Museums Scotland (**Fig. 65**).[18] The so-called 'Palissy' pieces were then believed to have been 'collected by Sir Andrew Fountaine in the reign of Queen Anne' (i.e. between 1702–7), therefore to be 'beyond all suspicion as to authenticity . . .'.[19] Around this time the issue of authenticity had become increasingly thorny.[20] There had been doubts that Bernard Palissy had ever produced

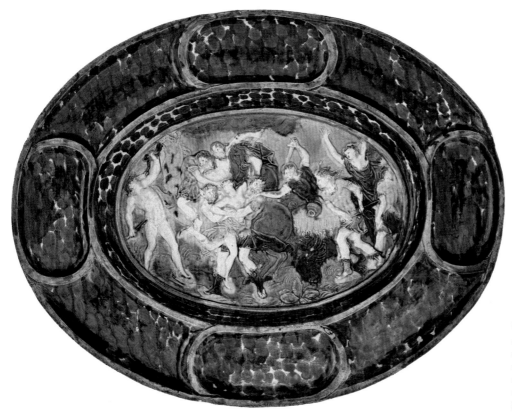

Figure 65 Dish with *The Battle of the Centaurs and Lapiths*, late 16th or 17th century, France, lead-glazed earthenware, h. 47cm, w. 36.8, d. 6.5cm. National Museums Scotland, A.1885.31

historiated items since the 1840s and 1850s.[21] They depicted people like Louis XIII (1601–1643) who had been born after Palissy's death,[22] or Henri IV (1553–1610) who had come to the throne after Palissy's imprisonment.[23] Many objects linked to his name were of questionable quality and appeared to be serially produced. It was increasingly argued that these were made by *suiveurs* and *continuateurs* rather than Palissy himself.

Jessica Denis-Dupuis has scrutinised the history of the *suite(s) de Palissy* and the now highly problematic 19th-century belief, based on scant evidence, in a workshop at Avon, near Fontainebleau. Although now roundly dismissed, many museums continue to attribute historiated pieces to an *atelier de Fontainebleau*.[24] Today, the term *poteries de Fontainebleau* continues to be cautiously used, but only in respect of lead-glazed ceramic figures.[25] Instead, we now know that around the end of the 1500s and into the 1600s workshops elsewhere, in Manerbe and Le Pré-d'Auge near to Lisieux in Lower Normandy for example, were making moulded ceramics decorated with mottled glazes. At least one, that of the *Maître au pied ocre*, has been pinned down to 1590–1620.[26] Such discoveries indicate that the geographical scope of post-Palissian moulded ceramics is greater than previously thought, and in 2012 a biscuit-fired platter showing *The Sacrifice of Isaac by Abraham* unearthed at Montpellier suggested that their chronological extent must also be rexamined. Dated to between 1660 and 1692 by the archaeological context, its finding suggests that the production of these pieces extended as far as southern France and continued well into the 17th century.[27] Comparative scientific analysis of material unearthed in the excavations of the Tuileries' Palissy workshop alongside post-Palissian works in French museums has shown that body and glaze composition may help distinguish Palissian,

early post-Palissian and later post-Palissian ceramics. In the fullness of time it may even be possible to identify the different workshops.[28]

Alongside archaeology and analysis, the traditional methods of art history can help make greater sense of post-Palissian ceramics. Christian Dauterman was the first to publish an extended treatment of the prints he believed played a role in the making of 'Palissy ware' in the Metropolitan Museum of Art.[29] He used 'Palissy ware' to mean 'pottery thought to have been made by Master Bernard' and objects 'in the manner of Bernard Palissy'.[30] He argued that the stock of 'cornucopias, stylized rosettes, and oval cartouches' used in 'Palissy borders was largely drawn from generic ornament prints of the time'.[31] He highlighted some decorative motifs with specific sources, such as the looping cord motif used in the border of some plates, or the winged putti filling the spandrels on the borders made to appear like mounted hardstones.[32] Dauterman saw these sources as signs that the majority of the New York pieces were later.[33] He argued that the identification of datable prints might clarify chronology.[34] Yet he concluded his argument by moving away from prints and focusing on the relationship between so-called 'Palissy ware' and metalwork. Recently, Jessica Denis-Dupuis has seen the use of goldsmiths' models as an important distinction between Palissy and later makers of moulded ceramics.[35]

To date, moulds rather than prints have been seen as key to the transmission of motifs in the study of post-Palissian lead-glazed moulded ceramics.[36] The biscuit-fired platter showing *The Sacrifice of Isaac by Abraham* found at Montpellier is so closely related to the Louvre example of the same motif that it has been argued moulds probably circulated, most likely moving outwards from Paris.[37]

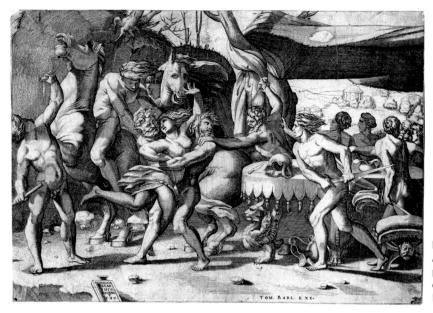

Figure 66 *The Battle of the Centaurs and the Lapiths*, Enea Vico, after Rosso Fiorentino, 1542, published by Tommaso Barlacchi, Italy, engraving, 28.5 x 41.3cm. British Museum, London, W,3.131

They appear even to have crossed the English Channel. Graham Slater has proposed that English-made imitations and variations of the *La fécondité* motif were made using original French moulds.[38] Such theses may be proven by comparative technologies already applied to London-made pipe-clay figurines.[39] This focus may be because very few of the at least a hundred different historiated subjects known for post-Palissian ceramics have actually been directly linked to engraved sources.[40] One of the most famous cases shows *The Nymph of Fontainebleau*. The dish is based on an engraving which purportedly captures the decoration on a metal vessel inspired by an earlier engraving conflating Rosso Fiorentino's (1494–1540) fresco of *Danae* in the Gallery of François I at Fontainebleau and a sculptural complement.[41] It has also been shown that the central scene

Figure 67 *Combat de Cavaliers et de Fantassins*, Carle Delange, 1862, Paris, lithograph, 52.8 x 35cm (reproduced in Delange *et al. Monographie de l'œuvre de Bernard Palissy: suivie d'un choix de ses continuateurs ou imitateurs*, Paris, 1862). National Art Library, Victoria and Albert Museum, shelfmark: 96.CC.14. Photo © Victoria and Albert Museum, London

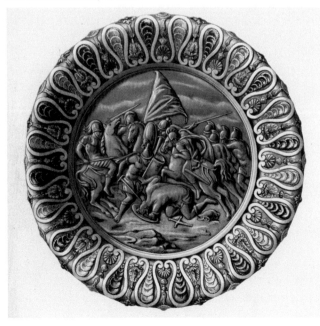

on a plaque depicting the *Allegory of Water*[42] draws upon an engraving after Maarten de Vos (1532–1603), but the text framing it is taken from Guillaume du Bartas's (1544–1590) *La Sepmaine ou Creation du monde* (1578).[43] Dishes decorated with the motif *Jupiter and Callisto* have been connected to an engraving by Pierre Milan (act. 1545–57). Dishes decorated with *Diana and Acteon* to an engraving by Jean Mignon (act. 1535–*c.* 1555) after a painting by Luca Penni (*c.* 1500/4–1556).[44] Broad similarities have been identified between dishes showing *The Childhood of Bacchus*, *The Baptism of Christ* and *The Sacrifice of Isaac by Abraham* and the styles of the engravers Étienne Delaune (*c.* 1518–1583), Martin Fréminet (1567–1619), Jacques I Androuet du Cerceau (1510–1584) and Mignon.[45]

The post-Palissian dishes in Edinburgh and London can also be shown to have connections with the artistic fervour at Fontainebleau. The Edinburgh dish was originally catalogued as *The Rape of the Sabines* (see **Fig. 65**),[46] but was known as *The Battle of the Centaurs and Lapiths* when published by Alexandre Sauzay (1804–1870), curator of the Louvre, in 1862.[47] Curators in New York, where there is another example with a different border, have suggested that a better title for the dish is *The Abduction of Hippodamia*.[48] They have identified that the composition is based on a 1542 engraving by the Italian printmaker Enea Vico (1523–1567) (**Fig. 66**). This print was probably made after a fresco by Rosso Fiorentino in the Gallery of François I and Giorgio Vasari suggested its subject was *The Rape of Helen of Troy*.[49] The dish illustrated in **Figure 64** was given the title *Combat de Cavaliers et de Fantassins* when published by Sauzay (**Fig. 67**).[50] This relates it to a suite of eight *Combats et Triomphes* (*c.* 1550–60) by the above mentioned Delaune. It also links it to the *Sala di Costantino* in the Vatican, the walls of which show the battle fought between Emperors Constantine I (*c.* 272–337) and Maxentius (*c.* 276–312) at the Milvian Bridge over the River Tiber in AD 312. The image on the dish focusses on a prone, face-down figure with a sword positioned above his neck. A figure like this can be seen in Delaune's *Autre Combat de Cavaliers et de Fantassins* (**Fig. 68**), and it also bears some similarity to the pitifully sprawled figure in Marco da Ravenna's print (1493–1527), made after Raphael's (1483–

Figure 68 *Autre Combat de Cavaliers et de Fantassins*, Étienne Delaune, 1550–60, France, engraving, 6.7 x 22.2cm. Victoria and Albert Museum, London, V&A: 22742:4. Photo © Victoria and Albert Museum, London

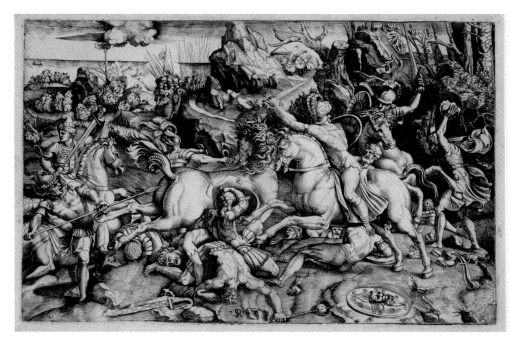

Figure 69 *Battle Scene*, Marco da Ravenna, after Raphael, 1520–5, Italy, engraving, 21.8 x 36.5cm. British Museum, London, 1868,0822.60

1520) designs for the fresco (**Fig. 69**).[51] Sources for the other historiated plates in the British Museum have yet to be found. *The Woman taken in Adultery* was also acquired from the Fountaine Collection,[52] and is known in versions in Rouen and Los Angeles.[53] The *Continence of Scipio* does not appear to be known in any other version and is not listed by Isabelle Perrin in her summary catalogue.[54]

Dauterman suggested that the identification of print sources should assist with dating. *The Abduction of Hippodamia* and *The Battle between the Cavaliers and Foot Soldiers* can both be related to sources produced during Palissy's lifetime. Yet it is now accepted that these dishes – as is true of all low-relief moulded ceramics – were made after his death. This raises the questions of how old the print was when it came to be used by potters in places like Manerbe and whether they used an original or a copy. Some prints had several incarnations. Dauterman identified the source for *The Creation of Eve* dish in the Metropolitan Museum as Jean Cousin the Younger's (c. 1522–1595) illustrations for a printed Bible published in its second edition by Jean Le Clerc (1587–1632/3) (Paris, 1614).[55] More recently however, Jean Bergeret has argued that dishes reproducing this scene are after Delaune's print of c. 1550–72.[56] Which example was used? This reminds us that we should remain open to later variations of an image, not least where these may have been more readily, widely or cheaply available.

This argument is exemplified by a dish in the Burrell Collection, Glasgow (see **Fig. 70** and Appendix). When Sir

William Burrell (1861–1958) and his wife Constance, Lady Burrell (1875–1961) acquired the dish, neither they nor dealer Murray Adams-Acton (1886–1971) recognised the subject depicted (**Fig. 71**).[57] It had been known for over a century that the motif showed Henri IV, Marie de Medici (1575–1642) and their family. It was therefore clear that it could not have been produced by Palissy as he had died before Henri's remarriage.[58] Alfred Tainturier (dates unknown) established the source as a print by Léonard Gaultier (c. 1561–1641) in 1863, making it one of the earliest post-Palissian pieces to be linked to an engraving (**Fig. 72**).[59]

Gaultier has been described as the 'graveur official de la cour de France'.[60] The engraving was published in Paris in 1602 by Jean Leclerc IV (1560–c. 1621/2) and is believed to have been made after a now-lost painting by François Quesnel (c. 1543/4–1616).[61] The significance of the scene is explained by columns of verse below the image. They tell us that we are not only looking at Henri IV, Marie de Medici and the infant dauphin, all seated, but also César, Duc de Vendôme (1594–1665), the legitimised son of Henri IV and Gabrielle d'Estrées (1573–1599), standing in the foreground. Aged 47, Henri, who had ascended to the throne more than a decade before, had remarried. In fathering the future Louis XIII, he had founded the Bourbon dynasty.

Gaultier's engraving is reproduced fairly faithfully in the centre of the Burrell dish (**Fig. 70**), with some practical concessions to details such as the removal of the floor tiles, the door to the right and the cross of the Order of the Holy

Figure 70 Dish with *Henri IV and Family*, after 1602, possibly 19th century, France, lead-glazed earthenware, h. 30.7cm, w. 25.5cm, d. 2.1cm. Glasgow Museums, The Burrell Collection, 40.49, gifted by Sir William Burrell and Constance, Lady Burrell to the City of Glasgow, 1944. Photo © CSG CIC Glasgow Museums Collection

Figure 71 Extract from Sir William Burrell's purchase book, 8 July 1948, 52.21:
'An exceptionally fine Palissy dish depicting a family enclosed by a wide border in vivid colours, the whole overlaid with a lustre glaze. / French Late XVI Century. Oval 12 x 10. / It is probable that the individuals depicted are those of the Monarch, his wife and the Dauphin with attendants in the background. The condition of the specimen is flawless'. Glasgow Museums, The Burrell Collection. Photo © CSG CIC Glasgow Museums Collection

Spirit on the table. The border comprises 28 panels each containing acanthus leaves topped by a pink flower and divided by blue and yellow pennants. The whole is enclosed within a thin string-like rim or lip. The Burrell dish is one of a number with this border type. Excavations at La Bosqueterie in Normandy in 2004 uncovered fragments of border decoration very close in style, suggesting that some may have originated near there.[62]

Scientific analysis undertaken by an inter-disciplinary team of French museum professionals on three Henri IV dishes – from the Louvre (**Fig. 73**), Sèvres (**Fig. 74**) and Lisieux (**Fig. 75**) – has sought to clarify when dishes with this subject were made. The composition of the blue and green lead silicate glazes was tested.[63] The glazes used in the Sèvres and Lisieux examples were similar to one another, but distinct from the Louvre piece, resulting in the proposal that the items were made in 'different workshops, each having different but related glaze chemistries'.[64] The study also concluded that, although the Sèvres and Lisieux dishes did show certain features 'typical of 17th-century production', other 'similarities, corroborated by the very different appearance of the objects, may suggest a 19th-century origin'.[65] Appearance refers to palette and size: about 30/31cm as opposed to 33cm. If we are to extrapolate, we

Figure 72 *Portrait of Henri IV and his Family*, Léonard Gaultier, 1602, published by Jean Leclerc IV, Paris, France, engraving, 25 x 30.9cm. British Museum, London, R,6.81

might assume that the Burrell dish, which is visually closer to the Sèvres and Lisieux examples and smaller (30 x 25cm) than the Louvre piece, is also of a later date.[66] As analysis of the Burrell dish was not possible, it was thought that pursuing provenance may provide further information. A survey of sales in the 19th and early 20th century (tabulated in the Appendix) indicated that there were a number of Henri IV dishes in circulation in a surprising variety of sizes, highlighting the need to understand not only the 17th- and 18th-century trajectory of dishes depicting this subject but also their 19th-century biography.

With Bernard Palissy presented as the great hero of the French nation – inspired by such personal sacrifices as the burning of his furniture to fuel his kiln – and a growing demand for owning his work, Palissian and what we now know to be post-Palissian pieces were clear candidates for copying and faking.[67] There was also a school of potter-artists known as the *Palissystes* who are well known for their homages to the master, and their works are celebrated and collected in their own right.

Georges Pull (1810–1889), for example, made his copy of the Henri IV dish, exhibited in the *Palais de l'industrie* exhibition of 1865 'd'après l'exemplaire du musée du Louvre' (see Appendix, number 13). The 'exemplaire' in question had been donated by Alexandre Charles Sauvageot (1781–1860). Arthur Henry Roberts's (1819–1900) painting, made in the year of the gift, captures Sauvageot at home surrounded by his collection (**Fig. 76**). Today, the whereabouts of the Pull exhibition dish remain unknown. Perhaps it was the dish – one centimetre smaller than the Louvre original – sold in 1903 in an auction of Pull's works as 'd'après le plat de la suite de Palissy' (Appendix, number 13).

Entry number 28 in the Appendix records the sale of a Henri IV dish in Bordeaux in 1897 attributed to 'Avisseau'.

Charles-Jean Avisseau (1795–1861), another prominent *Palissyste*, began copying Palissian/post-Palissian works in the 1820s. He had access to examples in the collection of the director of the ceramic manufactory in Tours where he worked. By the 1840s, he is said to have been producing pieces so similar that they were often mistaken for originals despite bearing signature and date.[68] Charles-Jean's children were among his artistic successors and as the auction catalogue does not give a forename we cannot be sure which 'Avisseau' is meant. Nor is it clear whether or not the attribution is based on a mark or an informed guess. It may be that in the mind of the auctioneer 'Avisseau' was tantamount to 'made in Tours'. Other *Palissystes* there certainly specialised in items with monarchist and revivalist decoration. Charles-Joseph Landais (1829–1908) is said to have produced copies of Henri IV dishes.[69] Pieces depicting Henri II and Henri IV have also been attributed to his son, Alexandre-Joseph (1860–1912), who employed a border pattern suggesting close knowledge of post-Palissian originals in making his notably larger works (some reaching nearly 45cm).[70]

Size appears to matter. Dishes measuring around 31–33cm correspond roughly in size to the dimensions of the Gaultier print. The majority of dishes listed in our Appendix are in the range between 30–33cm. From the 1850s onwards, however, a number of notably larger Henri IV dishes can be identified. In 1859, for example, a 38cm dish was sold at the Auguste de Montferrand (1786–1858) sale in London (Appendix, number 9). By 1867, a dish of 43cm x *c*. 35/37cm was being sold from the Berthon Collection, Versailles (Appendix, number 14).

A surviving example of the larger size Henri IV dishes is in the Musée national Adrien Dubouchè, Limoges (**Fig. 77**). The whereabouts of a near identical example acquired by the Philadelphia Museum in 1911 but later deaccessioned are

Figure 73 Dish with *Henri IV and Family*, after 1602, France, lead-glazed earthenware, h. 33.2cm, w. 27.3cm, d. 5cm. Musée du Louvre, Paris, OA1351, given by Charles Sauvageot, 1856. Photo © RMN-Grand Palais (musée du Louvre) / Daniel Arnaudet

Figure 74 Dish with *Henri IV and Family*, after 1602, possibly 19th century, France, lead-glazed earthenware, h. 31cm, w. 25.8cm, d. 2.9cm. Manufacture et musée nationaux, Sèvres, MNC6016, acquired 1863, provenance Guithon. Photo © RMN-Grand Palais (Sèvres, Manufacture et musée nationaux) / Martine Beck-Coppola

Figure 75 Dish with *Henri IV and Family*, after 1602, possibly 19th century, France, lead-glazed earthenware, h. 30.5cm, w. 25.5cm. Musée d'art et d'histoire de Lisieux, m. 86-1-4. acquired in 1986

Figure 76 *Vue intérieure d'une des pièces de l'appartement de monsieur Sauvageot*, Arthur Henry Roberts, 1856, Paris, France, oil on canvas, 48.5 x 59cm. Musée du Louvre, Paris, MI861. Photo © RMN-Grand Palais (musée du Louvre) / Stéphane Maréchalle

Figure 77 Dish with *Henri IV and Family*, after 1602, France, lead-glazed earthenware, h. 43.8cm, w. 36.8cm. Musée national Adrien Dubouché, Limoges, ADL7603, acquired 1882. Photo © RMN-Grand Palais (Limoges, Musée national Adrien Dubouché) / Tony Querrec

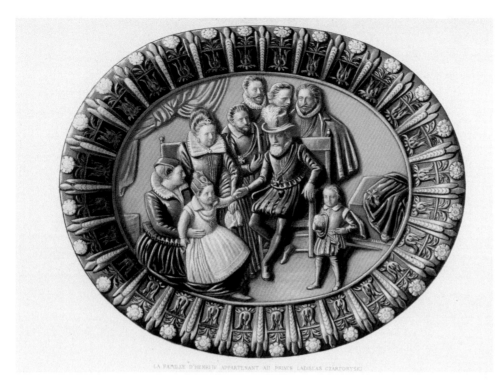

Figure 78 *La Famille Henri IV. Appartenant au Prince Ladislas Czartoryski*, Carle Delange, 1862, Paris, lithograph, 52.8 x 35cm (reproduced in Delange *et al. Monographie de l'œuvre de Bernard Palissy: suivie d'un choix de ses continuateurs ou imitateurs*, Paris, 1862). National Art Library, Victoria and Albert Museum, shelfmark: 96.GG.14. Photo © Victoria and Albert Museum, London

unknown.[71] It seems very likely that these larger dishes are all 19th-century. But who made them, where and when? Though it has not been possible to answer these questions definitively, a chromolithograph of a Henri IV dish belonging to Prince Ladislas Czartoryski (1828–1894) is worth highlighting. This lithograph was produced by Carle Delange (b. 1837) to illustrate Alexandre Sauzay's 1862 monograph on Palissy (**Fig. 78**).[72] Just as engravings were significant design sources in the 17th century, chromolithographs may have played a similar role in the 19th century.

The Burrell Henri IV dish neatly encapsulates the challenges faced by researchers of post-Palissian wares. It points to a rich and complex relationship with prints, both as design sources in the 17th century and means of disseminating information about post-Palissian wares in the 19th century. These dishes present an interesting case of double inspiration. Sauzay's sumptuously illustrated volume was published in a run of only 300 and must have been expensive, but the very fact that the lithographs were unbound would have allowed them to have been shared, studied and copied, just as presumably happened with Gaultier's engraving some 260 years previously. Prints were therefore potentially as much a site of encounter with post-Palissian vessels as public, private and factory collections.

There is much research still to be done on post-Palissian lead-glazed moulded ceramics, particularly with respect to their consumption before the resurgence of interest in the 19th century. Understanding more about who acquired them and how consumers viewed them, particularly in the early modern era, may provide an alternative vocabulary which allows for a better designation than post-Palissian. In the meantime, exploring how potters obtained, interpreted and transferred prints to their works provides opportunities to acknowledge creative autonomy and flair among the presently anonymous makers of these objects. It reminds us that a single object can lead us to question established narratives and to look for stories of innovation, knowledge transfer and entrepreneurship beyond the great names of the ceramic world.

Acknowledgements

The authors wish to thank the following for their generous help: Patricia Ferguson for inviting us to participate in this volume; editor Sarah Faulks, copy-editor and anonymous reviewers for scrutinising the text; Françoise Barbe for being extremely liberal with her knowledge and gracious with her corrections. We also thank Micael Ernstell, Lynn Makowsky, Lene Marius Jensen, Elżbieta Musialik, Susan Pacitti, Emma Perloff, Katarzyna Płonka-Bałus, Georgina Ripley, Martine Rognon, Judy Rudoe, Anna Sobecka, Etienne Tornier, Maggie Wilson, Catherine Yvard and Michaela Zöschg.

Appendix: tabulated list of sales of moulded dishes depicting Henri IV and his family

This list is not exhaustive and should be taken as a snapshot of known works and sales. The 'Other notes' column contains proposals as to the previous owners and known details of the post-sale lives of these objects.

	Date			From	To		Dimensions			Other notes
1.	Before 1817	–	Czartoryska 1828, 63, no. 681.	Auguste Choiseil-Gouffier	Princess Izabela Czartoryska	Taca fajansowa, ofiarowana przez fabrykantów fajansu w Bearn, Henrykowi IV. z fabryki przez niego założonej. Na tej tacy: wypukło wyrobiony obraz Henryka IV.; koło niego: Maria de Medicis, syn który ponim panował pod imieniem Ludwika XIII. i inne dzieci Henryka IV. oraz Sully, jego przyjaciel.	33	27	5.6	Our thanks to E. Musialik for informing us that this dish was given to Princess Izabela Czartoryska (1746–1835) by Auguste Choiseul-Gouffier (1752–1817).\n\nIzabela herself believed that this plate was once the personal property of Henri IV and that he had received it as a gift from the 'workers of the faience factory in Bearn that the king himself had founded'.\n\nSee also Delange *et al.*, 1862, pl. 76: 'Famille de Henri IV – Collection du prince Ladislas Czartoryski'.\n\nSee Audiat 1868, 304\nSee Teall 1919
2.	1849	11.– 13.04	Auction, Paris, Rue des Jeuneurs, lot 31	M. Covillard	–	Faïences de Palissy et autres - Plat ovale d'un bel émail, fond gris bleu, représentant Henri IV et sa famille.	–	–	–	August Covillard, Lyon, d. c.1860?
3.	1851	–	Publication, Du Sommerard, 1851.	–	Musée national du Moyen Age – Thermes de Cluny. Transferred 1977 to the Musée de la Renaissance, Ecouen, E.CL.1146	Faïence des continuateurs des travaux de Bernard de Palissy – plat ovale représentant la famille d'Henri IV.	33	–	–	
4.	1836	28.– 29.11	Auction, Paris, Place de la Bourse, lot 112	–	–	Un autre grand plat Henri IV et sa famille.	–	–	–	
5.	1837	08.03	Auction, Paris, Rue de las Cases, lot 47	Baron de Monville	–	Plaque ovale: Henri IV et sa famille: très fin email.	–	–	–	Hippolyte Boissel de Monville. French botanist (1794–1863)
6.	1838	19.– 21.02	Auction, Paris, Place de la Bourse, lot 122	–	–	Un autre [plat]: Henri IV avec sa famille, en Palizzi.	–	–	–	
7.	1849	26.– 28.03	Auction, Rue de la Ferme-des-Mathurines, lot 119	Charre	–	Médaillon ovale en travers avec bas-relief représentant Henri IV et sa famille, cadre dore.	–	–	–	Gilded border
8.	1856	–	Gift	Charles Sauvageot (1781–1860)	Musée du Louvre, OA 1351	–	33.2	27.3	6.0	

9.	1859	-	Auction, London, J. Parkins, lot 549	Auguste de Montferrand (1786–1858)		Medallion. Henri IV. Surrounded by his Family, with richly ornamented border. This fayence is of the school of Bernard Palissy.	38.1	-	-	1ft 3"
10.	1861	08.04	Auction, Paris, Drouot, lot 561	Prince Soltykoff (1806–1859)	Lugt MS. annotated 'Malinet'	Plat ovale: Henri IV, assis, entoure de sa famille et de plusieurs seigneurs de sa cour. Le bord évasé, et orne de godrons et de palmettes.	32	27	-	Provenance thereafter possibly sold to Malinet (dealer) See Tainturier 1863 See 1866, Auction, Paris, Douot, lot 47, Comte Raynal de Choiseul-Praslin: 'Plat ovale présentant le sujet de Henri IV et sa famille: bordure a fleurs et godrons. Faïence de la suite de Bernard Palissy. Collection Soltykoff'. See 1902, gift to Petit Palais ODUT1141 [Catalogue sommaire des collections Dutuit, 1907, p. 222, no. 1142 : Plat ovale – Henri IV entoure de la famille royale. Larg. 0,28 – long 0,33. Vente Soltykoff, avril 1861]
11.	1863	-	Acquisition	Guithon	Sèvres, Cite céramique, MNC 6 016	-	31	25.8	2.9	
12.	1864	-	Gift	Frédéric Boëke, Lyon	Musée des Beaux-Arts de Lyon, X 517-1 [previously H 509]	-	31.6	26.4	4.3	
13.	1865	-	Exhibition, *Catalogue des œuvres et des produits moderns: Palais de l'industrie, exposition de 1865*, 218–19: Georges Pull		-	Un plat ovale, famille Henri IV d'après l'exemplaire du musée du Louvre.	-	-	-	Made after Louvre, OA 1351 [33.2 x 27.3 x 6] Provenance thereafter possibly sold 1903, Auction, works by Georges Pull, lot 32, Plat ovale: la famille de Henri IV (d'après le plat de la suite de Palissy), 32cm
14.	1867	16.–20.12	Auction, Paris, Drouot, lot 29	Berthon, Versailles	-	Plat ovale de la suite de Bernard Palissy – Henri IV et sa famille; bordure a ornements.	43	35	-	Provenance thereafter 1894, Auction, lot 36: Plat ovale, faïence de la suite de B. Palissy: Henri IV et sa famille. Collection Berthon
15.	1868	-	Auction, lot 58	Un Amateur	-	Un plat ovale enterre émaillée attribue a B. Palissy et représentant Henri IV et sa famille.	-	-	-	
16.	1875	15.–17.04	Auction, Paris, Drouot, lot 65	Badouillot de Saint-Seine	-	Grand plat ovale borde de palmettes; au centre Henri IV et sa famille. Faïence de la suite de Palissy.	43	-	-	
17.	1877	26.–27.01	Auction, Paris, Drouot, lot 52	Amsterdam de Willet	-	Plat ovale a reliefs de la suite de Bernard Palissy. Henri IV et sa famille. Composition de neuf figures. Bords a fleurs et ornements.	32	26	-	Abraham Willet (1825–1888)?

18.	1877	17.01	Auction, Paris, Drouot, lot 82	-	-	Petit plat ovale représentant Henri IV et sa famille. Bordure a marguerites et ornements.	-	-	-	
19.	1877	-	Catalogue, Museum, Narbonne, 467	Mme la comtesse d'Exéa	Narbonne, musée archéologique	Plat ovale godronne … Henri IV et la reine sont entourés de leur famille et de plusieurs personnages de la Cour. Le décor de la bordure se compose de culots termines par une reine-marguerite: chaque fleur est séparée par un petit ornement. L'extérieur est couvert d'un email marbre nuance de bleu, de jaune et de brun violâtre.	-	-	-	Anne-Marie-Pauline Brocard-Doumerc, wife of Antone-Achille, comte d'Exéa (title granted in 1876).
20.	1882	-		-	Limoges, Musée national Adrien Dubouche, ADL7603	-	43.8	36.8	-	
21.	1883	20.04	Auction, lot 50	-	-	Plate ovale en faïence de la suite de B. Palissy, représentant la famille du roi Henri IV.	-	-	-	
22.	1883	12.–17.03	Auction, Paris, Drouot, lot 109	Mme Gabrielle Elluini (1849–1921?)	-	Plat de Bernard Palissy, scène d'intérieur, famille d'Henri IV.	-	-	-	
23.	1885	18.–30.05	Auction, Paris, Drouot, lot 507	M. Le Comte de la Béraudière	-	Plat ovale, a bords évasés, de la suite de Palissy, décoré en émaux polychromes et représentant, en bas-relief, Henri IV, Marie de Médicis, le Dauphin, Elisabeth de France, assise sur les genoux d'une dame d'honneur et quatre seigneurs de la cour. Bord décorés de tiges de marguerites alternant avec des montants ornemanisés.	33	27	-	Jacques-Victor, comte de la Béraudière (1808–1884)
24.	1886	06.04	Auction, lot 555	Édouard Fauché	-	Autre plat ovale de même style … avec sujet représentant Henri IV et sa famille.	30	25	-	Provenance thereafter : possibly 1948 Sir William Burrell bought from Murray Adams-Acton (12" x 10" [30 x 25]): 'An exceptionally fine Palissy dish depicting a family enclosed by a wide border in vivid colours, the whole overlaid with a lustre glaze. French, Late XVI Century. Oval.'

25.	1889	-	Publication, Tallebois 1889			Un spécimen de cette figuline, trouve a Mauléon fui présente a la Ste de Borde de Dax par M. Taillebois au course de l'une de ses séances en 1889.	31	27	-	Cited Nicolai 1936
26.	1891	28.05– 01.06	Auction, Paris, lot 313	Dr Vincenot	-	Bernard Palissy (suite de). Plat ovale représentant Henri IV et sa famille.	-	-	-	
27.	1895	25.– 29.11	Auction, lot 522	M. Harbaville, Boulogne sur Mer		Suite de Palissy. Plat ovale, décor a reliefs polychromes, Henri IV et sa famille, commencement du XVIIe siècle.	-	-	-	Possibly heirs of antiquarian Louis-François Harbaville (1791–1866)?
28.	1897	01.– 04.02	Auction, Bordeaux, lot 47	Madame de Rolland, Agen		Plat ovale, genre Palissy (Avisseau), représentant Henri IV et sa famille. Sur le marly, fleurons, gaines, et marguerites.	32	-	-	
29.	1899	21.03	Auction, Paris, Drouot, lot 105	Famille Beurdeley	-	Plat ovale. Henri IV et sa famille. Ecole de Bernard Palissy.	-	-	-	Possibly Alfred-Emmanuel Beurdeley (1847–1919), cabinet-maker.
30.	1911	-	Auction, New York	Robert Hoe III (1839– 1909)	Philadelphia Museum	-	43			Thereafter sold at auction Philadelphia, 28.10.1954, lot 794
31.	1911	-	Auction, New York	-	-	-	31			Cited Barber 1911: 'differed only from the [Hoe example] in the variation of the border design and the omission of the drapery at the right side of the group'.
32.	1911	-	Gift	Édouard de Évrard de Fayolle	Bordeaux, musée des Arts décoratifs, inv. 4747	-	30	25	3	Philippe Alexis Édouard de Évrard de Fayolle (1862– 1913) collector, curator at the Archaeological Museum in Bordeaux.
33.	1913	-	Auction, lot 81	M. X.	-	Bernard Palissy (Genre de) Plat ovale, représentant Henri IV et la famille royale.	-	-	-	
34.	1922	22.02	Auction, Paris, Drouot, lot 11	-	-	Faïences – Plat ovale, de la suite de Palissy, représentant Henri IV et sa famille. Au marli, des tiges fleuries juxtaposées.	-	-	-	
35.	1925	29.12	Auction, Paris, Drouot, lot 206	Edmond Corton	-	Palissy. Plat ovale en ancienne faïence décorée en relief au centre: Henri IV avec personages et enfants; bordure de fleurs.	-	-	-	
36.	1926	-	Gift	Ivan Traugott	National Museum Sweden	NMK 215/1926	33	27	-	Museum director, born 1871.

Notes

1 For the most recent bibliography and surveys of the historiography of Bernard Palissy, see Broomhall 2018, Ferdinand 2019, Rousseau 2019 and more generally the 2019 edition of Technè (vol. 47).

2 For what is now considered the definitive list of works by Palissy, see Gerbier 2019, n. 21.

3 Delécluze 1838; Piot 1842; Dumesnil 1851; Morley 1852; Salles 1855; Tainturier 1860; Delange, *et al.*, 1862; Tainturier 1863; Audiat 1868; Clément de Ris 1871; Burty 1886. For modern appraisals of these works and of the 19th-century revival in interest in Palissy, see Gendron 1992; Amico 1996a, Amico 1996b; Slitine 1997; Katz and Lehr 1996; Perrin 2001; Oger 2002; Viennet 2010; Pic 2012; and Dupuis 2016. Rosen 2018, 129, quoting directly from the work of Glénisson 1990 and Burty 1886, has noted the importance of the Romantic movement in the rehabilitation of Palissy. Most important and comprehensive is the 2019 edition of Technè (vol. 47). Barbe, Coulon and Denis-Dupuis 2019, 82, discuss the 1807 exhibition of art in commemoration of the Battle of Jena, as being the first exhibition of works by '*Bernard Palizi*, l'un des premiers potiers de terre et chimiste du quinzième siècle' in Paris, and probably in France. Between 1807 and 1820, specimens removed from German collections were accessible to the public in the Galerie d'Apollon, Paris.

4 Barbe, Bouquillon and Gerbier 2019, 7. See also Denis-Dupuis 2019, 64.

5 For a discussion of the term post-Palissian and its pitfalls, see Barbe, Bouquillon and Gerbier 2019, 7 and Barbe, Coulon and Denis-Dupuis 2019, 81. Denis-Dupuis 2019, 64, argues that now is the time to move away from such terms as *suite(s) de Palissy* and post-Palissian.

6 See n. 2. For a broader discussion of *rustiques figulines*, see Kris 1926; Shell 2004; Kayser 2006; Barbe 2010; Smith 2004, 2006 and 2014; Smith and Beentjes 2010.

7 On the history of these particular terms see Barbe, Bouquillon and Gerbier 2019, 7.

8 Denis-Depuis 2019, 64.

9 Barbe, Coulon, and Denis-Depuis 2019, 81.

10 Colonna 1546. On the influence of this publication, see Polizzi 1992; Amico 1996a and more recently Ferdinand 2012.

11 Palissy 1563; Palissy 1580. The most recent critical edition was issued under Palissy 2010. See also Ferdinand 2019. See also Andrews 2014/15; Bouquillon *et al.* 2013.

12 Palissy 1777; see also later editions such as Palissy 1844 and Palissy 1880; and the commentary in Dittmann 2016.

13 Palissy 1563; Palissy 1580.

14 English translation taken from Amico 1996a, 85.

15 Barbe, Bouquillon and Gerbier 2019, 7.

16 Now Sèvres MNC 5 055. Dufay *et al.* 1987 ; Dufay and Trombetta 1990; Kisch 1992; Amico 1996a, 125 n. 56; Pic 2012, 33, 43; Dupuis 2016, 28; Gerbier 2019, 14.

17 Aileen Dawson has chronicled the history of the British Museum's ceramic collections in a number of different publications, all of which give insight into its development. French lead-glazed moulded ceramics are touched on briefly. Relevant post-Palissian pieces in the Museum collection are: 1855,0730.3 dish with moulded reptiles and fish; 1883,1019.11 dish with strapwork decoration and putti; 1883,1019.12 dish with moulded reptiles; 1883,1019.14 dessert dish; 1883,1019.13 dish with moulded lizard; 1884,0616.1 discussed here (see **Fig. 64**); 1884,0616.2 fruit dish; 1885,0420.4 *The Woman taken in Adultery*, discussed here; and 1889,1204.1 *Continence of Scipio*, discussed here.

18 Other relevant pieces in the NMS collection are: A.1872.2.5 plaque showing *The Christ Child Leading St Joseph*; A.1880.1, dish with moulded reptiles and fish; A.1885.30, ewer with moulded reptiles and shells; and A.1891.42 oval dish showing the *Baptism of Christ*.

19 Moore 1988, 436 notes that this assertion cannot be confirmed. On the importance of provenance research in securely dating items, see Barbe, Coulon and Denis-Dupuis 2019.

20 In Barbe, Coulon, and Denis-Dupuis 2019, Barbe gives *c.* 1810–11 as being the earliest record of works attributed to 'Bernard Palissi et de ses Imitateurs' in the Musée du Louvre.

21 Discussed at length in Dupuis 2016. For early witnesses to this, see, for example, Dussieux 1841, 114; Du Sommerard 1851, 262, no. 3146. For an early discussion in English, see Morley 1852, 347. Morley takes the Henri IV dish as evidence that Palissy's brothers/nephews continued the workshop after his death, availing themselves of existing moulds.

22 See Bouquillon *et al.* 2018; examples are Cleveland Museum of Art, 1986.51 and Musée national Adrien Dubouché, Limoges ADL 7587.

23 For a recent catalogue entry on this dish, see Droguet 2010, 182, cat. 101. For another treatment of this motif in a discussion of French prints, see Burlingham *et al.* 1995, 429–30, cat. 172, on the example in Lyon. Perrin 2001, vol. 1, 73–4, discusses 19th-century approaches to the dating of the Henri IV dish. Dupuis 2016, 30–3 argues that the 'Avon' attribution, although apparently more specific, should be regarded in the same light as the nebulous phrases 'after Palissy' 'school of Palissy', 'circle of Palissy' and 'manner of Palissy'.

24 Pic 2012, 36; Denis-Dupuis 2019, 65–8.

25 We would like to thank Françoise Barbe for claryfying this point for us.

26 Barbe, Bouquillon and Gerbier 2019, 36. On the potteries and masters of this region, see Deville 1927; Colin-Goguel 1975; and Bergeret 2004a. See Bouquillon 2019, 91, on the absence of scientific analysis in these attributions.

27 Bouquillon *et al.* 2018, 5, citing Vaysettes and Vallauri 2012, 288, 290, fig. 90.

28 In addition to other publications already cited here, see Technè 2004, special edition on terracotta, with a section on 'Successeurs et influences tardives de Palissy'. In particular Bouquillon *et al.* 2004; Christman, Hewer and Castaing 2004; Rochebrune 2004. Most recently, Denis-Dupuis 2019, 64, has noted that the glazes used for pieces made in the reigns of Henri IV and Louis XIII are based on much simpler recipes. See also Gerbier 2019, 13–16, for a summary of the finds excavated from the Palissy workshop and on the importance of uniting conservators, geologists, analytical scientists, natural scientists, historians and curators in their research.

29 Dauterman 1962. See also McNab 1987 on the same collection.

30 Dauterman 1962, 272.

31 Dauterman 1962, 275–6.

32 Colonna 1546, and see Johann Theodor de Bry (1561–1623), after Maarten de Vos (1532–1603).

33 Dauterman 1962, 275–6, which he linked to plate MET 53.225.32 and subsequently dated 'late XVI century'.

34 Ibid., 281.

35 Jessica Denis-Dupuis 2019, 64 sees one distinction between Palissy and his followers in the fact that the master used goldsmiths' models and his followers drew on engravings. See also Crépin-Leblond 1997, passim.

36 An exception is Bergeret 2004b. See Denis-Dupuis 2019, 64, on the

'quantities of dishes mass produced from a single mould' as evidence of 'serial production for commercial purposes'. This approach is quite different to that of Palissy, who engaged with mould-making as part of his experimental process.

37 Musée du Louvre, MRR148.

38 On these platters, see Archer 2013, cat. A.95–100; Slater 1999. For French and English examples, see Musée du Louvre, OA5014, and British Museum, 1938,0519.1.CR.

39 Crichton-Turley 2019.

40 Perrin 2001, vol. 1, 210–41, and vol. 2, Appendix B and C, identifies at least a hundred different figurative subjects. This extensive, albeit not exhaustive, list could be broken down into 35 allegorical, 25 mythical, 12 Old Testament, 12 New Testament and 19 profane subjects. Today access to the inventory records used by Perrin in 2001 is much improved.

41 Amico 1996a, 37–40. On this print as a 'multimedia production', see Zalamea 2016.

42 Musée du Louvre OA3363.

43 Amico 1996a, 37–40.

44 Bergeret 2004b, 82 and cat. 162.

45 Ibid., 82.

46 A.1885.31. See Perrin 2001, vol. 1, 225.

47 Delange *et al.* 1862, unpaginated.

48 53.225.58. See examples of borders reproduced in Gibbon 1986, cat. 46. On the motif, see Perrin 2001, vol. 1, 225.

49 Moreover, it was further copied (and reversed) in Paris, c. 1550–83, by Étienne Delaune (British Museum, W,3.130) and in Italy by Benedetto Stefani (act. c. 1570–1580) (British Museum, W,3.132).

50 Delange *et al.* 1862, unpaginated. Another example of this motif is described in Perrin 2001, vol. 1, 237, as being in the Musée des Beaux Arts, Lyons, France. It has a diameter of 27cm. The border of the dish can be compared to other examples illustrated in Gibbon 1986, cats 46, 53 Allegory of Faith, cat. 54 Zeus and Callisto, cat. 60 Judgement of Solomon.

51 Thornton and Wilson 2009 (vol. 2), cat. 301, argue that this print is also the source of the battling figures in British Museum, 1851,1201.10; Fehl 1993; Giles 1999.

52 British Museum, 1885,0420.4; Delange *et al.* 1862, unpaginated.

53 Musée de la Céramique, Rouen 715 C (6.5 x 63 x 48.5cm); Lacma 82.9.13 ((6.03 x 63.18 x 47.94 cm) and note also: https://www.kahnetassocies.com/lot/24901/5331362?refurl=Suite+de+Palissy+%28Pr%C3%A9d%27Auge+ou+Manerbe%29+Coupe+ovale+%C3%A0o+d%C3%A9cor+polychrome+et+en+relief+au+centre+du+Ch (35 cm)[accessed 31.10.2020].

54 British Museum, 1889,1204.1; Perrin 2001, vol. 1, 210 onwards: 'Catalogue sommaire des themes figurant sur les ceramiques dites de Bernard Palissy.'

55 For the 1614 Bible, see Bibliothèque nationale de France, département Réserve des livres rares, A-1402 Source:https://gallica.bnf.fr/ark:/12148/btv1b86207594/f14.item. For the dish, see Metropolitan Museum, 53.225.36; Dauterman 1962, 281. By the time of Gibbon 1986, this motif had been reattributed to Bernard Salomon. However, we have been unable to identify this source.

56 See British Museum, 1834,0804.138. In other cases, scholars have linked them to Fontainebleau generally, but with different specific attributions. Of the three versions of the Fecundity motif, Perrin 2012, vol. 1, 214–15, has linked the first to a fresco by Rosso Fiorentino, while Gibbon 1986 has related it to the work of Francesco

Primaticcio (1504–1570). Likewise, the motif of *Pomona (Allegory of Earth)* has been linked with François Briot, Adriaen Collaert (c. 1560–1618) and Maarten de Vos variously (Bergeret 2004b, 92).

57 Recorded in Burrell's personal purchase book alongside English wine glasses, a Chinese cloisonné dish and an Iznik jug. It seems most likely that Burrell and Murray Adams-Acton thought the monarch shown to be Henri II (1519–1559). Henri's son, François II (1544–1560), would later become husband of Mary, Queen of Scots (1542–1587), giving the plate Scottish interest. This identification was made in relation to at least one other example: the plate in the Swedish Nationalmuseum, acquired from Ivan Traugott (1871–1952) in 1926 (see Appendix). We thank Lene Marius Jensen and Micael Ernstell of the Nationalmuseum in Stockholm for providing us with further information about this dish.

58 On the dating of this dish, see Denis-Dupuis 2019, 64 and n 23 above.

59 Tainturier 1863, no. 123; Bouvy 1932; Nicolai 1936.

60 Brugerolles and Guillet 2000, 7, citing Duportal 1924, 132. See also Leutrat 2016 for Gaultier and the discovery of his post-mortem inventory.

61 British Museum, R,6.81; 1895,0617.188; and 1848,0911.623, in reverse.

62 Dupuis 2016, 32. According to Nicolai 1936, 2: 'Un spécimen de cette figuline, trouve à Mauléon fui présente à la Ste de Borde de Dax par M. Taillebois au course de l'une de ses séances en 1889'. This statement appears to have been overlooked by researchers. It is likely that the publication meant is Tallebois 1889. We have been unable to access this publication to confirm.

63 Bouquillon *et al.* 2018. The blue glaze on the Louvre dish combined cobalt (Co), nickel (Ni), arsenic (As) and ground glass (frit), while on the Sèvres and Lisieux pieces only cobalt was present and in notably much higher quantities than the Louvre example. Likewise, the Louvre green glaze combined copper (Cu) and arsenic (As), while on the Sèvres and Lisieux examples only copper was present. Finally, on the Sèvres and Lisieux examples, the yellow glaze was achieved using lead (Pb) antimonite, something not found at all on the Louvre example. See also more recently discussions in Lehuédé, Castaing and Bouquillon 2019 and Bouquillon 2019, 95, 97, for further specific discussion of the green and blue glazes used in the three Henri IV dishes.

64 Bouquillon *et al.* 2018, 12.

65 Bouquillon *et al.* 2018, 15.

66 See Appendix. The Burrell Collection dish shares its reduced dimensions, at the present moment, only with a dish sold in 1886 from the Parisian collection of Édouard Fauché (dates unknown) in Paris. In the absence of further data, the Fauché Sale provides a definite *terminus ante quem* for the availability of the Burrell model.

67 Barbe, Bouquillon Gerbier 2019, 7.

68 Louvre des Antiquaires 1990, 33–6.

69 Ibid., 215.

70 Oger 2002, cats 21–2.

71 Barber 1911. See also Philadelphia Museum of Art 1916, cat. 151. Thank you to Lynn Makowsky, Penn Museum, and Emma Perloff, Philadelphia Museum of Art, for helping us to track down archival information about this dish.

72 Princes Czartoryski Museum, Cracow, inv. No. MNK XIII-3081. Photographic reproduction in Teall 1919, 19. We thank Elżbieta Musialik for providing us with information about this dish.

Chapter 7
Exotic Self-Reflections: Fashioning Chinese Porcelain for European Eyes

Helen Glaister

As trade between China, Europe and the Americas prospered throughout the 18th century, the visual lexicon of European prints provided a seemingly endless source of designs and subjects upon which the potters of China increasingly modelled wares destined for export to European markets. Decorative themes ranged from contemporary politics and literature to classical mythology and religion, maritime and naval subjects as well as European agriculture and the hunt, portraiture, pastoral scenes and even motifs of a mildly erotic nature; all could be seen surfacing Chinese porcelain for use or display in the fashionable 18th-century interior. The majority of these painted wares constituted cups, saucers, dishes and plates for the table and as such were made in multiple sets. Far less numerous was porcelain sculpture of Europeans after Western graphic sources, although it was not unknown. Among the earliest is a theatrical character, known as 'Nobody', manufactured in China in Jingdezhen between 1680 and 1700.[1] It was modelled after English delftware figural drinking vessels, whose origins can be traced to an engraving of the first decade of the 17th century.[2] There is also a well-known series of French courtiers painted in *famille-verte* enamels,[3] *c.* 1700, which has been associated with contemporary fashion plates engraved by the Parisian brothers Nicolas I (*c.* 1637–1718) and Robert Bonnart (1652–1729), although no exact source has been identified.[4] Small-scale white porcelain European figures and groups, sometimes historically identified as 'Dutchmen', acknowledging their role in international trade through the Dutch East India Company, were also produced in China at the kilns of Dehua around the same date, but have yet to be directly linked to any European print sources.[5]

This chapter focuses on two exceptionally rare examples of mid-18th-century Chinese porcelain figures of European subjects in the British Museum and their engraved sources, and in so doing examines the interplay between Western prints and the manufacture and reception of Chinese porcelain fashioned in European style (**Figs 79–80**). In the European context, these figures reveal how costume and external appearance variously defined Jewish identity over time and space, whether through rabbinic rulings, ethnic fashions or restrictive decrees imposed by non-Jewish authorities. In China, where these objects were expertly modelled and decorated by hand, these luxury porcelains materialised the 'exotic other'.

Standing at 42cm and 44cm, respectively, the unusually large scale of these two female figures, range of enamel colours and execution of design suggest they were both manufactured in the kilns in Jingdezhen, around 1740.[6] The costume of the first figure, stiffly posed, her hands at her sides, is decidedly European (**Fig. 79**). She wears a laced stomacher or bodice and a wide ruff, a folded collar that was fashionable from 1550 to 1650 but lingered on longer in the Dutch Republic. Her short cape and apron are blown by a gentle breeze and her hair is hidden by an unusual lace cap with peaked or conical ears.[7] The second figure stands with her arms outstretched as if dancing (**Fig. 80**). Her distinctive costume, with a long jacket over a pleated skirt, both slightly upswept, creating a sense of movement, has European features, but the jacket with its fitted silhouette, bell-shaped

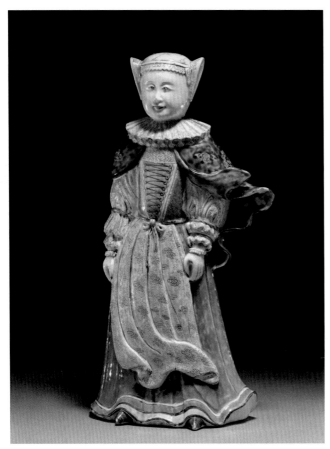

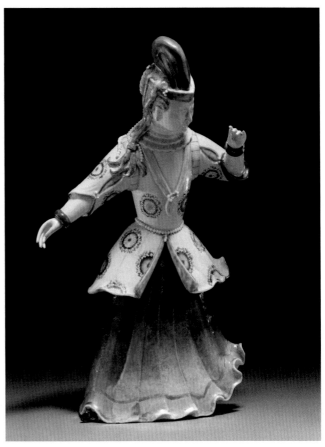

Figure 79 Figure of a woman in Jewish costume, *c.* 1740, Jingdezhen, China, porcelain decorated with overglaze enamels and gilding, h. 42.3cm. British Museum, London, 1963,0422.11

Figure 80 Figure of a woman in Turkish costume, *c.* 1740, Jingdezhen, China, porcelain decorated with overglaze enamels and gilding, h. 44cm. British Museum, London, 1963,0422.10

peplum and deep V-shaped neck resembles Safavid or Turkish fashions. Her long blonde hair is divided, looped, beribboned and intertwined with the band of her elaborate headdress, possibly with details suggesting feathers. Both figures were first shaped in moulds and assembled; the details, such as the beaded jewellery, were applied and finished by hand with polychrome enamel painting and gilding. They are certainly rare but not unique; at least 10 examples have been identified of the European woman and 5 of the 'Dancing Turk'.[8]

A male model is also known and together with the two female figures is widely considered to be part of a single group, perhaps constituting a small private commission due to the similarities between the modelling and enamelling, and the scarcity of Chinese porcelain figures of this type (**Fig. 81**).[9] The bearded male figure wears a broad-brimmed hat, a ruff, a long cloak and a striped sash hanging from his belt, while holding a red purse; only four examples have been published.[10] Again, all were manufactured at the kilns of Jingdezhen, China, around 1740 and comparisons between extant examples reveal the subtle individualisation of object design.

The European female and male models were formerly identified as a Dutch or German (Swabian) couple.[11] The majority were paired by collectors and antiques dealers in the 20th century according to established European customs and fashions of interior design. In 2008 Ronald W. Fuchs II discovered a close print source for the female figure, consequently identifying both models as German Jews,

although the male's costume and posture differ significantly to those in this image, suggesting an alternative graphic source and calling into question whether these two figures were originally intended to be a pair (**Fig. 82**).[12] The copperplate engraving, entitled 'Franckfurther Jud und Jüdin' (Frankfurt Jew and Jewess), depicts a couple standing on a low mound, with a city in the distance, presumably Frankfurt. The image was engraved by the Dutch illustrator and etcher Caspar Luyken (1672–1708), and published by Christoph Weigel (1654–1725) in the *Neu-eröffnete Welt-Galleria. Worinnen sehr curios und begnügt unter die Augen kommen allerley Aufzüg und Kleidungen unterschiedlicher Stände und Nationen* (Newly Opened World Gallery. In which all manner of very curious and pleasing attire and garments from various ranks and nations are brought before your eyes) (Nuremberg, 1703), with a dedication to Holy Roman Emperor Joseph I (1678–1711), by Abraham a Sancta Clara (1644–1709), a celebrated Discalced Augustinian monk living in Vienna, along with a single page of introductory text.[13] The collection of costume prints can be understood as a compendium of Viennese culture around 1700 and includes 100 individuals, from recognisable figures, such as Pope Clement XI (1649–1721), to the anonymous depiction of various occupations, ethnicities and other religious groups, illuminating our understanding of the European world view at the beginning of the 18th century.

The Jewish costume of the print is faithfully copied by the Chinese potter, offering insights into Jewish religious practice and belief as well as more widespread conventions

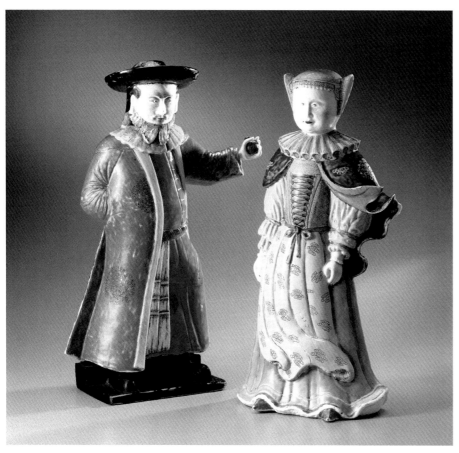

Figure 81 Figures of a man and woman in Jewish costumes, *c.* 1740, Jingdezhen, China, porcelain decorated with overglaze enamels and gilding, h. 43.2cm and 42.2cm. Gift of Leo A. and Doris C. Hodroff, Winterthur Museum, Delaware, 2000.0061.090, 2000.0061.091. Courtesy of Winterthur Museum, photo by Gavin Ashworth

in European female dress; the *kupke* (bonnet), the apron and the *brusttuch* (stomacher or bodice), a vertical strip of decorative material fastened with laces and tucked into the skirt, were common to numerous ethnic groups. In the Jewish community the apron ensured modesty, and symbolically divided the top part of the body from the lowly lower one, similar to the man's *gartl* (a belt or rope), and was prescribed by Jewish law (*Halakhah*).[14] Bonnets were adopted by Jewish women once they were married, as they were required to shave their heads and wear a head covering even at home. This example with cone-shaped ears is evidently a Frankfurt regional variation, and may be based on a typical cap with two starched wings of white linen, known as a *viereckiger schleier* (four-cornered veil), which was worn in a synagogue and on the Sabbath.[15] Of course, the engraving itself may not be entirely accurate, presenting instead a stereotype of how Frankfurt Jews were expected to look rather than reality.

A closer print source for the male figure in the same publication was first identified by William Motley in 2017, which depicts a Polish Jew ('Ein Polnischer Jud'), with perhaps Krakow in the distance (**Fig. 83**).[16] The engraved portrait is thought to be of Rabbi Nathan (Nata) ben Moses Han[n]over (d. 1683), author of *Yeven Mezulah* (The Abyss of Despair) (Venice, 1653), a Hebrew chronicle documenting Polish Jewish society and the tribulations of 17th-century Jewry during the Chmielnicki Massacre of 1648–9.[17] The costume of the porcelain figure includes a large cap, resembling a *barrette*, a long cloak and a striped sash, known as a *tallit* (prayer shawl); his divided beard is after the engraved image. By the mid-18th century, in most of Europe the beard was a sign of Jewish difference following

Figure 82 'Franckfurther Jud und Jüdin' (Frankfurt Jew and Jewess), Caspar Luyken, from Abraham a Sancta Clara's *Neu-eröffnette Welt-Galleria* (Newly Opened World Gallery), 1703, Nuremberg, Germany, etching and engraving, 27.4 x 19.3cm. Library of the Jewish Theological Seminary, New York

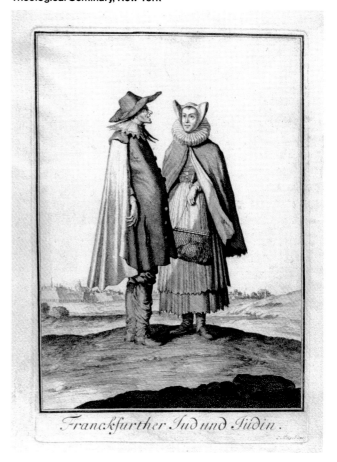

Franckfurther Jud und Jüdin.

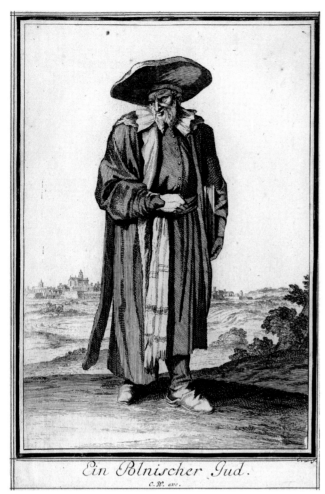

Figure 83 'Ein Polnischer Jud' (A Polish Jew), Caspar Luyken, from Abraham a Sancta Clara's *Neu-eröffnette Welt-Galleria* (Newly Opened World Gallery), 1703, Nuremberg, Germany, etching and engraving, 28.2 x 18.9cm. British Museum, London, 1866,0512.2987

prohibitions against shaving, clearly marking them as 'the other'.[18] The distinctive garments, such as the large 'white' *Judenkragen* (ruff), worn by both figures, were prescribed by Jewish anti-sumptuary laws and customs, originally intended to make the wearer less conspicuous. The once-fashionable ruff, long rejected by elite Christians, was adopted by the Jewish European community, and was not abolished in Eastern Europe until 1781.

These two engraved figures represent distinct Ashkenazi communities in the Jewish diaspora, which coalesced in the Holy Roman Empire, one based in Frankfurt and the other in Poland, the largest and most significant Jewish community in the world, thanks to a long period of religious toleration. While the Sephardic Jews moved to Spain, Portugal, North Africa and the Middle East, the Ashkenazi settled in Northern Europe, resulting in different ethno-cultural traditions. The public costumes of Jewish people were traditionally a sombre black or dark-coloured, as reflected in the monochromatic print, but in private the wealthy dressed more fashionably in colourful textiles.[19] In stark visual contrast, the Chinese decorator has rendered the Jewish figures in vivid multicoloured costume embellished with Chinese motifs, either on his own initiative and following Chinese conventions of enamelling on porcelain or as specified by whoever commissioned the figures. It is unlikely that the print original was hand-coloured,

indicating the extent to which the porcelain decorator adapted and interpreted individual design sources. In fact, both figures depart from the print originals, removing minor elements of the design, such as the woman's bag, and substituting new items, such as the red purse in the left hand of the man, which replaces the large book in the engraving.[20] This element was clearly part of the commissioned design, presumably ordered through a European merchant, and associates the male figure with commerce, the stereotypical money lender or usurer.

In rare Western porcelain models of Jewish figures cruel stereotypes persisted, and few were as neutral as the Chinese potter's interpretation of Luyken's engraving, which lacks any overt caricature.[21] In 1725 the Meissen porcelain factory produced a miniature or dwarf porcelain figure, identified as the fictional character Natan Hirschl, head of the Jewish community in Prague, 'prince of the Prague Jews and licensed puppet-master of Hebrew law, in his school uniform' ('Natan Hirschl der Pragerische Judenschaft Primas, und deß höbraischen Gesatzes approbierter Püpen-maister, in seinem Schulkleydt').[22] In the highly anti-Semitic representation, the old man wears the traditional ruff and *yarmulke* (skullcap), while holding a purse and cane. The figure was part of a series of 161 plaster models ordered from sculptors in Augsburg of 'various National types and other figures', identified as 'allerhand Nationen' (all kinds of nationals) and more specifically 'Zwergen Nationes' (dwarf nationals). Of these about a dozen were based on plates from *Neu-eröffnete Welt-Galleria*, the majority adapted as miniature figures and dwarfs.[23] Unlike Luyken's costume prints, these portraits, loosely based on Jacques Callot's (1592–1635) *Varie Figure Gobbi* (Nancy, *c.* 1621–5), pilloried various nations, professions and ethnic groups from all ranks of society, evidently filling a demand for this type of satirical imagery.

The other female figure, traditionally identified as the 'Dancing Turk', is similar to another engraving by Luyken in the *Neu-eröffnete Welt-Galleria*, 'Eine Tanzende Türkin' (A Dancing Turk), one of 16 plates depicting figures in Turkish costumes, indicating the popularity of this subject (**Fig. 84**). However, the porcelain figure's costume and posture is closer to that found in a Parisian print executed and published by Nicolas I Bonnart, 'Femme Turque d'Andrinople, en chambre' (Turkish woman from Adrianople, in bedroom), first identified by Luisa Mengoni in 2012 (**Fig. 85**).[24] The accompanying inscription beneath the engraving alludes to her exotic charms: 'Son oeil brunet, et sa maniere aizee, Demenderoient plus d'un epoux; Faut-il par malheur qu'un Jaloux, Nuit et jour la tienne enfermee' ('Her dark eye, and her elegant manner, demand more than one husband; unfortunately a jealous man must keep her shut away night and day').

The engraving situates the woman in the interior of a grand palace or seraglio, rather than Luyken's ornamental garden. The porcelain model corresponds closely to Bonnart's figure, although once more, as alluded to earlier, singular elements such as her headdress and beaded waist signal different origins and there may be another more precise print source yet to be identified. While the garments in the print original are richly ornamented in a European taste, the Chinese painter has decorated her tunic and skirt

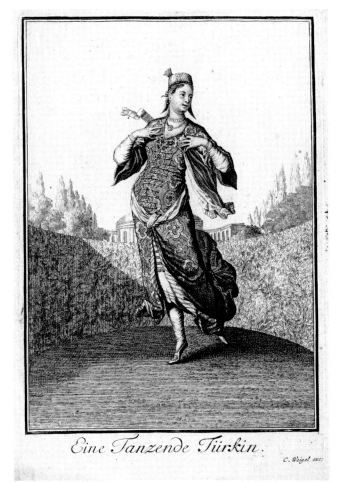

Figure 84 'Eine Tanzende Türkin' (A Dancing Turk), Caspar Luyken, from Abraham a Sancta Clara's *Neu-eröffnette Welt-Galleria* (Newly Opened World Gallery), 1703, Nuremberg, Germany, etching and engraving, 26.8 x 19.2cm. British Museum, London, 1871,1209.2859

Figure 85 'Femme Turque d'Andrinople, en chambre' (Turkish woman from Adrianople, in bedroom), made and published by Nicolas I Bonnart, c. 1680–1700, Paris, France, etching and engraving, 27.4 x 19.3cm. British Museum, London, 1871,0812.4686

with Sinicised decorative roundels and scrolling cloud motifs. The coloration of the British Museum example is particularly unusual, the light blue lace collar and *fichu* (kerchief) with jewelled fastening contrasting with the bright yellow jacket and dark orange skirt. Perhaps most striking are the blonde locks that cascade down her back, giving this figure an unusually European appearance compared with others of this type.

The continued popularity of *turquerie* (fashion for Turkish culture and style) in 18th-century European visual and material culture is evidenced by the production of porcelain figures in Turkish costume executed at Meissen, c. 1743, as well as other European factories, from which later Chinese figures were copied.[25] The Meissen figures dressed as sultans and sultanas, as well as Safavids, were after costume studies illustrating *Recueil de cent Estampes representant differentes nations du Levant* (Collection of One hundred Prints of the Various Nations of the Levant) (Paris, 1714–15).[26] The images were commissioned from the painter Jean-Baptiste Vanmour (1671–1737) by the French ambassador appointed to Istanbul, Charles, Comte de Ferriol (1637–1722), as a record of Ottoman court life and the social customs, classes and the occupations of Istanbul and the Ottoman Empire early in the 18th century. The *Recueil de cent Estampes* was a far more influential source for costumed porcelain figures, albeit through the Meissen examples with their paired figures of

sultans and sultanas, which were later copied at the Worcester porcelain factory, c. 1768–70.[27] In contrast, the female 'Dancing Turk' appears singly in European print and porcelain, without a partner and dancing for the enjoyment of her male audience, becoming a popular visual manifestation of the 'exotic other'. It is likely that the Chinese figure was also produced singly and intended to be viewed as such. It is also possible that the order was a sample and never fully completed.

European costume prints may be regarded as the starting point from which Chinese potters and decorators adapted and interpreted pictorial designs, as demonstrated in these figurines. While individual costume conventions are adhered to, such as the cone-shaped winged bonnet and large ruff of the Jewish woman and the wide-brimmed hat and sash of the man, both figures are enlivened through their posture and the suggestion of movement in the textiles. This observation could also be extended to the 'Dancing Turk' who is captured in dynamic motion. Furthermore, the plain undecorated cloth of the costume print has been replaced by dazzling patterned textiles embellished with detailed cloud scroll motifs and roundels on the skirts and cloak, referencing the rich decorative repertoire of Chinese textiles, hybridising the object. The fantastical colour palette of pastels is purely imaginary, utilising the latest Chinese enamelling technology to create a technicolour costume of

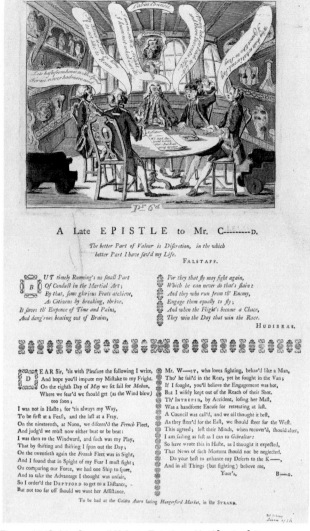

Figure 86 'Cabin Council/A Late Epistle to Mr. C[levlan]d', anonymous, 1756/7, published by Matthew Darly, London, hand-coloured etching and letterpress, 37.3 x 22.6cm. British Museum, London, 1868,0808.3996

pink, yellow, purple and eau de Nil. The detail of the print source has been picked out in fine black lines over the enamelled surface, delineating the folds of the ruff, the lace on the headdress and the lacing of the bodice. The expense of producing such large and intricately decorated objects at this relatively early date in the development of the *famille-rose* palette should be noted and would explain in part the rarity of such objects.

While the identity of the person or organisation that commissioned these figurines remains unknown, there has been much speculation regarding the Jewish subject matter of the two models. It has been noted that Sephardic Jews involved in trade with the East had moved from the Iberian Peninsula to Amsterdam, London and Vienna; some ordered Chinese armorial dinner services and may have commissioned objects such as this.[28] Sharon Liberman Mintz, Curator of Jewish Art at the Library of The Jewish Theological Seminary, in New York City, has linked figural images from *Die Neu-eröffnete Welt-Galleria* to four illustrations used in the decoration of a richly ornamented Esther scroll (*Megillah*), which recounts the story of Esther at the Jewish festival of Purim.[29] It was evidently created for members of the small but affluent Jewish community in Vienna in the

first decades of the 18th century. The figures selected from the costume print are dressed in Turkic style, perhaps reflecting the Turkish-Jewish community in Vienna. Following the Treaty of Passarowitz in 1718, Turkish Jews were allowed to live and trade freely in Vienna, while still subjects of the Sultan of Turkey. They were known to have 'brought to Vienna the distinctive costume of their native country and to have worn them in public'.[30] The link between Jewish and Turkish costume is intriguing, supporting the argument that the Chinese porcelain figures were indeed commissioned for wealthy Jewish individuals. Furthermore, the elaborate headdress of the 'Dancing Turk' bears close similarities to the costume of Polish Jews, as illustrated around a hundred years later in *Les Israélites de Pologne* (1846) by Léon Hollaenderski (1808–1878), suggesting that elements of this design can also be traced to regional Jewish costume.[31]

In the 18th century elite Jews in central Europe enjoyed great privilege at the leading courts, with trading networks that extended far across the Continent. They frequently acted as agents, provisioning armies with grain, timber and cattle and supplying diamonds and other luxury goods, as well as providing commercial credit or cash. A number of wealthy Jews were investors in the Dutch East India Company, such as Isaac de Pinto (1717–1787) who became a director of the Company in 1748; a blue-and-white Chinese porcelain service has the arms of the Pinto family, originally from Portugal, *c.* 1690–1700.[32] A handful of other Chinese armorial services are also associated with Jewish families, many of whom were based in England in the mid-18th century – including the Mendes da Costa, Lousada and D'Aguilar – and were active in the British East India Company, or were agents of the Company. The last Baron Diego Pereira d'Aguilar (1699–1759), also known as Moses Lopes Pereira, was a Portuguese financier, who lived in Vienna from 1722 to 1747, and was a patron of the arts in the Turco-Jewish community, before returning to London. Any of these global entrepreneurs would have had the opportunity to order these figures as special commissions, and equally to purchase them as consumers from merchants in Amsterdam, Vienna, London or elsewhere in Europe, as indeed did Admiral Byng, a non-Jew. By the mid-18th century, in many parts of Europe it was impossible to tell a Jew from a non-Jew, and these figures may have also served as a visual exhortation to uphold the traditional culture of Ashkenazi Jewry.[33]

Few of the Chinese porcelain figures forming this group have any 18th-century provenance, which might usefully suggest the original market or consumer of these wares. Two of the male models were apparently in the collection of Admiral John Byng (1704–1757), fifth son of Rear-Admiral George Byng, 1st Viscount Torrington (1663–1733), of Southill Park, Bedfordshire.[34] A Royal Navy officer, the infamous Byng was court-martialled and executed by firing squad for failing to relieve a besieged British garrison in 1756 during the Battle of Minorca, which fell to the French. At the time of his court martial following his arrest on a charge of cowardice, the pompous Byng was the subject of considerable satire, which frequently referenced his love of china collecting. While it was perhaps more of a trope to suggest his

Figure 87 The Chinese Room, Buxted Park, East Sussex, 1950. Image: © Alfred E. Henson/Country Life Picture Library

effeminacy, selfishness and corruption – he was accused of trying to escape jail dressed as a woman – Byng did leave a friend, Admiral Augustus Hervey, 3rd Earl of Bristol (1724–1779), a clock encased in 'Dresden' or Meissen porcelain.[35] A famous satirical broadside published by Matthew Darly (c. 1720–1780) transforms Byng's ship, HMS *Ramillies*, into a floating china warehouse, in which several porcelain figures can be seen among the jars and vases (**Fig. 86**).[36]

The two Chinese porcelain figures of the 'Frankfurt Jewess' and the 'Dancing Turk' at the British Museum were formerly in the collection of Basil Ionides (1884–1950) and his wife Nellie (1883–1962), daughter of Sir Marcus Samuel, 1st Viscount Bearsted (1853–1927) and heiress to the Shell Oil fortune. They were displayed in the Chinese Room of their country residence, Buxted Park, East Sussex, alongside a matching figure to form two pairs of each of these models (**Fig. 87**). Following their death, the pairs were split up with one of each selected for the Basil Ionides Bequest of Chinese 'Famille-Rose Porcelain' at the Victoria and Albert Museum (V&A), London, (**Figs 88–9**), which included many Chinese porcelain figures of Europeans, with the remaining examples passing to the British Museum. Comparisons between the objects reveal intriguing differences in design and execution, which may offer useful insights into their initial production and manufacture. The two women wearing Jewish costume are clearly produced from the same mould and the decorative palette is closely followed, apart from the interior of the cloak finished in a contrasting colour.[37] However, the pastel enamel decoration is more successfully achieved on the V&A example, in particular the eau de Nil, which is pitted and bubbled on the British Museum piece. The two dancing figures are also produced from the same mould, but the British Museum figure leans heavily forward, suggesting movement during the firing process, whereas the V&A figure stands upright. The colouration here is deliberately distinct, in both ground colour and the choice of decoration, the V&A piece emphasising the pastel colours of pink, yellow and blue whereas the British Museum model combines a striking egg-yolk yellow with the darker orange hues of the skirt. The detailing of the facial features on both V&A examples indicates a delicacy of brushwork affirming the skills of the decorator, unlike other figures in this group that are roughly finished with freckles and rouged cheeks. It has been suggested that the qualitative and stylistic variations noted here may indicate the production of a second consignment of slightly different specifications and results. Alternatively, these inconsistencies in design may be the mark of another hand or evidence that a variety of designs were stipulated in the original order. In the absence of further textual evidence, this remains purely speculative.

A shared fascination with 'the other' may be observed in the contemporary visual and material culture of China, where Europeans featured alongside other nationalities and ethnicities then considered at the periphery of the Sino-centric world, easily identified by their distinct costumes and

Figure 88 Figure of a woman in Jewish costume, *c.* 1740, Jingdezhen, China, porcelain with overglaze decoration and gilding, h. 42.3cm. Victoria and Albert Museum, London, C.94–1963. Photo © Victoria and Albert Museum, London

Figure 89 Figure of a woman in Turkish costume, *c.* 1740, Jingdezhen, China, porcelain with overglaze enamels and gilding, h. 44.5cm. Victoria and Albert Museum, London, C.95–1963. Photo © Victoria and Albert Museum, London

physiognomy.[38] Chinese prints also provided an invigorating decorative impetus to 18th-century porcelain design but this did not materialise in the manufacture of three-dimensional figural sculptures, which remained largely confined to the religious sphere. In contrast, the European enjoyment of figural sculpture, in particular objects manufactured from porcelain, flourished in the middle years of the century when these objects were produced. At that time, only the porcelain manufacturers of China were capable of successfully modelling and decorating such large and visually arresting pieces, on commission and at an affordable price, amalgamating unfamiliar monochrome and two-dimensional European print sources and incorporating elements of Chinese design and interpretation. Whoever commissioned this important, little-studied group of Chinese figures after European graphic sources, selected Chinese porcelain for its high material status and ability to assert their cultural and ethnic identity. To what extent these figurines represented the exoticised 'other' or perhaps a nostalgic 'self', depends entirely on the context in which they were originally seen.

Acknowledgement

I would like to thank Patricia Ferguson for her research into 18th-century Jewish costume.

Notes

1　In England, 'Nobody' came to represent the humble and honest 'Have-nots', as opposed to the powerful and arrogant 'Haves' or 'Mr Somebodies'. See Steedman 2013, 11–22.

2　A woodcut of the character appeared in the frontispiece of the Elizabethan play *Nobody and Somebody*, printed in 1606 for John Trundle (1575–1629), a publisher and bookseller in the Barbican, London, see Sargent 2012, cat. 244; a Chinese porcelain example is in the V&A: C.7&A–1951, along with an English tin-glazed earthenware model, *c.* 1680–85, V&A: C.4&A–1982, cited in Kerr and Mengoni 2011, 76.

3　In the 19th century, French terms were used to describe the dominant colour palette of enamels on porcelain, such as *famille-verte* and *famille rose.*

4　Howard and Ayers 1978, vol. 2, 580–1, cat. 601. Bonnart prints, including the 'Five Senses', were clearly sent by merchants to China as they appear on late 17th-century blue-and-white porcelain vases, jars and plates: see the entries by Luisa Mengoni in Lü 2012, 136–7, cat. 027, and 138–9, cat. 028.

5　Sargent 2012, cat. 100; and another example is in the British Museum, 1980,0728.666. These 'toys' were described as 'Dutch families' in a 1703 English cargo list, see Godden 1979, 266, 270.

6　1963,0422.11 and 1963,0422.10 see Krahl and Harrison-Hall 1994, 32, 73.

7　Lü 2012, 140–1, cat. 029.

8 Motley 2017, cat. 55.

9 Howard 1994, 253.

10 Two male figures, formerly owned by Admiral John Byng (1704–1757) before 1757, were sold separately in the 1980s: 1) Christie's, London, 6 July 1984, lot 589, with its original hand holding the purse, present location unknown; and 2) Christie's, London, 7 July 1986, lot 239, acquired for the Hodroff Collection, where it was paired with a European woman, and both are now in the Winterthur Museum, Winterthur, Delaware, 2000.0061.090 and .091 (Fuchs and Howard 2005, 208); 3) a male figure from the Copeland Collection, which was paired with a European woman in a Portuguese collection, sometime before 1962 (Beurdeley 1962, pl. XVIII, 91), is now in the Peabody Essex Museum, Salem, Massachusetts (Sargent 1991, 112–13, cat. 51); and 4) a male figure, paired with a European woman in the 1970s, was sold at Sotheby's, 18 January 2019, lot 321.

11 Howard and Ayers 1978, vol. 2, 613, cat. 641, citing a print source after Nicolas I Bonnart, *Paysanne de Suabe en Allemagne, c.* 1680–1700, in the British Museum, Prints and Drawings (P&D), 1938,0311.6.105.

12 Fuchs 2008, 39–40. The man's ethnicity was first proposed by David S. Howard, see Howard 1994, cat. 299.

13 There is no mention in the Nuremburg publication of the popular Viennese preacher's anti-Jewish tirades published earlier in *Judas Der Ertz-Schelm*, Salzburg, 1692, 201–3, cited in Diemling 2010, 88. Thirty plates from the print series are in the British Museum, 1866,0512.2984–9; 1871,1209.2502; 1871,1209.2712, .2713, .2716–8 and .2857–72; and 1881,112.220.

14 Patai 2013, 114.

15 Rubens 1981, cat. 1367.

16 Motley 2017, cat. 55.

17 Heller 2018. The title of his publication, *Yeven Mezulah*, is a quote from Psalm 69: 3.

18 In 1729 a Huguenot diplomat in London noted that if one saw a Jew wearing a beard one could be certain that he was either a rabbi or a very recent immigrant, see Endelman 1979, 122.

19 Turnau 1999.

20 The red purse is absent from the male figure sold at Sotheby's, 18 January 2019, lot 321, as the hand is a replacement; see condition report https://www.sothebys.com/en/auctions/ecatalogue/2019/a-collecting-legacy-property-from-nelson-happy-rockefeller-n10004/lot.321.html.

21 Another porcelain figure identified as Jewish was listed in the Chelsea Sale Catalogue on the Sixth Day's Sale, 3 April 1756, lot 49, 'Two figures of a mapseller and a Jew with his box of toys'. The Chelsea figure, probably depicting a pedlar, an unpainted example, identified as such, *c.* 1754, in the collection of Dr Peter

Bradshaw, was sold at Bonham's, 24 January 2007, lot 11; a Derby example selling bottles paired with a women selling trinkets, *c.* 1760, is in the V&A: 414: 168/A–1885.

22 For an example of the porcelain figure in the Landesgewerbemuseum, Stuttgart (inv. no. 26/152), see Rückert 1966, 849; and for the print source see British Museum, 1938,0617.12.60.

23 Clarke 1990. The latter were part of a larger group known as 'Callot dwarfs', as many were based on the comic plates in the series engraved by Elias Bäck (1679–1747) and published by Martin Engelbrecht (1684–1756), *Il Callotto resusciatato. Oder Neü eingerichtes Zwerchen Cabinet* (Il Callotto resusciato or Newly Furnished Cabinet of Dwarfs), Augsburg, *c.* 1714.

24 Lü 2012, 143, cat. 030.

25 For more on the European interest in Turkish costume, see Scarce 2002; and for a later Chinese porcelain figure of a Turkish girl after a Meissen prototype, *c.* 1760, part of the Basil Ionides Bequest in the V&A: C.100–1963, see Howard and Ayers 1978, vol. 2, 619.

26 Ducret 1973, 175–8.

27 See a pair in the British Museum, 1938,0314.84 and 85.

28 Howard 1974; Bachmann 2018.

29 Liberman Mintz 2002.

30 Liberman Mintz 2002, 84.

31 Hollaenderski 1846, 280. This feature was also coloured red in colour prints of the image, further supporting the link to the porcelain figures.

32 Bachmann 2018, fig. 21.1.

33 Endelman 1979, 121–3.

34 One of the two figures, sold at Christie's, London, 6 July 1984, lot 589, bore an old label on the base inscribed 'purchased at the unfortunate Admiral Byng's Sale in 1757', and passed by descent to the family of the vendor. No reference to a public sale in 1757 has been identified.

35 Cardwell 2004, 33, 38, 62.

36 A satirical poem, entitled *The British Hero and Ignoble Poltron Contrasted*, published in London in 1756, makes a similar observation about his love of porcelain: 'Our prudent Adm'ral held it wise, Not to expose the Ramelies To the Hard Blows of Iron Balls, Which would deface her Wooden Walls; Or might his Cabin Windows tare, And break his curious *China* Ware', also cited along with the engraving in Motley 2014, 68, and Cardwell 2004, 60.

37 The archives of the London dealer John Sparks Ltd record the purchase on 24 September 1936 by Mrs Ionides of a 'Pair of rare famille rose standing Dutch women' for the sum of £250. Day Book, September 1936, 103, File 7, John Sparks Ltd Archive, SOAS Archives and Special Collections, SOAS University Library.

38 Hostetler 2001; Lai 2019.

Chapter 8
'Aux plaisirs des dames': Designing and Redesigning a Meissen *bourdaloue*

Catrin Jones

Many European porcelain manufactories from Chantilly to Sèvres produced variants on the distinctive *bourdaloue* shape in the early to mid-18th century.[1] This small, portable lady's chamber pot provided an inventive solution in times of limited plumbing facilities, awkward formal dress and hours spent sitting at court. What makes the Meissen porcelain *bourdaloue* in the Holburne Museum's collection distinctive is that, following serious damage sustained at some point in its functional life, the vessel became an unusual example in the tradition of adapting luxury porcelain with gilded mounts (**Fig. 90**). Such embellishments often reflected changing tastes and integrated disparate objects into coherent visual stories in the fashionable interior. Here, the addition of an assemblage of mounts was more about disguising damage – a large crack and the loss of the handle – and perhaps also the original function of the vessel to appeal to a new collectors' market.[2] The afterlife of this intimate luxury object would see it transformed into an elaborate jardinière before it entered the collection of a Victorian gentleman. This chapter will explore the layered narratives of the *bourdaloue*'s original decorative scheme and consider the representation of women as the subject matter depicted on, and as consumers of, desirable porcelain.

The *bourdaloue* is recorded in William Chaffers's catalogue of 1887 of the Holburne Museum's collection as 'an oval vessel or *bourdaloue*, painted with subjects from Fontaine's fables, mounted with ormolu rim and foot, dragon handles'.[3] Sir Thomas William Holburne (1793–1874), a naval officer who inherited his family's baronetcy, had embarked on a Grand Tour in the 1820s that planted the seeds for a lifetime of collecting. His townhouse collection would form the founding bequest of The Holburne Museum, now housed in the former Sydney Hotel at the entrance to Bath's 18th-century pleasure gardens. The museum's records do not reveal when Sir William Holburne acquired the *bourdaloue* or when its transformation into a vase took place.[4] Holburne had inherited some ceramics, including an armorial service and a group of Wedgwood vases and plaquettes, and collected a wide range of porcelain and pottery, particularly maiolica, English 18th-century wares and East Asian export ware. He acquired a small and generally unremarkable collection of Continental porcelain (many of the most important works of Meissen came to the museum through various gifts during the 20th century), which makes the presence of such an exceptional piece in Holburne's collection all the more surprising.

Gilt-bronze, marble and rosewood mounts were once an integral part of how Sir William Holburne displayed his collection. The 1874 probate inventory of his home at 10 Cavendish Crescent, Bath, evokes a crowded space stuffed with his huge collection of paintings, ceramics and *objets de virtù*, but many objects were separated from their 19th-century display mounts in the 20th century, and only recently reassembled (**Fig. 91**).[5] The gilded mounts on the Holburne *bourdaloue* are an assemblage of different styles, dates and qualities. The liner was probably made to fit the piece. The rococo-style base and the naturalistic floral swags contrast with the neoclassical leaf motifs of the foot ring, and the dragon handles, while based on a form that appears in the 18th century, are almost certainly later and not of high

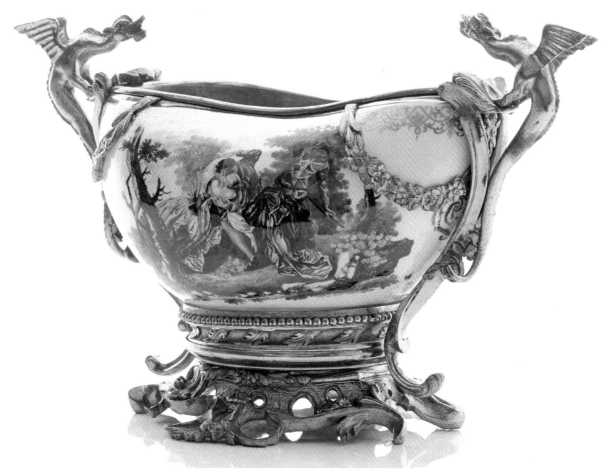

Figure 90 *Bourdaloue* or lady's chamber pot with dragon mounts, *c.* 1735–40, Meissen, Germany, hard-paste porcelain, enamels, later gilt-metal mounts added before 1887. Collection of Sir William Holburne, Holburne Museum, Bath, X1186. Photography Sylvain Deleu

quality.[6] These mismatched mounts are toned so as to look like a coherent set, and with the exception of the liner were clearly recycled from other objects. For instance, the burnishing of the leaf motifs on the ring at the base suggest that, inverted, it was once the collar of another vase. The reconfiguration of the *bourdaloue* raises questions about the sexual politics of the object from the time it was made to over a century later when it entered Holburne's collection in a very different guise.

In addition, Meissen's original decorative scheme for the *bourdaloue* has its own complex and layered meanings. The Königliche Porzellan Manufaktur, founded in Meissen in 1710 under Augustus the Strong, Elector of Saxony (1670–1733), was the first European factory to produce 'true' or hard-paste porcelain, and over the following half century, Meissen's luxury wares were marketed at elite consumers in the German-speaking lands as well as in Paris, Amsterdam and London. Records in the factory's archives show that the important designer, sculptor and modeller Johann Joachim Kändler (1706–1775), who had arrived at the factory in 1731, had by 1734 designed, '1 ovaler Pot Chamber, an dessen Henkel sich ein Frauenzimmer gesicht nebst einer feinen Muschel befindet, in dessen Muschel der Daumen zu liegen kommt bei den angreiffen, und lässet sich dieses Geschirr also sehr Commode halten'.[7] The important original element of the handle, which would have allowed the lady's maid or the user herself to hold it, is missing from the Holburne

bourdaloue, and the resultant holes repaired. Another example of the shape is in the Sammlung Ludwig, Museen der Stadt, Bamberg, Germany (**Fig. 92**), which shows the original effect: a graceful handle with a female mascaron (a frightening or grotesque mask) and shell thumbpiece.[8]

Figure 91 The *bourdaloue* in Figure 90 disassembled. Collection of Sir William Holburne, Holburne Museum, Bath, X1186. Photography Sylvain Deleu

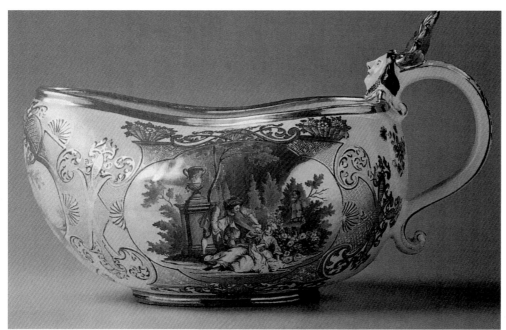

Figure 92 *Bourdaloue* or lady's chamber pot, *c.* 1740–5, Meissen, Germany, hard-paste porcelain, enamels, gilding, h. 14cm. Sammlung Ludwig, Museen der Stadt Bamberg, Germany, L47

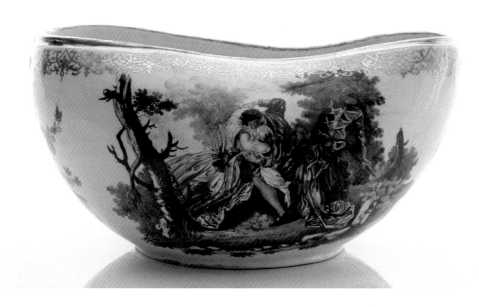

Figure 93 Detail of Figure 90, with lovers embracing and Harlequin, after Jean-Antoine Watteau. Collection of Sir William Holburne, Holburne Museum, Bath, X1186. Photography Sylvain Deleu

The enamel painting on the Holburne *bourdaloue* is of exceptionally high quality. Although the *Hausmaler* tradition of outside decorators painting on Meissen porcelain blanks makes definitive attributions challenging, the style suggests that one of Meissen's top painters of the period, Johann George Heintze (act. 1720–1748), Christian Friedrich Herold (1700–1779) or Bonaventura Gottlieb Häuer (1710–1782), might well have been responsible. Identification of the prints adapted for the painted decoration reveals a playful use of sources to add to the narrative of the object's form. The scene on one side, of an elegant man and woman caught in a twisting embrace in a landscape, copies an etching by Benoît Audran II (1698–1772) after a painting by Jean-Antoine Watteau (1684–1721) called *La Surprise* (1718–19), based on the title of the print, *La Surprise – Occupat Amplexu* (**Figs 93–4**), published in Paris in 1731.[9] The engraving of the central figures is translated in extraordinary detail into the porcelain decoration, down to the precise folds on the lady's dress and postures of the figures.

A number of painted details on the *bourdaloue* are changed and adapted. For heightened comedic effect the figure of Mezzetin tuning his guitar, a stock figure of the *commedia dell'arte*, is replaced with Harlequin, another character from the Italian comedy. The masked figure of Harlequin, with his distinctive patched costume and brandishing his slapstick, warns viewers that the lovers were indeed in for a surprise (**Fig. 95**). Harlequin is perhaps copied from a detail in *L'Amour au Théâtre Italien* (1734), also after Watteau. Both prints were included in *L'Oeuvre d'Antoine Watteau Peintre du Roy* (1735), plates 31 and 264, but the latter was engraved by Charles Nicolas Cochin père (1688–1754).[10] Combining details from more than one print source in a single image is common on Italian *istoriato* maiolica (see Thornton, Chapter 4), but is less frequently seen on Meissen porcelain, hinting that it was a bespoke commission with carefully contrived iconography.

Scenes after the French painter Watteau were enormously fashionable on Meissen porcelain from the late 1730s

Figure 94 *La Surprise – Occupat Amplexu*, Benoît Audran II, after Jean-Antoine Watteau, 1731, Paris, France, etching with some engraving on paper, 40.9 x 31.5cm. British Museum, London, 1838,0526.1.31

Figure 95 Detail of Figure 93. Collection of Sir William Holburne, Holburne Museum, Bath, X1186. Photography Sylvain Deleu

of prints and drawings acquired for the Saxon court to keep up with international designs and ideas, directly influencing the cultural policy of Saxony.[11] The lettering below the engraving of Watteau's *La Surprise* reveals that the original painting was owned by Jean de Jullienne who was instrumental in getting Watteau's paintings engraved, particularly important as so many of the originals were lost. In this case, the painting of *La Surprise*, thought lost, was acquired by the Getty Museum in 2017.[12] It is clear that the print was the source of inspiration for the porcelain decoration, but the comparison is nonetheless instructive, since it highlights the extraordinary painterly skill on show on the porcelain.

William Chaffers's mention of fables by Jean de La Fontaine (1621–1695) in his catalogue entry proved only partially correct: rather than one of his translations of Aesop's fables, the story depicted is in fact taken from his *Contes et Nouvelles en Vers* (1665), a series of poems with a distinctly salacious undertone. In the 18th century, Fontaine's *Contes* continued to inspire artists, such as François Boucher (1703–1770), Charles Michel-Ange Challe (1718–1778), Nicolas Lancret (1690–1743), Jean-Baptiste Joseph Pater (1695–1736) and Nicolas Vleughels (1668–1737), as well as their cultured patrons. The work became part of a collection of engraved illustrations, the *Suites d'Estampes Nouvelles pour les Contes de La Fontaine*, also known as *Suite de Larmessin* named after the principal engraver Nicolas de

onwards. His work was widely circulated through *L'Oeuvre d'Antoine Watteau Peintre du Roy*, also known as *Recueil Jullienne*, a compilation of 271 engravings by various artists after his paintings, many of which were in the collection of Jean de Jullienne (1686–1766), as well as his work as a designer. All four volumes were published by 1735, and within three years two sets had been acquired, one for the Meissen factory, which had been amassing working prints for the painters and designers since at least the 1720s, and the other for Dresden's Kupferstich-Kabinett, which housed a collection

Figure 96 Detail of Figure 90 with *La Jument du Compère Pierre*, after Nicolas Vleughels. Collection of Sir William Holburne, Holburne Museum, Bath, X1186. Photography Sylvain Deleu

Larmessin III (1684–1755); the series of 38 prints was published between 1736 and 1743. The scene on the reverse side of the *bordaloue, La Jument du Compère Pierre* (**Figs 96, 98**) is based on a drawing or painting in the series by Vleughels who interestingly was a close associate of Watteau.[13] Vleughels' artwork was probably engraved by Larmessin around 1736–7, however, the decoration on the porcelain is in reverse, so it may be that the Meissen painter used a reversed copy by the unidentified engraver known only as Jauvelle, perhaps a pseudonym, as it was probably a pirated copy (if published in France) – made around the same time to undercut the price of the original (**Fig. 97**).[14]

In the scene, a poor country peasant, Compère Pierre, is convinced by Messieur Jean to allow his wife, Magdalen, to be transformed into a mare to assist with the harvest, then to be restored each evening to her womanly form. Under the guise of performing this transformation, Messieur Jean is

Figure 98 Detail of Figure 96. Collection of Sir William Holburne, Holburne Museum, Bath, X1186. Photography Sylvain Deleu

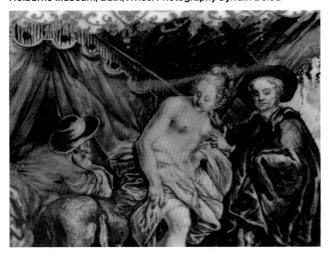

molesting Magdalen while her husband looks on complicitly. The licentiousness of the old man is indicated not only by his actions, but also by his dishevelled appearance, wrinkled stockings and the visual parallel drawn between him and the mare he attempts to conceal under the drapery. The themes of both prints, *La Surprise* and *La Jument du Compère Pierre*, suggest a man co-opting – by seduction or coercive control – a woman. How did these distinct yet thematically linked works come to be combined on this vessel?

Two studies have revealed the breadth and quality of the print sources available to Meissen's painters for use as decoration on their porcelain wares. Maureen Cassidy-Geiger has described, 'the lingering influence, and continuing availability, of 17th-century print material from France and Holland', both in the form of the prints themselves and old copperplates that were reprinted, reflected in the huge variety of material in the possession of the Meissen factory.[15] Her research has identified at least six prints by Vleughels listed in the 1846 inventory of the Meissen factory archives.[16] Claudia Bodinek's recent study on the factory's print collection explores the translation of prints onto porcelain, and features works by Watteau, whose decorative and figural scenes form a significant part of the study.[17] Perhaps Heintze, who 'worked as a drawing instructor from 1740 and was additionally in charge of the in-house print collection', or another painter with access to Meissen's vast archive, paired this knowing duo of prints to create pictorial unity.[18] Meissen's own description of the *bourdaloue* shape, which suggests consideration of the comfort of the user, is perhaps itself a play on the double meaning of the word 'commode'. For the designers and painters at Meissen, the humour and connection of such intimacy with sexuality seems an important part of the design concept.

The suggestive tone seen in the decoration on the outside of the *bourdaloue* continues on the interior with a playful

message in French, 'Aux Plaisirs des Dames', executed in gold, edged in black enamel. The round hole cut through the porcelain in the bottom is perhaps more surprising, and as it is unglazed around the opening was presumably not part of the original design (**Fig. 99**). A possible answer to this puzzle is provided by another example of this shape with the same inscription in a private collection, which includes a mirror mounted in the hole in the base (**Figs 100–1**).[19] In the *bourdaloue*, ostensibly a functional object but here elevated to an expensive status symbol, how might a woman, the presumed user, be expected to view the risqué stories depicted on an object that nonetheless claims to be made for her pleasure rather than her use? In this context, perhaps the addition of a mirror suggests the object was for a woman's own view, and by extension, her pleasure? Yet consider plate 3 of William Hogarth's series *The Rake's Progress*, published in 1735, in which a piece of polished plate is being brought into

the room in the Rose Tavern, Drury Lane, while a 'posture woman' undresses ready to dance on it. The implication, again, is one of performance (**Fig. 102**).

Two paintings of *La Toilette Intime* by Jean-Antoine Watteau and François Boucher show women using *bourdaloues*. Their opulent dress, the details of the interior and the presence of a servant in Watteau's painting point to the status that having a highly decorated porcelain vessel at this date would suggest. They capture at once the grandeur and banality of everyday life. Nicholas Mirzoeff has argued that the Goncourt brothers restored Watteau's reputation as the epitome of all that was enchanting in the 18th century, but their reading, and many subsequent art-historical interpretations of Watteau's paintings, foregrounded, 'both the seductiveness of woman in its various forms and her actual seduction by the *galants* of the court.'[20] By viewing these works as simply erotic, perhaps we have missed the

Figure 101 Detail of the interior of Figure 100 with mirror inset in the base of the *bourdaloue.* **Courtesy Elfriede Langeloh, Weinheim, Germany**

original, often startling and transgressive – even to today's eye – meaning of the works. The *Toilette Intime* paintings, along with Watteau's *The Remedy* (c. 1716–17; Getty Museum, 86.GB.594), appear at a point where luxury, openness and an inherent lack of privacy meet, but present the woman as an actor in an intimate, yet not overtly sexual, moment.

A Meissen *bourdaloue* of an earlier and less elaborate form, *c.* 1729–31, in the Gardiner Museum, Toronto (G83.1.624), also features *commedia dell'arte* characters and tackles similar themes to the Holburne example. Columbine takes cherries offered from a bowl held by a courtier – a symbol of the imminent loss of her virginity – while a bemused Harlequin stands behind her. In a visual joke in another scene, Harlequin offers a *bourdaloue* to a man dressed as a woman, whose breeches are revealed as they lift their skirt to prepare to use it. Inside, in a scene akin to a private parlour painting, on a bed a female nude in a veiled headdress awaits her lover, perhaps the man who peers round a curtain. Since no print source has been identified for these scenes, Meredith Chilton has suggested they might have been inspired by an actual *commedia* performance.[21] Such performances, which flourished at the Saxon court in the early 18th century, were improvised so no scripts survive, but perhaps a *bourdaloue* was used as a prop along with the catchphrase 'Aux Plaisirs des Dames'? Watteau's *Fête Galante* paintings, which explored the psychology of love, usually in a landscape setting, were frequently populated with stock *commedia dell'arte* characters that would no doubt have been recognisable to a contemporary audience, disseminating and popularising their sexual humour.

While no *commedia* characters are obvious in the Watteau-esque scenes on the Bamberg *bourdaloue* (see **Fig. 92**), it

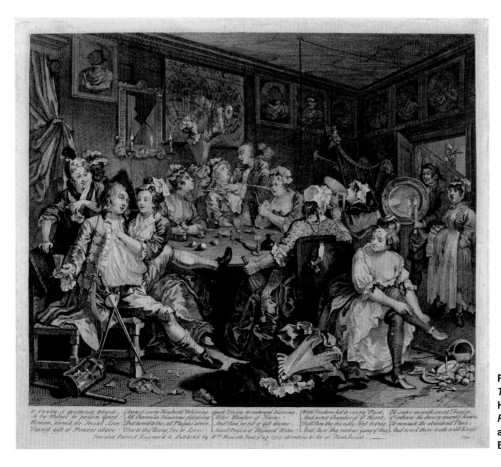

Figure 102 *A Room at the Rose Tavern Drury Lane*, **William Hogarth, 1735, London, from** *The Rake's Progress*, **plate 3, etching and engraving, 35.3 x 40.5cm. British Museum, London, S,2.40**

includes a scene from another licentious fable by Fontaine of the seduction of a young servant girl by her master, in *La Servante Justifiée* (*c.* 1743), after Nicolas Lancret and engraved by Larmessin, and part of the *Suite de Larmessin*.[22] The other *bourdaloue* in a private collection with the same inscription and inset mirror includes *commedia* characters Harlequin and Mezzetin among the amorous figures, both copied from *L'Autonne*, engraved by Nicolas Henri Tardieu (1674–1749) after a painting by Lancret, and published in Paris in 1730.[23] The interior of the Bamberg *bourdaloue* has not been cut out for a mirror, nor is it inscribed; instead it is painted with scattered *indianische Blumen*, Meissen's term for floral motifs inspired by Japanese Kakiemon. A fourth *bourdaloue* (similar to the Gardiner example, but without the thumbpiece), *c.* 1730–5, in the Rijksmuseum, Amsterdam (BK.17439), again includes scenes that refer to the object's function in a comic way, showing figures squatting or using a *bourdaloue*. Each quatrefoil is split into scenes in an unusual combination of Chinese and European figures, punctuated by characters viewed through a window, in a mirror or from behind a curtain. In one scene, a woman examines her face in the mirror, reflecting back on a scene in a garden of a figure crouching as another looks on.

The scenes depicted on these different *bourdaloues* refer to the meeting of private and public life in the 18th century. Ultimately, our reading of the decoration must depend on whom we consider the intended audience: the user, or a viewer. In a private, personal moment are we to imagine that the painted scenes, mirror and message inside the Holburne *bourdaloue* had the frisson of an in-joke with the user, or was this luxurious item designed with the titillation of a male admirer in mind?

Sir William Holburne, an unmarried Victorian gentleman living in a townhouse in Bath with his three sisters, might well have admired the high-quality painting on this Meissen vessel, but he was almost certainly not aware of the true meaning of its tongue-in-cheek decoration or the declaration that it was made 'for the ladies' pleasure', obscured by its gilded liner. Without archival resources to tell us how Sir William came to have this extraordinary object, we can only imagine whether he fully understood its complexity or the unified and specific meanings of its decoration. What we can say is that the dealer or previous owner, whoever they might have been, saw the potential in a damaged porcelain vessel to create an extraordinary confection, whose additions only partially conceal the story of sexual politics that the porcelain reveals.

Acknowledgements

I am grateful to Errol Manners, Dr Julia Weber and John Whitehead for their help in researching the *bourdaloue*. Particular thanks to Patricia Ferguson for the exchange of ideas and for inviting me to submit this article.

Notes

1 The use of the term *bourdaloue* to describe a chamber pot appears in the sixth edition of the *Dictionnaire de Trévoux* (Paris, 1771), 'On a aussi donné ce nom à une sorte de pot-de-chambre' (We also gave this name to a kind of chamber pot). It describes a vessel oblong or oval in shape with a slightly raised lip at one end and a handle at

the other allowing a woman to use it from a squatting or standing position. The name is associated with the Jesuit preacher Louis Bourdaloue (1632–1704), a renowned orator whose sermons were considered so engaging that the nobility even sent servants early in the morning to reserve seats. See Ducret 1953.

2 For another Meissen chamber pot, *c.* 1725–30, later mounted in ormolu to repurpose or disguise a broken handle, see Cassidy-Geiger 2008, cat. 266.

3 Chaffers 1887, 57.

4 A similar *bourdaloue* was in the Alfred Boreel Collection, sold in Amsterdam on 15 August 1908, lot 150, as a 'Nécessaire de toilette. Saxe. Décor de paysages animé de figures, anse à tête riante. Fond forme d'un petit miroir autour du quel est l'inscription: "Aux Plaisirs des dames"' (Necessity of the toilette. Saxony. Landscape scene animated with figures, handle with laughing head. Base forms a small mirror around which is the inscription: 'To the Pleasures of the ladies').

5 The original mention of the *bourdaloue* in Chaffers's 1887 catalogue was annotated at an unknown date in pencil '(19th-century mounts)'. A specialist survey of the collection carried out in 2000 noted that, 'although interesting [the *bourdaloue*] is in such poor condition and the mounts are late 19th century, that it should be removed from display'. The piece remained in store, and during an audit the author discovered the mounts unidentified in another store, their connection to the porcelain lost. A research and conservation project led to the *bourdaloue* going on permanent display in the Holburne Museum in 2016.

6 The dragon motif is described in the 1768 sale catalogue of the collection of Monsieur Louis-Jean Gaignat (1697–1768), a renowned collector, lot 92, 'Deux Vases d'ancienne porcelain-céladon, gauffrée, craquelée montés en buire avec un dragon'. In its wyvern form, it has often been associated with the early 19th-century antiques dealer Edward Holmes Baldock (1777–1845) of Hanway Street, London, but in this case there is no archival evidence to tie the Holburne's mounts to Baldock, and many of his creations were of higher quality than the Holburne dragons.

7 Translation: '1 oval chamber pot, on whose handle a woman's face is placed beside a fine shell, in the shell of which the thumb comes to rest when grasped, and makes it very comfortable to hold the vessel'. I am grateful to Dr Julia Weber of the Meissen archive for sharing these details from Meissen's archives. The description matches the oval form and decorative details of the *bourdaloue*. In surviving complete examples, the woman's face is positioned for a full view of the spectacle and the use of the term 'Frauenzimmer' suggests the woman mask portrayed was of a lower status, such as a lady's servant.

8 Bodinek 2018, fig. 171a.

9 For the print, see British Museum, 1838,0526.2.148.

10 P&D 138,0526.2.148; for a discussion of the publication, see the online entry for 1838,056.1.1.

11 Cassidy-Geiger 1996, 102; Bodinek 2018, 46. In 1741, in addition, the manufactory was given 230 engravings purchased by Johann Christian von Hennicke (1681–1752), which probably included works after Watteau and Nicolas Lancret, see Bodinek 2018, 84–5.

12 Getty Museum, 2017.72.

13 Bryson 1981, 104.

14 An example of the Larmessin engraving is in the National Galleries Scotland, inv. no. P9655. I am grateful to Antony Griffiths for his assistance dating the Jauvelle print.

15 Cassidy-Geiger 1996, 108, 114.

16 Ibid., 124.

17 Bodinek 2018.

18 Cassidy-Geiger 1996, 111.

19 The private collection *bourdaloue* was at one time with the antiques dealer Elfriede Langeloh, Weinheim, Germany. In addition to the Holburne model at least seven other examples of *bourdaloue*s with the inscription 'Aux Plaisir de Dames' or 'Aux Plaisirs des Dames' have been identified: 1) Alfred Boreel Collection, Amsterdam, F. Muller & Co., 15 August 1908, lot 150; 2) Collection Comtesse de Crisenoy de Lyonne, Pecker 1958, fig. 15; 3) Sotheby's, Zurich, 12 December 2001, lot 763; 4) Christie's, Geneva, 14 November 1983, lot 167; 5) Baroness Van Zuylen van Nijevelt, Christie's, 8 June 1956, lot 85; 6) Countess of Portarlington (1886-1975), Sotheby's London, 18 October 1955, lot 74, and Sotheby's, Geneva, 10 May 1988, lot 12; and 7) Guy Ledoux-Lebard (1910–2003), Pecker 1958,

figs 14 and 16, recently with Langeloh. I thank Christian Kirsch of Langeloh for sharing this list of comparable examples.

20 Mirzoeff 1994, 136.

21 Chilton 2002, 175. Chilton has also noted that the factory's blue crossed swords mark is enamelled, a feature of wares produced for the French market, *c.* 1729–31.

22 The other engraved sources on the Bamberg *bourdaloue* include: dancing figures from *La Contredanse*, after Watteau, engraved by Étienne Brion, *c.* 1700, published in 1731 with a seated lute player from Watteau's *Le Passe Temps* (https://www.britishmuseum.org/collection/object/P_1838-0526-2-71), engraved by Audran in 1729, plate 187, and under the lip, a couple in a landscape in puce monochrome are also taken from *La Contredanse* (see Bodinek 2018, figs 394, 398; also P&D 1838,0526.2.71).

23 For the print, see Bodinek 2018, fig. 166.

Chapter 9
Myth and Materiality: Admiral Anson's Chinese Armorial Dinner Service at Shugborough Hall, Staffordshire

Patricia F. Ferguson

Among the most celebrated Chinese armorial services made for the British market is the large 206-piece dinner service with the arms of Anson quartering Carrier, *c.* 1743–7, which survives at Shugborough Hall, Staffordshire (National Trust), the Anson family's ancestral seat (**Fig. 103**).[1] Its fame increased exponentially in the second half of the 20th century thanks to an anecdotal account that lionised a biased colonial encounter in Sino-British relations, between a British naval commander, Admiral George Anson (1697–1762), then Commodore, and grateful European and/or Chinese merchants resident in Canton (Guangzhou) that purportedly resulted in the commissioning or presentation of the service. The authenticity, symbols of empire and control embedded in this mythical narrative and its post-truth politics have been questioned and expanded on elsewhere by Stephen McDowall.[2] The Anson service is equally renowned for its decoration, which accurately copies an etching published in the deluxe edition of Admiral Anson's official or authorised account, *A Voyage Round the World, in the Years MDCCXL, I, II, III, IV* (London 1748). The print captures the paradisiacal landscape on Tinian Island, in the North Pacific, where in 1742 Anson's crew was stranded for several weeks, and features a breadfruit tree and coconut palm, which, among other produce, sustained them during this time (**Fig. 104**). Numerous publications, including those of the National Trust, repeat this presentation myth when referencing the service, and such repetition has led to familiarity and unhesitating acceptance.[3] Consequently, dating the service is political and controversial, but there is a duty to steer the popular belief in the much-published anecdote towards the inconvenient acceptance of the validity of the material evidence gathered here. In analysing the probable circumstances of the commissioning of this important service, this chapter also explores the early history of collecting armorial wares and the process of print production from drawing to publication.[4]

The myth

Since the 1950s, the armorial service, made in Jingdezhen, China, and decorated in Canton in polychrome overglaze *famille-rose* enamels (an opaque palette defined by the presence of pink, introduced around 1723) and gold, has been championed as a gift to Commodore Anson. When a fire broke out in Canton destroying some of the warehouses of the Danish and Swedish East India Companies and threatened to engulf the city, Anson's crew played a part in extinguishing it. In gratitude, the European merchants (though sometimes identified in the 20th-century literature as Chinese merchants) are said to have presented the armorial service to Anson. There was indeed a fire, but the incident took place less than two weeks before Anson's departure for England on 7 December 1743 on the HMS *Centurion* laden with the greatest Spanish prize ever captured at sea by an Englishman, at the time an officially sanctioned form of piracy. While such a large bespoke service could never have been produced in such a short time, in theory it could have been ordered and sent to England the following season when completed, however, there is no evidence to confirm this gift or presentation. In addition, the entire design of the service is

Figure 103 Admiral Anson's armorial service in a cabinet at Shugborough Hall, Staffordshire. Image © National Trust / Sophia Farley

frequently attributed to Sir Peircy Brett (1709–1781), First Lieutenant of the *Centurion*, and not just the 'life-saving' breadfruit tree and the coconut palm, recorded in the etching of Tinian Island after Brett's journal drawings, published in Anson's *Voyage*. Writers have also attributed to Brett the views of 'The Anchorage, Whampoa' and 'Plymouth Sound, Devon' painted in panels around the rim, as well as the romantic vignettes of the so-called 'Valentine' and 'Absent Master' patterns flanking the breadfruit tree. Of the 5,000-plus armorial services made for the English market only a mere handful may be so precisely dated, making the Anson service and its narrative exceedingly important to the study of Chinese export porcelain.

By chance, the *Centurion* was in China on two occasions. The ship was part of a squadron of eight sent to attack Spain's possessions in the Pacific in September 1740 and capture their annual trading vessel laden with tax revenues sailing from Manila to Acapulco, during the War of Jenkins' Ear (1739–48). Only the *Centurion* succeeded and survived. Both layovers were emergency situations when the vessel needed revictualling and refitting. The first, between November 1742 and February 1743, following their recuperation on Tinian, was when Anson forced his way to Canton to meet with Chinese merchants in order to get permission from the Viceroy of Canton for provisioning. During that sojourn Anson is only recorded as having purchased two waistcoats on the account of Thomas Liell (d.1774), an East India Company (EIC) supercargo, who was in charge of selecting the cargo of tea, silk and china, with the *Defence*.[5] The infamous second visit to Canton was

between October and December 1743, when Anson, as Commander of a British warship and having captured the prize of the Spanish galleon *Nuestra Señora de Covadonga*, valued at about £500,000, refused to submit to mercantile trading practices, demanding instead the privileges of a high-ranking emissary of the British Crown.[6] The tense stand-off, which threatened the complex trade relations over a mere two years' worth of custom duties on EIC imports, ended in humiliation for Anson.[7] While Anson was in Canton twice there is no documentary evidence that he purchased Chinese porcelain or any other works of art, although there are a number of items in the collection at Shugborough that date from the period, such as a mug with the so-called 'Absent Master' pattern, *c.* 1740–50 (**Fig. 105**).

The source of the myth that foreign merchants in Canton presented the service to Anson in recognition of his crew's services in extinguishing the fire appears to be an article in *Country Life* by Christopher Hussey (1899–1970), the revered architectural historian, which was published on 11 March 1954.[8] This narrative was repeated without challenge until McDowall's paper was published in 2013. While the fabrication may have been a family anecdote, it is worth surveying earlier literature surrounding the service to find support for Hussey's revelation. At least two other pieces from the Shugborough service are no longer in the collection, and their historiographies offer further insight into understanding how the anecdote developed.

The historiography

On 8 March 1923, a dinner plate from the service was included in the sale of the collection of the genealogist Frederick Arthur Crisp (1851–1922), held by Puttick and Simpson, a London auction house founded in 1794.[9] Of the 350 lots, few record any provenance; however, the following appears at the end of the description of lot 3: 'Anson, quartering Carrier, A plate enamelled with an English pastoral scene, the border with the arms and crest, a griffin's head, and with shipping scenes. On the reverse, an anchor erect, *famille rose*, *Ch'ien-lung* (241)', together with the note 'Admiral Lord Anson voyaged round the world in 1742; created a peer in 1747. The plate probably part of a presentation service'.[10] The number 241 links the plate to Crisp's privately printed catalogue *Armorial China: A Catalogue of Chinese Porcelain with Coats of Arms in the Possession of Frederick Arthur Crisp* (1907), where it appears in alphabetical order on page 1, unillustrated and with no such provenance or history. The plate is next referenced in *Armorial Porcelain of the Eighteenth Century* (1925), by Major Sir Algernon Tudor-Craig (1873–1943), of Century House Galleries, a dealer specialising in Chinese armorial porcelain. It appears on page 30, unillustrated, dated *c.* 1755, with no additional information, apparently not warranting 'its own special claim to notice'. The service was not mentioned in an earlier publication by another genealogist, William Griggs (1832–1911), in his *Illustrations of Armorial China*, London (1887).[11]

Collecting Chinese armorial porcelain was a relatively new field; Joseph Marryat (1790–1876), in *A History of Pottery and Porcelain: Medieval and Modern* (1868), one of the most comprehensive early survey of ceramics, makes no reference to the subject. Instead, Sir Augustus Wollaston Franks

Figure 104 Plate with the arms of Anson quartering Carrier of Wirksworth, *c.* 1743–7, Jingdezhen, China, porcelain, polychrome enamels and gilding, diam. 22.9cm. Shugborough Hall, Staffordshire. Image © National Trust / Robert Morris

(1826–1897), antiquarian and Keeper of the Department of Antiquities at the British Museum, should be credited with having contributed greatly to its serious study.[12] A few examples were noted in his *Catalogue of a Collection of Oriental Porcelain and Pottery Lent for Exhibition* (London, 1878), held at Bethnal Green, a branch of the then South Kensington Museum, now Victoria and Albert Museum; they were listed under porcelain with foreign designs, which included Chinese porcelain misidentified as being painted in Lowestoft in Suffolk.[13] Franks acquired armorial ceramics alongside rare signed and dated documentary specimens of European pottery and porcelain, which now form the core of the important ceramics collection at the British Museum. Armorial ceramics complemented his interest in armorial bookplates and bookbindings commissioned by noble British families.[14] While almost nothing is known about where he acquired his ceramic items, it is interesting that he 'seems to have given a standing order to several booksellers to send him any books or odd volumes, of which the chief value lay in the stamped arms, and which they were willing to sell for a small sum, and to have taken his chance'.[15] Franks may have had a similar arrangement with antiques dealers or the owners of 'Crockery shops', who knew of his interest in documentary ceramics, including armorials, which provide valuable information in establishing chronological stylistic developments.

Among the 350 Chinese armorial porcelain specimens in the British Museum acquired by Franks is a soup plate from the Anson service, which, according to the Register of

Acquisitions for the Department of British and Medieval Antiquities (Vol. 7), was 'presented by the Earl of Lichfield' to the British Museum on 16 June 1892 (**Fig. 106**).[16] This must have been Thomas Francis Anson, 3rd Earl of Lichfield (3rd creation) (1856–1918), of Shugborough,

Figure 105 Mug with the 'Absent Master' pattern, *c.* 1740–50, Jingdezhen, China, porcelain, painted in enamels and gilding, h. 11.8cm. Shugborough Hall, Staffordshire. Image © National Trust / Sophia Farley

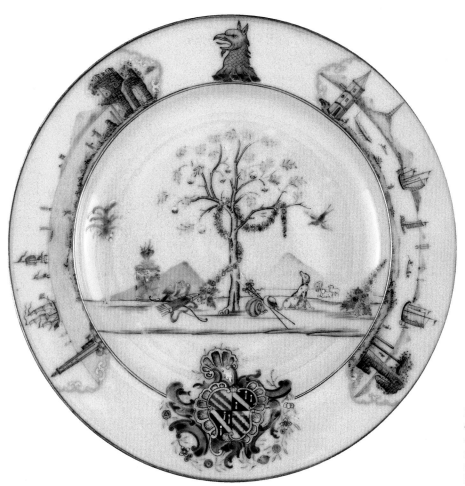

Figure 106 Plate with the arms of Anson quartering Carrier of Wirksworth, *c.* 1743–7, Jingdezhen, China, porcelain, polychrome enamels and gilding, diam. 22.9cm. British Museum, London, Franks.831.+

Staffordshire, who succeeded to the title on the death of his father, Thomas George Anson, 2nd Earl of Lichfield (1825–1892) on 7 January 1892, descendants of Admiral Anson through his sister Janette (1690–1771). A small paper label on the back of the British Museum soup plate is inscribed in ink, 'Lord Anson was in Canton in 1743. Vide his Voyages IV. Baron 1747'; the paper is torn and may have lost some of the original message (**Fig. 107**). The label is in the hand of the 3rd Earl, who was an antiquarian with an interest in ceramics and served as the unofficial family historian; there

Figure 107 Underside of the plate in Figure 106 with the anchor device and a paper label. British Museum, London, Franks.831.+

are other objects at Shugborough with similar notes. Inscribed paper labels are frequently found on items in historic collections, notably from the 19th century; it was a simple system of recording information for posterity. Few country-house collections documented these histories systematically in journals or ledgers as was the practice with the professionalisation of museums.

At the time of the gift to the Museum, a lengthier catalogue description was entered in the Register of Acquisitions, based on notes created by Franks recorded on both sides of a card in the British Museum Archives, also dated 16 June 1892:

1/2]

'Plate: porcelain painted in enamel colours with

gilding: in the centre a conventional landscape

with pastoral emblems: below on the side &

rim is the shield of arms of ^Admiral Lord^ Anson ^without coronet or supporters^, surrounded

by rococo ornament ^in which a patch of ermine^: in the rim, Lord Anson's crest

& two panels containing a view of a ~~harbour~~ ^river mouth (probably Canton)^ with

shipping: brown edges gilt: on the back is an

anchor and cable.~1743–47~

D. 9" [inches] Given by the Earl of Lichfield, 1892

^George^ ~~Lord~~ Anson was in Canton in 1743 and was created a

Figure 108 'A View of the Watering Place at Tenian', Joseph Wood, after Sir Peircy Brett, London, 1745, etching, 22.2 x 44.5cm, published in Anson's *A Voyage Round the World* (1748). British Museum, London, 1918,0423.56

Baron in 1747. With the design of cf 763+, 765+, 824+

& 833+

1 & 4 Anson 2 & 3 Carrier

2/2

The Bread-fruit tree & palm in the central design

~~The tree in the central design is the Bread-fruit tree~~

are evidently

~~is apparently~~ taken from a drawing ~~which is~~

~~engraved in the book of Lord Anson's Voyages~~

of the "Watering Place at Tenian" where ~~Lord~~ Anson

landed in 1742, afterwards published in

~~an engraved plate~~ a copper plate engraving in

Anson's Voyage round the World, Plate XXXI'.[17]

Franks had evidently followed up on the 3rd Earl's 'Vide his Voyages' clue and proposed the depiction of the breadfruit tree and palm was based on a drawing after 'A View of the Watering Place at Tenian', which appeared as a copperplate etching, plate XXXIV, in Anson's, *A Voyage Round the World*, published in London in 1748 under the name of Richard Walter (1716–1785), chaplain of the *Centurion* (**Fig. 108**). From his research in heraldry, Franks surmised that the design source predated Anson's creation as a baronet, and presumed it was a drawing associated with the print that was sent to China. Significantly, there is no mention in the entry of the presentation of the service by the merchants of Canton, which the 3rd Earl, an antiquarian, would presumably have shared with Franks.

While the 3rd Earl was clearly aware of the print source, the Anson family had recognised and acknowledged the importance of the breadfruit tree even earlier. McDowall has identified a note sent to the 3rd Earl dated 1859 and written by Lady Forester, probably Mary Anne Jervis (*c.* 1803–1893), wife of George Weld-Forester, 3rd Baron Forester (1807–1886) of Willey Park, Shropshire. In it she states that her grandmother, perhaps Mary Ricketts, née Jervis (1737–1828), of Meaford Hall, Staffordshire, sister of

the Admiral of the Fleet, John Jervis, 1st Earl of St Vincent (1735–1823), had seen the service at Shugborough.[18] She recalled that Admiral Anson 'on his departure from the island brought away with him a sprig of this shrub, & had a beautiful service of porcelain with sprig and berry painted on it'. If not heard first hand from the Admiral himself, Mary Ricketts may have learnt of the service's history from his elder, bachelor brother Thomas Anson (1695–1773), who lived at Shugborough with two of their sisters. The letter does not record the remarkable story of its presentation by the grateful merchants of Canton and by Lady Forester's grandmother's account it suggests he ordered it himself.

The print source

In the absence of any documentary evidence establishing that the presentation story is authentic, it is worth examining closely the material evidence, in particular the print source from *Voyage Round the World* depicting the breadfruit and palm used for part of the decoration. The edition was not officially published until May 1748, which presents a problem, as on 11 June 1747 Admiral Anson was created 1st Baron Anson of Soberton, Southampton (Hampshire), for his victory at the Battle of Cape Finisterre. His arms were redesigned to include a baron's coronet and a sea lion, also illustrated in his *Voyage*, and a seahorse as supporters. These new arms were added to elements of his silver service as well as some carved amethyst seals still at Shugborough.[19] His arms changed again after his marriage on 25 April 1748, to Lady Elizabeth Yorke (1725–1760), daughter of Philip Yorke, 1st Earl of Hardwicke (1690–1764). The order, if commissioned by Admiral Anson, must have been placed before 1747, otherwise it should have had different arms.

Typically, a bespoke order included a drawing of the coat of arms, which was hand-coloured or had inscribed notes indicating the colours, although by this date an engraved bookplate was often supplied. The orders were generally placed with an EIC agent, possibly with a more senior role such as a supercargo, who may have had considerable liberty in the choice of pattern, choosing from the latest designs in a Canton merchant's shop. Anson's coat of arms included as a crest a griffin's head erased and the arms were of Anson

Figure 109 'A View of the Entrance of the Port of Acapulco', and below 'The Papps Bearing No(rth) Dist(ance) 7 Leagues', Sir Peircy Brett, c. 1742–45, paper, grey wash, 34.2 x 50cm. National Maritime Museum, Greenwich, London, PAJ0779. Photo © National Maritime Museum, Greenwich, London

Figure 110 'A View of the Entrance of the Port of Acapulco', after Sir Peircy Brett, 1745–6, London, etching, 22.2 x 51.3cm, published in *A Voyage Round the World* (1748), plate XXXII. British Museum, London, PPA409794

quartering Carrier of Wirksworth, Derbyshire, his mother's arms, which he was entitled to use alongside his older brother, Thomas. Presuming that Anson had had the money to place the order while in Canton in 1743, or even 1742, it would have been completed by the following season and could have been delivered later as private trade on an EIC East Indiamen, subject to the usual custom duty.[20] No such order was recorded in the candid unpublished report, 'Secret History of Affairs at Canton in the Year 1743', written by Edward Page (act. 1722–1766), the EIC's chief supercargo during the 1743 season.[21]

As noted by Franks, the breadfruit tree and palm in the centre of the service were based directly or indirectly on a drawing by Sir Piercy Brett. The remarkable breadfruit tree, laden with edible, but tasteless, potato-like fruit with a scent of fresh bread when cut, is a member of the fig family and one of the highest-yielding trees. The scene represents an episode in the lengthy voyage of the *Centurion*, when Anson's crew, suffering from scurvy, received sustenance not only from the breadfruit and coconuts, but also from the rich local produce and animals found on Tinian Island, a Spanish possession in the Pacific. The tree evidently fascinated Anson, who as a naval officer was trained in the

importance of collecting and recording exotic plants, especially those with potential commercial use. It is no surprise that he may have taken cuttings to later propagate as economic crops in Britain, perhaps on his family's estate, or store in a herbaria.

All of the 42 etchings in the publication were apparently after journal drawings by Brett, made as accurate geographical reports recording their route and containing important topographic intelligence, which would have been kept alongside Anson's logbook with his nautical charts. Several drawings attributed to Brett in ink and grey wash associated with plates in the deluxe 1748 publication, prepared either while at sea or upon his return, survive at the National Maritime Museum (NMM), at Greenwich (**Fig. 109**).[22] The eight sheets (some containing two drawings) were presented to the National Maritime Museum by the noted ethnographic collector Captain Alfred Walter Francis Fuller (1882–1961) on his death.[23] The finished drawings have ruled lines, titles, texts and reference keys for a copperplate engraver to follow, suggesting they were executed by him after his return to England or by a professional draughtsman in London. In comparing one of the drawings of the port of Acapulco with the etching, it is

apparent how the engraver has enhanced the image, adding vessels and altering the clouds (**Fig. 110**). 'A View of the Watering Place at Tenian' is among the originals missing from the group of eight drawings.

The publication of *Voyage* was delayed because of legal disputes over the distribution of the prize, which was only resolved in May 1747. The generously illustrated publication, still costly despite its subscribers, was on hold until Anson had received his three-eighths share of the prize, about £91,000, the equivalent in today's figures of £13,125,000.[24] Anson used some of the money to build up one of England's grandest silver services made by Paul de Lamerie (1688–1751), much of it engraved with his new arms, he purchased a house on St James's Square, and improvements were made to the ancestral estate, including a Chinese House in the garden.[25] De Lamerie was also patronised by Anson's political mentor and future father-in-law, Philip Yorke, 1st Earl of Hardwicke, then Lord Chancellor.

In fact, the engravings that appeared in *Voyage* had actually been completed several years before the publication date according to the accounts of the engraver Arthur Pond (1701–1758), hired to turn Brett's drawings into copperplates, which are now in the British Library. On 6 December 1745, Pond noted payment to 'Mr Wood', probably the engraver Joseph Wood (1720–1763/4), for completing a large 'View of Tenian, 4.8.6' on a copper plate.[26] Consequently, engraved prints of this image were available by December 1745, when the drawing was no longer required by the engraver; either an engraving or the drawing could have been sent to Canton. Of course, if the NMM drawings are copies of Brett's original artwork prepared for the engraver, then Brett's sketches would have been available to send earlier in 1745. However, in the absence of the original drawings, and having observed how the engraver alters details in the drawings, the artists in Canton were most probably supplied with the engraving.

The Chinese porcelain version includes only the breadfruit, entwined with a European-style floral garland, and the palm, flanked by two distinctive French vignettes in the centre.[27] On the left are generic symbols of courtship represented by billing doves perched on Cupid's bow and arrows, laid down in submission, while two burning hearts are offered up on an altar to love. This popular pattern, which sometimes includes a draped sailcloth, is known as the 'Valentine' pattern because of its sentimental subjects; it was later copied on Worcester porcelain, *c.* 1756–8.[28] On the right is the 'Absent Master' pattern, with the attributes of a shepherd: his hat, a *musette de cours* (bellows or bagpipe), two beribboned *houlettes* (crooks with metal tips), sheep and two pining hounds awaiting their master's return. On other porcelain objects found elsewhere, the 'Absent Master' pattern is centred on a solitary pine tree, where the absent shepherd once sat playing his pipes, as on a Chinese mug at Shugborough (**Fig. 105**).[29]

Similar vignettes within more ornate frames were painted as border panels on other Chinese export services, *c.* 1742–6, as on a dinner plate in the Victoria and Albert Museum, in combination with a third panel with two pairs of ducks, representing matrimonial discord and harmony (**Fig. 111**). Significantly, more finely painted examples of both vignettes in border panels feature on the rim of a service with the arms of Lady Anson's brother, Philip Yorke, 2nd Earl of Hardwicke (1720–1790) and his wife Lady Jemima Campbell, 2nd Marchioness Grey (1723–1797), who married in 1740; their service may have inspired the design of Anson's, who may already have been under the influence of his future wife, who also enjoyed drawing.[30] The amorous subject of these vignettes would have had an obvious appeal to naval officers separated from their loved ones and examples are often found on teawares and drinking vessels acquired in China as gifts or mementos. The European sources for these three images have not been identified; they may perhaps have been printed on fans or other ephemeral items (**Fig. 112**). While Brett, who was a friend of the family, has been identified as having supplied the drawings for the Chinese House, built *c.* 1747, there is no evidence that he invented the stock 'Valentine' or 'Absent Master' patterns.[31]

Of the other elements of the designs frequently attributed to Brett, the two waterscapes painted on the rims of the Shugborough service, within simple Chinese-style cartouches, are not included among the 42 plates illustrating Anson's *Voyage*. The left side is interpreted as a view of Plymouth Sound, Devon, an EIC harbour, also used by the Royal Navy. At one end is John Rudyard's (1650–*c.* 1718) Eddystone lighthouse (1709–55) and at the other a ruin, separated by ships flying the British flag. The Chinese export trade authority David S. Howard (1928–2005) identified the ruin as a derelict block house overlooking the Mount Edgcumbe estate; however, it may be the sham folly, still on the estate, built *c.* 1737–47, by Richard Edgcumbe, 1st Baron Edgcumbe (1680–1758), reusing stones from local churches.[32] It was unlikely to have been an admired topographical feature when Anson sailed from Portsmouth in 1740. The right side depicts a view of the anchorage on the Pearl River at Whampoa (Huangpu), with a tower on Bogue Fort, the Pazhou, and another pagoda, sampans, junks and a ruin. These scenes exist on other armorial services, as on a service for the Jacobite John Arbuthnott, 5th Viscount of Arbuthnott (1692–1756), of Kincardineshire, Scotland, *c.* 1745–6.[33]

Among the plates and dishes from the Anson service still at Shugborough, there is an unusual plate with the same crest and coat of arms, but instead of the breadfruit tree and palm in the centre, there is a garland-wrapped pine tree typical of the stock 'Absent Master' pattern identified above, and a smaller pine tree for balance (**Fig. 113**).[34] On the rim are two stylised hibiscus and peony sprays in gold outlined in iron-red enamel, motifs found on other armorial services, *c.* 1742–6. While perhaps produced in error or for an unrealised second service, it may have been an early sample plate, rejected when the design was altered to include Brett's breadfruit tree and palm along with views of 'The Anchorage, Whampoa' and 'Plymouth Sound, Devon'.

Anson's EIC agent in Canton placing the order on his behalf may have revised the order having seen other service patterns already in production during the short season when they commissioned goods, such as the Murray family service, *c.* 1745–6. The central design of the Murray service is identical to the sample plate, combining the 'Valentine' and 'Absent Master' patterns and garlanded pine tree, as

Figure 111 Plate with border panels including the 'Valentine' and 'Absent Master' patterns, c. 1745, Jingdezhen, China, porcelain with polychrome enamels and gilding, diam. 22.9cm. Victoria and Albert Museum, London, V&A: C.1418–1910. Photo © Victoria and Albert Museum, London

well as two elongated waterscapes that appear on the rim of the Anson service, 'The Anchorage, Whampoa' and 'Plymouth Sound, Devon'.[35] Interestingly, four other services recorded with the breadfruit pattern all have the same gold sprays found on the rejected sample plate.[36]

Finally, each piece in the Anson service is painted on the underside with an 'anchor erect, entwined with a cable [rope] proper', a discrete feature added at considerable expense. Historically, this familiar nautical motif of an anchor entangled in rope was known as a 'foul' or 'fouled' anchor and indicated a dire situation (**Fig. 107**). However, from 1725 it was also the official emblem of the Lords Commissioners of the Admiralty, as depicted on a silver badge worn by the oarsman of the Admiralty barge, as on an example made by William Lukin (act. 1699–c.1755) in London, 1736–7.[37] The

use of the emblem was limited to senior naval officers. Anson was not appointed to the Admiralty Board until 27 December 1744, six months after his return to London. While not definitive in and of itself, it again suggests the service was ordered after 1744, perhaps conceived to furnish his new apartments at the Admiralty in Whitehall.[38]

The Anson service would have been one of several armorial services produced during a specific season in Canton. Fashions changed every few years with new designs and motifs provided by foreigners and adapted by the Chinese craftsmen. These exclusive patterns were quickly pirated, often with some variation. Howard has observed that the Anson service was part of a group that 'differs greatly from anything which had gone before', referring in particular to the European landscape panels inspired by

Figure 112 Unmounted fan-leaf with an altar to love, a shepherd and shepherdess, c. 1780, France, etching, hand-coloured, 11.3 x 36.7cm. British Museum, London, 1891,0713.637

Figure 113 Plate with variant pattern and the arms of Anson quartering Carrier of Wirksworth, c. 1743–7, Jingdezhen, China, porcelain, polychrome enamels and gilding, diam. 22.5cm. Shugborough Hall, Staffordshire. Image © National Trust / Robert Morris

tablewares produced at the Meissen porcelain factory in the 1730s.[39] The majority of services from this group seem to have Scottish provenances and only one has a tenuous personal link with Anson: the group were possibly commissioned before the Battle of Culloden in April 1746, when success was in their sight.[40] The group emphasises the international character of the Canton trade and explains how French and German designs were frequently synthesised by Chinese artists to create new design motifs for a global audience.

Conclusion

The order was presumably placed by Anson after he returned to England, and probably between December 1745 and June 1747. Two of his nephews, sons of his sister Janette and her husband Sambrooke Adams (d. 1734), were EIC supercargoes, Anson Sambrooke Adams (1727–1746) and George Adams (1731–1789); a third, William Adams (1729–1748), was with the Royal Navy.[41] Contracts with supercargoes were signed almost a year before their departure, allowing time to organise their private trade, where enormous personal profits could potentially be made. In March 1746 Anson Sambrooke Adams was to be a supercargo on the *Sandwich* bound for Canton, under chief supercargo Thomas Liell and Captain John Petre (d.1750); however, Adams died at Portsmouth just before its departure.[42] The ship's Daily Journal records that the *Sandwich* arrived in Whampoa on 16 October 1746, departed on 19 February 1747 and arrived in England on 21 October 1747. While most of the private trade was under the care of

Petre and Liell, the Journal does record '1 box Admir Anson'.[43] The box may have contained the sample plate, with the full service returned to England the following year on another EIC vessel.[44] The armorial service is not identifiable in any 18th-century inventories associated with the Ansons at Shugborough, but the Admiral also had a London townhouse or Moor Park, Hertfordshire, his country seat. On the Admiral's death in 1762, the service was inherited by his brother Thomas Anson and there is no evidence of where or how it was stored or displayed until the 20th century. Fortunately, it escaped a forced auction in 1842 resulting from the extravagances of Thomas William Anson, 1st Earl of Lichfield (1795–1854), and along with other heirlooms of the *Centurion* has been displayed in a glazed cabinet in the Billiard Room since at least 1918 (**Fig. 103**).[45]

Given the paucity of public monuments raised in his honour during his lifetime, this service survives as a tribute to Admiral Anson's extraordinary tenacity during his lengthy circumnavigation of the globe, which on the one hand almost cost the EIC its lucrative monopoly, but on the other transformed him into a national hero following his successful capture of the Spanish galleon. His subsequent administrative reforms professionalised the Royal Navy and paved the way for Britain's victories during the Seven Years' War (1756–63). In revising the mythical narrative, the importance of the service in the history of Chinese export porcelain production is unchanged, as it remains one of the few narrowly datable armorial services for the English market, albeit just a few years later, based on the production date for at least one of its print sources.

Notes

1 National Trust Collections website, NT1271545, http://www. nationaltrustcollections.org.uk/object/1270529 [accessed 26 October 2020]

2 McDowall 2013, 1–17.

3 Jackson-Stops 1985, cat. 377.

4 For a shorter version, see Ferguson 2016, 76–7.

5 National Maritime Museum (NMM), Greenwich, UPC/2/f.39.

6 Williams 1999, 246.

7 Markley 2009, 229.

8 Hussey 1954, 592–3, where it was dated *c.* 1745.

9 Typical of early Chinese armorial porcelain collectors, Crisp also collected armorial bookbindings.

10 One of the provenances frequently listed was 'J.J. Howard Collection', presumably the genealogist Joseph Jackson Howard (1827–1902), Maltravers Herald of Arms Extraordinary, 1887–1902, an early collector of Chinese armorial porcelain and bookplates. Howard had been the co-author with Crisp of the 21-volume *Visitations of England and Wales* (1893), recording the lineage of various families undertaken by officers of arms (or Heralds) between 1530 and 1688.

11 A plate from the Child family's dinner service, lent by the Earl of Jersey of Osterley Park, was illustrated, along with many examples from the collection of Sir Augustus Wollaston Franks. For the Child service, see Ferguson 2016, 60–1.

12 Harrison-Hall 1997.

13 Among the few recorded provenances is the early collector, the Reverend Charles Walker (d. 1887) of Brighton, a liturgist and author.

14 Dawson 1997.

15 Pollard 1970, 243.

16 British Museum, 1892,0616.1; Krahl and Harrison-Hall 1994, 100. This was not unique; a few other examples were given by descendants of the original commissioning families: Grantley (1891,1012.1), Macclesfield (1894,0725.1) and Stuart (1888,0201.1). The last has an old paper label recording the provenance.

17 I thank Francesca Hillier, British Museum Archivist, for this information.

18 The note has not been identified, but is recorded in a letter sent to the 3rd Earl dated 1912, among the Anson Papers, SRO, D615/ P(S)/1/4/56, cited in McDowall 2013, 7. Mary Ricketts' father, Swynfen Jervis (1701–1771), was a subscriber to the deluxe edition of *Voyage*.

19 For the seals, see NT 1271468.1 and 1271468.2.

20 Howard 1974, 46.

21 British Library, India Office Records (IOR), RP4323.

22 NMM, Greenwich, PAJ0775–PAJ0780.

23 NMM, Greenwich, PAJ1971-2.

24 https://www.nationaltrust.org.uk/shugborough-estate/features/ george-anson

25 Williams 1999, 216–18; and Hartop 1994.

26 British Library, Add Ms 23,724, f. 121.

27 Howard and Ayers, 1978, vol. 1, 206.

28 Spero and Sandon 1996, 147, cat. 136.

29 NT 1270529.

30 See also a plate in the Victoria and Albert Museum (C.1418–1910), with the arms of John Drummond (1723–1774) impaling Charlotte Beauclerk (1726–1793), who married in December 1744, *c.* 1745–6, in Howard 1974, 319 and 320; and see the text for her portrait, where she holds one of her drawings, NT 1271067.

31 A travel record of 1782 by Thomas Pennant (1726–1798) noted the Chinese House 'is a true pattern of the architecture of that nation, taken in the country by the skilful pencil of Sir Percy [*sic*] Brett: not a mongrel invention of British carpenters', see Pennant 1782, 67–9.

32 Howard 1974, 46–8.

33 Ibid., 327. Lord Arbuthnott was executor of his wife's father's estate and sold her family barony at Prestongrange and Dolphinston in May 1745, see Baker 2000, 22–4.

34 NT 1271545.1.18.

35 Howard 2003, 207.

36 For example, the services with the arms of Watson, Stirling and Stewart in Howard 1974, 321–2; and MacPherson in Howard 2003, 204.

37 Victoria and Albert Museum, 8879–1863.

38 I thank Jenny Wraight, Admiralty Librarian, Royal Navy, and Dr. Nicholas A.M. Rodger, historian of the Royal Navy, for their assistance.

39 Howard 1974, 46–8.

40 A service sharing many features may have been made for Vice Admiral Charles Watson (1714–1757), who fought with Anson at Cape Finisterre; in 1741 he had married Rebecca Buller (1718–1800), co-heiress of Combe Martin, although her arms are not included on the service, see Howard 1974, 321; and footnote 36.

41 British Library, IOR, RP 4324, 65, 'The Company had obliged Lrd Anson in sending out his Nephew, Mr Adams, and after his death a Brother of his, a supercargo to China in their service'.

42 British Library, IOR/E/3/109, f. 201 and f. 401.

43 British Library, IOR/MAR/B/606A.

44 George Adams, who inherited the Shugborough estate in 1773, went out on the *Sandwich* on 21 December 1748 to Canton and returned 8 July 1750, British Library, IOR/E/3/110 ff. 100v-03.

45 Staffordshire Record Office, Stoke, Staffordshire, Anson Papers, D.615/E(H)/16.

Chapter 10
From *stampa* and *riporto* to *giochi di bambini*: Transfer Printing and Iconographic Sources at Carlo Ginori's Porcelain Manufactory at Doccia

Alessandro Biancalana

Iconographic sources derived from engravings and drawings were fundamental for porcelain manufacturers, revealing their cultural aspirations and ambitions: even the Ginori Porcelain Manufactory, at Doccia, in Sesto Fiorentino, near Florence, was not exempt. Vezzi's Venetian factory (1720–7), the first hard-paste porcelain factory in Italy, although short-lived, employed print sources that Doccia, the most long-standing and commercially successful Italian hard-paste porcelain factory, also employed, and both continued the tradition developed in Renaissance maiolica (tin-glazed earthenware) (see Thornton, Chapter 4 and Sani, Chapter 5). When the Doccia manufactory was founded in July 1737 by the skilled entrepreneur Marchese Carlo Ginori (1702–1757), it produced only maiolica; about two years later, however, it began to produce porcelain as proven by documents recording payments for *provvisionanti alla porcellana* ('providers or suppliers of porcelain materials').[1] Print sources were at the forefront of its decorative designs, and this chapter considers a fraction of these; that is, those associated with Ginori's experimental transfer printing on porcelain, executed under the glaze in cobalt blue between 1748/9 and 1752/3, as well as the importance of print culture at the manufactory, and the potential impact on Florentine culture and the city's economic growth.

Print culture and the acquisition of iconographic sources

Carlo Ginori, an expert chemist, was in fact the factory's arcanist who knew the secret process of porcelain manufacture, the arcanum, and developed its pastes, enamels and enamel colours. He called on the Viennese Johann Georg Deledori (or Giorgio delle Torri) (act. at Doccia 1737–43) to build the kilns and then to direct them, as Deledori was familiar with the porcelain works founded in Vienna by Claudius Innocentius du Paquier (d. 1751) in 1718; there is, however, no secure evidence that Deledori had been employed at the Vienna factory.[2] Others who assisted included: a young farmer from Doccia, Jacopo Fanciullacci (1705–1793), who, upon the death of the Marchese Carlo, became the arcanist of the factory; the artist Carl Wendelin Anreiter (1702–1747), who, having previously worked at Du Paquier, was the head painter from 1737 until his departure in 1746; and the sculptor Gaspero Bruschi (1710–1780), who was head of the sculptors and turners (*lavoranti alla ruota*).[3] Bruschi not only managed the warehouse and their retail shops selling maiolica and porcelain, but was also responsible for the prints and drawings used by the painters, making acquisitions as well as caring for their preservation.[4] Bruschi's role is documented in the manufactory's papers in the Archivio Ginori-Lisci, Florence:

> It will be his principal duty to keep accurate storage of all those forms and models, drawings and anything else that exists in the factory. . . . Since designs are the soul of the factory . . . He will also review in particular the painters of porcelain, maiolica and the printers, so that they may develop aesthetic skills, always showing them the best originals so that they can imitate them, and therefore always improve their work.[5]

Gaspero Bruschi was the manufactory's artistic director in all but name.

As inspiration, Doccia painters relied on prints of well-known works, but also on drawings; payments for drawings

of various kinds are recorded in the cash registers. Although today nothing survives, the head of the painters Anreiter, or less probably Bruschi himself, may have provided their own drawings to serve as design sources for the Doccia painters to copy, just as Johann Gregorius Höroldt (1696–1775) did for painters at Meissen. New illustrated books, prints and drawings were constantly sourced during Carlo Ginori's period and that of his successors, his son Lorenzo (1734–1791) and his nephew Carlo Leopoldo Ginori-Lisci (1788–1837). They commissioned work from artists, made purchases from Florentine booksellers and also received items as gifts. In May 1742 Carlo Ginori commissioned from the painter Giuseppe Romei (1714–1785), who at that time was working in Doccia, 'un libretto di stampe per disegnare a d.a Fabbrica' ('a booklet of prints for drawing at the factory'), and later, on 20 February 1748, Romei was paid 'per pittura di diversi disegni di maschere' ('for painting various drawings of masks').[6] On 16 October 1744 the Florentine printer and merchant Giuseppe Allegrini (act. 1744–1778) received a fee 'in conto della tiratura di diversi Rami per prove per la Fabbrica delle Porcellane' ('on account for printing several copperplates as tests for the porcelain factory').[7] In May 1745 there was a payment to 'Filippo Morghen per disegni'.[8] As a youth, between 1742 and 1744 Filippo Morghen (1730–1807) worked at the Doccia factory as a painter of *chicchere* (tea bowls or beakers); he later became a renowned engraver.[9] There are also several payments to the engraver (*stampatore*) Giuseppe Allegrini, as on 12 January 1746, 'per aver tirato diverse stampe, Cartelle grandi e piccole' ('for having printed several prints, large and small folios'); on 21 December 1748 'per un conto di diverse prove e Tirature di Rami di diversi Colori' ('for an account of various proofs and copperplate prints of different colours'); and for expenses 'per tirar Rami' ('to pull from copperplates'), which continued throughout 1750 and 1751.[10] On 17 August 1749 they purchased from Pietro Tomasello (n.d.) 'N. 65 stampe mezzo foglio grotteschi, e n. 31 dette paesi diversi per detta Fabbrica' ('65 half-sheets engraved with grotesques, and 31 different landscapes for said factory').[11]

The following year the esteem for iconographic sources and their importance to the factory became more evident when payment was made to the *Libraro* ('bookseller') Giovanni Francesco Fabbri (n.d.), 'per 6 giornate impiegate a Doccia a Legare diverse Stampe per servizio della Pittoria' ('for 6 days working at Doccia binding different prints for the painting department'). Again, in 1754, an employee Antonio Ristori (act. 1747–1753) was paid 'per la legatura di diversi Tomi di stampe in Rame' ('for the binding and expenses of various volumes of copperplate prints').[12] Two lists of the books once kept in the factory are retained among the manufactory's archival documents. Some of these bound prints and publications are today identifiable in the library of the Museo Richard-Ginori of the Manifattura di Doccia, now in storage in the Archivio di Stato di Firenze. The older list is neither particularly detailed nor precise: one entry notes, for example, '6° Libro di scherzi di putti e varj ornamenti' ('6th book of trifles of putti and various ornaments').[13] This perhaps describes pattern plates from *Disegni Diversi Joan Giardini inv: et delin. Maxi. Joseph Limpach*

pragensis sculp. Romae (Prague, 1714), with engravings by Joseph Maximilian Limpach (act. 1700–1730), after Giovanni Giardini (1646–1721); a copy is in the library of the Richard-Ginori Museum of the Manifattura di Doccia.[14] Such publications subsequently formed an important nucleus as partially documented in the second list, which although undated, is probably post-1779 as it lists 'Mattei Museum Tom. 3', presumably a reference to the three-volume study of antiquities by Ridolfino Venuti (1705–1763) and Giovanni Cristofano Amaduzzi (1740–1792), *Vetera Monumenta Quae In Hortis Caelimontanis Et In Aedibus Matthaeiorum Adservantur* (Rome, 1776–9).[15]

It is not always easy to recognise the volumes in the second and longer list by their abbreviated titles, especially if no similar texts are in the museum's library. The following are among those that are identifiable: 'Museo Odescalchi Tom. 2', probably the study of engraved gems or glyptic art by Pietro Santi Bartoli (1635–1700) and Niccolò Galeotti (1692–1758), *Museum Odescalchum, sive, Thesaurus Antiquarum Gemmarum cum Imaginibus in Iisdem Insculptis, et in Iisdem Exculptis*, 2 vols (Rome, 1751–2); and 'Museo del Gori Tom. 3', presumably the publication on ancient inscriptions found in Etruria by Antonio Francesco Gori (1691–1757), *Museum Etruscum exhibens insignia veterum Etruscorum monumenta*, 3 vols (Florence, 1736–47). The entry 'Tutte le Opere di Calcografia Camerale' no doubt refers to the publications of the leading Roman workshop for printing and engraving founded in 1738 by Pope Clement XII (1652–1740), who was the great-uncle of Elisabetta Corsini (1709–1775), the wife of Carlo Ginori. In addition, 'Monumenti di Roma Barbu' is probably the volume with 128 views of Rome's monuments and antique sculpture by the French artist and engraver Jean Barbault (1718–1762), *Les plus beaux monuments de Rome ancienne, ou recueil des plus beaux morceaux de l'antiquité romaine qui existent encore, gravés en 128 planches avec leur explication* (Rome, 1761); and 'Figure di Moufocon Tom. 2' is presumably the influential work by the French antiquarian Bernard de Montfaucon (1655–1741), *L'antiquité expliquée et représentée en figures* (Paris, 1719–24), in 15 volumes.

Interest in the antique continues with a reference to 'Vasi Etruschi Tom.3', doubtless Pierre-François Hugues d'Hancarville (1719–1805), *Antiquites etrusques, grecques, et romaines tirees du Cabinet de M. Hamilton* (Rome, 1766); in March 1771 d'Hancarville gave the Marchese Lorenzo Ginori 'i due primi consaputi tomi de Vasi Etruschi' ('the first two volumes of Etruscan vases known to us') with the promise 'di consegnarle il 3° Tomo subito che venga alla luce' (to deliver the third volume immediately it comes to light).[16] King Ferdinand IV of Naples (1751–1825) donated to Lorenzo Ginori three of the first five volumes of the eight-volume *Le Pitture antiche d'Ercolano e contorni* (Naples, 1757–92), the official publication of the excavations at Herculaneum.[17] These publications would later be integrated with others acquired by Carlo Leopoldo Ginori-Lisci.[18] In 1785 Lorenzo Ginori commissioned Girolamo Candia, a young architect employed in the studio of Giuseppe Valadier (1762–1839), to produce as many as 200 views of Rome, presumably for use in the manufactory.[19] The engraver and antiquities dealer Giovanni Trevisan, named Volpato (1735–1803), was also involved; in 1778 he was enthusiastically presented to the

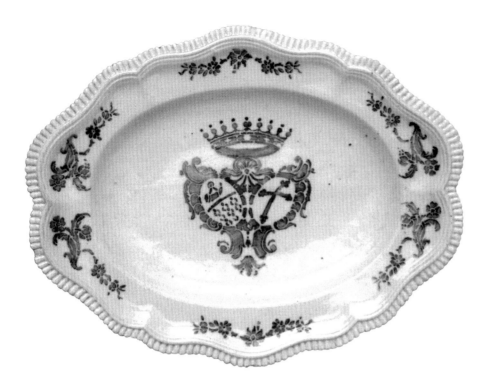

Figure 114 Platter or under tray, decorated *a stampa* or stencilled in cobalt blue with the arms of Carlo Francesco Gerini and Anna Maria Franceschi of Florence, 1748–50, Ginori factory, Doccia, Italy, hard-paste porcelain, l. 30.5cm. Private collection

Marchese by the director of the Gallerie degli Uffizi in Florence, Tommaso Puccini (1749–1811): 'I don't know if you have seen the magnificent plan of the School of Athens [after Raphael], here in Rome: this is engraved by Volpato who had some direction from [Anton] Men[g]s'.[20] Two other volumes present in the aforementioned list are also interesting – '*6 Libro di scherzi di putti e varj ornamenti. 7° Libro di giochi di bambini e delli esercizi militari*' (6th book of jokes of putti and various ornaments. 7th book of games of children and military exercises) – but there is no longer an exact match in the library of the Museo Richard-Ginori of the Manifattura di Doccia. Today, the library contains many other publications and numerous loose prints on different subjects ranging from architecture, ornamental cartouches and chinoiserie to landscapes, further confirming the great heterogeneity of the iconographic sources of the Doccia factory.

A stampa or stencilled decoration

Prints were clearly important for Carlo Ginori, both personally (he collected carved gemstones and was a great connoisseur) and professionally when acquired for the factory's own use. The above discussion provides rare insight into the establishment of an in-house print collection at Doccia. Even more significant is the fact that the manufactory was the first European factory to print on porcelain, probably as a direct result of Ginori's scientific investigations into decorative techniques. The simplest was a stencilling technique executed in monochrome cobalt blue under the glaze; it was already in production by 1743, when there are references to a *stampa* ('printed'), although it is now commonly called a *stampino*.[21] The term refers more to the execution of the technique, which had been used by Italian potters elsewhere for decades, rather than to the actual decoration, which is predominantly floral (*blau a fiori*) or sometimes combined with heraldic devices on rare armorial services (**Fig. 114**).[22] Designs were drawn and cut into sheets

of paper or lamb skins (the former were used for flat surfaces and the latter for curved forms). The cut-out sheets of floral piercing (*traforo*) were placed onto the objects, and the colour was washed over the sheets with a brush so that, through the fretwork, it created the design on the unglazed porcelain (biscuit), which was then glazed and fired.[23] This simple *a stampa* technique would have been easy to teach the painters of Doccia, the majority of whom were, at least initially, largely unskilled with limited artistic abilities.

From the outset the technique met with great success, as confirmed by Carlo Ginori himself in a letter from Livorno, probably dated 1747: 'Remember to have big, white, printed and smooth coffeepots, like the ones already sent, which give great pleasure'.[24] The workers executing this decoration were not called *pittori* ('painters'), but *stampatori* ('printers'). Bastiano Buonamici, called Micio (act. 1743/7-1763), appears to have been the main practitioner of this technique, which he produced from at least 1747, when he himself claims to paint 'in blau', until 1760, when it is said that 'in tempo avanzato dipinge a stampa' ('in his spare time he paints with prints/stencils'), together with a certain Gaetano Dini (n.d.).[25]

Among the *a stampa* design inspirations was hand-painted blue-and-white Medici porcelain produced in Florence under the patronage of Francesco I de' Medici, Grand Duke of Tuscany (1541–1587), between 1575 and 1587. It resembled Chinese porcelains of the Ming era (1368–1644), as well as Ottoman Iznik ware found in the grand-ducal collections.[26] Typically, Medici porcelain is decorated with stylised floral designs, and occasionally with heraldic devices, and often bears the mark of the dome of the cathedral of Florence. Significantly, some of the Doccia *a stampa* porcelains are also deliberately marked with the dome motif.[27] Francesco I, like Ginori, was fascinated with science and new technologies, and in emulating Medicean porcelain, the Marchese was perhaps hoping to revive the great cultural heritage of Florence and its artistic vitality, succeeding where others had

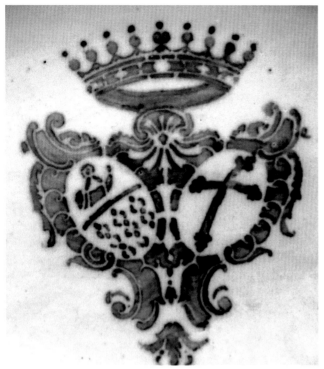

Figure 115 Detail of the arms on a tray decorated *a stampa* or stencilled in cobalt blue with the arms of Carlo Francesco Gerini and Anna Maria Franceschi of Florence, 1748–50, Ginori factory, Doccia, Italy, hard-paste porcelain. Private collection

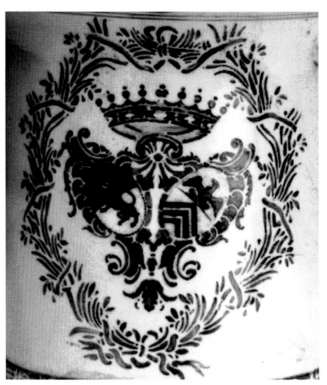

Figure 116 Detail of the arms on a cistern (*cista*), decorated *a stampa* and *a riporto* or transfer-printed in cobalt blue with the arms of Laura Isola and Francesco Marana of Genoa, within a stencilled escutcheon, 1748–50, Ginori factory, Doccia, Italy, hard-paste porcelain. Museo Nazionale d'Arte Medievale e Moderna di Arezzo, Italy

failed or lost interest. Since 1737, Florence had been under the rule of the House of Lorraine, based at the Viennese court of Empress Maria Theresa of Austria (1717–1780) and her husband Francis I, Grand Duke of Tuscany (1708–1765), and the city was struggling without the patronage of local courtiers and the nobility to stimulate the economy.

A riporto or transfer-printed decoration

The other type of printed decoration was transfer printing from a copperplate, which in order to distinguish it from the previous technique, is today called a *riporto* ('carry-over/transfer').[28] Historically, the factory did not differentiate between the two techniques, using the term *a stampa* for both. The earliest reference to this innovative technique appears in a letter written by Carlo Ginori to Jacopo Fanciullacci, dated 16 December 1750, found among the documents preserved in the Ginori-Lisci Archive. In it Ginori refers to a type of 'press', new and different from the one already in use: 'Maier can continue to make other copperplates of similar size to the original one, and shortly, we shall wait to see how the print turned out on the plate and the tray'.[29] On 15 March 1751 another document mentions the new technique employed by Buonamici:

> Have a further printing trial made of your blue colour from delicate engravings from the enclosed copperplate, in some lid of a snuffbox, which you will send back to me on Sunday with the aforementioned copperplate so that I can have it engraved more deeply in those areas where that is necessary, but tell Micio to be very careful to wash off well all the colour from the skin and make sure first to clean the colour from the copper thoroughly, with which a pull has been taken here.[30]

A riporto involved engraving the design on a copperplate, inking it and transferring the design or image onto the unglazed porcelain object, which was a very delicate and complex procedure. The blue-printed decorations produced at Doccia are always in underglaze and feature additional details executed with freehand painting. This technique was probably used only between 1748/9 and 1752/3.[31] In practice it anticipated the transfer-printing process that emerged in England from around 1751, which began as an overglaze technique, suggesting the two approaches developed independently. English manufacturers were so successful with the method throughout the 18th and 19th centuries that it is often considered incorrectly a uniquely English invention.[32]

Four categories of *a riporto*, or transfer-printed decorations, have been identified on early Doccia porcelain:
1. armorials;
2. topographical or architectural views, of which only a tray is known;
3. genre subjects, including nudes, in pastoral landscapes;
4. children's games.

These transfer-printed patterns executed in cobalt blue under the glaze are based on a variety of printed sources and appear on many different shapes and forms: plates with plain, lobed or fluted rims, beakers, cups and saucers, pot-pourri vessels and one snuffbox.

The earliest examples of *a riporto* decoration are two armorial table services, one printed with the arms of Carlo Francesco Gerini (1684–1733) and his wife Anna Maria Franceschi of Florence (d. 1764), who married in 1716, both are *c.* 1748–50 (**Figs 114–15**); this is interesting because it

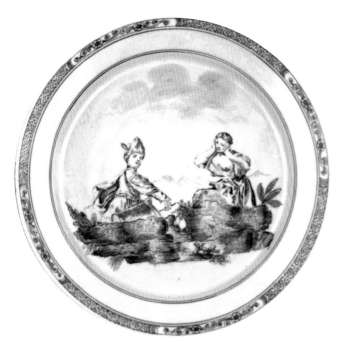

Figure 117 (left) Plate, decorated *a riporto* or transfer-printed in cobalt blue with figures after *La Gerusalemme Liberata*, c. 1748–53, Ginori factory, Doccia, Italy, hard-paste porcelain, diam. 22.6cm. Private collection

Figure 118 (above) Tailpiece Canto IX, after Giovanni Battista Piazzetta, 1745, Venice, Italy, in *La Gerusalemme Liberata*, etching and engraving. Reproduction. Private collection

suggests the service commemorates their earlier wedding. The other service has the arms of Laura Isola (d. 1772) and Francesco Marana of Genoa, whose biographical dates are unknown, but he was reportedly still alive in 1756 (**Fig. 116**). The majority of the service is decorated *a stampa*, but the heraldic details appear to have been transfer-printed from a copperplate.[33] Alternatively, they were probably placed either on the unglazed biscuit porcelain body using 'seals' and 'punches' specially prepared and executed by famous gem engravers such as Felice Bernabé (1720–after 1766),[34] or imprinted on paper using the same transfer-printed technique.

The second type, topographical views, is represented by a rectangular tray printed in a dark cobalt blue with a view of the Grand Canal in Venice, after a painting by Canaletto (1697–1768), engraved by Antonio Visentini (1688–1782), published by Giovanni Battista Pasquali (act. 1742) in three parts as *Urbis Venetiarum prospectus celebriores ex Antonii Canal tabulis XXXVIII aere espressi ab Antonio Visentini in partes tres distribuiti* (Venice, 1742) and reprinted in 1751.[35] There is a reference to such views being acquired for the factory in a letter dated 20 October 1752: 'Pagati a Donato Martini Procaccia di Venezia per provvista di un Esemplare di Stampe in Rame contenente le vedute di Venezia di Giovan Battista Pasquali, e N. due dette degli Albrizzi, provviste in detta città per servizio della Fabbrica' ('Payment to Donato Martini Procaccia of Venice for providing a copy of copperplate prints containing the views of Venice of Giovan Battista Pasquali, and number two, called "degli Albrizzi", acquired in said city for the factory's use').[36] The etching, entitled *Hinc ex Aede Charitatis, illinc ex Regione S. Vitalis usque ad Telonium*, part 1, plate III, is faithfully reproduced on the porcelain tray, with the addition of hand-painted clouds and surrounded by *a stampa* floral sprays. As is often the case, the image on the Doccia porcelain represents only half of the engraving, the left-hand side, rejecting the more important view of the Chiesa di Santa Maria della Consolazione, perhaps intended for use as another topographical pattern. The factory may have planned to produce a tableware

pattern featuring topographical views. To date, however, this is the only example to have been identified.

The third type, genre subjects, is the largest group, primarily found on tablewares, especially plates, and is based on 17th-century Dutch engravings and contemporary Venetian and French print sources, marking a first and as yet undefined transition away from the Medicean influence and the traditional canons of the late Baroque towards the fashionable rococo. The motifs are either single or double figures, sometimes of half-length, printed *a riporto* in the centre of the plate. The majority derive from engravings by the Venetian painter Giovanni Battista Piazzetta (1683–1754), which were included in the sumptuously illustrated *La Gerusalemme Liberata* (Jerusalem Delivered) (Venice, 1745). The heroic poem by Torquato Tasso (1544–1595) was published in two volumes by Giambattista Albrizzi (1698–1777), with a dedication to Empress Maria Theresa of Austria. Interest in Tasso's chivalric love story was revived in the 18th century in the form of operas and in art furnishing private palaces. The best known is the Tasso Cycle, 1742–5, painted by Giovanni Battista Tiepolo (1696–1770) in the Palazzo Cornaro in Venice. Ginori, who was not a subscriber to Albrizzi's publication, evidently considered the engravings appropriate for reproduction on his porcelain, hoping to capitalize on the popularity of the book to encourage commissions from the nobility and the high clergy.

The figures on the plates, however, bear little relation to the poem itself as they are primarily based on the ornamental headpieces and tailpieces of the chapters or Cantos. For example, the image of a drummer and a woman covering her ears transfer-printed on a soup plates is derived from a tailpiece at the end of Canto IX, but excludes the ornamental scroll device and dog in the bottom half of the print (**Figs 117–18**). Other images use just one figure appropriated from a larger group, so losing their original context. For example, a plate formerly in the collection of Enrico Questa (1923–2016) of Turin includes the entire figure of a seated shepherd from the final vignette of Canto

Figure 119 Plates, decorated *a riporto* or transfer-printed in cobalt blue with figures after *La Gerusalemme Liberata* (left), *c.* 1748–53, Ginori factory, Doccia, Italy, hard-paste porcelain, diam. 22cm. Courtesy Sotheby's, Milan

VIII, but lacks the other figures and sheep (**Figs 119**, left, and **120**); another with a single woman holding a flower garland is taken from a group in a tailpiece from Canto II, which featured a second woman, a child playing with a dog and a cow (**Figs 121–2**); and finally, a lone seated shepherd in **Figure 123** is from the elaborate headpiece at the start of Canto XIX (**Fig. 124**). There are also images that combine figures from two different engraved plates on one porcelain

Figure 120 Tailpiece Canto VIII, after Giovanni Battista Piazzetta, 1745, Venice, Italy, in *La Gerusalemme Liberata*, etching and engraving. Reproduction. Private collection

plate, as in **Figure 125**: the man with his back to the viewer is from the headpiece in Canto X (**Fig. 126**) and the seated woman without her cow and other details is from the tailpiece to Canto III (**Fig. 127**). It is interesting that the factory did not choose to re-create a more legible iconographic programme by reproducing the most popular and easily recognisable scenes from Tasso's love story.

In December 2020, two unpublished plates appeared at an Italian auction house, together with two others published by Bondi, which expand the corpus of *a riporto* decorated objects made at Doccia (**Fig. 128**). They are painted with figures in the countryside in a rather simple scheme typical of other objects *a riporto*, with small buildings in the distance. The figure of the woman with the spindle is once again taken from the Tailpiece Canto VIII after Giovanni Battista Piazzetta, in *La Gerusalemme Liberata*, 1745, Venice (**Fig. 120**), the source for the other is as yet unidentified. The standing male character on the other plate is taken from a detail of the Headpiece Canto II in *La Gerusalemme Liberata*, while the dog on his right is taken from the full-page engraving of Canto XIV.

Typical of this group, *a riporto* decorators have placed the figures in an idealised pastoral landscape, hand-painting the bold rockwork, the distant mountains and farmhouses, and often adding a tree on the left-hand side. The coarse hand-painting, possibly by the same hand, is consistent across the group, superficially creating a unified pattern, enhanced by the Chinese-inspired hand-painted latticework border around the rim, the floral scrollwork on the undersides, framed with a fine brown-edge. Ten different printed images in this specific pattern were published by Roberto Bondi in 1971 (along with several duplicates) and this chapter includes an additional six, bringing the total number of identified designs to 16.[37] The Chinese-style latticework and line bands on the rim and foliate sprays on the underside are extremely similar to an unusual Chinese export porcelain service

Figure 121 Plate, decorated *a riporto* or transfer-printed in cobalt blue with figure after *La Gerusalemme Liberata*, *c.* 1748–53, Ginori factory, Doccia, Italy, hard-paste porcelain, diam. 22.4cm. Private collection

Figure 122 Tailpiece Canto II, after Giovanni Battista Piazzetta, 1745, Venice, Italy, in *La Gerusalemme Liberata*, etching and engraving. Reproduction. Private collection

hand-painted after a European botanical print of a naturalistic rose, *c.* 1740–9: an example is in the Ariana Museum, Geneva.[38] A Chinese service in this pattern, or elements of it, was presumably in Italy, when it was copied by the Doccia factory, and hand-painted on various plates and wares; the pattern was in production in 1747, when it was first described as *con Rosa* (with roses), and still popular in 1757 as *rosa canina'* (rose hips). It is difficult to prove if this pattern which evidences a European printing source on Chinese porcelain, inspired Carlo Ginori to attempt to print from copper plates onto his porcelain body, but what is

certain is that the 'rose hips' in cobalt blue is done before transfer-printing and it continued to be produced, probably as a replacement, into the last quarter of the 18th century. A similar type of rose had also been painted on maiolica at Doccia, described as *a rosa* (at rose), since the formation of the factory in July 1737.

Among the more idiosyncratic subjects within this group is a plate in the British Museum printed and painted with a *plein-air* scene of a painter seated before an easel accompanied by a child (**Fig. 129**).[39] The original print source, 'The Distressed Painter', depicts an artist in a dark interior with his wife

Figure 123 Plate, decorated *a riporto* or transfer-printed in cobalt blue with figure after *La Gerusalemme Liberata*, *c.* 1748–53, Ginori factory, Doccia, Italy, hard-paste porcelain, diam. 22.6cm. Private collection

Figure 124 Headpiece Canto XIX, after Giovanni Battista Piazzetta, 1745, Venice, Italy, in *La Gerusalemme Liberata*, etching and engraving. Reproduction. Private collection

Figure 125 Plate, decorated *a riporto* or transfer-printed in cobalt blue with figures after *La Gerusalemme Liberata*, c. 1748–53, Ginori factory, Doccia, Italy, hard-paste porcelain, diam. 22.5cm. Private collection

Figure 126 Headpiece Canto X, after Giovanni Battista Piazzetta, 1745, Venice, Italy, in *La Gerusalemme Liberata*, etching and engraving. Reproduction. Private collection

Figure 127 Tailpiece Canto III, after Giovanni Battista Piazzetta, 1745, Venice, Italy, in *La Gerusalemme Liberata*, etching and engraving. Reproduction. Private collection

Figure 128 Plates decorated *a riporto* or transfer-printed in cobalt blue, c. 1748–53, Ginori factory, Doccia, Italy, hard-paste porcelain, diam. 22.4cm. Courtesy Casa d'Aste Pandolfini, Florence

grinding paints in the background watched by a child. It is after a painting by the Utrecht artist based in Rome, Andries Dirksz Both (1612/13–before 1642); his drawing of it, *c.* 1624–40, is also in the British Museum.[40] A popular subject, it was the source for several prints: a German engraving for the Dutch or German market by the printmaker Georg Walch (1656–1722) published in Nuremburg between 1632 and 1654 by Paulus Fürst (1608–1666); a French print, known as *Le Peintre raté*, engraved by Nicolas Viennot (act. 1630–1635) and published in Paris by Philippe II Huart (act. *c.* 1635–*c.* 1670); and another variation in reverse published in Paris, *c.* 1680–90, by Pierre Landry

Figure 129 (left) Plate, decorated *a riporto* or transfer-printed in cobalt blue with the 'The Distressed Painter', after Nicolas Viennot or Georg Walch, *c*. 1748–53, Ginori factory, Doccia, Italy, hard-paste porcelain, diam. 22.2cm. British Museum, London, 2010,8004.1

Figure 130 (above) Déjeuner tray, decorated *a riporto* or transfer-printed in cobalt blue with a young painter, *c*. 1748–53, Ginori factory, Doccia, Italy, hard-paste porcelain, l. 26.2 cm. Private collection

(*c*. 1630–1701).[41] It is the most sophisticated image in the group and may have specifically referenced the potential threat to painters of the new *a riporto* technique.

A recently discovered tray adapted from a form with two recesses for serving an individual with a beaker of hot coffee and a glass of water, is also decorated with a painter though much younger, in front of an easel in the countryside; compared to other *a riporto* decorated objects, it has a very bright and glassy enamel (**Fig. 130**). The figure is somewhat reminiscent of a painting by François Boucher (1703–1770), *The Landscape Painter*, formerly in the Baron Edmond Adolphe de Rothschild (1926–1997) collection, which appeared on the art market in 2012.

Nudes also featured in the *a riporto* decoration of this group, at least one of which was based on a tailpiece in *La Gerusalemme Liberata*, but the print sources for the others have not been securely identified.[42] The example in the right-hand side of **Figure 119** is perhaps after a much older engraving of 'Susanna im Bade' (*Susanna Surprised by the Elders*) (1555), by the German printmaker Heinrich Aldegrever (1502–1561), from a four-part series entitled 'The Story of Susanna' (**Fig. 131**). The architectural background of the original print has been replaced with the factory's standard hand-painted landscape. Two different female nudes appear on the sides of a two-handled pot-pourri vase with a pierced cover (**Fig. 132**). One is after a celebrated painting of *Susanna Surprised by the Elders* by Jean-Baptiste Santerre (1651–1717), dated 1704, now at the Louvre, Paris, although the elders, a crucial element of the narrative, are not included; the contemporary print source is unidentified (**Fig. 133**). The nude on the other side of the pot-pourri vase may depict Diana at the Bath, but the source is also unknown (**Fig. 134**).[43]

The artistic focus of Ginori's factory gradually moved away from the baroque taste fashionable under the factory's leading Viennese-trained painter Anreiter, who departed in 1746, in favour of the rococo, which became prominent around 1763 with the work of the sculptor Giuseppe Bruschi (act. 1749–1804), nephew of Gaspero, in Parma.[44] However,

the suggestive eroticism of the *estampe galante* – humorous prints that chronicle the French aristocracy and their mannerisms especially those associated with Jean-Antoine Watteau (1684–1721) and Jean-Baptiste Pater (1695–1736), so popular at the Meissen porcelain factory from the late 1730s – features in only three rare *a riporto* examples. These include two dessert plates after silver shapes, perhaps once part of

Figure 131 *Susanna Surprised by the Elders*, Heinrich Aldegrever, 1555, Germany, engraving, 8 x 11.3cm. British Museum, London, Gg, 4S.10.

Figure 132 Pot-pourri or pierced covered bowl, decorated *a riporto* or transfer-printed in cobalt blue with a nude, *Susanna at the Bath*, *c.* 1748–53, Ginori factory, Doccia, Italy, hard-paste porcelain, h. 17.5cm. Private collection

Figure 133 *Susanna at the Bath*, Carlo Antonio Porporati, after Jean-Baptiste Santerre, 1773, Italy, etching and engraving, 53 x 39cm. British Museum, London, 1868,0822.82

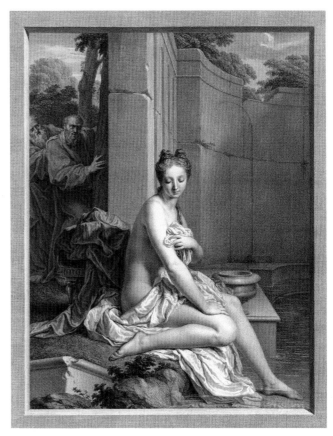

the same dessert service.[45] A transfer-printed image of a well-dressed woman sitting awkwardly in a hand-painted rocky landscape on one of the plates is copied from a figure in a formal garden in *Les deux Cousines*, after Watteau, engraved in Paris in 1729–31 by Bernard Baron (1696–1762) (**Figs 135–6**). The image on the other is taken from *La Danse*, after Pater, engraved by Pierre Filloeul (1696–active until 1754) and published in Paris in 1738 (**Figs 137–8**).[46] Both fashionable prints were used at Meissen in the 1740s (see

Figure 134 Pot-pourri or pierced covered bowl, decorated *a riporto* or transfer-printed in cobalt blue with a nude, *c.* 1748–53, Ginori factory, Doccia, Italy, hard-paste porcelain, h. 17.5 cm. Private collection

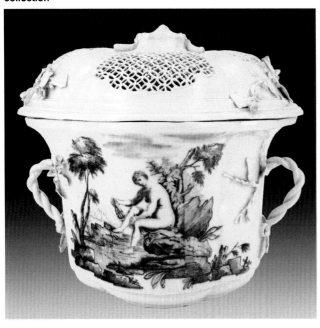

Jones, Chapter 8).[47] Another *a riporto* rococo-inspired image appears on the inside lid of an outsized table snuffbox (*tabacchiera da tavolo*) with cameos, which is after Watteau's *Le teste a teste*, engraved by Benoît Audran II (1698–1772), published in Paris in 1727, which appeared as plate 175 in the influential *L'Oeuvre d'Antoine Watteau*.[48]

A giochi di bambini or children's games

The fourth type of *a riporto* transfer-printed decoration at Doccia, a subgroup of the genre subjects, are known as *a giochi di bambini* or children's games, and referred to historically as *a stampa . . . con Puttini blau* ('blue boys').[49] The iconographic theme of children's games originates in the baroque taste for classical representations of processions, dances and games with *amorini* (representations of Cupid, the god of love in Roman mythology), at play, but also a fascination with themes from everyday life expressed in the famous painting *Kinderspiele (Giochi di ragazzi*, or Boy's Games) (1560) by Pieter Bruegel the Elder (*c.* 1526/30–1569).[50] Over 90 different games are depicted in the painting with many drawing inspiration from the activities described by François Rabelais (1494–1553) in his five novels of *The Life of Gargantua and Pantagruel* (1532–64). Similar themes were produced in Vienna at the Du Paquier factory, primarily after woodcut illustrations by Francis Cleyn (*c.* 1582–1658), which appeared in the emblem book by Otto van Veen (1556–1629), *Amorum emblemata, figuris Aeneis incisa*, published in Antwerp in 1608 with engravings by Cornelis Boel (*c.* 1576–after 1621).[51] At Doccia, the motif was mainly inspired by the publication *Les Jeux et les Plaisirs de l'Enfance* (Paris, 1657), with etchings by Claudine Bouzonnet-Stella (1641–1697), after drawings by her uncle, the Lyons painter Jacques Stella (1596–1657); but also by the series of prints by

Figure 135 Plate, decorated *a riporto* or transfer-printed in cobalt blue with figure after Jean-Antoine Watteau, *c.* 1748–53, Ginori factory, Doccia, Italy, hard-paste porcelain, diam. 21.5cm. Private collection

Figure 136 *Les deux Cousines*, Bernard Baron, after Jean-Antoine Watteau, 1729–31, Paris, France, etching, 33.9 x 38.7cm. British Museum, London, 1874,0808.1951

Figure 137 (above) Plate, decorated *a riporto* with figure after Jean-Baptiste Pater, *c.* 1748–53, Ginori factory, Doccia, Italy, hard-paste porcelain, diam. 21.5cm. Private collection

Figure 138 (right) *La Danse*, Pierre Filloeul, after Jean-Baptiste Pater, 1738, Paris, France, engraving, 49 x 36cm. Jerome Robbins Dance Division, The New York Public Library

Giacinto Gimignani (1606–1681), *Scherzi e giuochi diverse de putti* (Rome, 1647), and drawings by Cornelis Holsteyn (1618–1658), engraved by Michiel Mosijn (act. 1640–1655), in *Verscheyde aerdig kinderspel* (Amsterdam, 1655). The Meissen porcelain manufactory also produced a pattern with the same subject, largely after Bouzonnet-Stella, called *Kinder à la Raphael*; however, the Saxon manufactory only made it after 1760 and it was hand-painted.[52]

Three variations have so far been recorded in the *a Puttini blau* decoration:

1. decoration with young boys in small scale;
2. 'mixed' decoration with young boys in small scale and floral sprays *a stampa*
3. decoration with young boys in large scale.

Of the first type the most important example is the large eight-lobed coffee pot in the Richard-Ginori Museum of the

Figure 139 Coffee pot, decorated *a stampa* floral and *a riporto* or transfer-printed in cobalt blue with children's games after Jacques Stella, *c.* 1748–53, Ginori factory, Doccia, Italy, hard-paste porcelain, h. 28.5cm. Museo Richard-Ginori della Manifattura di Doccia, Sesto Fiorentino, Florence, inv. no. 6813

Manifattura di Doccia (**Fig. 139**); the cover, mounted in gilt bronze, is decorated *a stampa* with small branches of flowers.[53] The body is printed with engravings after Bouzonnet-Stella arranged as a sort of collage. There are three scenes on one side, which read from left to right: *La Toupie*, plate 22, *La Balançoire*, plate 4, and *Le Sabot*, plate 3. On the opposite side there is a scene from *Le Cercle et le Bilboquet*, plate 39, a central scene from *Le Jeu des Espingles*,

Figure 142 *Les Bouteilles de Savon*, Claudine Bouzonnet-Stella, 1657, 11.6 x 14.2cm, published in *Les Jeux et les Plaisirs de l'Enfance*, plate 8. Reproduction. Private collection

LES BOUTEILLES DE SAVON
Ceux cy se gourment tout de bon Mais souvent parmy les grans
pour ces Bouteilles de Savon on void naistre des differens
Comme si cestoit des Pistoles ; pour milles choses plus frivoles.

Figure 140 Teapot, decorated *a stampa* floral and *a riporto* or transfer-printed in cobalt blue with children's games, *c.* 1748–53, Ginori factory, Doccia, Italy, hard-paste porcelain, h. 28.5cm. Victoria and Albert Museum, London, C.407–1928

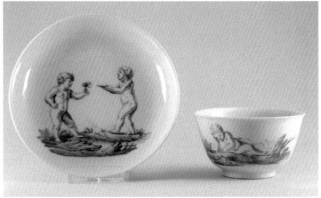

Figure 141 Tea bowl and saucer, decorated *a riporto* or transfer-printed in cobalt blue with children's games, *c.* 1748–53, Ginori factory, Doccia, Italy, hard-paste porcelain, cup: h. 4.5cm, diam. 8.2cm; saucer: diam. 12.5cm. Private collection

plate 6, along with a detail of a child bending down borrowed from *Le Sabot*, added to balance the design, and on the far side, two children, one a detail from *Le Brelan*, plate 31, while the other is perhaps a reworking by the engraver. Similar small-scale prints after Bouzonnet-Stella are found on a teapot, formerly in the Dr Bernard Watney collection, 'mixed' with hand-painting and stencilled motifs, of the second type.[54]

Of the third type, the large-scale children, the best-known example is the teapot in the Victoria and Albert Museum (**Fig. 140**); the cover is also decorated *a stampa* with a floral band.[55] The teapot has two different scenes: one side has a seated child from *Le Chaval Fondu*, plate 21, and a standing child from *La Glissoire*, plate 33. On the other side, the dog standing on its hind legs is perhaps after a Dutch etching of a Savoyard playing a violin with a performing hound by Carel Dujardin (1626–1678), dated 1658, in the British Museum; the source of the children with drums and cymbals has not been identified.[56] The large-scale putti are also found on tea bowls (*tazze a ciotola*, or cup-shaped bowls) and saucers in several private collections: these were described in an inventory dated 1757 as '*516 chicchere con Puttini blau*' ('516 cups with blue putti') (**Fig. 141**).[57] The

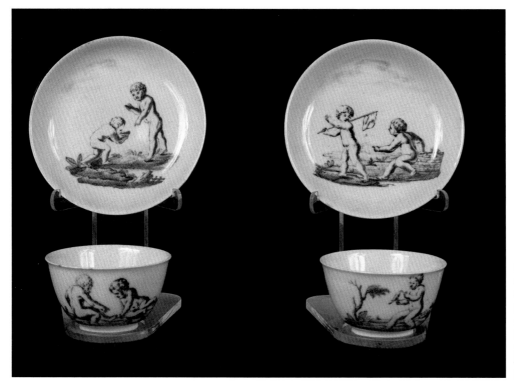

Figure 143 Tea bowls and saucers, decorated *a riporto* or transfer-printed in cobalt blue with children's games, c. 1748–53, Ginori factory, Doccia, Italy, hard-paste porcelain, cup: h. 4.5cm, diam. 8.2cm; saucer: diam. 12.5cm. Private collection

scenes are rarely straightforward copies, with the factory engravers combining elements from various sources: only one of the figures on the saucer in **Figure 141** is taken from the large group of boys in *Les Bouteilles de Savon* (**Fig. 142**). The laborious and complex process required to produce these designs was short lived, although the factory continued to use the *giochi di bambini* print sources, but hand-painted on Meissen-style (*alla sassone*) polychrome painted wares.[58] Two other cups have a putto on one side and a landscape with trees and houses on the other. In one, the engravings of *La Fossette aux Noyaux*, plate 16, and *La Rangette*, plate 15, are partially reported, while on the saucer the child behind is taken from plate 8, *Les Bouteilles de Savon*, and the standing one perhaps from plate 11, *Le Petit Feux*; on another cup the child derives from plate 2, *Le Dada*, and on the saucer the seated one from plate 18, *La Marelle a Cloche Pie*, while the standing child is from plate 12, *Le Coline Maillard*, although it is not represented here with the flag (**Fig. 143**).

Conclusion

This chapter has identified the various categories of *a riporto* transfer-printed decoration produced at the Ginori manufactory – armorials, topographical views and genres subjects with its subcategory of children's games – and has explored their individual iconographic sources and meanings. Based on the rare surviving material, production was small scale, particularly complex, short lived and in the end proved to be unsuccessful, only the stencilled floral decoration commonly called *a stampino*, continued in use until the 19th century. This brief investigation considers only a small part of the much larger body and spectrum of print sources employed at the Ginori manufactory, the majority being used by factory painters. The iconographic programmes were ultimately guided by the aesthetics and cultural philosophy of Carlo Ginori himself. Driven by his strong historical Tuscan heritage, ingenuity and

entrepreneurial curiosity, Ginori's new techniques and modern technologies, evoking the spirit of Medicean porcelain, aspired to regenerate Florence out of its seemingly inexorable decline.

Notes

1 Biancalana 2009, 27–8.
2 Biancalana 2005, 95–103.
3 Archivio Ginori-Lisci, Florence (AGL), XV, 2, f. 137, II, *Manifattura di Doccia. Documenti vari*, c. 673v. The c. in the Ginori Lisci archive refers to *Carte*, sheets or individual pages.
4 Biancalana 2009, 41–2.
5 AGL, XV, 2, f. 138, *Manifattura di Doccia. Documenti vari*, fasc. 3, c. 211r. The original text for the editor's translation above: 'Sarà Sua principale cura di far tenere esatta custodia di t.te quelle forme e Modelli, Disegni ed altro che in qualunque modo esista nella Fabbrica. [...] Siccome il Disegno è L'Anima principale della fabbrica [...] Rivedrà anche particolarmente i Pittori di porcellane, di Maioliche e li Stampatori acciò t.ti faccino con buon gusto. mettendogli sempre in vista i migliori originali perchè possino imitarli, e piuttosto sempre migliorare i loro lavori'.
6 Biancalana 2007, 39–42; AGL, *Libri di Amministrazione 210. Quaderni di Spese Quotidiane 1737–1747*, c. 258; AGL, *Libri di Amministrazione 213. Quaderni di Spese Quotidiane 1746–1749*, c. 208.
7 AGL, *Libri di Amministrazione 210. Quaderno di spese quotidiane 1737–1746*, c. 218.
8 AGL, XV, 2, f. 138, *Fabbrica delle Porcellane di Doccia. Dimostrazioni e Ristretti*, fasc. 109, c. 1.
9 AGL, IX, 1, *Conti e Ricevute Sen. Carlo Ginori 1741–1746*, c. 26.
10 AGL, *Libri di Amministrazione 210. Quaderno di spese quotidiane 1737–1746*, c. 230; AGL, *Libri di Amministrazione 213. Quaderni di spese quotidiane 1746–1749*, c. 213.
11 AGL, *Libri di Amministrazione 216. Quaderno di spese quotidiane 1749–1754*, c. 200.
12 Ibid. AGL, c. 204 and 210.
13 d'Agliano 2005, 78; and for the complete list, see Biancalana 2009, 186.

14 Victoria and Albert Museum, E.5549–1908.

15 Biancalana 2009, 186–7.

16 AGL, XIII, 1, f. 4, *Lorenzo Ginori. Lettere diverse dirette al medesimo. 1768–1775*, c. 634r.

17 AGL, XIII, 1, f. 5, *Lorenzo Ginori. Lettere diverse dirette al medesimo 1761–1770*, c. 442r/v.

18 Rucellai 2018, 428–9, cat. 126.

19 Biancalana 2016, 70–5.

20 British Museum, 1869,0410.2132; AGL, XIII, 1, f. 6, *Lorenzo Ginori. Lettere diverse dirette al medesimo. 1775–1790*, c. 403. The original text for the editor's translation above: '*Non so se abbiate veduta la carta magnifica uscita fuori qui in Roma della Scuola d'Atene: Questa è intagliata da Volpato il quale ha avuto qualche direzione da Mens*'.

21 Biancalana 2009, 146; AGL I, 2, f. 37, *Fabbrica delle Porcellane di Doccia. Scritture e Documenti*, fasc. 2.

22 Mallet 2011, 103–11.

23 Ginori-Lisci 1963, 40.

24 AGL, XV, 2, f. 137, I, *Manifattura di Doccia. Documenti vari*, c. 928v. For the original text for the editor's translation above: '*Si ricordino di far fare de Caffettieri grandi bianchi stampati, e Lisci come i mandati che piaccono molto*'.

25 AGL, XV, 2, f. 138, *Manifattura di Doccia. Documenti vari*, fasc. 2.

26 Spallanzani 1978.

27 d'Agliano 2002, 44–5.

28 Bondi 1971, 38–41.

29 AGL, XV, 2, f. 137, I, *Manifattura di Doccia. Documenti vari*, c. 938v. The original text for the editor's translation above: '*Il Maier può seguitare a fare altri rami a simile grandezza del fatto, e in tanto s'aspetta di vedere come sia ben riuscita nel Piatto, e Vassoio la detta stampa*'.

30 Ibid., c. 974.

31 Biancalana 2009, 147–8; Mallet 2011, 89–115; Mallet 2012, 10–42.

32 Mallet 2011, 93–4.

33 Ibid., 100–1; Biancalana 2009, 181–3; Rucellai 2017, 224.

34 AGL, *Libri di Amministrazione 213. Quaderno di spese quotidiane 1746–1749*, cc. 211–12.

35 Sotheby's 2007, lot 201; a beaker, possibly with a Venetian view, in the Doccia Museum, was published by Bondi 1971, Tav. XIIc.

36 AGL, *Libri di Amministrazione 216. Quaderno di spese quotidiane 1749–1754*, c. 207.

37 Bondi 1971, figs XVI and XVII; see also the example published in d'Agliano *et al.* 2001, cat. 30.

38 Ariana Museum, inv. no. AR 08460, see Biancalana 2009, 159.

39 British Museum, inv. no. 2010,8004.1, and another is in a private collection, see Dawson 2010.

40 British Museum, inv. no. 1836,0811.75.

41 British Museum, 1876,0510.573; BNF, Hennin Collection, 4661; and British Museum 1996,0713.18.

42 See the nude accompanied by a child, published by Bondi 1971, Tav. XVII, top row, middle, which is after Canto I.

43 See a preparatory drawing of about 1716 by Jean-Antoine Watteau (Albertina Graphische Sammlung, Vienna, inv. no. 12008) for his painting now at the Louvre, inv. no. 7836, engraved by Pierre-Alexandre Aveline (1702–1760), or perhaps a detail in a drawing of 1595 by Hans Rottenhammer (1564–1625), entitled *Diana and Actaeon* (see Antiqua.mi 2017).

44 Biancalana 2010, 100–27.

45 Perhaps the 'da Frutte centinato' ('lobed or ribbed fruit dish') noted in AGL, I, 2, f. 37, *Fabbrica delle Porcellane di Doccia. Scritture e documenti*, fasc. 7, 12.

46 See the entry by Alessandro Biancalana in Perlès 2016, 20–7, cat. nos 5–6.

47 Bodinek 2018, 265 and 510–11.

48 d'Agliano *et al.* 2001, 246, cat. 184.

49 AGL, I, 2, f. 37, *Fabbrica delle Porcellane di Doccia. Scritture e Documenti*, fasc. 6; Frescobaldi Malenchini *et al.* 2013, 51, cat. 27.

50 Kunsthistorisches Museum, Vienna, Gemäldegalerie, inv. no. 1017.

51 Kräftner, Lehner-Jobst and d'Agliano 2005, 337–41, cats 182–4.

52 Müller-Scherf 2016, 9–36.

53 Kräftner, Lehner-Jobst and d'Agliano 2005, 343, cat. 187.

54 Mallet 2012, 20, figs 17–19; Mallet 2011, 97, figs 17–19.

55 Frescobaldi Malenchini *et al.* 2013, 51–2, cat. 27.

56 British Museum, inv. no. J,28.24, Hollstein 52.I.

57 AGL, I, 2, f. 37, *Fabbrica delle Porcellane di Doccia. Scritture e Documenti*, fasc. 6.

58 Kräftner, Lehner-Jobst and d'Agliano 2005, 347, cat. 192; Dawson 2009, 28; d'Agliano 1997, 19.

Chapter 11
Jefferyes Hamett O'Neale (act. 1750–1801): Porcelain Painter and Print Designer

Sheila O'Connell

Jefferyes Hamett O'Neale is well known to historians of English ceramics as a painter on Chelsea and Worcester porcelain in the 1750s and 1760s, but his career is an example of how an artist in 18th-century Britain could succeed in more than one field.[1] As a member of the Society of Artists from 1763 to 1784, he showed his miniature paintings in the Society's annual exhibitions up to 1772.[2] He also designed prints, working chiefly for the major London publisher Robert Sayer (1725–1794), as well as for producers of political prints in the early 1760s.[3]

O'Neale's name suggests that he may have come to England from Ireland, but no records of his birth or early life in either country have yet been discovered. His earliest known work is subjects from Aesop's *Fables* painted on Chelsea porcelain in the early 1750s (**Fig. 144**). In the 1750s and 1760s he was also working for James Giles (1718–1780) painting Chinese export porcelains (**Fig. 145**).[4] His lively animals, especially those painted on Chelsea dishes of the 'Warren Hastings' type, include characteristic features that recur in prints of the following decade: exaggeratedly long tails, snarling mouths, eyes with flattish lower lids and arched upper lids; horses and other equines have small ears, scanty manes and prominent neck muscles. Other distinctive motifs are flights of distant birds high in the sky, modest country houses with steeply pitched roofs and small windows, and tall, spindly trees with tufts of leafy branches. Where draped classical or Oriental figures appear in O'Neale's work they are elongated with small heads, and by contrast burly sailors, huntsmen or older *commedia dell'arte* characters are shown with strongly marked facial figures and frown lines between their brows (**Fig. 146**).[5]

O'Neale's first known design for a print is a celebration of the British naval victory at Quiberon Bay on 20 November 1759 published shortly after the event by John Ryall of Fleet Street (**Fig. 147**). It is lettered 'J.H. ONeal del' and includes characteristic motifs: birds in the sky; a farmhouse with steeply pitched roof; tufted trees.[6] The emblematic use of animals to represent human activities would have been familiar to O'Neale from his work on the *Fables*: a hawk (Admiral Sir Edward Hawke) stands on the prostrate (French) cock, and chickens flee in all directions; two chickens driven into the sea represent the *Thésée* and the *Superbe*, which were sunk in the battle; two others lying dead are the *Heros* and the *Soleil Royal*, which were driven on shore and burnt.

This patriotic print was made for a market that was rejoicing in British success in the Seven Years' War (1756–63) against France, but when George II died in October 1760 his grandson moved to end the war. The peace negotiations launched by George III and his minister Lord Bute were deeply unpopular especially to merchants and financiers in the City of London who knew that they would lose newly acquired trading opportunities if territories won in the war were returned. The political crisis inspired a spate of satirical prints as part of the vicious campaign that led to the resignation of Lord Bute after only 11 months as prime minister.[7] Among these prints is a group designed by O'Neale for Edward Sumpter, John Williams and other publishers in Fleet Street. None of them bears his name – anti-government publications could lead to the pillory or a

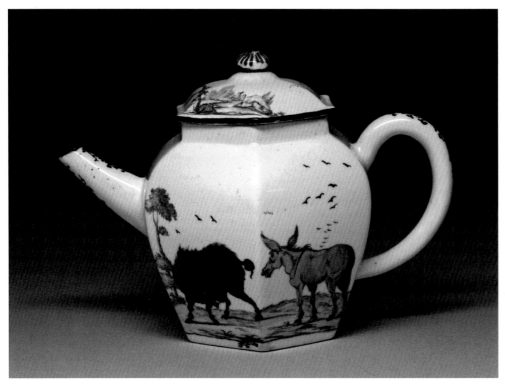

Figure 144 Teapot with fable of the Boar and the Ass, painted by Jefferyes Hamett O'Neale, 1752–4, Chelsea factory, England, soft-paste porcelain, enamels, unmarked, h. 11.4cm. British Museum, London, 1887,0307,II.78

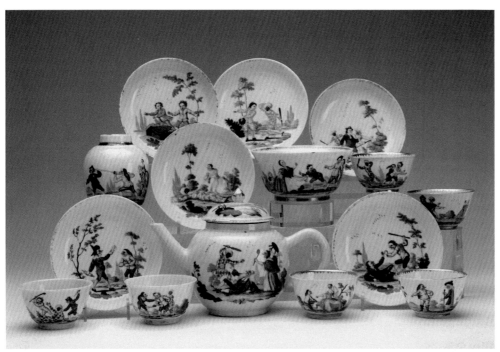

Figure 145 Tea service with scenes from the *commedia dell'arte*, painted by Jefferyes Hamett O'Neale, in the James Giles atelier, London, c. 1756–60, Jingdezhen, China, porcelain, enamels and gold, unmarked, teapot: l. 17.6cm. Courtesy E. & H. Manners, London

Figure 146 Teapot from Figure 145

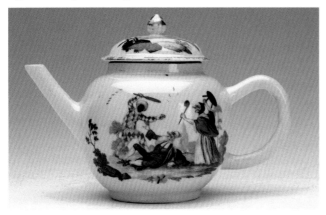

prison sentence – but the style is undoubtedly his and familiar motifs can be identified.

Satire allowed free range for O'Neale's creative imagination. Arguably the most inventive compositions appeared in two prints produced immediately after the ratification of the peace treaty in February 1763: *The Heroes of the Times* and *The Proclamation of Proclamations*. The first of these concerns the Bill to introduce an excise on cider. Bute's opponents led by John Wilkes are shown attacking the Excise monster, a dragon that has seized Magna Carta. Bute himself slips away with French and Spanish allies, the devious Henry Fox (a fox) at his heels. In the sky above Minerva flies in to defend the opposition against two outrageously grotesque figures squirting venom from a huge

syringe. They represent Lord Mansfield, who as Lord Chief Justice had found that Wilkes could be prosecuted for sedition, and the Duke of Bedford, chief negotiator for the peace (**Fig. 148**). *The Proclamation of Proclamations* is equally fanciful. The chief herald arrives to announce the Peace to an unruly London street crowd. He rides a horse with ass's ears and long spikes emerging from its hoofs, and wears a large boot signifying his allegiance to Lord Bute. Above flies a parody of Fame with a long nose, devil's wings and tail, and a wooden right leg; she wears stays and has a large boot on her left leg (**Fig. 149**).

Once Bute had resigned and the furore over the peace treaty had died down, O'Neale does not seem to have designed any further political prints, but his skill as a designer of prints had clearly been recognised. His name appears in publishers' advertisements in the 1760s, and for at least another 20 years he provided designs for Robert Sayer of Fleet Street.[8] He also continued working as a 'china painter'. He lived in Worcester from 1767/8 to 1770. The painting on a Worcester garniture at the British Museum (**Fig. 150**), signed 'O'Neale invt & c', includes a scowling man and animals with O'Neale's typical characteristics. He was back in London in 1770 probably working for William Duesbury (1725–1786) at Chelsea, and certainly for Josiah Wedgwood (1730–1795) and Thomas Bentley (1731–1780). Wedgwood wrote to Bentley in December 1770 anxious about the high wages (three guineas a week) being paid to O'Neale, but the following November he was pleased to comment that 'O'Neale works quick'.[9]

The Ladies Amusement

O'Neale's designs for prints are best known to ceramic historians and enthusiasts from examples in a facsimile of *The Ladies Amusement* produced in 1966.[10] The facsimile is a useful reference for those searching for sources for 18th-century decoration on ceramics and other materials, but mid-20th-century photographic reproduction does no justice to the delicacy of the original prints (**Fig. 151**).

Figure 147 *The English Hawke and the French Cock. A Fable*, William Elliott, after Jefferyes Hamett O'Neale, 1760, etching with engraved lettering, 32.5 x 21.6cm. British Museum, London, PD 1868,0808.4120

The Ladies Amusement was first recorded in the *Gentleman's Magazine* in February 1760 where it appears in a list of newly published books. It was sold by Robert Sayer for two guineas coloured and 18 shillings plain. The contents are described on the title pages of surviving copies of this first edition in

Figure 148 *Representing the Heroes of the Times supposed to be concerned in the Grand Political Uproar*, anonymous, after Jefferyes Hamett O'Neale, 1763, etching with engraved letters, 25.5 x 36.1cm. British Museum, London, PD 1868,0808.4302

Figure 149 *The Proclamation of Proclamations, or the most glorious and memorable Peace that ever was proclaimed in this or any other Metropolis throughout the World*, anonymous, after Jefferyes Hamett O'Neale, 1763, etching, 23.7 x 30.7cm. British Museum, London, PD 1868,0808.4305

the Museum of Worcester Porcelain (inv. no. C1/3 A31) and in the Cooper Hewitt, National Design Museum Library, New York (NK9900. L3 1762a quarto):

> The Ladies Amusement; or, Whole Art of Japanning made easy. Illustrated in upwards of One Thousand different Designs, on One Hundred and Twenty-two Copper Plates; consisting, Of Flowers, Shells, Figures, Birds, Insects, Landscapes, Shipping, Beast[s], Vases, Borders, &c. All adapted in the best Manner for joining in Groupes, or being placed in single Objects. Drawn by Pillement, and other Masters. And excellently Engraved. The most approved Methods of Japanning; from the Preparation of the Subject to be decorated, to its being finished: with Directions for the due Choice of Composition, Colours, &c. &c. N.B. The above Work will be found extremely useful to the Porcelaine, and other Manufactures depending on Design.[11]

This last sentence reveals that, in spite of its title, *The Ladies Amusement* was not merely intended to help leisured women to pass their time pleasantly. The book certainly found its way into grand houses – two surviving copies have bookplates of aristocratic owners of the late 18th century – but Sayer was providing a compendium of fashionable motifs to be used as models for producers of decorative objects by both amateurs and professionals.[12] The preface to the facsimile notes that:

> many of its attractive designs have been identified on lacquered furniture, silver tea-caddies, enamels, textiles, Pontypool japanned wares and a variety of contemporary English ceramics. It was used at the manufactories of Worcester, Bow and Chelsea, probably by Josiah Wedgwood and also by Sadler and Green of Liverpool for their tiles.

A second edition, described as such on the title page, with 200 plates, was issued within six years and sold for five guineas coloured and £1.10s plain. Copies include the volume from which the facsimile was made and others in the

National Art Library at the Victoria and Albert Museum (Special Collections, 11.RC.N.5), the Department of Drawings and Prints at the Metropolitan Museum of Art (33.24) and the Morgan Library, New York (PML59354, E2 55B). These volumes consist of the 122 plates of the first edition with additions that vary slightly in each copy.

From then on the publication history of *The Ladies Amusement* becomes more complicated. Title pages of volumes at Rhode Island School of Design (TP942.6.3 1760z) and the Museum of Worcester Porcelain state that they are the 'Third Edition' with 'Two Hundred and Eighty Copper Plates', but the stock catalogue issued by Sayer in 1766 lists a third edition with 250 plates, still priced at five guineas coloured and £1.10s plain.[13] In 1775 the catalogue produced by Sayer and his partner John Bennett includes what was again described as the third edition, but with the number of plates increased to 300, priced at five guineas coloured and two guineas plain. By 1795 the firm had passed to Robert Laurie (1755–1836) and James Whittle (1757–1818); the volume appears in their catalogue, but the title has been amended to *The Ladies Amusement, and Designer's Assistant*. It now contained only 150 plates and was priced at two guineas coloured and one guinea plain.[14]

A late volume formerly in the collection of Major William Henry Tapp (1884–1959) has this amended title. Interestingly in the present context, O'Neale is named as one of the designers whose work is included: '. . . Upwards of One Thousand different Devices, Drawn by Pillement, O'Neale, and other Masters. Neatly Engraved on One Hundred and Fifty Copper Plates, with Instructions in Letter-Press . . .'.[15] The Tapp volume is, however, not entirely as described: after the first 150 plates a further 86 have been added, numbered in sequence indicating that they were intended by the publisher to be bound together. Examination of the watermarks and publication details

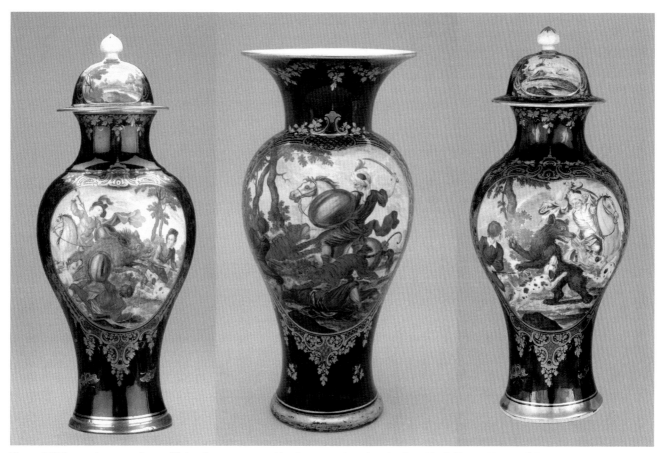

Figure 150 Three-piece garniture with hunting scenes and landscapes, signed and painted by Jefferyes Hamett O'Neale, c. 1770, Worcester, England, soft-paste porcelain, h. 38cm and smaller. British Museum, London, BEP 1923,0215.1.CR, 1923,0215.2.CR and 1923,0215.3.CR

engraved on many of the plates shows that, although they were first published in the 1750s and 1760s, this volume was reissued as late as 1821. Some of the early rococo designs have been omitted, and a few in the later neoclassical taste added, but the majority of the plates, including O'Neale's, were clearly still in demand after more than 60 years.

While the earlier volumes contain six plates attributable on stylistic grounds to O'Neale, this later volume has about 40 plates after his design usually with five motifs on each plate, and many lettered with his name.[16] Just over half of them contain designs for fables similar to the paintings on

Chelsea porcelain in the 1750s (**Fig. 152**). The remainder have a huge range of designs, delicately drawn and often with a hint of humour: animals, birds, insects, flowers, fruit and scenes with ruins and obelisks, pairs of lovers and huntsmen. There are usually about nine designs on each of these plates, together with the odd small insect or flower spray.

Reference to 'editions' of *The Ladies Amusement* simplifies its origins. All surviving copies vary to a greater or lesser extent even where they retain the same title page and this reflects the fact that the volume was actually a compilation. Sayer and other publishers would sell prints individually or in sets of different sizes to suit their customers. Artisans

Figure 151 Title page to facsimile of *The Ladies Amusement; or, Whole Art of Japanning Made Easy*. British Museum, London, P&D library E.1.36

Figure 152 Samuel Sparrow after Jefferyes Hamett O'Neale, plate from *The Ladies Amusement*, c. 1766, published c. 1821. Courtesy E. & H. Manners, London

THE
LADIES AMUSEMENT;
OR, WHOLE
ART of JAPANNING
MADE EASY.
Illustrated in upwards of Fifteen-Hundred different DESIGNS, on Two Hundred Copper Plates;
CONSISTING,
Of Flowers, Shells, Figures, Birds, Insects, Landscapes, Shipping, Beasts,
Vases, Borders, &c.
All adapted in the best Manner for joining in Groupes, or being placed in single Objects.
DRAWN BY
PILLEMENT and other Masters,
And excellently ENGRAVED.
To which is added, in LETTER-PRESS,
The most approved Methods of JAPANNING; from the Preparation of the Subject to be decorated, to its being finished ;
WITH
DIRECTIONS for the due Choice of COMPOSITION, COLOURS, &c. &c.
The SECOND EDITION,
N. B. *The above Work will be found extremely useful to the PORCELAINE, and other Manufactures depending on Design.*
LONDON:
Printed for ROBERT SAYER, Map and Printseller, at the Golden-Buck, opposite Fetter-Lane, Fleet-Street.

Figure 153 *South West View of the Three Nightingales, commonly called the Sluice House*, Jefferyes Hamett O'Neale, 1782, London, pen, ink and wash on paper, 17.5 x 22cm. British Museum, London, PD 2015,7084.1

would be unlikely to purchase volumes costing several guineas, but they would have made good use of sets of half a dozen prints for two shillings or less. Surviving catalogues of Sayer's stock and that of his successors include a substantial number of 'Drawing and Copy-Books' providing patterns to be used on decorative objects. Many can be recognised in the listings in successive catalogues for decades. In Major Tapp's late volume (see Appendix), for instance, the lettering on plate 25 shows that it also served as title page to 'A New & Useful Collection of the most Beautiful Flowers, on 20 Copper Plates, drawn after Nature By J. Pillement', a particularly fine set that appears, priced at six shillings, as no. 16 in the 1776 catalogue produced by Sayer and Bennett. Their 1775 catalogue, furthermore, has an entry on page 149 that indicates that prints found in *The Ladies Amusement* or other sets could be bought individually:

> Japanning Prints On Three hundred copper-plates, containing above 2000 new, beautiful, and decorative designs, neatly engraved, and principally adapted for the amusement of the ladies, being easily cut out, and when composed into a mass or divided into particulars; they consist of figures grouped or single, European and Chinese buildings, ornaments, landscapes, ruins, beasts, birds, insects, fruit, flowers, shells, borders, &c. &c. In short, scarce any subject, foreign and domestic, but what may be found in this collection, and may be had in sets or separate, coloured or plain.[17]

Later life
O'Neale's most successful period was from the mid-1750s to the early 1770s, but from then on his career seems to have waned. At the beginning of the 1780s he made a number of drawings in pen and ink with brown-grey wash chiefly of places that were then on the outskirts of London; several are signed with the initials 'Ô N' written in the same way as the signature on the Worcester porcelain garniture mentioned above (**Fig. 153**).[18] These drawings were preliminary studies

for prints and appeared in at least four different contexts from 1780 to 1792 or later. There were two quite distinct series published by Robert Sayer and his successors; a series of illustrations in the *London Magazine*; and others in George Walpoole's *New Universal British Traveller*. O'Neale is included in the list of 'the most capital Painters and Designers of England, Scotland and Ireland' on the title page of Walpoole's book, but examination of the illustrations shows that rather than commissioning these artists to draw new views of the British Isles the publisher, Alexander Hogg, had simply had copies made of existing prints.

No record has been found of O'Neale as a 'china painter' after 1770 and he is last known as a print designer around 1790 when he was making small views of London streets as magazine illustrations. These views are no longer populated with the active figures that enlivened his earlier designs and Hilary Young was right to say that 'even allowing for lack of skill on the part of the engraver, [they] are hack works of no distinction.'[19] A sad final record appeared in 1795: an official complaint that 'Jeffery Hamett Oneale' had become chargeable on the parish of St Sepulchre and should be returned to the nearby parish of St Dunstan where he should be cared for by the Overseers of the Poor. The parish of St Dunstan's includes Fleet Street where O'Neale's career as a designer had blossomed 30 years earlier.[20]

Appendix
Known copies of *The Ladies Amusement*
1. Smithsonian Institution Libraries, Cooper Hewitt Smithsonian Design Library, New York (call no. TP942 . L15 1760 folio). First edition, 1760, 122 plates, some missing. Uncoloured. Formerly in the collection of Major William Henry Tapp (1884–1959).
2. Museum of Worcester Porcelain, Worcester, UK (inv. no. C1/3 A31). First edition, 1760, 122 plates. Coloured.

Formerly in the collection of Charles Wilson Dyson Perrins (1864–1958).

3. Present whereabouts unknown. Second edition, 1762, 200 plates. Coloured. Formerly in the collection of Elizabeth Chellis (1903–2007) of Boston, Massachusetts, and reproduced as a facsimile volume by the Ceramic Book Company, Newport, Monmouthshire, UK, in 1959, later sold at Sotheby's, London, 20 June 1960; the Ceramic Book Company published a second edition in 1966.

4. Victoria and Albert Museum, London, National Art Library, Special Collections, London (call no. Sp.Colls. II.RC.N.5). Second edition, 1762, 200 plates. Uncoloured. Formerly in the collection of William Edkins (1813–1891), Bristol, UK.

5. Morgan Library, New York (acc. no. PML59354, call no. E2.55.B). Second edition, 1762, 200 plates, some missing. Uncoloured . Formerly in the collection of John Ward, 1st Viscount Dudley and Ward (c. 1700–1774), of Dudley, Worcestershire. Presented to the Library by Mrs E.F. Hutton (1908–2002) in 1969.

6. Metropolitan Museum of Art, Department of Drawings and Prints, New York (inv. no. 33.24). Second edition, 1762. 200 plates, title pages missing. Coloured. Purchase 1933.

7. Rhode Island School of Design, Fleet Library, Providence (call no. TP942.L3 1760z), version of the third edition, c. 1766, 280 plates, some illustrations cut out. Uncoloured. Formerly in the collection of Bernard Edward Howard, 12th Duke of Norfolk (1765–1842), later the Merrymount Press, Boston, and presented to the Library by Selma Ordewer in memory of Daniel Berkeley Bianchi (1904–1993).

8. Museum of Worcester Porcelain, Worcester (inv. no. C1/3 A32). Third edition, c. 1766, 280 plates. Uncoloured. Formerly in the collections of Anna Maria Burrough, her name is embossed in gold on the cover, and Charles Wilson Dyson Perrins (1864–1958).

9. E. & H. Manners, London. Later edition, c. 1795–1821, 150 plates, plus 86 supplementary plates. Formerly in the collection of Major William Henry Tapp (1884–1959).

10. Private collection, Jersey. Later edition, c. 1795–1821. Unseen, coloured.

Notes

1 For fuller accounts of O'Neale's career, see Tapp 1938; Hanscombe 2010.

2 Graves 1907, 184.

3 O'Connell and Baker 2011.

4 For a similar 10-piece partial Chinese porcelain tea service, also painted with *commedia dell'arte* scenes attributed to Jefferyes Hamett O'Neale, see BM, Franks. 654.c; the matching teapot is in the National Museums Scotland, Edinburgh, see NMS450.47.

5 Several examples are illustrated in Hanscombe 2010, 77–9.

6 On European prints, 'del', an abbreviation of 'delineavit' ('he drew'), is the standard abbreviation following the designer's name, invariably appearing at the lower left of the image; since lettering was the work of a specialist engraver, spelling is often inaccurate.

7 For a full account of the extraordinary attacks to which Bute was subjected, see Brewer 1973. For descriptions and digital images of prints in the British Museum now attributed to O'Neale, as well as his drawings and painting on porcelain, see www.britishmuseum.org/collection.

8 John Cooke of Paternoster Row announced in *The St James's Chronicle* on 21 September 1762 that the frontispiece to *Jemmy Buck's Witty Jester, or, The Funny Pocket Companion* was 'Adorned with a most elegant frontispiece, drawn by Mr O'Neal [*sic*]'; an advertisement in *The London Chronicle* on 17 January 1764, for Thomas Lloyd's *General History of England*, to be published in 50 numbers, stated that the first number was to include 'a whole-length print of his Majesty from a Drawing of Mr. O'Neale'.

9 Quoted in Tapp 1938, 6–7.

10 *The Ladies Amusement*, Newport, Monmouthshire, 1966; this facsimile was derived from a copy of the volume of the 2nd edition, published in 1762, formerly in the collection of Elizabeth Chellis (1903–2007) of Boston, Massachusetts.

11 The Cooper Hewitt volume was owned by Major Tapp in the 1940s; I listed the two volumes separately in Appendix III to Hanscombe 2010, 186, but having since seen the Cooper Hewitt volume that bears Tapp's annotations, I realise it is clearly the same copy.

12 The Morgan Library copy (PML59354) was formerly in the collection of John Ward, 1st Viscount Dudley and Ward (c. 1700–1774), and the Rhode Island School of Design copy (TP942.L3 1760z) was in the collection of Bernard Edward Howard, 12th Duke of Norfolk (1765–1842).

13 For a list of print-publishers' catalogues and their whereabouts, see Griffiths 1984.

14 *Robert Sayer's New and Enlarged Catalogue For the Year MDCCLXVI*, 135, no. 9; *Sayer and Bennett's Enlarged Catalogue of New and Valuable Prints*, 1775, 116, no. 17; *Laurie and Whittle's Catalogue of New and Interesting Prints*, 1795, 80, no. 9.

15 Now in the collection of E. & H. Manners, London.

16 Nos 108–13 in the facsimile (see n. 10 above).

17 'Japanning' imitated Oriental lacquer work on boxes, trays and small pieces of furniture; such objects were coated with layers of lacquer and decorated with coloured motifs, usually chinoiserie or floral designs.

18 For a detailed account of these drawings and related prints, see O'Connell 2010, 138–43, 158–63, cat. nos 135–40; the drawing of the *Three Nightingales* (cat. no. 135, p. 158) has since been presented to the British Museum by the Estate of Bernard Watney (2015,7084.1).

19 Young 1997, 220.

20 Hanscombe 2010, 13. Major Tapp's assiduous researches in London records of the latter part of the 18th century discovered a number of O'Neales and O'Neils, but none who can be firmly identified as Jefferyes Hamett or a member of his family.

Chapter 12
Propaganda on Pots: 'King Louis's Last Interview with his Family' on a Creamware Mug, 1793–5

Caroline McCaffrey-Howarth

'He was come to take his last farewell of them. We shall not attempt to describe the despair of the august sufferers' claimed an account from the *Anecdotes of the last 24 Hours of the Life of Louis the XVI*, which featured in the *Northampton Mercury* on Saturday 9 February 1793.[1] Despite such proclamations, the British public were subjected, often in harrowing detail, to this supposedly indescribable event, with a proliferation of visual and written literature, art and design that represented the tragic last interview between King Louis XVI (1754–1793) and his family, the night before his execution, which took place on 21 January 1793.[2]

Typical of these items is an English creamware quart ale mug, transfer-printed in black enamel, possibly made in Liverpool, shortly after Louis XVI's execution, which is now in the collection of the British Museum (**Fig. 154**).[3] The mug depicts the King consoling his wife Queen Marie Antoinette (1755–1793) as their children cling to them in the tower of the Square du Temple, in Paris, where they were imprisoned during the French Revolution. The printed image in an oval format is framed within a plain thin border of double lines, and enhanced with decorative laurel-leaf branches, which have been slightly cropped; they appear pendant from the rim, and again on the lower sides and above the base beneath the title. The inscription at the bottom reads 'The last interview of Louis the Sixteenth with his Family', thus confirming the subject matter for the viewer. At first glance, this ceramic printed mug is merely an artistic representation of a recent historical tragedy, yet this chapter argues it can also be interpreted as a tool of social and political agency, offering a multiplicity of meanings. The French Revolutionary imagery acting as a tool of political propaganda represents anti-Republican rhetoric; however, in showing the defeat of the French King it also alludes simultaneously to the potential disintegration of monarchical regimes, achievable through democratic revolution. Ingrained within this transfer-printed ceramic object are different cultural codes. These raise questions about Franco-Anglo relations, and British pro- and counter-Revolutionary political agendas, and reflect the changing historical and cultural discourses of the day. First, we will consider how historical context reveals the politics embedded within the cultural production of this mug. Next, particular attention will be given to its process of manufacture, and its functional and social capacity, primarily as a vessel used for toasting and tavern conversation. Finally, the motivations behind the selection of this specific print and its dual political agency will be discussed.

King Louis XVI was overthrown in August 1792 after an uprising against the monarchy occurred at the Tuileries Palace, in Paris, where the royal family had been resident. This marked the beginning of the First Republic and soon growing hostility towards the monarchy led to the decision to try the King in December 1792. Throughout the highly publicised trial the National Convention treated Louis XVI as an ordinary man; accused of betraying the nation of France, he was charged as 'a tyrant who constantly applied himself to obstructing or retarding the progress of liberty'.[4] On 20 January 1793 a sentence of death was read to Louis XVI by the Convention delegation, and he was guillotined

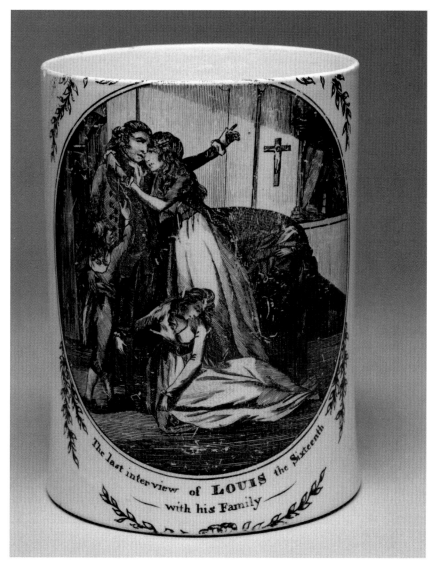

Figure 154 Mug with *The last interview of Louis the Sixteenth with his Family*, 1793–5, perhaps Liverpool, England, creamware, transfer-printed in black, h. 14.9cm. British Museum, London, 1986,1017.1

the following morning. Eleven days after his execution, on 1 February 1793, France declared war on Britain and the Dutch Republic.[5] As Peter Mandler has observed, the English reaction to the French Revolution was extremely complicated.[6] The events of the Revolution were greeted with varied responses: although many welcomed the freedom of the French Revolution, there was also anxiety about the violent treatment of the French monarchy by the Republicans, intensified by an anti-Gallican contingent in Britain, and a growing concern for the longevity of monarchical hegemonic structures.[7] At its inception many viewed the French Revolution as the epitome of the French Enlightenment, while members of the Whig party believed that France was finally moving towards a more constitutional and liberal government, similar to Britain. Even Josiah Wedgwood (1730–1795) considered the Revolution to be 'a very sudden and momentous event' from its beginning.[8] However, in 1790 the Anglo-Irish politician Edmund Burke (1729–1797) delivered an impassioned speech to Parliament asking that it reconsider its response to the French situation and contemplate the reality if such an episode were to occur on British soil:

> To have mansions pulled down and pillaged, their persons abused, insulted and destroyed . . . their families driven to seek refuge in every nation throughout Europe, for no other reason

than this, that, without any fault of theirs, they were born gentlemen and men of property, and were suspected of a desire to preserve their consideration and their estates.[9]

Burke's protestations soon influenced public opinion through the publication of his book *Reflections on the Revolution in France* (London, 1790), which highlighted the fact that the monarchy as an institution deserved respect. He deplored the treatment of the French royals, especially Queen Marie Antoinette, whom he described as a 'morning-star, full of life, and splendour, and joy'.[10] Writing to Burke in January 1790, Thomas Paine (1737–1809) confirmed Burke's worst fears, that the 'Revolution in France is certainly a forerunner to other Revolutions in Europe'.[11] As the Revolution progressed many came to agree with Burke's point of view, with the execution of the King confirming the inhumane nature of French Republican politics; as Burke lamented: 'the age of chivalry is gone'.[12] Fear continued to grow among the aristocratic and patrician classes for the future of their control, reinforced by rising Republican sentiments in England. Notably, Paine's *Rights of Man*, published in two parts in 1791 and 1792, defended the democratic and egalitarian goals of the French Revolution. Most importantly for our purposes, Paine's publications benefited from inexpensive reprinting costs and subsequently both texts circulated widely in Britain and Ireland: 20,000 copies

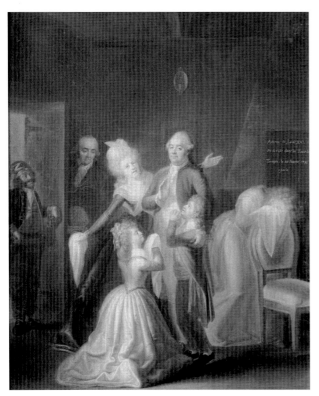

Figure 155 *Les adieux de Louis XVI à sa Famille le 20 janvier 1793*, Jean-Jacques Hauer, Paris, 1794, oil on canvas, 53 x 46cm. Le Musée Carnavalet, Paris, acc. no. P1988, 1961, gift of baronne Elie de Rothschild. Photo © RMN-Grand Palais / Agence Bulloz

Societies, first in Sheffield, and then in London and other towns from 1791 onwards. Our printed ceramic mug existed within this wider political framework of rising dissent within regional cities, as people sought greater knowledge of Republican principles that opposed the idea of a hereditary government ruled solely by the aristocracy.

Whether or not the British public sympathised with the Revolutionary Republicans, it is evident that an appetite existed for visual and written imagery relating to the tragedies that befell the royal family. This was fuelled in part by the life-size working models of the French guillotine exhibited at No. 28 Haymarket and No. 45 Oxford Street in London immediately following Louis XVI's death in 1793 and more widely by the numerous paintings, engravings, written accounts and publications dramatising the King's final hours.[14] Among the better-known paintings was *Les adieux de Louis XVI à sa famille* (1794) by the Paris-based German artist Jean-Jacques Hauer (1751–1829), now at Le Musée Carnavalet in Paris (**Fig. 155**). The American-born, London artist Mather Brown (1761–1831) created three different versions of his painting of *The Last Interview*, one of which toured the north of England and was the subject of an engraving by Peltro William Tomkins (1759–1840), published in London on 1 January 1795.[15] A similar version of *The Last Interview* by the English portrait painter Charles Benazech (1767/8–1794), which emphasised the King's Catholic faith with a strong *pietà*-like composition,[16] was engraved several times: firstly, around 1793, by Luigi Schiavonetti (1765–1810), an Italian who came to England in 1790, and then again by the Flemish engraver Anthony Cardon (1772–1813), who had only just arrived in London when it was published by Paul Colnaghi (1751–1833) on 12 September 1794, as well as

were sent to the north of Ireland, and cities such as Liverpool, Leeds and Sheffield were targeted.[13] The dissemination of such radical political ideas was even further encouraged by the establishment of Corresponding

Figures 156–7 Left to right: (Figure 156) Mug with a guillotine scene, possibly engraved by Thomas Rothwell, c. 1793–5, traditionally attributed to Cambrian Pottery, Swansea, Wales, pearlware, transfer-printed in blue underglaze, h. 8.7cm. British Museum, London, 1887,0307,H.59; (Figure 157) mug with a guillotine scene, printed by John Aynsley, c. 1793–5, Lane End, Staffordshire, England, creamware, transfer-printed in black, h. 12.2cm. British Museum, London, 1988,1201.1

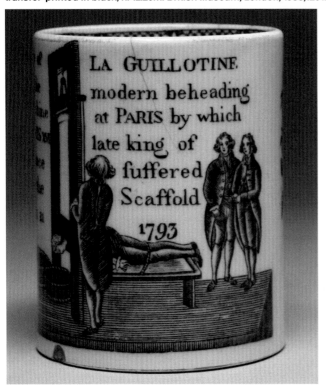

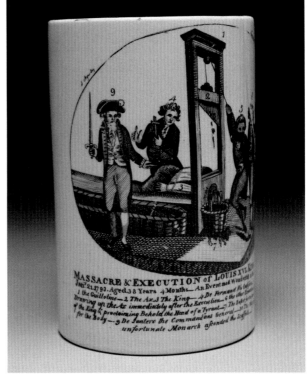

others.[17] There were also several renditions based on the work of the London portrait painter and engraver, Domenico Pellegrini (1759–1840). One entitled *The Kings Departure from His Disconsolate Family* was produced as an etching and stipple engraving by the Neapolitan London-based engraver Mariano Bovi (1757–1813), published on 1 January 1794; it became part of a six-print series published in 1806, *A Graphic History of Louis the Sixteenth, and the Royal Family of France*.[18] This rapidly expanding market for prints fuelled by the consumer revolution of the 18th century, particularly among the upper middle classes, coincided with the demand for ceramic objects that fulfilled both utilitarian and decorative functions among the middling classes.

During the 1790s, transfer-printed ceramics afforded a relatively inexpensive means of mass-producing representations of contemporary and historical events. Several other transfer-printed ceramics produced in Britain became potent vehicles for these histories, some of which featured *The Last Interview* of Louis XVI, as well as his execution by guillotine. Examples appear on ceramic mugs and jugs, including those traditionally attributed to the Cambrian pottery factory in Swansea, possibly engraved by Thomas Rothwell (1740–1807), and also on wares made in Staffordshire and Liverpool (**Figs 156–7**).[19] A slightly smaller creamware mug of Louis XVI's *Last Interview*, now at the Victoria and Albert Museum (V&A) (**Fig. 158**), provides a useful comparison with the British Museum version. Although only a few pieces apparently survive, it is likely that many more were made. The V&A printed creamware mug, from Staffordshire, depicts Louis XVI and his family in a simple cell-room, and the oval format framed within double lines beneath a drapery swag appears above a text panel: 'LOUIS XVI taking leave of his FAMILY the morning of his EXECUTION. Farewell Queen, Children, Sister, Louis cries / Abate your grief & dry those streaming eyes / And O! my Son if e'er the Crown you wear /, Think of my fate & steer your course with care'. The source of the image is a rare

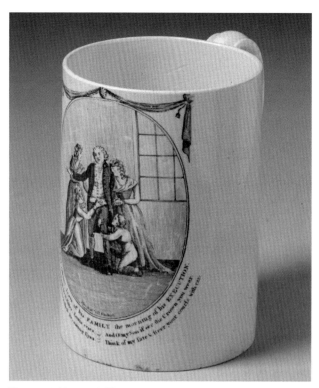

Figure 158 Mug, with *The Last Interview between Louis XVI and his Family*, engraved by Thomas Radford, printed by Thomas Fletcher & Co., *c.* 1793–5, Shelton, Staffordshire, creamware, transfer-printed in black, h. 11.7cm. Victoria and Albert Museum, London, V&A: 3638–1901. Photo © Victoria and Albert Museum, London

engraving probably published on 6 March 1793 by C. Sheppard, No. 15, St Peter's Hill, Doctors Commons, London, who specialised in cheap prints for a popular market, especially ballads.[20] It was one of many engraved versions of the scene which typically included a plain window, humble setting and a triangular *pietà*-like composition of the figures, such as a hand-coloured etching by Isaac Cruikshank (1764–1811), published on 8 March 1793 and now at the British Museum (**Fig. 159**).

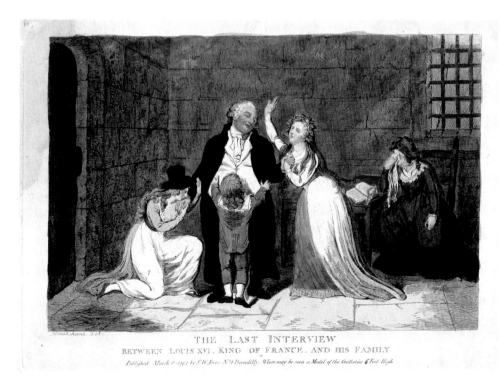

THE LAST INTERVIEW
BETWEEN LOUIS XVI, KING OF FRANCE, AND HIS FAMILY

Figure 159 *The Last Interview Between Louis XVI, King Of France, and His Family*, Isaac Cruikshank, 1793, published by S.W. Fores, 8 March 1793, London, hand-coloured etching, 27.3 x 37.6cm. British Museum, London, 1878,0511.1411

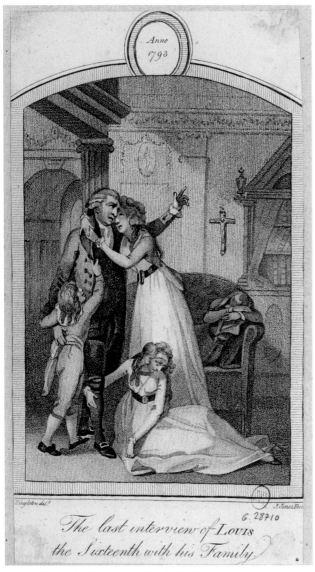

Figure 160 *The last interview of Louis the Sixteenth with his Family*, John Jones, after Henry Singleton, 1793, published by C. Lowndes, Drury Lane, London, 27 April 1793, engraving, 21.1 x 11.5cm. Musée Carnavalet, Histoire de Paris, G.28710. Image CC0 Paris Musées / Musée Carnavalet

The image on the V&A mug records the printer's name, signed in the plate, 'Fletcher & Co. Shelton'. Thomas Fletcher (1762–1802), a former Liverpool 'pot painter', moved to Shelton, in Staffordshire, around 1791, where he described himself as a 'pot printer' and became involved in several manufacturing partnerships.[21] As a 'black printer', Fletcher did not engrave the copperplates; rather he hired or commissioned engravers, and also purchased finished engraved plates. The engraving on the mug has been attributed to Thomas Radford (act. 1778–1800), who was an engraver, later based in Shelton, primarily working for the potters John and Ralph Baddeley, until his death.[22] Fletcher, who from 1796 focused on 'the Business in the Printing Line' (or 'black printing'), evidently had a large stock of plates at his disposal. On 30 August 1800, around the time of Radford's death, the *Staffordshire Advertiser* announced 'TO BE SOLD BY AUCTION . . . All those valuable COPPER PLATES, for Black Printing, late in the possession of Mr Thomas Fletcher, Black Printer of Shelton; comprising upwards of 450 well selected useful Copper Plates, of the

most approved Patterns . . . enquire of Mr. THOMAS BADDELEY, Engraver, Hanley'.[23] Fletcher was clearly an enterprising black printer whose name is frequently found on engraved designs from this period.

Capitalising on this contemporary interest in the French Revolution and the ever-increasing number of print sources, it is likely that the British Museum's printed ceramic mug was produced between 1793 and 1795.[24] This is particularly interesting as it demonstrates how quickly the market in England was reacting to larger historical events across Europe. Primarily, the transfer print is based on a little-known engraving by John Jones (act. 1745–1797), after an original drawing by the illustrator Henry Singleton (1766–1839) (**Fig. 160**).[25] It also owes much to another more widely publicised engraving by John George Murray (act. 1793–1856) once again based on a drawing by Singleton (**Fig. 161**). Although both prints after Singleton focus on the same scene, there are some differences.[26] Most notably, in one a crucifix hangs on the wall, to which Louis points directly, its presence emphasising his Catholic faith (**Fig. 160**); while in the other Louis gestures towards a globe upon a bookcase on the right-hand side (**Fig. 161**). The latter version with globe was included in a rather anecdotal, yet semi-historical publication by John Gifford (1758–1818), entitled *A Narrative of the Transactions Personally Relating to Lewis the Sixteenth, from the Period of his Evasion from Paris to his Death* (London, 1793). In 1795 Gifford's book was reprinted with several newspaper announcements championing its reissue, celebrating the engravings 'from original drawings by Singleton'.[27] Throughout the book Gifford praised the French King's paternal nature, whom he imagined had 'retained his recollection to the last', and this was represented visually by Singleton in his rather sentimental versions of King Louis XVI's *Last Interview*. Given its inclusion in various editions of Gifford's book, the print featuring the globe appears to have been disseminated more widely. Yet the print on the ceramic mug is based on the example with the crucifix, reinforcing Louis's role as a religious martyr, who is resigned to God's will. Why did the designer of the printed mug choose this particular print? Was this simply based on availability, was it less expensive or does it suggest a form of artistic agency over its political message?[28]

Certainly, there are similarities between the image selected by the potters and the numerous engraved versions circulating on the market during this period, especially given the composition and arrangement of the figures, which are characterised by the intimate setting, triangular composition of the family, dramatic hand gestures and the traumatic despair of both royal children. An emotional and sentimental atmosphere dominates, as the King is locked in an intimate embrace with his family, and in accordance with contemporary accounts, the children Marie-Thérèse Charlotte (1778–1851) and Louis-Charles (1785–1795) have collapsed at their father's feet.[29] Nevertheless, here, Louis XVI and Marie Antoinette, caught in a loving embrace, are presented in a much more youthful manner in comparison to many known prints. Louis looks directly at his wife and Queen, and not towards heaven, suggesting the importance of his role as a father and husband. Louis's sister Madame Élisabeth (1764–1794) appears as a distraught figure,

collapsed in grief onto a fashionable, curved-back sofa, a feature typically found on the right-hand side of such images. The enamel on the mug has bled in the fine hatched lines almost obscuring the figure, and it is just possible to decipher the presence of Élisabeth, of whom one single hand is distinctly visible, with another placed on top, seen in the detail in **Figure 162**.

Who controlled the politics of this chosen printed design? Some printers, such as Fletcher, relied on outside engravers for the provision of the costly copperplate engravings, many of whom would have been based in London. However, it may have also have been a regional engraver based in Liverpool who designed and engraved this copperplate of Louis XVI's *Last Interview*.[30] In Liverpool there was a longer tradition of professional engravers associated with the ceramics trade, such as Thomas Billinge (*c.* 1741–1816), who from 1794 was the proprietor of the *Liverpool Advertiser and Marine Intelligencer*, as well as Jeremiah Evans (act. 1757–1785). From the 1750s onwards, Liverpool was known for its expertise in overglaze transfer printing, championed by the onglaze printing firm of John Sadler (1720–1789) and Guy Green (d. 1799), neither of whom were engravers.[31] Both Billinge and Evans supplied Sadler and Green with engravings between 1757 and 1765. The firm famously printed on Staffordshire ware sent to them by Josiah Wedgwood, having established an ongoing working relationship with the potter in 1761, a business arrangement that continued under Green after the death of Sadler until 1795.[32] They also carried out a variety of transfer printing on pottery and porcelain from Liverpool, Longton Hall and Worcester.

By 1793–5, the British Museum's mug could have been made at a pottery in Staffordshire, South Wales, Yorkshire (mainly Leeds) or Liverpool, few of which marked their wares. Unfortunately, unlike the Victoria and Albert Museum mug, the British Museum's mug is not signed in the plate by the engraver or printer. Freelance black printers in Staffordshire and Liverpool, active around 1793–5, who signed their work and could be responsible for the printing on this mug, include: Guy Green; Thomas Fletcher; John Aynsley (d. 1829), of Lane End in Staffordshire, an engraver and black printer active from around 1788 until 1810; Richard Abbey (1754–1819), a Liverpool engraver and printer, who had been apprenticed to Sadler in 1767, before going freelance and eventually working in France, until the outbreak of war in 1793, when he returned to Liverpool; and another Liverpool black printer, Joseph Johnson (d. 1805), who signed the print on a creamware jug in the British Museum 'Jph. Johnson Liverpool'.[33] Between 1785 and 1808, Johnson established himself as a black printer near Liverpool, although apparently based in Newburgh, Lancashire. Numerous surviving examples with the Johnson imprint also incorporate the name of an engraver, such as 'R[ichar]d Abbey Sculpt', 'R[ichard]. Walker Sculpt', an engraver active in Liverpool from 1790, and 'T. Clarke Sculp'.[34] At the time, a sizeable industry was based in Liverpool, printing on wares made in Staffordshire and elsewhere, arriving via the Trent & Mersey Canal, and increasingly many of these pieces were exported to America.

Although it cannot be said with certainty where the

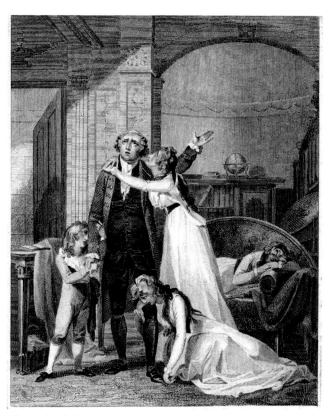

Figure 161 *The Last Interview of Louis XVI and his Family*, John George Murray, after Henry Singleton, 1793, published by W. Locke(t), 4 May 1793, London, engraving, 17.7 x 14.2cm. British Museum, London, 1871,1209.5705

British Museum mug was manufactured, its printed scene may well have been applied in Liverpool; the laurel leaves resemble those on a printed creamware jug marked 'I. Johnson', donated to the Metropolitan Museum of Art, New York.[35] As already noted, the image has been cropped to fit on the ale mug and was probably originally designed for a larger mug, plate, teapot or jug. Other more sophisticated black printers commissioned copperplates in graduated sizes appropriate to the vessels being printed on, perhaps further evidence of the immediacy in circulating it to maximise profits. The whole image with its uncropped laurel-leaf design has been found on a baluster-shaped jug, standing 24cm, paired on the other side with Louis XVI at the scaffold before his execution, 'Massacre of the French King'.[36] Rarely do two images on a vessel share a common theme, suggesting it was produced while it was still newsworthy.

Transfer printing not only enabled a more affordable means of mass-producing decorative ceramics, but they also retailed at relatively cheap prices, with printed creamware punchbowls costing between two and five shillings.[37] Measuring 14.9cm in height, this ceramic mug can be identified as a quart mug for ale, in accordance with standardised English law from June 1700, which demanded that beer or ale could only be served in a 'full Ale Quart or Ale Pint, according to the said standards' in order to combat immoral drunken behaviour.[38] It is likely, therefore, that this printed ceramic mug would have been used for drinking ale in a public tavern or private domestic interior.[39] Incorporated into the consumption habits and social activities of the middle and working classes, our ceramic

Figure 162 Detail of Figure 154 showing Madame Élisabeth on the sofa

mug with its printed imagery of a recent political and historical event may have shaped the tavern conversation or enabled the users to express certain political beliefs as they toasted and interacted with their social peers.[40]

Informed by the context and cultural production of this creamware ale mug it is now possible to consider briefly the plurality of politics behind its printed imagery. As Sean Willcock has observed, the large number of visual and written accounts of Louis's final interview with his family invited contemporaries 'to sympathise with a man being torn from his loved ones, and thus to identify indirectly with Louis's (and so Britain's) monarchical politics'.[41] Linda Colley too has argued that there was an increasing anxiety among the British aristocracy and political leaders regarding the health of King George III, which was combated by a growth in sentimental propaganda. In many ways the circulation of such sympathetic visual imagery aligned with the proliferation of literature that championed George III as a father to the British people. Notably, he was defended publicly by the poet and Reverend James Hurdis (1763–1801) in 1794 for his ability to observe 'all religious and domestic duties'.[42] Moral quandaries echoing contemporary discourse are also alluded to here: for example, in 1759 Adam Smith (1723–1790) had noted the importance of the honourable family as a symbol of moral value declaring that 'without parental tenderness [parents] appear monsters'.[43] In our *Last Interview* mug, users are reminded to be loyal to one's family and to God; this filial piety is underscored by the paternal figure of Louis, no longer a King but still a father, who gestures to the one true King and father of all Christians, represented by the crucifix on the wall. The decision to use the Jones print after the Singleton drawing with a crucifix could be interpreted as a deliberate political motif to distribute moral, religious and familial values throughout all social hierarchies, which concurrently encouraged consumers to sympathise with the monarchy and condemn the brutality of the Republican Revolutionaries. This ceramic printed mug could therefore be understood as an object of political significance located within wider strategies that sought to celebrate the role of George III as a respected constitutional monarch. However, given the rising counter-Revolutionary sentiments across Britain, especially in cities like Liverpool, where this mug was most likely produced, such a hand-held vessel could also have acted as a political tool, as it confirmed that monarchical and aristocratic power structures could be challenged, not only in France, but also in England.

Embedded with various political codes, this printed creamware ale mug is representative of contemporary interest in French Revolutionary politics. It also possessed the capacity to function within an aesthetic and decorative scheme, or as a vessel for social consumption in taverns. Its apparent mass production expanded the dissemination of Revolutionary print culture and opened up the possibilities for shaping political agendas across a wider array of social classes. By manipulating recent historical and political prints from the French Revolution onto English creamware mugs, the print designers, copper engravers, transfer printers, potters and consumers entered into a shared political economy of ceramic print design whereby a simple ale mug, representing a supposedly indescribable event, possessed the potential to act as a tool of political agency and propaganda.

Notes

1 Saturday, 9 February 1793, *Northampton Mercury*, 2.
2 In fact, there were conflicting accounts about this final interview between King Louis XVI and his family, and a lack of reliable information abounded. Some claimed to have overheard the entire conversation, and others, most importantly Louis's valet Jean-Baptiste Cléry (1759–1809), stated that, while the meeting could be seen through a glass door, 'it was impossible to hear anything'. As historian John Barrell has claimed, certain newspapers such as the *Morning Chronicle* were reluctant to present any significant account of this final meeting, see Barrell 2000, 57.
3 Acc. no. 1986,1017.1. Transfer printing on the surface of glazed vessels or plates was by this time an industrial process involving flexible 'bats' or slabs of gelatinous glue. These picked up the linseed oil that coated the engraved copperplate, which was then deposited onto the object using the glue bat, meaning it could fit onto the contours of a variety of shapes, see Hyland 2005, 11.
4 Hunt 2013, 54–5.
5 Crook 2002, 20–1.
6 Mandler 2006, 3.
7 Bindman 1989, 10–12; and also, see Quince 2010, 50.
8 Reilly 1992, 287.
9 Colley 1992, 159. It is worth noting briefly the sentimentality of Burke's particular political rhetoric, which can be understood within a wider move towards sentimentality in literature and politics from the later 1780s onwards. In part this was adopted in order to reinforce the paternal sentimentality inherent within the structure of a family system, as well as a monarchical system, in order to protect the public perception of King George III (1738–1820). Also, see Barrell 2000, 49–54.
10 Watson 2003, 40. For a more detailed discussion of Burke's influence on public opinion against the French Revolution, see Blakemore and Hembree 2001.
11 Fennessey 1963, 103.
12 Collins 1999,165.

13 The significant dissemination of Paine's Republican politics and democratic knowledge through print culture across Britain and Ireland at this time cannot be underestimated, see Verhoeven 2013, 28–70; Mee 2016, 84–7.

14 For more information on the theatrical use of the model guillotine displays, see Altick 1978, 86.

15 British Museum, 1987,1003.24; Bindman 1989, cat. 95.

16 Musée de l'Histoire de France, Château de Versailles, MV 5831; RF 2297.

17 British Museum, 1917,1218. 2929; Bindman 1989, cat. 92; and for Cardon, see a print in the Metropolitan Museum of Art (MMA), 62.557.178.

18 British Museum, 1917,1208.997; Bindman 1989, cat. 94. Other engravings based on this same scene are by engravers Carlo Deviens, published in London in 1793 (De Vinck 5104), and Carlo Lasinio (1759–1838), also published in London, around 1794 (De Vinck 5124), both of which are at the Bibliothèque nationale de France.

19 For a greater discussion of 'La Guillotine' Cambrian wares, see Tanner 2013.

20 An example was with the antique dealer Robert Pugh, Carmarthen in 2021. On 6 March 1793, Sheppard published another equally rare print of the 'Death of Louis XVI King of France who was beheaded Jany. 21 1793', with the following verse, 'When on the Scaffold he did say / Wringing his hands with upcast eyes / Receive my Soul, O God I pray / And Oh forgive my Enemies'; an example is in the Musée Carnavalet: Histoire de Paris, 18.8 x 13.7cm., inv. no. G28736. They were clearly marketed as a pair or as part of a series, as both images were transfer-printed on either side of a jug, attributed to Liverpool, in the Cyril Earle Collection, see Earle 1915, 198, cat. no. 362.

21 http://printedbritishpotteryandporcelain.com/who-made-it/ fletcher-printer (accessed 30 June 2020); see Godden 1964, 251; Smith 1970, 37.

22 http://printedbritishpotteryandporcelain.com/who-made-it/ radford-engraver (accessed 30 June 2020).

23 Hampson 2000, 45; and for Thomas Baddeley (b. 1762), see Williams-Wood 1981, 160–3.

24 David Bindman has examined in greater detail than can be afforded here the differences between the various engravings showing the King's 'final interview' with his family, see Bindman 1989, 50–2.

25 John Jones was a stipple engraver and print seller based in Great Portland Street, Marylebone in London from 1783–97. Although it is probable that a large number of these prints were produced, very few are known today. A more complete example is in the Bibliothèque nationale de France, Paris, inv. no. De Vinck, 5112.

26 Two preparatory studies for this family grouping by Henry Singleton now exist in the collection at the British Museum, inv. no. 1943,0213.13, pen and grey ink with grey wash and black chalk.

27 *Hereford Journal*, Wednesday 18 November 1795, 2; *Reading Mercury*, Monday 23 November 1795, 4; *Cambridge Intelligencer*, Saturday 21 November 1795, 1; *Kentish Gazette*, Friday 20 November 1795, 3.

28 Other prints emphasised the religious connotations, yet in a distinctly more satirical manner. Notably, James Gillray's (1756–1815) hand-coloured etching depicting *Louis XVI Taking Leave of His Wife & Family* published two months after the King's execution satirises his commitment to religion, as a monk brandishes a crucifix, see Bindman 1989, cat. 96.

29 For example, see John Bartholomew, *The Fall of the French Monarchy* (London, 1794); and *The Accusation, Trial Defence, Sentence, Execution, and Last Will, of Lewis XVI* (Edinburgh, 1793), 95.

30 Jonathan Gray has also come to the conclusion that many copperplates were indeed engraved in London and then sent on to places such as Swansea or Staffordshire for printing, see Gray 2012, 6. However, it is more likely that most prints in Liverpool were engraved there, see Hyland 2005, 11.

31 As Pat Halfpenny has noted, Sadler and Green commissioned engravers who needed 'to ensure that the depth and detail of the etched and engraved copper plates were appropriate to the printing technique employed'. See Halfpenny 1994, 14–16.

32 See Wood 2014, 17; Berg 2005, 137; Young 1999, 204.

33 See British Museum, 1971,0402.1 and 1910,0208.1

34 Williams-Wood 1981, 122 n. 10, and fig. 57, http:// printedbritishpotteryandporcelain.com/who-made-it/walker-engraver (accessed 30 June 2020); and for a Liverpool trade card engraved by R. Walker, *c.* 1800, see British Museum, D,2.508; and see n. 32, 1910,0208.1.

35 Acc. no. 14.102.428. While the decorative motif of laurel leaves feature on a variety of earthenwares at this time, these particular laurel leaves are visually similar to other pieces thought to be of Liverpool production. Such motifs also feature on a number of patriotic American scenes found on much Herculaneum pottery, see Hyland 2005, 60–1.

36 Rosebery's, West Norwood, 9 May 2006, lot 46; another jug with the same paired images was sold at Cheffin's, Cambridge, 25 June 2003, lot 24, h. 18cm. A similar, but not identical, image of the Massacre scene paired with 'Marie Ann Charlotte La Corde, assassinating Marat, the French Regicide in his own house' in the S. Robert Teitelman Collection, where the plates have illegible engraver's signatures and 'Liverpool', see Teitelman, Halfpenny and Fuchs 2010, 293, cat. 143.

37 Drakard 1992, 29–32.

38 Leadbetter 1766, 261.

39 As historians Danielle Thom and Karen Harvey have argued, towards the end of the 18th century, printed pottery including punchbowls and mugs was found frequently in commercial alehouses and taverns, see Thom 2015 and Harvey 2008, 207.

40 Taverns as sociopolitical spaces gained popularity during the Revolutionary period, especially in the 1790s in England as men and women gathered to discuss contemporary political and philosophical thought, see Chumbley 2009, 48.

41 Willcock 2013, 132.

42 Contemporary accounts including the tragedy written by John Bartholomew, *The Fall of the French Monarchy*, London, 1794, 85, reinforced the King's dedication to his family and to God as Bartholomew imagines his plea: 'May Heav'n send comfort to my weeping Queen!', Act V, Scene II; see also Hurdis 1794, 25.

43 Smith 1790, 74.

Chapter 13
Pots for Poets: Ceramics Up-Close in Japanese Prints, including Hokusai's *Everything Concerning Horses*

Mary Redfern

Sumptuously printed with glittering metallic pigments, a pitcher, basin and towel for morning ablutions sit alongside a porcelain jardinière decorated in underglaze blue (**Fig. 163**). While ceramics can sometimes be glimpsed in Japanese woodblock prints, more often than not they are relegated to the background of a scene, their depiction only cursory. In this print, 'Talisman' (*Mayoke* 馬除), designed for the Yomo-gawa or 'Four Directions Group' (四方側, hereafter Yomo poetry group) in 1822 by Katsushika Hokusai (1760–1849), however, the viewer can enjoy the details of the jardinière's landscape design and even read the characters inscribed beneath its gracefully out-turned mouth.

This elegant artwork belongs to a category of prints known as *kyōka surimono* (狂歌摺物). Translating simply as 'printed things', the term *surimono* is used to describe Japanese woodblock prints commissioned for private distribution rather than those intended for commercial sale. Produced in small editions often using luxurious techniques, *kyōka surimono* were created at the request of (mostly amateur) poets and poetry clubs during the late 18th and early 19th centuries. They are named after the concise witty verses – *kyōka* – that appear in each print.[1]

Kyōka poetry groups were conspicuous for the manner in which they bridged the social divisions of their day. Under the Tokugawa shogunate, the bulk of Japanese society was divided into a hierarchy of four hereditary groups: at the top the ruling samurai warrior class, then food-producing peasants, industrious artisans and lastly merchants (judged parasitic). When the fever for *kyōka* took hold in Edo (modern Tokyo) in the late 18th century, poetry gatherings enjoyed a mixed attendance of samurai and townspeople. In the years that followed, feudal lords, wealthy merchants, leading actors and famed artists are all known to have adopted pen names and taken their places in poetry groups, as did many women.[2]

At times, however, official endeavours towards 'moral reform' had an impact on membership of these literary salons. Under the Kansei Reforms of the 1790s, samurai were pushed to abandon frivolous recreations.[3] Against this backdrop, renowned *kyōka* master Ōta Nanpo (1749–1823), a lower-ranking samurai, was among those who publicly distanced themselves from *kyōka*, handing the name Yomo to poet Yomo no Magao (1752–1829) in 1795.[4] Such straitening of attitudes proved episodic. Magao encouraged wider popularisation of *kyōka*, and the Yomo poetry group that he led flourished. By the end of the 1820s, it extended to an estimated three thousand members, reaching far beyond the limits of Edo.[5]

Literally meaning 'wild verse', *kyōka* are by turns playful, parodic and laden with puns and allusion that the astute reader was expected to untangle. The artists selected by poetry groups to design *surimono* (as exemplified by Hokusai) could add additional layers to the game as they brought their own ingenuity to bear. Often, as here, prints were created for exchange at the New Year: in this case, celebrating the Year of the Horse in 1822.

In a game with the print's recipient, the characters inscribed upon the jardinière offer the first clue to Hokusai's visual puzzle and the poem it accompanies. Three place names are cited: 'Mii, Ishiyama and Hira'. The familiarity of these scenic locales stems from their inclusion in the 'Eight views of Ōmi' (Ōmi *hakkei* 近江八景), Japan's localised

Figure 163 'Talisman' from *Everything Concerning Horses*, Katsushika Hokusai, 1822, Japan, colour woodblock print on paper, 20.1 x 17.6cm. British Museum, London, 1937,0710,0.212

transposition of the Chinese literary and artistic theme 'Eight views of the Xiao and Xiang Rivers' *(Xiaoxiang Bajing 瀟湘八景)* introduced in the Song dynasty (960–1279). With three of the eight already in hand, the others can be sought out within the print: the long bridge of Seta spanning the basin; the 'floating' pavilion of Mangetsu Temple at Katada on the side of the pitcher; the castle at Awazu on the billowing towel that is itself a reference to the returning sails at Yabase (a rendering borrowed from Suzuki Harunobu's (1725?–1770) *Eight Views of the Parlour*); and the miniature potted pine articulating the ancient pine at Karasaki caught in night rain.[6]

The poem written by Sanseitei Ma'umi (a pen name) can be read as follows:

In the first rays

of the spring sun

on Lake Biwa

Mirror Mountain

also glitters.[7]

Completing the composition (and the source of Hokusai's initial inspiration), the poem refers to the New Year's first sunrise over Lake Biwa. Looking back to the mirror-like surface of the water in the basin, it may now be identified as

this famous lake at the heart of Ōmi province and, as a mirror, perhaps also the 'Talisman' alluded to in the print's title, *Mayoke*.[8]

Focusing on this exquisite print that solicits such close reading and others belonging to the series from which it is drawn – *Everything Concerning Horses (Uma zukushi 馬盡)* – this chapter explores the place of ceramics in Japan's still-life *surimono* prints.

Still life *in surimono*

Kyōka surimono produced in Edo during the late 18th and early 19th centuries feature many of the same subjects and genres found in Japan's commercially published woodblock prints of that time. These include genre scenes, beauties, actor prints and landscapes. Themes drawn from the literature of Japan and China are similarly common to both categories of print but are explored to a deeper level in *kyōka surimono* (a matter of little surprise given the interests of the poetry groups that commissioned them).[9] Where *surimono* diverge remarkably from their commercially published contemporaries, however, is in the rendering of carefully composed arrangements of inanimate objects or 'still lifes' (**Fig. 164**). Infrequently encountered among commercial prints, this genre flourished in *surimono*.[10]

Figure 164 *Cut Flowers and Mackerel*, Kubo Shunman, late 1790s or early 1800s, Japan, colour woodblock print on paper, 17.9 x 49cm. Chester Beatty, Dublin, CBL J 2805. Image © The Trustees of the Chester Beatty Library, Dublin

It has been suggested that the still-life genre accounts for approximately 20 per cent of *kyōka surimono*.[11] In the case of the *Horses* series, a total of 30 prints are known.[12] Of these, three prints combine to form a panoramic triptych view of horse-related locales on the Sumida River in Edo, and one shows a boy playing with shells to make the sound of a horse trotting, but the majority are still lifes, and each of the remaining 26 prints shows a diverse array of objects participating in equally diverse plays on the series' equine theme.[13] For comparison, to mark the Year of the Snake in 1821 for the Yomo poetry group, Hokusai designed the *surimono* series *Matching Game with Genroku Poem Shells* (*Genroku kasen kai awase* 元禄歌仙貝合).[14] The *Shells* series of 36 prints includes 15 still lifes, 17 genre scenes with figures, three landscapes and one depiction of animals (cranes on a beach).[15]

Figure 165 *Sweets in a Cut-glass Bowl*, Totoya Hokkei, 1821, Japan, colour woodblock print on paper, 21.6 x 19cm. Chester Beatty, Dublin, CBL J 2105. Image © The Trustees of the Chester Beatty Library, Dublin

The precursors that inspired the development of still life as a genre within *surimono* are diverse. Possible examples that have been cited include Chinese printed works (manuals on painting and single-sheet colour prints) and European still lifes encountered in print, as well as Japan's decorative arts.[16] The popularity of the genre in *surimono* may also stem from 'treasure matching' (*takara awase* 宝合) competitions hosted by *kyōka* poetry groups. At these events, unusual or intriguing objects were brought forward for examination and lyric exposition.[17] It would be tempting to imagine the exquisitely tactile glass bowl of confectioneries (**Fig. 165**) depicted by Totoya Hokkei (1780–1850), a student of Hokusai, being admired at a poets' gathering, inspiring their verses and, ultimately, the production of the print. That one of those poets was himself a confectioner makes the theory seductive, but as yet we simply do not know.[18]

As in the 'Talisman', in many cases the objects depicted in *surimono* are unlikely to represent specific real-world counterparts. As such, they fulfil a different function. Possessing an allusive potential akin to the poets' carefully chosen words, these objects evoke cherished places, passing seasons, warm sentiments and cultivated engagements.

Putting pots on paper

In still-life *surimono* ceramics are brought forward to take their place among assemblages from the scholar's desk, local specialities and exotic treasures, and the most exquisitely refined aspects of the everyday. As such, the recipient of a *surimono* may find in their hands an inkpot emblazoned with the poet's personal device (**Fig. 166**) or a sturdy wine flask from the kilns of Bizen province – local to the poetry circle whose verses it accompanies (**Fig. 167**).[19] As with the myriad other objects found in *surimono*, the inclusion of ceramics is sometimes a direct response to the poem, but by no means always. Returning to the *Horses* series, both situations are apparent.

Sanseitei Ma'umi's ode to Lake Biwa as featured in the 'Talisman' makes no mention of ceramics, but Hokusai introduces the blue-and-white porcelain jardinière as vessel and canvas for four of Ōmi's eight scenic views. Another print from this series, entitled 'Horse orchid' (*Baran* 馬蘭), features verses taking the warbler as their theme, but the aspidistra

Figure 166 *Seals, Carving Tools, Ink Box and Plum Branch*, Ryūryūkyo Shinsai, 1820, Japan, colour woodblock print on paper, 21.6 x 19cm. Chester Beatty, Dublin, CBL J 2257. Image © The Trustees of the Chester Beatty Library, Dublin

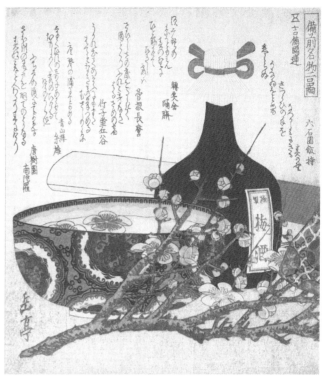

Figure 167 'Ceramic wine flask' from *Two Famous Products of Bizen Province*, Yashima Gakutei, *c.* 1823, Japan, colour woodblock print on paper, 20.5 x 18.3cm. Metropolitan Museum of Art, New York, H.O. Havemeyer Collection, Bequest of Mrs. H. O. Havemeyer, 1929, JP2115

plant of its title is contained in a similarly elegant planter.[20] As Daniel McKee has suggested, this print forms a fitting companion to 'Talisman' with Hokusai depicting and naming the renowned landscape of Matsushima upon the vessel's walls, while using the accompanying objects to allude to Miyajima and Ama no Hashidate, a scenic grouping known as the 'Three great landscapes' (*Sankei* 三景).[21]

On the other hand, the cup decorated in overglaze red resting on a lacquer saucer in Hokusai's print 'Horse-driving coins' (*Koma hikizeni* 駒曳銭) (**Fig. 168**) was probably incorporated as a vessel for tea described by poet Shōbaitei Kiraku, who wrote:

The smell of flowers

wafts over the good-luck tea

the piercing cold

of pickled plums

New Year's Eve in spring.[22]

In the print 'Sōma ware' (*Sōmayaki* 相馬焼) (**Fig. 169**), a Sōma tea bowl with its characteristic galloping horse (**Fig. 170**) is invoked in the title and aptly accommodates the poem by Shūfūen Hananushi, which also refers to tea drinking:

If conditions are just right

the buds of plants can sprout

even in the midst of light snow

in the shrine of springtime

the 'new-old' tea.[23]

As a reminder of the poets behind the print, the lidded porcelain vessel partly concealed by the cup carries the

stylised flying crane of the Shūchōdō, an affiliated sub-circle of the Yomo poetry group.

As *surimono* artists devised images to accompany the *kyōka* poets' verse they layered new meanings over the poetry. A large part of the pleasure of *surimono* is found from moving

Figure 168 'Horse-driving coins' from *Everything Concerning Horses*, Katsushika Hokusai, 1822, Japan, colour woodblock print on paper, 21.6 x 18.3cm. Rijksmuseum, Amsterdam, RP-P-1958-282

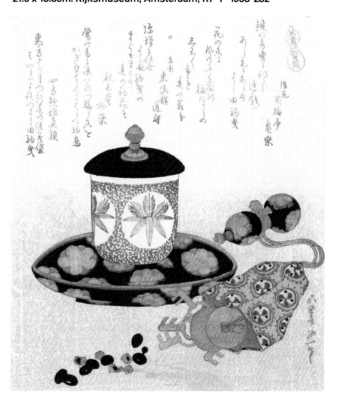

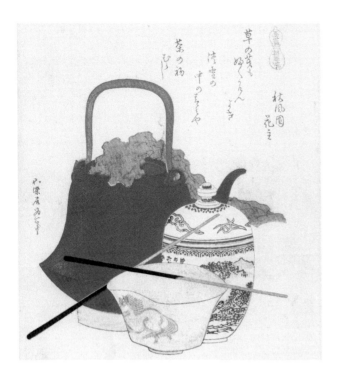

Figure 169 (left) 'Sōma ware' from *Everything Concerning Horses*, Katsushika Hokusai, 1822, Japan, colour woodblock print on paper, 20.6 x 18.3cm. Rijksmuseum, Amsterdam, RP-P-2000-211

Figure 170 (above) Tea bowl with galloping horse, 18th century, Fukushima Prefecture, Japan, Sōmayaki, stoneware, iron-oxide, h. 8.6cm. British Museum, London, Franks.1847

back and forth between these two components – text and image – to untangle the many messages therein.

Auspicious things

Introduced by either poet or artist, the ceramics in *kyōka surimono* can also be vessels for meaning. Here too there is scope to find resonance with European vanitas and memento mori still lifes of the 17th century featuring exotic porcelains weighed down with allegorical and moral significance. However, while vanitas paintings exhort the viewer to reflect upon the ultimate worthlessness of worldly luxury in the face of mortality, *kyōka surimono* tender a very different affirmation.

One of the most frequently encountered types of ceramic within *kyōka surimono*, still life or otherwise, are porcelain jardinières functioning as containers for flowering adonis (*Adonis amurensis* of the Ranunculales order). This plant can be seen in the 'Talisman' print, its yellow petals peeping out beneath the branches of the miniature pine. While the pine as mentioned above evokes one of Ōmi's eight scenic views, the adonis has its own role to play.

A hardy plant indigenous to Japan, the golden buds of adonis can be found pushing their way through the last frosts and snows to herald the spring. In this sense, its flowers stand culturally alongside those of the plum, closely associated

Figure 171 'Colts of the shōgi board' from *Everything Concerning Horses*, Katsushika Hokusai, 1822, Japan, colour woodblock print on paper, 20.6 x 18.4cm. Rijksmuseum, Amsterdam, RP-P-1958-290

Figure 172 'Plant seller' from *Eighteen Illustrations for a Ladder to the Ancient Language*, Totoya Hokkei, 1831, Japan, colour wood-block print on paper, 20.5 x 18.2cm. Chester Beatty, Dublin, CBL J 2131. Image © The Trustees of the Chester Beatty Library, Dublin

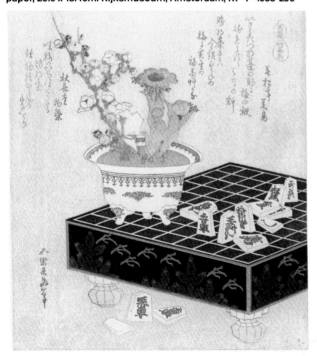

with the celebration of the New Year. Indeed, the two can sometimes be found paired together in *surimono*, as in the porcelain planter resting on a game board in the print 'Colts of the shōgi board' (*Shōgikoma* 将棊駒) also from the *Horses* series (**Fig. 171**).

With the common name *fukujusō* (福寿草) or 'plant of good luck and long life', adonis was cultivated by Edo's plant sellers as an inherently auspicious gift (**Fig. 172**).[24] The frequent recurrence of this plant in *kyōka surimono*, invariably in a ceramic planter, is a reminder of the function of these prints. During the peak of Japan's *kyōka* craze, *surimono* occupied a special place in the rounds of gift giving and celebration that ushered in the New Year among such literary circles. The driving purpose of these and other customs marking the festive period was to ensure the world's successful renewal at the turning of the year. Many *surimono*, including the *Horses* series, were produced expressly for this moment.

As a living plant its buds just beginning to open, the inclusion of adonis may test the application of the term 'still life', but it tests further the associations that the term carries. Indeed, the Japanese term *seibutsu-ga* (静物画), meaning 'still life' or '*nature morte*', was not used critically until the 1910s.[25] Rather than a moral warning of life's transience or the reflection of *nature morte*, auspicious New Year *surimono* layer the quiet reassurance of the familiar with the joyous promise of the world's rebirth.

Conclusion

Still-life compositions found a popularity among Japan's poetry groups that was not reflected in commercially published prints. Although the objects depicted within *surimono* may be imagined, the prints commissioned during the heyday of *kyōka* circles nonetheless offer a unique glimpse of ceramics from the perspective of this playful literary sphere. From tactile tea utensils to elegant jardinières, articles for the desk or for carousing, the ceramics found in *surimono* embody both exuberant luxury and cultivated refinement while repeatedly referring back to the social networks from which they are drawn. Sometimes, these ceramics take an active role in playful puzzles of allusion crafted between poet, artist and recipient. At others, they are there simply because their inclusion is natural. Perhaps it is in this that we see the true place of ceramics as suggested by *surimono*: an integral component of a world to be renewed.

Notes

1 Adopting the structure of Japan's classical *tanka* poetry but more freely conceived, *kyōka* poems comprise five lines with a total of 31 syllables, arranged 5-7-5-7-7.

2 That is not to say that these divisions were eclipsed within *kyōka* groups. Poets' hereditary status was sometimes recorded in *kyōka* books, and certain groups or circles were markedly less diverse than others, see Kok 2017, 125–9.

3 Thompson 1991, 57. As Sarah Thompson details, commercially published prints came under strict censorship during periods of reform. As works for private distribution *surimono* were treated differently. The *kiwame* ('certified') seal used from 1790 to 1842 to

indicate censors' approval of commercial prints, for example, is not found on *surimono*. However, official restrictions on private printing were effected around 1800, with a system of inspection and prohibition of excessive luxury in *surimono* at that time, see Kobayashi 2008, 53.

4 A *surimono* marking this succession is discussed in Kobayashi 2008, 47–9.

5 Carpenter 1995, 42–5.

6 Suzuki Harunobu, 'Returning sails of the towel rack' (*Tenuguikake no kihan* 手拭掛の帰) from the series *Eight Views of the Parlour* (*Zashiki hakkei* 座敷八景), *c*. 1766. An example of this print can be found in the collections of the Metropolitan Museum of Art, acc. no. JP155. The British Museum's collection includes an erotic reworking of the same subject, also by Harunobu, 1937,0710,0.41.

7 Translation from Keyes 1985, vol.1, 228.

8 The characters employed in the title of this print mean 'horse' and 'to expel', and so can be translated as 'stockade'; see the catalogue entry by Asano Shūgō in Clark 2017, cat. 115. However, the more common homophone *mayoke* means 'talisman', which with the poem's reference to a mirror – a particularly potent object in Japanese cultural tradition – solicits the translation adopted here and elsewhere.

9 Kok 2017, chapter 5; and Carpenter 2004.

10 For varied examples of still life *surimono*, see Ostier 1978.

11 Meissner 1970, 20.

12 *Kyōka surimono* were produced both as stand-alone works and in series of varying extents. The *Horses* and *Shells* series designed by Hokusai are among the larger *surimono* series produced; the largest series known that was issued as one set comprised 55 prints, see Kok 2017, 17.

13 The collections of the Rijksmuseum contain 20 of the 30 prints known from this series, including the panoramic triptych and boy playing mentioned above: Forrer 2013, cats 245–62. A further five prints can be seen in the catalogue of the Frank Lloyd Wright collection of *surimono*: Mirviss and Carpenter 1995, cats 33–4, 183–5. Examples of the remaining works are reproduced as follows: McKee 2008, cat. 164; McKee 2006, cat. 27; Schmidt and Kuwabara 1990, cat. 48; Asano 1997, cats 222, 297.

14 The use of shells to represent a Snake Year stems from shell gathering on the tidal island of Enoshima, home to shrines to the goddess Benten, herself associated with snakes. For details of this series, see Asano 1998, and Forrer and Keyes 1979.

15 Asano 1998, 35.

16 Hillier 1979, 75–6; van Rappard-Boon and Bruschke-Johnson 2000, 55; Croissant 2005, 227–9.

17 Carpenter 2011, 117–21.

18 Mirviss 2003, 28.

19 For discussion of these works, see Keyes 1985, vol. 2, cat. 289 and Carpenter 2008, cat. 42.

20 McKee 2008, cat. 164.

21 Ibid., 306.

22 Translation from van Rappard-Boon and Bruschke-Johnson 2000, 90.

23 Translation from McKee 2006, 93.

24 On the popularity of gardening, see Tōkyō-to Edo Tōkyō Hakubutsukan 2013.

25 Croissant 2005, 217.

Chapter 14
'Remember them that are in Bonds': A Plate Made for the Abolition Movement

Ronald W. Fuchs II and
Patricia F. Ferguson

In 1836 the American activist Angelina Grimké (1805–1879) wrote how abolitionists raised awareness of the plight of enslaved people by 'telling the story of the colored man's wrongs, praying for his deliverance, and representing his kneeling image constantly before the public eye on bags and needle-books, card-racks, pen-wipers, pin-cushions, &c.'.[1]

While she was referring specifically to textiles, Grimké could just as easily have been speaking of the wide range of teapots, cups, saucers, plates and other ceramics that abolitionists used to turn public opinion against slavery. Among these is a small bone china plate made between 1829 and 1845, probably at the Minton factory in Stoke-on-Trent, England, and decorated with an overglaze transfer-printed image in sepia-brown of a female figure of African descent clutching a Bible and kneeling beside her broken shackles, above the motto exhorting viewers to 'Remember them that are in Bonds' (**Fig. 173**). This seemingly modest plate illustrates the significant role that objects, women and religion played in the movement to abolish slavery in the British Empire and the United States in the first half of the 19th century.[2]

The movement to abolish slavery was one of the earliest social justice movements in the Western world. Abolitionists pioneered many tactics that are common today among advocacy groups, including the use of objects decorated with eye-catching and provocative imagery to promote their cause. Such things could be very persuasive; Benjamin Franklin (1706–1790) thought that jasperware medallions made by Josiah Wedgwood (1730–1795) decorated with an image of a kneeling enslaved man in chains imploring 'AM I NOT A MAN AND A BROTHER' would 'have an effect equal to that of the best written pamphlets in procuring favour to these oppressed people' (**Fig. 174**).[3]

Abolitionists employed objects decorated with anti-slavery imagery to help raise awareness of the plight of enslaved people, to give people a way to show that they supported the cause, and to sell to raise money to pay for other activities like lecture tours, publications and lobbying efforts. While prints and textiles probably made up the majority of the objects decorated with anti-slavery imagery, ceramics were also used to promote abolition. From the 1770s to the 1860s, ceramic medallions, vases, tablewares and especially teawares were emblazoned with images and inscriptions that confronted viewers with the suffering of enslaved men, women and children, and forced them to question whether or not slavery was wrong. In most cases, the images and inscriptions were copied from illustrations in anti-slavery pamphlets, which were published in large numbers in the 18th and 19th centuries.

The image on this plate of the kneeling woman clutching a Bible with broken shackles lying in the foreground is directly copied from the frontispiece of Mary Dudley's *Scripture Evidence of the Sinfulness of Injustice and Oppression, Respectfully Submitted to Professing Christians, in Order to Call Forth Their Sympathy and Exertions, on Behalf of the Much-Injured Africans*, a 26-page long tract that was published in London in 1828 (**Fig. 175**).[4] *Scripture Evidence of the Sinfulness of Injustice and Oppression* is a compilation of passages from the Bible condemning slavery.

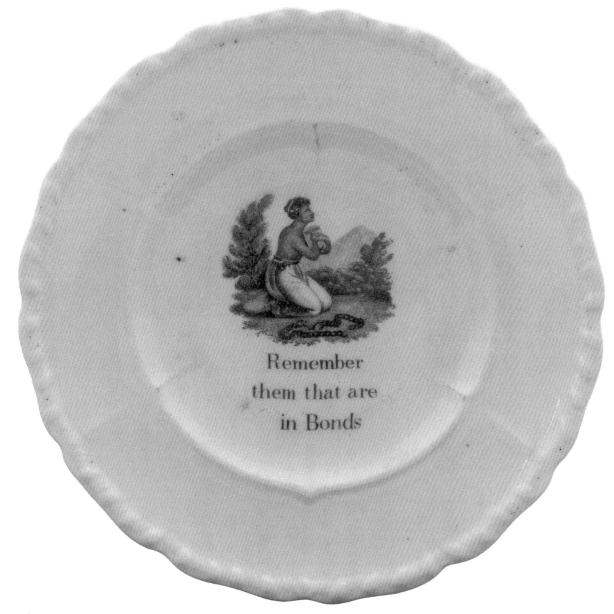

Figure 173 Plate, transfer-printed with an image of a female freed from slavery, 1829–45, attributed to the Minton factory, Stoke-on-Trent, Staffordshire, England, bone china, diam. 15.2cm. Reeves Museum of Ceramics, Washington and Lee University, Museum Purchase, inv. no. 2014.3.1

Mary Dudley (1782–1847) was a Quaker who was active in the London Female Anti-Slavery Society. Her obituary noted that:

> The education of the poor, and the abolition of Negro slavery, were objects of peculiar interest to her. During the years of anxious labour which preceded Negro emancipation in the West Indies, she was unceasing in her endeavours to make known, in this country, the wrongs of Africa, and consequent degradation of vast numbers among our fellow-subjects in those extensive colonies; thus calling forth Christian sympathy, in order to augment the weight of influence against what she was wont to call, 'our great national sin'.[5]

Dudley was part of a new generation of women active in the abolition movement. While both black and white women had been involved in the movement since its beginnings in the 18th century, they became increasingly active in the 1820s, founding women's anti-slavery societies, circulating petitions, publishing poems and prose, and raising funds by organising bazaars and making objects, usually textiles, for sale. 'Where they existed, they did everything', wrote one male activist on their contribution.[6]

In Dudley's tract the image of the kneeling woman is paired with the caption 'This Book tell Man not to be cruel; Oh that Massa would read this Book'.[7] Her tract was designed to do just that, by providing biblical evidence to be marshalled in the attack on slavery. In the first decades of the 19th century abolitionists increasingly used religion to advocate emancipation, citing biblical teachings to argue that slavery was a sin. Angelina Grimké advised those questioning the morality of slavery to:

> Read then on the subject of slavery. Search the Scriptures daily, whether the things I have told you are true. Other books and papers might be a great help to you in this investigation, but they are not necessary . . . The *Bible* then is the book I want you to read in the spirit of inquiry, and the spirit of prayer.[8]

The caption that accompanies the image in the tract does not appear on the bone china plate; instead, 'Remember them that are in Bonds' appears beneath the figure of the

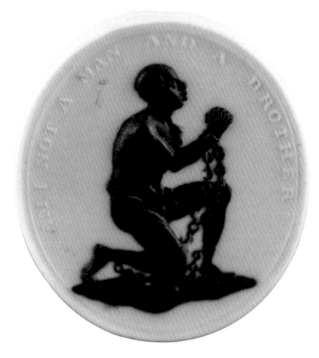

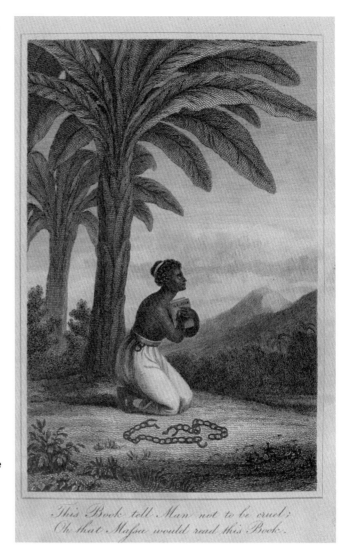

Figure 174 (above) Medallion with the seal of the Society for Effecting the Abolition of the Slave Trade, 1787–1800, Josiah Wedgwood's Etruria Factory, Staffordshire, England, jasperware (unglazed stoneware), h. 3.2 cm. Reeves Museum of Ceramics, Washington and Lee University, Museum Purchase with Funds Provided by W. Groke Mickey, 2014.27.1

Figure 175 (right) Frontispiece from Mary Dudley, *Scripture Evidence of the Sinfulness of Injustice and Oppression, Respectfully Submitted to Professing Christians, in Order to Call Forth Their Sympathy and Exertions, on Behalf of the Much-Injured Africans,* 1828, London, copperplate etching and engraving. Division of Rare and Manuscript Collections, Cornell University Library

kneeling woman.[9] The text is from the New Testament Book of Hebrews, chapter 13, verse 3: 'Remember them that are in bonds as bound with them; and them that suffer adversity, as being yourselves also in the body'. Whoever designed the plate probably thought the text that accompanied the original image in *Scripture Evidence of the Sinfulness of Injustice and Oppression* was too long, and that a shorter, pithier statement that was already in use by abolitionists would be more effective.

What was essentially an order to 'remember them that are in bonds' was a popular motto among abolitionists. It was adopted as early as 1826, when 'Remember those in bonds, as bound with them; and them that suffer adversity, as being yourself also in the body' appeared with another image of an enslaved woman on the frontispiece of the *First Report of the Female Society for Birmingham, West Bromwich, Wednesbury, Walsall, and their Respective Neighbourhoods, for the Relief of British Negro Slaves,* a pamphlet published in Birmingham, England. Variations on this biblical passage were used as a caption to images in other publications, on banners at anti-slavery fairs, on printed and embroidered textiles, and on other ceramics.[10]

Founded in 1825, the Female Society for Birmingham was the first organised, female-led abolition society. Its goal, which was mirrored by the successive female abolition societies in Britain and the United States, was the 'Amelioration of the

Condition of the Unhappy Children of Africa, and especially of Female Negro Slaves'.[11] Without the tools of political power available to men, many women focused their efforts on raising awareness of the cruel conditions in which the enslaved lived.[12] One way that they did this was by producing domestic and personal objects decorated with images that highlighted the suffering of the enslaved, especially women. The Birmingham Society, for instance, developed or borrowed a number of different images of enslaved women, which they used to illustrate pamphlets and tracts or adorn printed cloth work bags that were given away or sold (**Fig. 176**).[13] The bags were often filled with anti-slavery tracts such as Dudley's *Scripture Evidence of the Sinfulness of Injustice and Oppression,* which is known to have been distributed by several women's anti-slavery societies in Great Britain.[14]

Women also organised anti-slavery fairs, which were gatherings in which abolitionists heard lectures, bonded with one another and shopped for souvenirs whose sale generated funds for anti-slavery activities and helped spread the anti-slavery message. As a review of an anti-slavery fair held in Boston in 1837 reported:

> there was a great variety in the articles [for sale], and many of them were very handsome and tasteful. The ladies have ever regarded the pecuniary benefit derived from these sales as but one of several reasons in their favor. The main object is to keep the subject before the public eye, and by every innocent expedient to promote perpetual discussion.[15]

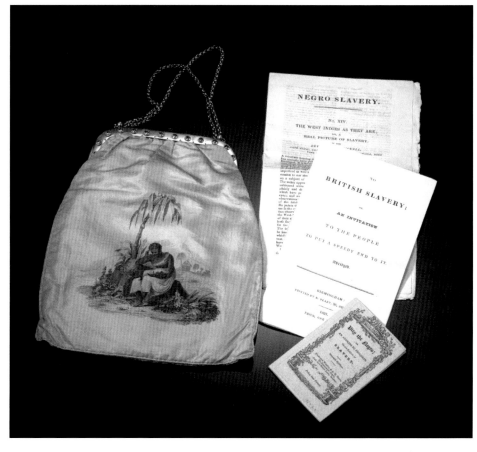

Figure 176 Work bag (reticule) printed for the Female Society for Birmingham with pamphlets, *c.* 1827, England, silk, printed, steel frame and chain, l. 23.5cm. Victoria and Albert Museum, London, V&A: T.20–1951. Photo © Victoria and Albert Museum, London

This small plate (**Fig. 173**), probably for bread and butter, muffins or cake, is part of a group of ceramics similarly transfer-printed in sepia-brown with anti-slavery images and mottoes. Most of these pieces are made of bone china, but there are also blue- or brown-tinted earthenware items, the latter known as 'drabware'.[16] All are unmarked, but their shapes, which include teawares, dessert and breakfast plates, egg cups, jugs, butter tubs, beehive-shaped honeypots, candlesticks, spill vases for matches, pen-trays and 'Nautilus' inkwells, are attributed to the Minton manufactory in Stoke-on-Trent, Staffordshire (**Fig. 177**).[17] The company was founded in 1796 by Thomas Minton (1765–1836), who with his son Herbert (1793–1858) revived the production of bone china in 1824.

The Minton family, along with many of the leading Staffordshire pottery families such as the Wedgwoods, Meighs, Keelings and Ridgways, were members of the Hanley and Shelton Anti-Slavery Society.[18] Herbert Minton and his wife, Anne (d. 1841), had also been subscribers to the Female Society for Birmingham since its founding; their names appear in the first four reports.[19]

In the *Fifth Report of the Female Society for Birmingham, . . . for the Relief of Negro Slaves*, published in 1830, Herbert Minton is mentioned not only as a benefactor but also as a supplier of 'Anti-Slavery China'. The final page of the *Fifth Report* notes that, 'Anti-Slavery China may be purchased, at prime cost, of SARAH BEDFORD & SON, New Street, Birmingham, and Associations and District Treasurers can have any quantity by writing to HERBERT MINTON, China Manufacturer, Potteries, Staffordshire.'

The Quaker Sarah Bedford (1768–1847), née Hawker, also a subscriber to the *Female Society for Birmingham, . . . for the Relief*

of Negro Slaves, was a prominent glass and china retailer with an elegant shop at 14 New Street in Birmingham (**Figs 178–9**).[20] The entrepreneurial Bedford may have even had a hand in negotiating the production of the anti-slavery china with Minton on behalf of the Female Society for Birmingham.

The scene on this small plate (**Fig. 173**) is one of three such transfer-prints on this group of wares attributed to the

Figure 177 Sugar bowl, possibly made at the Minton Factory, Stoke-on-Trent, Staffordshire, 1829–45, lead-glazed, lavender or blue-tinted earthenware. Reeves Museum of Ceramics, Washington and Lee University, Museum Purchase with Funds Provided by W. Groke Mickey 2020.4.1

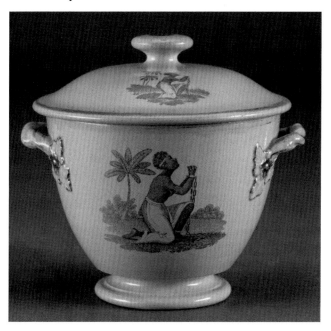

Figure 178 (far left) Trade card of Sarah Bedford & Co., 14 New Street, Birmingham, William and Thomas Radclyffe, c. 1817, Birmingham or London, etching on paper, 8.5 x 6.5cm. British Museum, London, Banks,66.5

Figure 179 (left) Trade card of S[arah] Bedford & Co., c. 1830, Birmingham, etching and engraving on paper, 19.4 x 12.4cm. British Museum, London, Heal,37.7

Figure 180 Card with Phoebe (or Quasheba) from the *Jamaica Royal Gazette*, c. 1826–8, Birmingham, Great Britain, published by the Female Society for Birmingham. Schomburg Center for Research in Black Culture, Archives and Rare Books Division, New York Public Library, New York

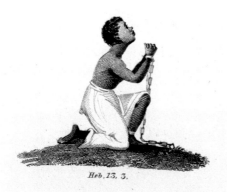

Heb. 13. 3.

PHŒBE.
Jamaica Royal Gazette, Oct. 7, 1826.
35—12 Spanish-Town Workhouse.
 Notice is hereby given, that unless the undermentioned Slave is taken out of this Workhouse, prior to Monday the 30th day of October next, she will on that day, between the hours of 10 and 12 o'Clock in the forenoon, be put up to Public Sale, and sold to the highest and best bidder, at the Cross-Keys Tavern, in this Town, agreeably to the Workhouse Law now in force, for payment of her fees.
 PHŒBE, a Creole, 5 feet 4½ inches, *marked* NELSON *on breasts, and* I O *on right shoulder, first said to one Miss Roberts,* a free Black, in Vere, secondly, to Thomas Oliver, Esq. St. John's, but it is very lately ascertained that her right name is Quasheba, and she belongs to Salisbury-Plain plantation, in St. Andrew's; Mr. John Smith is proprietor. May 11
 Ordered, that the above be published in the Newspapers appointed by Law, for Eight Weeks.
 By order of the Commissioners,
 T. RENNALLS, Sup.

 " To admit *Slave-evidence* (of course cautiously and properly guarded) and to abolish the *whipping of women,* are two desirable points, and would destroy topics used with much effect against the Colonies."
 Letter of J. R. Grosett, Esq. (a West India Proprietor,) to the Editor of the Jamaica Journal and Kingston Chronicle, August 1, 1826.

Minton factory; all are of women and are frequently accompanied by passages from the Bible condemning slavery. A second image depicts the justice-seeking, kneeling woman in shackles (**Fig. 180**). Almost certainly after the frontispiece of the *First Report of the Female Society for Birmingham, . . . for the Relief of British Negro Slaves*, the figure of a kneeling female was clearly based on Josiah Wedgwood's famous anti-slavery medallion (**Fig. 174**).[21] As the Society's unofficial emblem, it also appeared on tracts included in the albums of anti-slavery images and literature that were created by anti-slavery societies with excerpts from the *Jamaica Royal Gazette*, as here, dated 7 October 1826, where the figure is titled 'Phoebe', but also identified by her African name 'Quasheba', common in the Akan-speaking region of Ghana (**Fig. 180**).[22]

 The third image depicts a distressed mother holding a child in her lap (**Fig. 181**). This scene was printed on a range of fabric items that were made for sale or to be given away by the Female Society for Birmingham (**Figs 176, 182**).[23] During the Society's first year, 1825–6, some two thousand such work bags with different anti-slavery images were produced and distributed across Britain.[24] Some found their way to the United States, where in 1837 anti-slavery societies in Boston, New York and Philadelphia commissioned 100 pieces of silk stamped 'from the plate representing a slave mother and her infant sitting under a tree' to create purses or work bags (reticules) of their own.[25]

 It seems that such images circulated freely and were often shared with or copied by other anti-slavery organisations and manufacturers for their own products. Although the Minton factory had at least three engravers on staff around 1831, and so was capable of engraving its own copperplates, there are apparently no surviving records in the Minton Archives of these anti-slavery pictures.[26] The Female Society

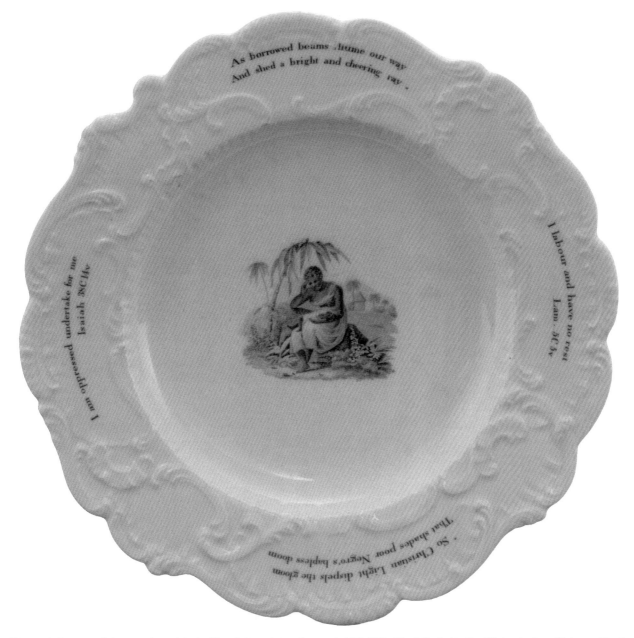

As borrowed beams illume our way
And shed a bright and cheering ray

I labour and have no rest
I am . 5C.3v

I am oppressed undertake for me
Isaiah 38.14v

So Christian Light dispels the gloom
That shades poor Negro's hapless doom

Figure 181 Dessert plate, transfer-printed with a distraught mother and child, 1829–45, attributed to the Minton factory, Stoke-on-Trent, Staffordshire, England, bone china, diam. 22.8cm. Reeves Museum of Ceramics, Washington and Lee University, Museum Purchase with Funds Provided by W. Groke Mickey, 2018.18.1

for Birmingham may have provided Minton with the engraved copperplates for these images and mottoes for their exclusive use, and when no longer required, they may have been returned to them or recycled.[27]

This image of the mother and child, and most likely the others, was by the Birmingham artist Samuel Lines (1778–1863), who was recorded on 13 April 1826 in the *Minute Book of the Ladies' Society for the Relief of Negro Slaves, 1825–1852*:

> 8th Minute That the thanks of this meeting be also presented to S. Lines, who has readily and with the utmost kindness executed all the Drawings for this Society, without receiving any remuneration for efforts which without this aid, must have cost this Society a large sum and have prevented some of its exertions for the relief of Negro Slaves and that he be likewise requested to receive on the Society's Albums, to preserve as a memento of the gratitude of its Members.[28]

While we have no idea what our plate or other comparable pieces cost, transfer-printed bone china was not terribly expensive, making them something that would have been easily afforded by a middle-class consumer. Not surprisingly, similar examples whose history is known belonged to committed abolitionists.[29] A tea and coffee service is believed to have been owned by Jane Moor Fisher (1789–1877), an Irish Quaker, living in Youghal, Co. Cork, who was described as a 'zealous supporter of the anti-slavery cause' in her obituary in the *Annual Monitor* (1878); it is now in the Special Collection of the Library of the Religious Society of Friends (Quakers) in Britain, London (**Fig. 183**).[30] The service is in the Minton factory's Shape 'G', 'Berlin Embossed', recorded in the Shape Book, *c.* 1827, identified by its raised vine and grape bunch moulding.[31] Around the rim are Minton's stock scattered bouquets printed in sepia framing an anti-slavery image.[32] All three figural images are included but there are no mottoes.

Another example is a partial dessert set consisting of four dessert plates and an oval centrepiece or comport with the

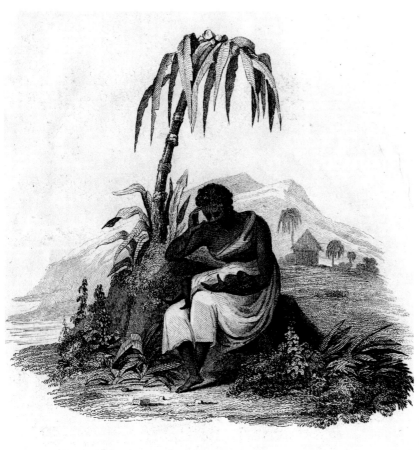

Figure 182 *An Enslaved Woman Despairingly Holding Her Child, under a Palm Tree*, after Samuel Lines, 1828, England, etching on paper, 12.4 x 13.5cm. British Museum, London, 2006,0929.43

kneeling enslaved woman image, in the National Museums Liverpool (**Fig. 184**).[33] The shape of the dessert plates is identical to that in **Figure 181**, and resembles Shape E, 'Dresden Embossed', illustrated among the teawares in the Minton factory's Shape Book, and the shape of the oval pedestal, matches Shape Q, possibly 'Bath Embossed', in the same manuscript.

This service may have been owned by the devout Quaker, prominent anti-slavery campaigner and wealthy shipping merchant James Cropper (1773–1841), of Fearnhead, near Ormskirk, or his son John Cropper (1797–1874), of Dingle Bank, south Liverpool; the family's firm, Cropper, Benson and Company, was Liverpool's largest importer of East Indian sugar.[34] Instead of emphasising the inhumanity of slavery, the elder Cropper promoted an economic argument for its gradual abolition, successfully circulated in a number of pamphlets in which he declared his own interests in East India sugar, as in his *Relief for West-Indian Distress, Shewing the Inefficiency of Protecting Duties on East-India Sugar, and Pointing Out Other Modes of Certain Relief* (London, 1823). His son John attended the well-publicised London anti-slavery convention in 1840, and in 1853 he and his wife Anne (1797–1876) entertained the American abolitionist Harriet Beecher Stowe (1811–1896), author of *Uncle Tom's Cabin* (1852), on her tour of England.[35]

A Cropper family descendant, Frances Anne Cropper Conybeare (1848–1933), described the service in her memoirs:

> The meals at Dingle were at one time served on crockery of Quaker drab specially manufactured. Each article of this ware showed a negro in chains holding up his hands as he exclaims:

'Am I not a man and a brother?' or 'Remember them that are in bonds.' Thus was the great cause of negro emancipation kept before the minds of those who partook of the hospitality of the house as they glanced at the plates, the beehive honeypot, the candlestick each with its touching appeal.[36]

That our small plate, like so many of the ceramics decorated with anti-slavery images, is from a tea set is not coincidental. Tea drinking was an important social ritual in the 1800s, and the tea table, around which people gathered for companionship and conversation, was seen as an opportunity for voicing anti-slavery sentiments. Tea drinking was especially associated with women, who shared their anti-slavery message with family and friends at teatime. One early anti-slavery poem by William Cowper (1731–1800) was even subtitled *A Subject for Conversation at the Tea Table*, suggesting just how anti-slavery writings and teaware decorated with anti-slavery imagery were deployed to provoke and facilitate discussion.[37]

By decorating teawares, desk sets, breakfast and dessert services, which were used in genteel and feminine activities, abolitionists also domesticated and normalised the idea of abolition. The calls for abolition were expanded from just the male-dominated public sphere to include the female-dominated home. This helped the message reach new audiences, especially women and children.[38] The choice of images and text, such as the kneeling enslaved woman holding a Bible on our plate, also made abolition less threatening. The reference to a shared humanity and a shared Christian faith between black and white was designed to arouse sympathy, not fear. The woman is shown praying, or even pleading, literally on her knees, for

Figure 183 Cake plate, transfer-printed with the figure of a distraught mother and child, 1829–45, attributed to the Minton factory, Stoke-on-Trent, Staffordshire, England, bone china, w. 24cm. © The Library of the Religious Society of Friends (Quakers) in Britain, London

Figure 184 Centrepiece, transfer-printed with justice-seeking kneeling female figure, still shackled, 1829–45, attributed to the Minton factory, Stoke-on-Trent, Staffordshire, England, bone china, 33.5 x 28 x 16.2cm. National Museums Liverpool, The International Slavery Museum

salvation, in the form of better treatment at least, if not for freedom. Her stance mirrors that of other anti-slavery imagery that shows enslaved Africans as powerless, on their knees, imploring heaven or white society for their freedom.[39]

In 1837 the Philadelphia Female Anti-Slavery Society wrote that:

We have this year held a sale of useful and fancy articles, from which we have received unexpected pecuniary profit ... Most of the articles were adorned with anti slavery prints, or appropriate mottos. The most important results of such sales, is, we think, the silent, unobtrusive, and extensive dissemination of anti-Slavery truth. The form of the chained

and kneeling slave, pictured on needle book or a pin-cushion, may arouse the latent sympathies of many a heart, and suggest to many a conscience the reproving inquiry, 'What hast thou done for the redemption of thy brother?[40]

Raising money, raising awareness and, most importantly, raising questions in people's minds about what they should do to end slavery was the purpose of objects like this small plate (**Fig. 173**). As one activist noted, 'when pincushions are periodicals, and needle-books are tracts, discussion can hardly be stifled, or slavery perpetuated'.[41]

Notes

1 Grimké 1836, 23. Grimké and her sister Sarah (1792–1873), who grew up in a Southern slave-holding family, are acknowledged as among the earliest American females to publicly advocate the abolition of slavery.

2 The United States and Great Britain officially ended their respective participation in the slave trade in 1807. Slavery was abolished within the British Empire in 1834, and officially ended in 1838. In the United States, the Emancipation Proclamation freed enslaved people in states 'in rebellion against the United States' in 1863 and the Thirteenth Amendment to the United States Constitution abolished slavery in 1865.

3 Benjamin Franklin to Josiah Wedgwood, 15 May 1788, quoted in Reilly 1989, 115; and see also Bindman 2012, vol. IV, part 1, 43–50. Similar images with an enslaved kneeling female under the banner 'Am I not a Woman and a Sister?' appeared in George Bourne's *Slavery Illustrated in Its Effects upon Women* (1837), which highlighted connections between the anti-slavery and women's rights movements. While these images successfully communicated the humanitarian mission of the abolition movement, they only present one view of the enslaved, as passive people pleading for their emancipation, when in reality many Africans actively fought against their own enslavement through acts of resistance and through self-emancipation.

4 Margolin 2002, 81–109, 100. The same image appeared as a tract framed by extracts from a poem entitled 'A Negro Woman's Lamentation', published by the English religious writer and philanthropist Hannah More (1745–1833) in *Sorrows of Yamba, or the Negro Woman's Lamentation* (London, 1797); see the example in the Michael Graham-Stewart Slavery Collection at the National Maritime Museum, Greenwich, London, inv. no. ZBA2552.

5 Anonymous 1848, 40–1.

6 Midgley 1992, 44.

7 Dudley 1828, frontispiece.

8 Grimké 1836, 17.

9 The *Scripture*'s caption does appear elsewhere on a bone china jug attributed to the Minton factory in Staffordshire, in the Willet Collection, Brighton Museum and Art Gallery, see Beddoe 2015, 140, and on a drabware plate, see Margolin 2002, 100, fig. 39.

10 Margolin 2002, 101–2.

11 Midgley 1992, 44.

12 For the Society's other images of enslaved women suffering humiliation under the hands of the plantation owners, not found on Minton bone china ware, see British Museum, 2006,0929.42–44 and 64.

13 Yellin 1989, 10.

14 Midgley 1992, 58.

15 Anonymous, 1837, 3.

16 A lavender or blue-tinted earthenware jug, probably Minton, with a kneeling enslaved woman, is in the Wilberforce House Museum, Hull, inv. no. 1979.117; for drabware teawares, see Margolin 2002, figs 37–40.

17 An unmarked, bone china 'Nautilus' inkwell attributed to the Minton factory is in the Wilberforce House Museum, Hull, 1954.7 and for an unmarked bone china pen tray, see Winterthur Museum, Garden & Library, inv. no. 2003.0024; and for egg cups attributed to Minton, see Gray 2008, fig. 20. Early English bone china was rarely marked with a manufacture's name, although sometimes a pattern number was added, and Minton only began consistently marking their wares in the 1840s.

18 Jones 1998, 153 and 249, citing Hanley, Staffordshire County Council, Stoke-on-Trent City Archives, MSS Minute Book of Hanley and Shelton Anti-Slavery Society.

19 As further evidence of their interest in the abolitionist movement, around 1835–40 the Minton factory issued figural biscuit (unglazed) bone china models of anti-slavery campaigner William Wilberforce (1759–1833) and Hannah More.

20 Listed in *Pigot's Directory of Warwickshire* (1828–9 and 1835).

21 A similar subject, but reversed, appears alongside the *Third Report of the Female Society for Birmingham, . . . for the Relief of Negro Slaves* (1828), at the front of the *Album*. It was probably after a drawing by Samuel Lines (1778–1863).

22 The image was hand-painted on a work bag in the Weld Grimké Collection, William L. Clements Library, University of Michigan, formerly owned by the early activist Angelina Grimké. It was also painted on ceramics: see two bone china sugar bowls, inscribed on the reverse in gold, 'East India Sugar not made By Slaves. By Six Families using East India, instead of West India Sugar, one Slave less is required', *c.* 1825–30, h. 11.8cm, in the Museum of London, inv. no. 87.213/4, and the Colonial Williamsburg Foundation, Williamsburg, Virginia, inv. no. 1998–37. 'East India' sugar was most likely from India, although sugar was also imported into Europe from Dutch settlements in Indonesia.

23 Midgley 1992, 98. The series may have been inspired by illustrations after Robert Smirke (1753–1845), in *Poems on the Abolition of the Slave Trade*, by James Montgomery and others, published in London in 1809. Lines' original drawings, if they survive, have never been published.

24 Midgley 1992, 57, quoting from the *First Report of the Female Society for Birmingham*, 6.

25 Detailed in a series of letters at the Boston Public Library, see Taylor 2010, 121; Taylor 2008, 117.

26 See Priestman 2001 for a survey of the factory's copperplate archive before its sale by Royal Doulton; information provided by Chris Latimer, City Archivist, Stoke-on-Trent.

27 Godden 1978, 152.

28 The Library of Birmingham, Wolfson Centre for Archival Research, MS 3173/1/1.

29 A cup and saucer in the same shape and pattern as **Fig. 173**, designated 'K' in the Minton factory's Shape Book, now in the Library of the Religious Society of Friends (Quakers) in Britain, London, inv. no. M.O.37A&B, since 1916, and formerly in the collection of Joseph and Elizabeth Taylor of Middlesboro, Kentucky, was apparently purchased with money saved from not buying West Indian sugar. Thanks to Melissa Atkinson for this information.

30 Thanks to Melissa Atkinson for this information.

31 Stoke-on-Trent City Archives, Minton Archives, Minton Shape Book, SD1705/MS1584.

32 Thanks to Janis Rodwell for this attribution.

33 Inv. nos 54.124.2–5, currently on display at the International Slavery Museum, Liverpool; one of the plates is illustrated in Walvin 2005, 89, fig. 180. The service has the same four biblical texts and lines from an unidentified poem: 'As borrowed beams illume our way and shed a bright and cheering ray', 'I labour and have no rest, Lam.5C5V', 'So Christian Light dispels the gloom that shades poor Negro's hapless doom' and 'I am oppressed undertake for me, Isaiah 28C14V'. Elements from a similar dessert service are in the Lisa Unger Baskin Collection, which were acquired as a set in London in the 1970s and are now in the in the

Rubenstein Rare Book & Manuscript Library, Duke University, I thank Lisa Unger Baskin for this information.

34 The object documentation files have a note provided by the donor in 1954, 'made for Quaker, Cropper (George)'. Thanks to Nicola Scott for this information. For more on Cropper's import of East India sugar business, see Bosma 2013, 59. There is a creamware jug, made at the Herculaneum Factory, Liverpool, 1803–9, inscribed with the name of Cropper's firm advertised in the transfer print, now at Winterthur, Delaware (2007.0031.007).

35 Such wares were clearly ordered into the early 1840s, as seen in elements from a breakfast service with egg cups (Minton's Shape 'K') printed with the image of the kneeling enslaved figure, above an inscription, 'Take courage – go on – persevere to the last. Thomas Clarkson Age 84'. The inscription is a quote from a speech on 12 June 1840 given by the British abolitionist Thomas Clarkson (1760–1846), a founder of the Society for Effecting the Abolition of the Slave Trade, at the Anti-Slavery Convention held in Freemasons' Hall, in London, noted in the text, which disappointingly for many in the audience excluded female delegates. A selection was on loan to the British Empire and Commonwealth Museum, Clock Tower Yard, Temple Meads, Bristol BS1 6QH, around 2007. Anti-slavery china may still have been for sale in 1845. An unmarked Minton tea set, of Bath shape, c. 1835–40, with scenes of the kneeling enslaved figure, in the collection of Historic New England, Boston, Massachusetts (1961.168A), was once owned by James Buffum (1807–1887), a Quaker and politician from Lynn, Massachusetts, who was in England in 1845, accompanying Frederick Douglass (1817–1895), a former slave and author, on an abolitionist speaking tour.

36 Conybeare 1925, 56–7, cited in Burman 1996, 17. Thanks to Nicola Scott for this reference. To date no examples from the Minton group have been identified with a black male figure and the famous quote. However, a rare unmarked Staffordshire covered sugar bowl, c. 1830, produced elsewhere, printed with a kneeling enslaved man above the motto 'AM I NOT A MAN AND A BROTHER', is in the collection of the Friends Historical Library of Swarthmore College, Swarthmore, Pennsylvania.

37 William Cowper, *Pity the Poor Africans*, 1788, quoted in Midgley 1992, 32.

38 Atkin 1997.

39 Guyatt 2000, 99–100.

40 *Philadelphia Female Anti-Slavery Society* 1833–8, 37–8.

41 Anonymous 1838, 6.

Chapter 15
Appropriated Heroes: Prints, Pots and Political Symbols in Revolutionary China

Mary Ginsberg

Revolutionary societies require a political vocabulary for people to deal with rapid change. Images and text make unfamiliar ideas comprehensible. In newly established communist countries, for example, concepts such as 'class struggle' and 'five-year economic plan' would have been meaningless to most citizens. New symbols clarify and promote revolutionary goals. Some symbols are ideology-specific: in the communist case, again, the hammer and sickle. Others take on varied meanings, such as the red five-pointed star, which had military significance long before the Bolshevik Revolution, but was ubiquitous in communist states.[1]

The propaganda of revolutionary societies uses multiple and mutually reinforcing forms of iconography. The same message appears on calendars, posters, stamps, magazine covers and, of course, on less ephemeral objects such as prints and ceramic pots. Peter Chelkowski and Hamad Dabashi describe such mobilisation programmes as 'the massive orchestration of public myths and collective symbols . . . the crescendo of common memories and shared sentiments'.[2]

The visual language of revolution, then, includes the old and familiar, as well as the new and radical. While declaring the overthrow of the old society and everything it stands for, revolutionary authorities also employ aspects of traditional culture: time-honoured formats, myths and designs help people adapt to new rules and ideas. In China, folk art was an important strand of propaganda, prescribed by Mao Zedong (1893–1976) as early as 1926. Formats such as New Year prints, or *nianhua*, were readily accepted by the rural population, using instantly recognisable symbols, like peaches and dragons.[3] Motifs and legends took on new forms. Familiar door gods appeared in the uniform of the People's Liberation Army (PLA): everyone understood who the new protectors were.

A number of motifs would be recognisable to all in China. Appearing on various media, they are often identical. What is more interesting is when similar images carry different meanings – or, better still, get appropriated by different actors over time, to refer to something else altogether – sometimes not part of the propaganda programme at all.

Most of the objects included here are in the collections of the British Museum. The selection of revolutionary ceramics used to be quite limited, mainly heroic sculptures and some commemorative dishes. In 2013 the Museum received a donation of 373 teapots (with a few cups) from Professor Alfreda Murck, who collected them during her years living in Beijing. These span the 20th century, and many have iconographic significance. The 20th-century revolutionary prints collection is rich and diverse, so the hard part was choosing from the numerous relevant works.

Shared motifs

After the establishment of the People's Republic of China (PRC) in 1949, all arts production was mobilised in the service of the state. Continuing the Maoist policies adopted during the 1942 Yan'an Conference on Literature and Art, there was to be no art for art's sake.[4] Rather, art was to edify the masses (workers, peasants, soldiers). Artists were to learn from the masses, immersing themselves in the people's lives to create work of ever-improving quality and revolutionary realism.

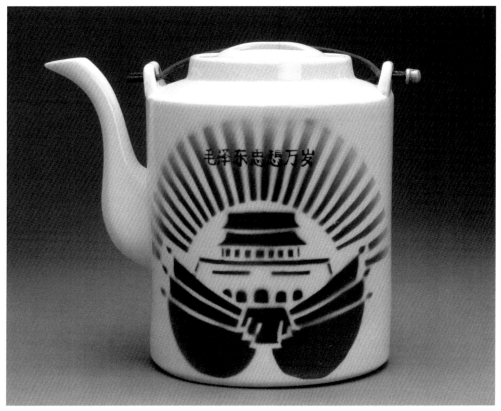

Figure 185 Teapot with Tian'anmen Gate, undated, Jingdezhen, China, porcelain, metal, h. 23cm. British Museum, London, 2013,3007.240, donated by Alfreda Murck

Similar or identical revolutionary imagery appeared on all media, and the source is often identifiable. The design on the teapot in **Figure 185** is clearly a standard one, appearing front and centre on the cover of the pattern manual published by Chen Zhifo (1896–1962), *Yingyong meishu tu'an bian* 应用美术图案编 (Applied Arts Pattern Book) (Shanghai, 1952) (**Fig. 186**). The motif shows Tian'anmen Gate (where Mao declared the founding of the PRC in 1949) under the rays of a red sun, representing rising China and, later, Chairman Mao himself.[5] The red banner below is a symbol of socialism, communism and revolution.

Printed models and instruction books were in keeping with the centuries-old tradition of painting manuals, such as the late-Ming *Ten Bamboo Studio Manual of Painting and Calligraphy* (*Shizhuzhai Shuhuapu* 十竹齋書畫譜) (first published in 1633), and Qing dynasty *Manual of the Mustard Seed Garden* (*Jieziyuan Huazhuan* 芥子園畫傳) (first volume published in 1679). Instruction manuals with propaganda motifs were made for children and their teachers, as well as for professional artists. Drawing books with step-by-step guidelines and room for copying were issued for students at each grade level.[6] Moreover, a teacher's edition was published for every issue, with instructions on how to interpret and present each image in the magazine.

Children were often shown as political actors in propaganda imagery. A 1953 teapot and a 1950 *nianhua* bear identical scenes: the lead child carries the national flag and the group behind lifts a portrait of Chairman Mao (**Fig. 187**).[7] The slogan on the 1950 print reads, 'Celebrate the establishment of the People's Republic of China', while the later teapot's inscription is 'Celebrate peace'. The image is suitable for both messages and was used on posters, magazine covers, dishes and other media throughout the 1950s, with a variety of slogans.

Selected motifs persisted for decades, sometimes crossing national boundaries. A woman driving a tractor originally appeared in the revolutionary imagery of the Soviet Union and followed in China and other communist countries.[8] The tractor is symbolic of mechanisation and progress, so a tractor-driving woman is a symbol of both economic and social development. The motif featured on early PRC stamps and banknotes and on prints and posters during the

Figure 186 Cover from a design manual, Chen Zhifo, 1952, Shanghai, China, paper, 17.1 x 14.5cm. Private collection, London

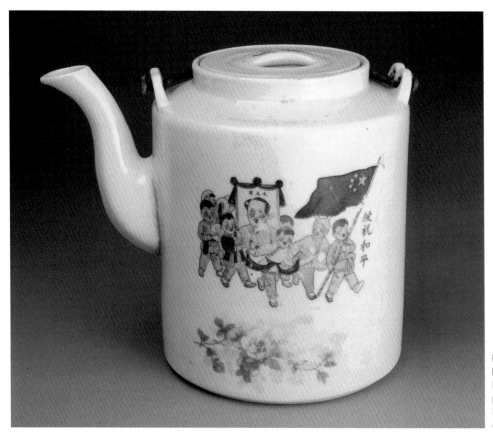

Figure 187 Teapot with children holding a portrait of Chairman Mao, 1953, Jingdezhen, China, porcelain, metal, h. 18.6cm. British Museum, London, 2013,3007.158, donated by Alfreda Murck

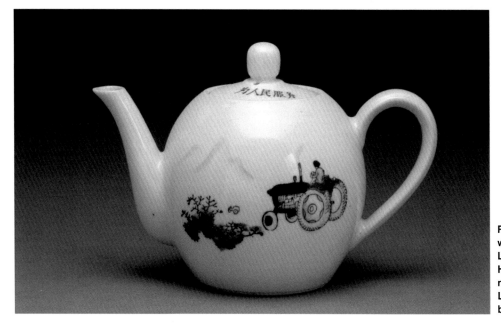

Figure 188 Small teapot with a woman driving a tractor, 1967, Lisheng Ceramic factory, Liling, Hunan province, China, porcelain, metal, h. 18.6cm. British Museum, London, 2013,3007.264, donated by Alfreda Murck

Great Leap Forward (1958–62). The image persisted into the Cultural Revolution (1966–76), in graphics and on ceramics. The slogan varied with the times and campaign. The Great Leap Forward images promote new socialist agriculture, while a Cultural Revolution teapot encourages us to 'Serve the people' (**Fig. 188**).[9]

The Great Leap Forward was Mao Zedong's attempt to catch up economically with the West, adopting drastic production methods in agriculture and industry. It failed badly and led to the death by starvation of 30–40 million people. As a result, Mao lost much of his influence, and the country turned to a more pragmatic development programme in the early 1960s. By the mid-60s, Mao wanted

to rekindle the revolution and in 1966, with the PLA and students supporting him, launched the Great Proletarian Cultural Revolution. Mao aimed to destroy old habits, traditions and beliefs, to make way for the new society. Violence and chaos ensued for about two years, but order was gradually restored under revolutionary committees. The Cultural Revolution officially ended after Mao died in September 1976.

During those years, all aspects of life were politically mobilised and propagandised. Mao's wife, Jiang Qing (1914–1991), controlled cultural production, performance and display. Her preferred art forms were revolutionary opera and ballet, and her few approved creations were ubiquitous.

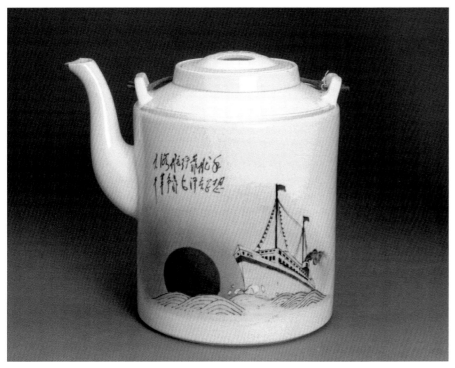

Figure 189 Teapot with a rising sun and boat, 1966–76, Jingdezhen, China, porcelain, metal, h. 27cm. British Museum, London, 2013,3007.255, donated by Alfreda Murck

Figure 190 *Sunrise at Nanhu* (South Lake), Shi Handing, 1981, China, printed in ink and colour on paper, 40.8 x 54.5cm. British Museum, London, A1992.0716,0.169

Illustrations of the model works, their characters and stories, appeared on posters, comic books, calendars, dishes and teapots. Their presentation followed the prescribed formula, 'red, bright, shining' (*hong, guang, liang* 红光亮). The heroic characters and important scenes in these works are readily identifiable from standard iconography in all formats, whether graphic, ceramic or performative. Several of the Murck teapots depict these operas and many present other familiar imagery from the Cultural Revolution.[10] The British Museum also houses a number of ceramic figural groups – revolutionary heroes – in the style of this period.[11]

The iconography may look similar on several pieces – ceramics, graphics and/or other media – but the messages or campaigns are unrelated. They may be promoting specific

policies or long-term propaganda themes. Sometimes the message is spelled out in a slogan; at other times, viewers have to know their semiotics. A red boat and sunrise signify two unrelated themes on a teapot and print (**Figs 189–90**). Both motifs on the Cultural Revolution-era teapot refer to Chairman Mao, which says: 'When sailing on high seas, rely on the helmsman; when making revolution, rely on the thought of Mao Zedong'. The Mao personality cult during the Cultural Revolution exceeded anything known before: billions of badges, posters, dishes and myriad other objects were adorned with Chairman Mao or referential icons. Among his other titles, Mao was the 'Great Helmsman' and the 'reddest red sun in our hearts'. The imagery on this teapot, therefore, is all about Chairman Mao.

Figure 191 *Great Criticism*, 1966–76, China, ceramic, glazed, h. 37cm, w. 25cm. British Museum, London, 1998,1216.1-6

In Shi Handing's (b. 1930) 1981 print, the same motifs – rising red sun and boat – refer to the founding of the Chinese Communist Party (CCP) in 1921. This is recognisable because the boat is a well-known one. The first congress of the CCP was held secretly in Shanghai, but the police found out about it, so the delegates moved the last session to this boat on South Lake (Nanhu). The distinctive boat is not consistently shown in red, as in this print, but it is always followed by the little one. A Chinese scholar visiting the British Museum saw the print and remarked, 'When Westerners see a man and woman riding a donkey under a star, they know it's about the birth of Jesus. When Chinese see this boat, it's about the birth of the Communist Party.'

The teapot was made at a state-run pottery in Jingdezhen, Jiangxi province, and was therefore official production. The print was made several years after the Cultural Revolution, when artists were relatively freer to choose their own styles and subject matter. Art for art's sake was permitted in the early 1980s: without the red boat, the print is a landscape at sunrise.

In the late 1980s and early 1990s artists availed themselves of the sometimes freer cultural atmosphere, commenting on rapidly changing social and political conditions. Wang Guangyi (b. 1955) combined Cultural Revolution imagery with Andy Warhol's (1929–1987) pop style to criticise consumerism and the commodification of life in China. His well-known *Great Criticism* series (Coca-Cola, Prada, Nike, Bentley, etc.) employed the heroic workers, soldiers and cadres seen, for example, in this Cultural Revolution tile (**Fig. 191**).[12] The ceramic tile is from

a set of six in the British Museum, also called *Great Criticism*, whose target was anti-revolutionary capitalist readers.[13]

Scholars have analysed Wang's deliberately ambiguous stance: 'To leftists, particularly in this period of retrenchment, it read as a politically satisfactory critique of capitalism and China's commodification; to others, after the fall of the Berlin Wall, it suggests the opposite, the inevitable victory of capitalism over leftist ideology.'[14] Appropriating standard propaganda imagery made it difficult to ban, whatever the artist's intention. It is ironic that the critic of commercialisation made his point profitably in oil paintings, prints and silkscreened T-shirts. Wang made countless versions of this theme, some of which sold for over a million dollars apiece.

Appropriated heroes

While ceramic tiles and Wang Guangyi's works feature stock figures – worker, farmer, soldier and cadre – named individual characters have also been appropriated and adapted over the decades, used officially, aesthetically and in protest. These include both historical and fictional heroes.

Lei Feng (1940–1962) is China's most famous model soldier/citizen. His father was killed by the Japanese during the War of Resistance to Japan (1937–45), and his mother killed herself after abuse by a rapacious landlord. This left Lei Feng an orphan, who was brought up in a state institution. He joined the PLA and was extremely loyal to the Communist Party and to Chairman Mao. His goal was to serve the revolution, socialism and communism. He darned his fellow soldiers' socks, read stories to children, gave his money to poor people and helped old women cross the street. He died in a freak accident, when his best friend drove backwards into a telephone pole, which fell over and killed him.[15]

The following year, on 5 March 1963 seemingly out of the blue, Chairman Mao gave the instruction (in his authoritative, easily recognisable calligraphy) to 'Learn from Comrade Lei Feng' ('*Xiang Lei Feng tongzhi xuexi*' 向雷锋同志学习). Lei Feng's diary was found, listing all his 'anonymous' good works, and it turned out that someone had taken a great many photographs of him performing these deeds.[16]

He has been promoted as a model of selflessness and modesty ever since. Every year on 5 March, China celebrates Learn from Lei Feng Day, when all citizens are encouraged to perform altruistic deeds for others. His legend has survived the many twists and turns of Chinese politics. During the Cultural Revolution, Lei Feng was portrayed as Chairman Mao's loyal soldier. In the 1980s, with policy focusing on education and the Four Modernisations, children were encouraged to 'Study as hard as Lei Feng'.[17]

He is commemorated with statues, parks, a museum, memorial hall and other landmarks. The British Museum has at least ten posters of Lei Feng, several prints and four ceramic pieces (teapots and sculptures).[18] There are scores of different posters in other collections.[19] An online game, *Learn from Lei Feng* (*Xue Lei Feng* 学雷锋), was launched in 2006. However, Lei Feng seems to have lost some of his popular magic in recent years, and many people are openly cynical about the story. A new Lei Feng campaign was unveiled on 5 March 2013, the 50th anniversary of Mao's original proclamation.

Three full-length documentary films were released, but were screened to empty theatres all over China.[20]

A recently acquired painting in the British Museum highlights a different aspect of the legend (**Fig. 192**): Lei Feng should be emulated for his outstanding, well-publicised deeds, but also because he was a completely ordinary, unremarkable man, and the revolutionary machine needs those people. Our hero wrote that he wanted to serve as a 'never-rusting nail', the ever-trusty cog in the wheel: 'It is only by the many, many interconnected and fixed screws that the machine can move freely, increasing its enormous work power. Though a screw is small, its use is beyond estimation. I am willing to be a screw.'[21]

Qu Leilei (b. 1951) included Lei Feng in his *Empire* series, using Qin Shihuang's (259–210 BC) Terracotta Army to underline this notion of institutional standardisation: the cog in the wheel.[22] Although the 8,000 terracotta soldiers all look different, they were in fact made from piece moulds. They were formed into various standing or kneeling positions, and painted with individual details, but they were, first and last, standardised figures. Putting Lei Feng into a Terracotta Army uniform pointedly conveys China's historical denial of individualism – a remarkable appropriation of this national hero.

Another hero whose story has been adapted within the national political culture is Lu Xun (1881–1936). Arguably the most important writer in 20th-century China, Lu Xun was born near the end of the fading and failing Qing dynasty (1644–1911). He is best known for his stories and essays, wherein he criticised the narrow-minded spirit, inhumanity and political darkness of late imperial and early Republican China (1912–49). He was scathing, independent and individual. He demanded change and the freedom to criticise those who resisted it. He was a leader among 1930s left-wing intellectuals, but never joined the Communist Party.

His legacy has been (ab)used by succeeding generations, interpreted to support the cultural policies of many campaigns. When rebellion has been encouraged, Lu Xun has been the foremost exemplar: a few years after he died, Mao Zedong deified him as a great, brave thinker, cultural leader and loyal revolutionary.[23] But when conformity was required, his critical polemics have been discounted. Just a few years later, as writers and artist were being 'rectified' for demanding freedom of expression, at Yan'an Mao wrote: 'Under the rule of dark forces, Lu Xun rightly fought back with burning satire and freezing irony . . . But in our communist bases, where democracy and liberty are granted in full, we do not need to be like Lu Xun'.[24] In 1957, when asked how Lu Xun would have fared under the People's Republic, Mao replied, 'If Lu Xun were still alive, he would probably not be in prison, but he would have fallen silent'.[25] Celebrated or criticised by different sides during the Cultural Revolution and subsequent political campaigns, Lu Xun today is officially regarded as the founder of modern Chinese writing and a leading light of the anti-imperialist May 4th Movement (emphasis on anti-imperialist, in conformity with the prevailing 'Century of Humiliation' historical narrative).

Outside China, Lu Xun is less well known, particularly with respect to his vital contribution to the visual arts. He

Figure 192 *Learn from Comrade Lei Feng*, Qu Leilei, 2012, London, hanging scroll, ink on *xuan* paper, 171 x 91cm. British Museum, London, 2014,3031.2/ Ch.Ptg.Add. 801, donated by the artist

founded the Modern Woodcut Movement, making prints an agent for social change. He published the works of European Expressionists, sponsoring the first exhibitions of this art and holding classes to teach printing techniques to young artists. Lu Xun considered black-and-white woodcuts the ideal revolutionary format: fast and cheap to produce and distribute, dramatic in style and content.

In China he has been revered by generations of printmakers, who have produced countless portraits of Lu Xun: not only woodblocks, but also using lithography, silkscreen and *shuiyin* (water-based ink) techniques. The British Museum holds at least seven portrait prints of Lu Xun, including one made by the revolutionary artist Li Qun (1912–2012) in 1936, a copy of which was in Lu Xun's collection when he died.[26]

The Museum also has a 1961 portrait by Zhao Yannian (1924–2014), entitled *Strong but Kind: Portrait of Lu Xun* (**Fig. 193**), which carries the inscription, 'When there are a

Figure 193 *Strong but Kind: Portrait of Lu Xun*, Zhao Yannian, 1961 (reprint 1990), Hangzhou, China, woodblock print, 29.9 x 42.1cm. British Museum, London, 1995,1113,0.37

thousand fingers pointing at a man, he gives them a stern look, but he willingly serves the worthy'. Zhao Yannian, a quintessential artist of revolutionary China, greatly admired Lu Xun and produced a 60-print illustrated version of his best-known tale, *The True Story of Ah Q (Ah Q zheng zhuan* 阿Q 正傳). The Museum holds a full copy of this masterpiece.[27] Many other pre-eminent artists illustrated the stories of Lu Xun, including Gu Yuan (1919–1996), Yan Han (1916–2011) and Zhang Huaijiang (1992–1990).

Artists and writers today invoke Lu Xun in their written and visual expressions of contemporary China. They present him as passionate critic, cosmopolitan cultural revolutionary and independent visionary: a rather different interpretation from the official account of this hero.

Monkey (*Sun Wukong*) – the imaginary hero of Wu Cheng'en's (1500–1582) novel *Journey to the West* (*Xiyouji* 西游记) – was another nonconformist, who has appeared in many guises from early modern China until today.[28] This 16th-century novel relates the extended journey of the Buddhist

Figure 195 Teapot with black peonies and a poem, painted by Luo Fatai, 1913, Jingdezhen, China, porcelain, metal, h. 18cm. British Museum, London, 2013,3007.26, donated by Alfreda Murck

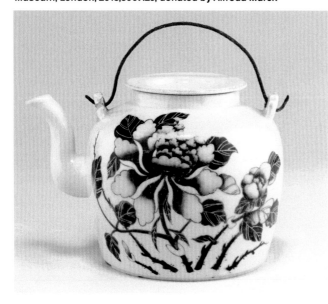

Figure 194 *Monkey Thrice Beats the White Bone Demon*, Zhao Hongben, 1977, poster, 77 x 53cm. Stefan R. Landsberger Collection, Amsterdam. Courtesy of IISH/ Landsberger Collection

pilgrim Tang Sanzang and his travelling companions: a supernatural monkey and a pig, among others. Monkey has great powers, but is a trickster hero and a rebel.[29]

The British Museum has many objects portraying Monkey, including a 17th-century coloured woodblock print that was part of Sir Hans Sloane's (1660–1753) founding gift, and a 16th-century roof tile.[30] The story is well known across Asia, and the Museum's holdings also include a 19th-century Japanese print and a netsuke featuring Monkey.[31] Those objects are illustrative of popular culture and are pre-political in intent. Two of the Murck teapots are decorated with scenes from the novel, but as they were made in the communist period may carry revolutionary meaning (more of which below).[32]

Monkey came to political fame during the 1940s in Zhang Guangyu's (1900–1965) colourful *manhua* masterpiece, *Manhua Journey to the West* (*Xiyouji manhua* 西遊記漫画).[33] Its narrative was loosely based on Wu Cheng'en's journey, but the subject was in fact the moral, political and economic bankruptcy of late Republican China. After the establishment of the People's Republic, Zhang's Monkey was the basis for China's first full-length animated film, *Uproar in Heaven* (1961 and 1964).

Monkey was also appropriated for various reasons during and after the Cultural Revolution. Mao Zedong jokingly referred to himself as a monkey king. He invoked the maverick character when supporting the Red Guards, declaring that 'It is justified to rebel'. One of the radical Red Guard factions called itself Sun Wukong.[34]

Figure 196 *The Poet-Stateman Qu Yuan*, Yang Newei, 1942, wood-block print, 16.4 x 13cm. British Museum, London, 1980,0630,0.163, purchase funded by Brooke Sewell Permanent Fund

Figure 197 *Premonition*, Zhang Zhengyu, 1966, China, pair of hanging scrolls, ink on paper, 136.8 x 33.8cm. British Museum, London, 1996,0614,0.20-1-2, donated by Yang Xianyi through Gordon Barrass

When Mao died, Jiang Qing and her three sidekicks (the 'Gang of Four', who had wielded great power) were locked up. This was extremely popular in a nation exhausted by radical politics. A poster published in 1977 shows a well-known scene from *Journey to the West, Monkey Thrice Beats the White Bone Demon* (**Fig. 194**). Poster expert Stefan Landsberger suggests this may be seen as an allegory: Monkey, who personifies the Chinese people, defeating Jiang Qing. The timing of its publication is surely appropriate, but Chinese poster designers say that it was 'pure' coincidence.[35] The two Murck teapots decorated with this same episode were made 1977–80, so within the same sort of time frame.[36] It seems less likely that officially produced ceramics would be referencing the downfall of Jiang Qing, so perhaps it was coincidental in every case. We are never likely to know.

In the succeeding decades, marked by less intense and less intrusive politics, Monkey has returned to popular culture. Our hero, variously interpreted, is the subject of a great many books, prints, comics, stage plays, films, television shows and video games.[37]

Finally, a few words about Qu Yuan (343–278 BC), whose 2,300-year legend combines political loyalty, heroic martyrdom, autonomy and integrity in the face of corruption. This loyal minister of Chu (Warring States, 480–221 BC) was twice slandered to the kings he served and twice unfairly exiled. He spent many years travelling around the countryside, collecting tales and writing poetry.[38] When Chu fell to Qin Shihuang, Qu Yuan walked into the Miluo River with rocks in his pockets and died.[39]

His story is the subject of much literature and great art. As poet and scholar, he was depicted by Li Gonglin

(*c.* 1049–1106) in the Song dynasty (960–1279), Zhao Mengfu (1254–1322) in the Yuan (1271–1368) and Chen Hongshou (1598–1652) in the Ming (1368–1644). In the 20th century, Fu Baoshi (1904–1965), Guan Shanyue (1912–2000), Huang Yongyu (b. 1924) and others have painted Qu Yuan.[40]

The British Museum has a few objects invoking Qu Yuan as dissident. A 1913 teapot, decorated with black peonies, probably signifies sorrow over the fallen Qing dynasty (1911) and the fate of those formerly in high positions (**Fig. 195**). Alfreda Murck suggests that the black monochrome peonies are a reference to Qu Yuan's last poem, *Huai sha* 懷沙 (Embracing Sand), in which he laments his life's reversals: 'White is changed to black; the high are cast down and the low made high.'[41]

In the Republican era, Qu Yuan was invoked less subtly, but with sharp dissent, by Guo Moruo (1892–1978), the left-wing writer, historian and all-round cultural giant. In his 1942 play called *Qu Yuan*, the Chu King Huai (r. 328–299 BC) stands for Nationalist leader Chiang Kai-shek (1887–1975).[42] Made in same year, Yang Newei's (1912–1982) print was probably also made as a protest against the Generalissimo (**Fig. 196**). His works often showed human tragedies caused by government failings in wartime.

A final invocation of Qu Yuan at the British Museum appears on a calligraphy by the cartoonist and painter, Zhang Zhengyu (1904–1976) (**Fig. 197**).[43] His boldly written couplet was taken from Qu Yuan's most famous poem, *Li Sao* 离骚 (Encountering Sorrow). Zhang wrote these lines in the increasingly tense atmosphere of 1966, just before the beginning of the Cultural Revolution:

I look West toward Mt Yanzi, but do not proceed,

Afraid that the shrike will sing before the equinox.[44]

Basically, the couplet means he feared that all hell was about to break loose, which indeed it did. Zhang survived rough treatment during the Cultural Revolution, but died just days after the Gang of Four were arrested in 1976.

Qu Yuan appeared again after the 1989 Tian'anmen protests in the works of Chinese diaspora artists. Within China, Qu Yuan is still the hero of state-sponsored documentaries, children's films and the inevitable online video game. He is on postage stamps of China, Taiwan and South East Asia. Everyone wants a piece of Qu Yuan.

The British Museum collections include rich holdings of Chinese political art: thousands of prints, pots, paintings, posters, badges, papercuts, sculptures and other objects. Of course, many share designs and messages. From a design perspective, aspects of production may be the most important angle. From a historical perspective, a more interesting line to follow is how the same symbols were used in propaganda campaigns delivering a variety of messages. Going a step further, I tried here to show how several symbolic figures – long-term heroes – were appropriated over time, officially and sometimes very unofficially, by different agents. The interpretations are sometimes clear, sometimes subtle, occasionally hidden: you need to know your symbols.

Notes

1 The five-pointed star has political interpretations: the five fingers of the worker's hand, the five continents and the five groups who will lead the revolution (workers, peasants, soldiers, youth and intelligentsia).
2 Chelkowski and Dabashi 2000, 6.
3 *Nianhua* are called New Year prints because they were sold in great quantities and changed in people's homes for the Spring Festival, or Chinese New Year. The term refers, however, to popular single-sheet prints, traditionally with such folk imagery as protective door gods. Folk art was a major strand of communist propaganda imagery, and *nianhua* was the main print format until around 1959. From then on, the poster format, more familiar to Western viewers, dominated propaganda graphics.
4 McDougall 1980.
5 The slogan on the teapot reads, 'Long live Mao Zedong thought' (*Mao Zedong sixiang wansui* 毛泽东思想万岁).
6 *Shaonian Ertong Tuhua* 少年儿童图画 (Young Children's Drawing) and *Ertong Tuhua* 儿童图画 (Children's Drawing).
7 For the teapot, see British Museum, 2013,3007.158; the *nianhua* is in a private collection.
8 Socialist realism has been wryly defined as 'girl meets tractor'.
9 For the teapot, see British Museum, 2013,3007.264.
10 See the following teapots: *The Red Lantern* (British Museum, 2013,3007.277); *Taking Tiger Mountain by Stratagem* (British Museum, 2013,3007.278); *The White-Haired Girl* (British Museum, 2013,3007.280).
11 For examples collected in China, donated by Gordon and Kristen Barrass, see British Museum, 1998,1006.3–6.
12 Andina and Onnis 2019.
13 British Museum, 1998,1216.1–6.
14 Andrews and Shen 2012, 260.
15 There is some debate as to the accuracy of this biography.

16 The *Diary of Lei Feng* (*Lei Feng Riji* 雷锋日记) has been reproduced in numerous versions, including an illustrated one for children. While many scholars consider it at least partly a posthumous fake, a Chinese source claims that excerpts were published in the newspaper *Progress* in 1959–60. See Osnos 2013.
17 Launched as official policy by Deng Xiaoping in the late 1970s, the Four Modernisations campaign was aimed at the development of agriculture, industry, national defence, and science and technology.
18 See, for example, two teapots, 2013,3007.283 and 2013,3007.284; and for a portrait bust, see 2005,0127.3.
19 See, for example, the Stefan R. Landsberger Collection and International Institute for Social Democracy (www.chineseposters. net).
20 *Lei Feng's Smile, Young Lei Feng* and *Lei Feng 1959*.
21 Quoted in Chan 1985, 63.
22 Qu Leilei has lived and worked in the UK since he left China in 1985.
23 Mao Zedong, 'On new democracy' (1940), quoted in Goldman 1982, 447.
24 Lovell 2010.
25 Yan 2011, 287.
26 British Museum, 1999,0705,0.8.
27 British Museum, 1993,0707,0.1–60.
28 The novel was published anonymously in 1592, but Wu Cheng'en is widely believed to be its author. It is better known outside China under the name *Monkey*, as abridged and translated by Arthur Waley (1889–1966), who was Assistant Keeper of Oriental Prints and Manuscripts at the British Museum, 1913–29.
29 Tang Sanzang is the fictional counterpart of the Chinese monk Xuanzang (602–664), who spent 17 years travelling to India for Buddhist scriptures.
30 For the print, see British Museum, 1928,0323,0.20.
31 For the carved ivory netsuke, see British Museum, F.967.
32 Macdonald 2016, 27.
33 *Manhua* is generally translated as 'cartoon', but like the Japanese word *manga*, carries broader connotations.
34 Macdonald 2016, 27.
35 Landsberger undated.
36 See British Museum, 2013,3007.326 and 327.
37 For a list, see https://en.wikipedia.org/wiki/List_of_media_adaptations_of_Journey_to_the_West (accessed 5 February 2019).
38 Qu Yuan is often called the father of Chinese poetry because the *Chu Ci* 楚辞 (Songs of Chu, better known in English as *Songs of the South*) is the first collection of verse attributed to a named poet. There is some debate as to its authorship.
39 The reasons for his suicide are uncertain, but the glow of martyrdom remains. In popular culture, his death is commemorated every year by the Dragon Boat festival, referencing the people who raced in boats to search for his body.
40 For a comprehensive account of the Qu Yuan legend, see Croizier 1990.
41 Murck 2009, 240. Black peonies do not occur in nature, as white ones do.
42 Croizier 1990, 30. This is a time-honoured device in China: use a historical figure to criticise a contemporary one, without having to name him.
43 British Museum, 1996,0614,0.20.1–2. Twin brother of Zhang Guangyu above (*Manhua Journey to the West*).
44 Translated in Barrass 2002, 121.

Bibliography

d'Agliano, Andreina 1997. 'Fonti delle decorazioni pittoriche della porcellana europea fra Rococò e Neoclassicismo', in Marilena Mosco and Edit Revai (eds), *L'immagine riflessa; dalla stampa alla porcellana*, Leghorn, 18–23.

d'Agliano, Andreina 2002. 'Fonti Iconografiche di alcune decorazioni pittoriche di Doccia', *Ceramica Antica* 3, 44–66.

d'Agliano, Andreina 2005. 'Die Gründung der Manufaktur Doccia', in Kräftner, Lehner-Jobst and d'Agliano, 77–93.

d'Agliano, Andreina *et al.* (eds) 2001. *Lucca e le Porcellane della Manifattura Ginori Commissioni patrizie e ordinativi di Corte; Lucca and the Porcelain of the Ginori Manufactory. Works Commissioned by Aristocratic Families and Court Patronage*, Lucca.

Altick, Richard D. 1978. *The Shows of London*, Cambridge, Massachusetts.

Amico, Leonard N. 1996a. *Bernard Palissy: In Search of Earthly Paradise*, Paris.

Amico, Leonard N. 1996b. 'Bernard Palissy and "Saint-Porchaire" Ceramics', *Studies in the History of Art* 52, Monograph Series II: Saint-Porchaire Ceramics, 26–51.

Andina, Tiziana and Erica Onnis (eds) 2019. *The Philosophy and Art of Wang Guangyi*, London.

Andrews, Julia F. and Kuiyi Shen 2012. *The Art of Modern China*, Berkeley and Los Angeles, California.

Andrews, Noam 2014/15. 'The space of knowledge: artisanal epistemology and Bernard Palissy', *RES: Anthropology and Aesthetics* 65/66, 275–88.

Anonymous 1826. *First Report of the Female Society for Birmingham, West Bromwich, Wednesbury, Walsall, and their Respective Neighbourhoods, for the Relief of British Negro Slaves*, Birmingham.

Anonymous 1837. 'The ladies' fair', *The Liberator*, 2 January, Boston.

Anonymous 1838. 'Ladies' fair', *The Liberator*, 12 January, Boston.

Anonymous 1848. *Annual Monitor for 1849 or Obituary of the Members of the Society of Friends in Great Britain and Ireland for the Year 1848*, York.

Antiqua.mi 2017. *Diana al bagno dipinto fiammingo del XVII secolo*, Milan, October, published at http://antiqua.mi.it/Diana_Ott17.html (accessed 30 June 2020).

Archer, Michael 2013. *Delftware in the Fitzwilliam Museum*, London.

Aretino, Pietro 1960. *Lettere: il primo e il secondo libro*, Milan.

Ariosto, Ludovico 1983. *Orlando Furioso*, trans. by Guido Waldman, Oxford and New York.

Asano Shūgō 浅野秀剛 1997. *Sujintachi no okurimono – Edo no surimono* 『粋人たちの贈り物 – 江戸の摺物 (Gifts of the connoisseurs – Edo Surimono), Chiba.

Asano Shūgō 浅野秀剛 1998. 'Surimono Genroku kasen kai awase to Uma zukushi o megutte' 「摺物「元禄歌仙貝合」と「馬尽」をめぐって」 (Regarding the Surimono Series *Matching Game with Genroku Poem Shells and Everything Concerning Horses*), in Asano Shūgō 浅野秀剛 and Yoshida Nobuyuki 吉田伸之 (eds), *Ukiyo-e o yomu* 4: Hokusai 『浮世絵を読む 4：北斎』 (Reading Ukiyo-e 4: Hokusai), Tokyo, 33–50.

Atkin, Andrea 1997. '"When pincushions are periodicals": women's work, race, and material objects in female abolitionism', *ATQ: American Transcendental Quarterly* 11(2), 93–113.

Attwood, Philip 2003. *Italian Medals c.1530–1600 in British Public Collections*, London.

Audiat, Louis 1868. *Bernard Palissy: étude sur sa vie et ses travaux*, Paris.

Ayers, John 1969. *The Baur Collection, Geneva: Chinese Ceramics*, 4 vols, Geneva and London.

Bachmann, Roberto 2018. 'Chinese porcelain ordered by Portuguese Jews in the diaspora', in Claude B. Stuczynski and Bruno Feitler

(eds), *Portuguese Jews, New Christians, and 'New Jews': A Tribute to Roberto Bachmann*, Leiden, 473–88.

Baker, Sonia 2000. *Prestongrange House*, Prestonpans.

Baldrian-Hussein, Farzeen 1986. 'Lü Tung-pin in Northern Sung literature', *Cahiers d'Extrême – Asie* 2, 133–69.

Balleri, Rita, Andreina d'Agliano and Claudia Lehner-Jobst (eds) 2018. *Fragili tesori dei principi : le vie della porcellana tra Vienna e Firenze*, Leghorn.

Barbe, Françoise 2010. 'A la redécouverte des créations de Bernard Palissy: l'aiguière et le plat à décor de "rustiques figulines" du musée du Louvre', *La revue des musées de France* 60(5), 24–33, 110–11.

Barbe, Françoise, Anne Bouquillon and Aurélie Gerbier 2019. 'Introduction', *Technè* 47, 6–11.

Barbe, Françoise, François Coulon and Jessica Denis-Dupuis 2019. 'Le collectionnisme des xviie et xviiie siècles. Les céramiques post-palisséennes de provenance ancienne dans les collections françaises', *Technè* 47, 80–9.

Barber, Edwin A. 1911. 'Purchases at the Robert Hoe Sale', *Bulletin of the Pennsylvania Museum* 9, 35, 41–4.

Barrass, Gordon S. 2002. *The Art of Calligraphy in Modern China*, London.

Barrell, John 2000. *Imagining the King's Death: Figurative Treason, Fantasies of Regicide, 1793–1796*, Oxford.

Bartsch, Adam von 1803–21. *Le peintre graveur*, Vienna.

Beddoe, Stella 2015. *A Potted History: Henry Willett's Ceramic Chronicle of Britain*, Woodbridge, England.

Bindman, David *et al.* 2012. *The Image of the Black in Western Art*, Volume IV, Houston, Texas, and Cambridge, Massachusetts.

Bosma, Ulbe 2013. *The Sugar Plantation in India and Indonesia: Industrial Production 1770–2010*, Cambridge.

Burman, Lionel 1996. 'Pottery and the slave trade', *Northern Ceramic Society Newsletter* 101, March, 17–18.

Berg, Maxine 2005. *Luxury and Pleasure in Eighteenth-Century Britain*, Oxford.

Bergeret, Jean (ed.) 2004a. *800 ans de production céramique dans le pays d'Auge*, exh. cat., Musée de Lisieux, Lisieux.

Bergeret, Jean 2004b. 'Les "Suites de Palissy", une vaisselle d'apparat et une vision du monde (hors les rustiques figulines)', in Jean Bergeret (ed.), *800 ans de production céramique dans le pays d'Auge*, 82–97.

Beurdeley, Michel 1962. *Chinese Trade Porcelain*, Rutland, Vermont.

Biancalana, Alessandro 2005. 'Carl Wendelin Anreiter von Ziernfeld und Giorgio delle Torri', in Kräftner, Lehner-Jobst and d'Agliano, 94–103.

Biancalana, Alessandro 2006. 'Terre, massi, vernici e colori della Manifattura Ginori dalla sua nascita agli albori del XIX secolo', *Faenza* 4–6, 48–92.

Biancalana, Alessandro 2007. 'I pittori della manifattura di Doccia dal 1740 al 1784', *Amici di Doccia, Quaderni* 1, 32–59.

Biancalana, Alessandro 2009. *Porcellane e maioliche a Doccia, La fabbrica dei marchesi Ginori. I primi cento anni*, Florence.

Biancalana, Alessandro 2010. 'Il viaggio di Giuseppe Bruschi a Parma. I prototipi delle porcellane di origine francese a Doccia', *Amici di Doccia, Quaderni* 4, 100–27.

Biancalana, Alessandro 2016. 'La scultura a Doccia dopo la morte di Carlo Ginori: naturale sviluppo o involuzione?', *Faenza* 102(1), 62–83.

Bindman, David 1989. *The Shadow of the Guillotine: Britain and the French Revolution*, London.

den Blaauwen, Abraham L. 2000. *Meissen Porcelain in the Rijksmuseum*, Amsterdam.

Blakemore, Steven and Fred Hembree 2001. 'Edmund Burke, Marie Antoinette, and the Procédure Criminelle', *The Historian* 63(3), Spring, 505–20.

Blanchegeorge, Éric and Céline Lécuyer 2011. *Majoliques italiennes du musée Antoine Vivenel de Compiègne*, Compiègne.

Bodart, Diane H. 2003. 'L'Immagine di Carlo V in Italia tra trionfi e conflitti', in Francesa Cantù and Maria Antonietta Visceglia (eds), *L'Italia di Carlo V: guerra, religione e politica nel primo Cinquecento, atti del convegno internazionale di studi, Roma, 5–7 aprile 2001*, Rome.

Bodinek, Claudia 2018. *Raffinesse im Akkord: Meissener Porzellanmalerei und ihre grafischen Vorlagen*, Dresden.

Bondi, Roberto 1971. 'La decorazione a riporto nella produzione primitiva di Doccia', *Faenza* 1–4, 38–41.

Bouquillon, Anne 2019. 'Les céramiques post-palisséennes de provenance ancienne dans les collections françaises: analyse des glaçures', *Technè* 47, 90–101.

Bouquillon, Anne *et al.* 2013. 'Bernard Palissy: scientist and potter of the Renaissance in France', in David Saunders, Marika Spring and Andrew Meek (eds), *The Renaissance Workshop. The Materials and Techniques of Renaissance Art*, London, 152–9.

Bouquillon, Anne, Jacques Castaing, Françoise Barbe, Thierry Crepin-Leblond, Laurence. Tilliard, Shelley Reisman Paine, Bruce Christman and Arthur H. Heuer 2018. 'French decorative ceramics mass-produced during and after the 17th century: chemical analyses of the glazes', *Archaeometry* 60(5), 1–20.

Bouquillon, Anne *et al.* 2004. 'Le problème des "suites de Palissy" au Pré-d'Auge', *Technè* 20, Terres cuites de la Renaissance, 83.

Bouvy, Eugène 1932. 'La famille d'Henri IV à propos d'une estampe de Léonard Gaultier', *L'Amateur d'Estampe*, 161–76.

Brewer, John 1973. 'The misfortunes of Lord Bute: a case-study in eighteenth-century political argument and public opinion', *The Historical Journal* 16(1), 3–43.

Brokaw, Cynthia J. 2005. 'On the history of the book in China', in Cynthia J. Brokaw and Kai-wing Chow (eds), *Printing and Book Culture in Late Imperial China*, London, 3–54.

Brokaw, Cynthia J. and Christopher A. Reed 2010. *From Woodblocks to the Internet: Chinese Publishing and Print Culture in Transition, Circa 1800 to 2008*, Leiden.

Broomhall, Susan 2018. 'Feeling divine nature: natural history, emotions and Bernard Palissy's knowledge practice', in Raphaële Garrod and Paul J. Smith (eds), *Natural History in Early Modern France* (Intersections 58), Leiden and Boston, Massachusetts, 46–69.

Brucker, Gene 2005. *Living on the Edge in Leonardo's Florence, Selected Essays*. Berkeley, California.

Brugerolles, Emmanuelle and David Guillet 2000. 'Léonard Gaultier, graveur parisien sous les règnes de Henri III, Henri IV et Louis XIII', *Gazette des Beaux-Arts* 135, 1–24.

Bryson, Norman 1981. 'Watteau and reverie: a test case in "combined analysis"', *The Eighteenth Century* 21(2), 97–126.

Burlingham, Marianne *et al.* 1995. *La gravure française à la Renaissance à la Bibliothèque nationale de France (sous la dir. de Cynthia Burlingham, Marianne Grivel, Henri Zerner), Los Angeles, Armand Hammer Museum of Art; New York, Metropolitan Museum of Art; Paris, Bibliothèque nationale de France, 20 avril – 10 juillet 1995*, Los Angeles, California.

Burty, Philippe, 1886. *Bernard Palissy: ouvrage accompagné de 20 gravures*, Paris.

Bush, Susan and Hsio-yen Shih 1985. *Early Chinese Texts on Painting*, Cambridge, Massachusetts, and London.

Calegari, Grazia 2001. 'Alcuni rapporti tra i Della Rovere e la corte spagnola', in M.L. Brancati (ed.), *Pesaro nell'eta dei Della Rovere*, vol. II, 307–22.

Cardwell, John M. 2004. *Arts and Arms: Literature, Politics and Patriotism during the Seven Years War*, Manchester.

Carpenter, John T. 1995. 'Ways of reading surimono: poetry-prints to celebrate the New Year', in Joan B. Mirviss and John T. Carpenter, *The Frank Lloyd Wright Collection of Surimono*, New York, 36–59.

Carpenter, John T. 2004. 'Textures of antiquarian imagination: Kubo Shunman and the *Kokugaku* Movement', in Amy Reigle Newland (ed.), *The Commercial and Cultural Climate of Japanese Printmaking*, Amsterdam, 77–113.

Carpenter, John T. (ed.) 2008. *Reading Surimono: The Interplay of Text and Image in Japanese Prints*, Leiden.

Carpenter, John T. 2011. 'Cultural symbolism in still-life surimono' in Maribeth Graybill (ed.), *The Artist's Touch, the Craftsman's Hand: Three Centuries of Japanese Prints from the Portland Art Museum*, Oregon, 109–34.

Cassidy-Geiger, Maureen 1996. 'Graphic sources for Meissen porcelain: origins of the print collection in the Meissen archives', *Metropolitan Museum Journal* 31, 99–126.

Cassidy-Geiger, Maureen 2008. *The Arnhold Collection of Meissen Porcelain: 1710–50*, New York.

Caygill, Marjorie and John Cherry (eds) 1997. *A.W. Franks: Nineteenth-Century Collecting and the British Museum*, London.

Chaffers, William 1887. *Catalogue of the Holburne of Menstrie Art Museum Bath*, London.

Chan, Anita 1985. *Children of Mao: Personality Development and Political Activism in the Red Guard Generation*, London and Basingstoke.

Chang, Pin-tsun 1990. 'Maritime trade and local economy in late Ming Fukien', in Vermeer, 63–83.

Checa Cremades, Fernando 1999. 'Christianitas afflicta, La batalla de Mühlberg y la lucha contra los protestantes', in Fernando Checa Cremades, *Carlos V La imagen del poder en el Renacimiento*, Madrid.

Chelkowski, Peter and Hamid Dabashi 2000. *Staging a Revolution: The Art of Persuasion in the Islamic Republic of Iran*, London.

Chen Jian 陈坚 and Wenda Ma 马文大 (eds) 2000. *Song Yuan ban ke tu shi* 宋元版刻圖釋 (Annotated Illustrations of Woodblock Prints of the Song and Yuan), 1–4, Beijing.

Chen Runmin 陳潤民 (ed.) 2005. *Qing Shunzhi Kangxi chao qinghuaci* 清順治康熙朝青花瓷 (Qing Dynasty Blue-and-White Porcelains of the Shunzhi and Kangxi Periods), Beijing.

Chia, Lucille 2002. *Printing for Profit: The Commercial Publishers of Jianyang, Fujian (11th–17th century)*, Cambridge, MA, and London.

Chia, Lucille and Hilde De Weerdt 2011. *Knowledge and Text Production in an Age of Print: China, 900–1400*, Leiden.

Chilton, Meredith 2002. *Harlequin Unmasked: The Commedia dell'Arte and Porcelain Sculpture*, New Haven, Connecticut.

Christie's 1984. *Fine Chinese Export Porcelain, Paintings, Metalwork and Related Works of Art*, London, 6 July.

Christie's 1986. *Fine Chinese Export Porcelain and Works of Art*, London, 7 July.

Christie's 1993. *Important Italian Maiolica from the Arthur Sackler Collection*, vol. 1, New York.

Christie's 2005. *Catalogue of Chinese Ceramics and Works of Art, Including Export Art*, London, 12 July.

Christman, Bruce, Arthur H. Hewer and Jacques Castaing 2004. 'Palissy ceramics in the collection of the Cleveland Museum of Art', *Technè* 20, Terres cuites de la Renaissance, 92–6.

Chumbley, Joyce 2009. *Thomas Paine: In Search of the Common Good*, Nottingham.

Cioci, Francesco 2002. 'In Urbino nell'anno 1534', *Faenza* 88(1–6), 110–21.

Cioci, Francesco 2009. *Francesco Maria I della Rovere. La Villa Imperiale di Pesaro*. Urbino.

Clark, Timothy (ed.) 2017. *Hokusai: Beyond the Great Wave*, London.

Clarke, Timothy H. 1990. 'Die *Neu-eröffnete Welt-Galleria*, Nuremberg, 1703, als Stichvorlage für sogenannte Callot-Zwerge', *Keramos* 127, January, 3–27.

Clément de Ris, Louis 1871. *Notice des faïences françaises: faïences dites de Henri II; faïences de Bernard Palissy; faïences diverses*, Paris.

Clifford, Timothy 1991. 'Some unpublished drawings for maiolica and Federigo Zuccaro's role in the "Spanish Service"', in Wilson, 166–76.

Clifford, Timothy 2012. 'Disegni di Taddeo e Federico Zuccari e dei loro contemporanei per la maiolica', in Marino Marini (ed.), *Fabulae pictae: Miti e storie nelle maioliche del Rinascimento*, exh. cat., Museo Nazionale del Bargello. Florence, 94–109.

Clifford, Timothy and John V.G. Mallet 1976. 'Battista Franco as a designer for maiolica', *Burlington Magazine* 118, 387–410.

Clough, Cecil H. 2005. 'Clement VII and Francesco Maria Della Rovere, Duke of Urbino', in Gouwens and Reiss, 75–108.

Clunas, Craig 1981–2. 'The west chamber: a literary theme in Chinese porcelain decoration', *Transactions of the Oriental Ceramic Society* 46, 69–86.

Colin-Goguel, Florence 1975. 'Les potiers et tuiliers de Manerbe et du Pré-d'Auge au XVIIIe siècle', *Annales de Normandie* 25(2), 99–116.

Colley, Linda 1992. *Britons: Forging the Nation, 1707–1837*, New Haven, Connecticut.

Collins, Owen 1999. *Speeches that Changed the World*, Louisville, Kentucky.

Colonna, Francesco 1546. *Hypnérotomachie ou discours du songe de Poliphile*, trans. by Jean Martin, Paris.

Conybeare, Frances A. 1925. *Dingle Bank, The Home of the Croppers*, Cambridge.

Crépin-Leblond, Thierry 1997. *Une orfèvrerie de terre: Bernard Palissy et la céramique de Saint-Porchaire*, Paris.

Crichton-Turley, Courtenay-Elle 2019. 'Investigating London's post medieval pipe clay figurines from 1500–1800: critiquing 3D approaches to mould generation analysis via English and transatlantic case studies', PhD dissertation, University of Sheffield.

Crisp, Frederick A. 1907. *Armorial China: A Catalogue of Chinese Porcelain with Coats of Arms in the Possession of Frederick Arthur Crisp*, London.

Croissant, Doris 2005. 'Hokusai and Takahashi Yuichi: changing concepts in still-life painting', in John T. Carpenter (ed.), *Hokusai and His Age: Ukiyo-e Painting, Printmaking and Book Illustration in Late Edo Japan*, Amsterdam, 217–33.

Croizier, Ralph, 1990. 'Qu Yuan and the artists: ancient symbols and modern politics in the post-Mao era', *The Australian Journal of Chinese Affairs* 24, July, 25–50.

Crook, Malcolm 2002. *Revolutionary France: 1788–1880*, Oxford.

Curtis, Julia B. and Stephen Little 1995. *Chinese Porcelains of the Seventeenth Century: Landscapes, Scholars' Motifs and Narratives*, Seattle and London.

Czartoryska, Izabela 1828. *Poczet pamiątek zachowanych w Domu Gotyckim w Puławach*, Warsaw.

Da Ming huidian 大明會典 (Collected Statutes of the Great Ming), reprint of the 1587 edition, Taipei, 1963.

Dauterman, Carl Christian 1962. 'Snakes, and creatures with tails', *The Metropolitan Museum of Art bulletin* 20(9), 272–85.

Dawson, Aileen 1997. 'Franks and European ceramics, glass and enamels', in Caygill and Cherry, 200–19.

Dawson, Aileen 2009. 'Unexpected treasures – Doccia porcelain in the British Museum', *Amici di Doccia, Quaderni* 3, 12–31.

Dawson, Aileen 2010. 'An artist on porcelain – a Doccia porcelain plate in the British Museum', *Keramos* 210, 121–30.

Delange, Carle, Alexandre Sauzay, Henri Delange and C. Borneman 1862. *Monographie de l'œuvre de Bernard Palissy: suivie d'un choix de ses continuateurs ou imitateurs*, Paris.

Delécluze, Etienne-Jean 1838. *Bernard Palissy, 1500–1589*, Paris.

Denis-Dupuis, Jessica 2019. 'Sur les traces des producteurs de céramiques à glaçure plombifère et à décor moulé des règnes de Henri IV et de Louis XIII', *Technè* 47, 62–71.

Deville, Étienne 1927. *La céramique du pays d'Auge: l'art de terre a Manerbe et au Pré-d'Auge*, Paris, Brussels.

Diemling, Maria, 2010. 'The ethnographer and the Jewish body: Johann Jacob Schudt on the civilisation process of the Jews of Frankfurt' in Fritz Backhaus (ed.), *The Frankfurt Judengasse: Jewish Life in an Early Modern German City*, London, and Portland, Oregon, 85–98.

Dittmann, Reinhart 2016. *Naturerkenntnis und Kunstschaffen: Die Discours admirables von Bernard Palissy, Übersetzung und Kommentar*, Berlin and Boston, Massachusetts.

Drakard, David 1992. *Printed English Pottery: History and Humour in the Reign of George III, 1760–1820*, London.

Drey, Rudolf E.A. 1991. '*Istoriato* maiolica with scenes from the Second Punic War. Livy's history of Rome as source material', in Wilson, 51–61.

Droguet, Vincent 2010. *Henri IV à Fontainebleau: un temps de splendeur*, exh. cat., musée national du Château de Fontainebleau; Réunion des Musées Nationaux, Paris.

Duara, Prasenjit 1988. 'Superscribing symbols: the myth of Guandi, Chinese god of war', *The Journal of Asian Studies* 47(4), 778–95.

Ducret, Siegfried 1953. 'Bourdalous', *Keramik-Freunde der Schweiz* 26, 15–17.

Ducret, Siegfried 1973. *Keramik und Graphik des 18. Jahrhunderts. Vorlagen für Maler und Modelleure*, Braunschweig.

Dudley, Mary 1828. *Scripture Evidence of the Sinfulness of Injustice and Oppression, Respectfully Submitted to Professing Christians, in Order to Call Forth Their Sympathy and Exertions, on Behalf of the Much-Injured Africans*, London.

Dufay, Bruno *et al.* 1987. 'L'atelier parisien de Bernard Palissy', *Revue de l'Art* 78, 33–60.

Dufay, Bruno and Pierre-Jean Trombetta 1990. 'Un atelier d'art et d'essai aux Tuileries', in Jean-Luc Massay, *Bernard Palissy: mythe et réalité*, Saintes, 56–67.

Dumesnil, Alfred 1851. *Bernard Palissy: le potier de terre*, Paris.

Duportal, Jeanne 1924. 'L'oeuvre grave de Leonard Gaultier (XVIe–XVIIe siècle)', *Byblis. Miroir des arts du livre et de l'estampe* 3 (12), 129–134.

Dupuis, Jessica 2016. 'La céramique dite "d'Avon": retour historiographique et mise au jour d'une attribution légendaire', *Revue de l'art* 3(193), 27–34.

Du Sommerard, Edmond 1851. *Catalogue et description des objets d'art de l'Antiquité, du Moyen-Age et de la Renaissance exposés au musée / Musée des thermes et de l'Hôtel de Cluny*, Paris.

Dussieux, Louis 1841. *Recherches sur l'histoire de la peinture sur émail dans les temps anciens et modernes, et spécialement en France*, Paris.

Earle, Cyril 1915. *The Earle Collection of Early Staffordshire Pottery*, London.

Elman, Benjamin A. and Martin Kern (eds) 2010. *Statecraft and Classical Learning: The Rituals of Zhou in East Asian History*, Leiden.

Endelman, Todd M. 1979. *The Jews of Georgian England, 1714–1830: Tradition and Change in a Liberal Society*, Philadelphia, Pennsylvania.

Esposito, Anna and Manuel Vaquero Pineiro 2005. 'Rome during the Sack: chronicles and testimonies from an occupied city', in Gouwens and Reiss, 125–42.

Fantoni, Marcello 2000. *Carlo V e l'Italia: Seminario di studi*, Georgetown University a Villa Le Balze, 14–15 December, Rome.

Fehl, Philipp P. 1993. 'Raphael as a historian: poetry and historical accuracy in the Sala di Costantino', *Artibus et Historiae* 14(28), 9–76.

Fennessey, R.R. 1963. *Burke, Paine, and the Rights of Man: A Difference of Political Opinion*, New York.

Ferdinand, Juliette 2012. '"À l'imitation du souverain fontenier". Eaux et fontaines dans l'oeuvre de Bernard Palissy', in Rosanna Gorris Camos (ed.), *'Le salut par les eaux et par les herbes'. Médecine et littérature en France et en Italie aux XVIe et XVIIe siècles*, Verona.

Ferdinand, Juliette 2019. *Bernard Palissy: artisan des réformes entre art, science et foi*, European Identities and Transcultural Exchange, I, Berlin.

Ferguson, Patricia 2016. *Ceramics: 400 Years of British Collecting in 100 Masterpieces* (National Trust Series), London.

Ferris, Alice M. 1968. 'Seventeenth century transitional porcelains: the development of landscape painting', *Oriental Art* 14, Autumn, 184–93.

Fisher, Carney T. 1990. *The Chosen One: Succession and Adoption in the Court of Ming Shizong*, Sydney and London.

Fong, Grace S. 2008. *Herself an Author: Gender, Agency, and Writing in Late Imperial China*, Honolulu, Hawaii.

Forrer, Matthi 2013. *Surimono in the Rijksmuseum Amsterdam*, Leiden.

Forrer, Matthi, Willem R. van Gulik and Jack Hillier (eds) 1979. *A Sheaf of Japanese Papers*, The Hague.

Forrer, Matthi and Roger Keyes 1979. 'Very like a whale? Hokusai's illustrations for the Genroku poem shells', in Forrer, van Gulik and Hillier, 35–57.

Frescobaldi Malenchini, Livia *et al.* (eds) 2013. 'The Victoria and Albert Museum Collection', *Amici di Doccia, Quaderni* 7.

Fuchs, Charles Dominique 1993. *Maioliche istoriate rinascimentali del Museo Statale d'Arte Medioevale e Moderna di Arezzo*, Arezzo.

Fuchs II, Ronald W. 2008. 'European subjects on Chinese porcelain', *Transactions of the Oriental Ceramic Society* 72, 35–41.

Fuchs II, Ronald W. and David Sanctuary Howard 2005. *Made in China: Export Porcelain from the Leo and Doris Hodroff Collection at Winterthur*, Winterthur, Delaware.

Fu Hongchu 1995. 'Historicizing Chinese drama: the power and politics of Yuan *Zaju*', PhD dissertation, University of Michigan.

Geisberg, Max (ed.) 1974. *The German Single-leaf Woodcut: 1500–1550*, 4 vols, New York.

Gendron, Christian 1992. 'Les imitateurs de Bernard Palissy au XIXe siècle', in *Bernard Palissy: 1510–1590. L'écrivain, le réformé, le céramiste*, Albineana, Cahiers d'Aubigné 4, 201–6.

Gerbier, Aurélie 2019. 'Trois décennies d'études palisséennes: apports d'une approche interdisciplinaire', *Technè* 47, 12–17.

Gere, John A. 1963. 'Taddeo Zuccaro as a designer for Maiolica', *Burlington Magazine* 105, 306–15.

Giacomotti, Jeanne 1974. *Catalogue des majoliques des musées nationaux*, Paris.

Giardini, Claudio 1996. *Pesaro. Museo delle Ceramiche* (Musei d'Italia – Meraviglie d'Italia, 33), Bologna, Milan and Rome.

Gibbon, Alan 1986. *Céramiques de Bernard Palissy*, Paris.

Giles, Laura M. 1999. 'A drawing by Raphael for the Sala di Costantino', *Master Drawings* 37(2), 156–64.

Gillman, Derek 1984. 'Ming and Qing ivories: figure carving', in William Watson (ed.), *Chinese Ivories from the Shang to the Qing*, London, 35–50.

Ginori-Lisci, Leonardo 1963. *La porcellana di Doccia*, Milan.

Ginsberg, Mary 2013. *The Art of Influence: Asian Propaganda*, London.

Glénisson, Jean 1990. 'L'image de Palissy dans l'histoire de France', in Jean-Luc Massay, *Bernard Palissy: mythe et réalité*, Saintes, 96–106.

Godden, Geoffrey A. 1964. *Encyclopaedia of British Pottery and Porcelain Marks*, London.

Godden, Geoffrey A. 1978. *Minton Pottery and Porcelain of the First Period 1793–1850*, London.

Godden, Geoffrey A. 1979. *Oriental Export Market Porcelain and its Influence on European Wares*, London.

Godoy, José-A. and Silvio Leydi 2003. *Parures triomphales. Le maniérisme dans l'art de l'armure italienne*, Milan.

Goldman, Merle 1982. 'The political uses of Lu Xun', *The China Quarterly* 91, 446–61.

Gouwens, Kenneth 1998. *Remembering the Renaissance: Humanist Narratives of the Sack of Rome*, Leiden, Boston and Cologne.

Gouwens, Kenneth and Sheryl E. Reiss (eds) 2005. *The Pontificate of Clement VII, History, Politics, Culture*, Aldershot.

Graves, Algernon 1907. *The Society of Artists of Great Britain, 1760–1791; the Free Society of Artists, 1761–1783; a Complete Dictionary of Contributors and Their Work from the Foundation of the Societies to 1791*, London.

Gray, Jonathan 2008. 'Ceramics and slavery: an overview', *Transactions English Ceramic Circle* 20(2), 327–38.

Gray, Jonathan 2012. *Swansea's Printed Wares: A Re-assessment*, published in https://www.transcollectorsclub.org/resources/Gray,JonathanTCC_2011-1.pdf (accessed 1 July 2020).

Gresta, Riccardo 2002. 'Giulio da Urbino e Xanto Avelli: una collaborazione difficile?', in Gian Carlo Bojani (ed.), *La maiolica italiana del Cinquecento. Il lustro eugubino e l'istoriato del ducato di Urbino, Atti del convegno di studi, Gubbio, 21, 22, 23 settembre 1998*, Florence, 148–52.

Griffiths, Antony 1984. 'A checklist of catalogues of British print publishers c. 1650–1830', *Print Quarterly* 1(1), March, 3–22.

Grimké, Angelina 1836. *Appeal to the Christian Women of the South*, New York.

Guicciardini, Luigi 1993. *The Sack of Rome*, trans. and ed. by James H. Macgregor, New York.

Guo Zhaokun 郭兆昆 and Lu Yimu 盧亦木 1997. 'Wan Ming nü wenxuejia, shufajia Xing Cijing shulüe' 晚明女文學家、書畫家邢慈靜述略 (Brief discussion of the late Ming female writer, calligrapher and painter Xing Cijing), *Dezhou shizhuan xuebao* 德州師專學報 (Journal of Dezhou Teachers' College) 13(3), 20 and 43–4.

Guyatt, Mary 2000. 'The Wedgwood slave medallion: values in eighteenth-century design', *Journal of Design History* 13(2), 93–105.

Halfpenny, Pat 1994. *Penny Plain, Twopence Coloured*, Stafford.

Hampson, Rodney 2000. *Pottery References in the Staffordshire Advertiser, 1795–1865*, Hanley, Staffordshire.

Hanscombe, Stephen 2010. *Jefferyes Hamett O'Neale: China Painter and Illustrator (d. 1801)*, London.

Harrison-Hall, Jessica 1997. 'Oriental pottery and porcelain', in Caygill and Cherry, 220–30.

Harrison-Hall, Jessica 2001. *Catalogue of Late Yuan and Ming Ceramics in the British Museum*, London.

Hartop, Christopher 1994. 'Admiral George Anson and his de Lamerie silver', *The Magazine Antiques*, June, 850–7.

Harvey, Karen 2008. 'Barbarity in a teacup? Punch, domesticity and gender in the eighteenth century', *Journal of Design History* 21(3), Autumn, 205–21.

Hegel, Robert E. 1981. *The Novel in Seventeenth-Century China*, New York.

Heller, Marvin J. 2018. 'R. Nathan Nata ben Moses Hannover: the life and works of an illustrious and tragic figure', published at https://seforimblog.com/2018/12/nathan-nat-ben-moses-hannover/ (accessed 27 April 2019).

Hillier, Jack 1979. 'Still-life in Surimono', in Forrer, van Gulik and Hillier, 75–84.

Hirst, Michael 1981. *Sebastiano del Piombo*, Oxford.

Hislop, Ian and Thomas Hockenhull 2018. *I Object: Ian Hislop's Search for Dissent*, London.

Holcroft, Alison 1988. 'Francesco Xanto Avelli and Petrarch', *Journal of the Warburg and Courtauld Institutes* 51, 225–34.

Hollaenderski, Léon 1846. *Les Israélites de Pologne*, Paris.

Hook, Judith 1972. *The Sack of Rome*, London.

Hostetler, Laura 2001. *Qing Colonial Enterprise: Ethnography and Cartography in Early Modern China*, Chicago, Illinois.

Howard, David S. 1974. *Chinese Armorial Porcelain*, London.

Howard, David S. 1994. *The Choice of the Private Trader: The Private Market in Chinese Export Porcelain Illustrated from the Hodroff Collection*, London.

Howard, David S. 2003. *Chinese Armorial Porcelain*, Volume 2, London.

Howard, David S. and John Ayers 1978. *China for the West: Chinese Porcelain and Other Decorative Arts for Export Illustrated from the Mottahedeh Collection*, 2 vols, London and New York.

Hsü Wen-chin 1986. 'Fictional scenes on Chinese transitional porcelain (1620–ca. 1683) and their sources of decoration', *Bulletin of the Museum of Far Eastern Antiquities* 58, 1–146.

Huang Jing 黃靜 2015. 'Yuandai shehui wenhua dui Yuan qinghua ciqi de yingxiang' 元代社會文化對元青花瓷器的影響 (The influence of Yuan-dynasty social culture of Yuan blue-and-white porcelains), in Shanghai Museum, vol. 2, 341–53.

Huang Wei 黃薇 2018. 'Zhongguo gudai qingtongqi faxian yu yanjiu shi' 中國古代青銅器發現與研究史 (The history of the discovery and study of the Chinese ancient bronzes), PhD dissertation, Shaanxi Normal University.

Hunt, Lynn 2013. *Family Romance of the French Revolution*, London.

Hurdis, Rev. James 1794. *Equality: A Sermon*, London.

Hussey, Christopher 1954. 'Shugborough, Staffordshire – II: the seat of the Earl of Lichfield', *Country Life*, 4 March, 590–4.

Hyland, Peter 2005. *The Herculaneum Pottery: Liverpool's Forgotten Glory*, London.

Idema, Wilt L. and Stephen H. West 2016. *Records of the Three Kingdoms in Plain Language*, Indianapolis, Indiana.

Ivanova, Elena 2003. *Il secolo d'oro della maiolica. Ceramica italiana dei secoli XV–XVI dalla raccolta del Museo Statale dell'Ermitage*, exh. cat., Museo Internazionale delle Ceramiche, Faenza.

Jackson-Stops, Gervase (ed.) 1985. *The Treasure Houses of Britain: Five Hundred Years of Private Patronage and Art Collecting*, Washington, DC.

Jang, Ju-Yu Scarlett 2008. 'The Eunuch Agency Directorate of Ceremonial and the Ming Imperial Publishing Enterprise', in David Robinson (ed.), *Culture, Courtiers, and Competition: The Ming Court (1368–1644)*, Cambridge, Massachusetts, 116–85.

Jing, Anning 1996. 'The eight immortals: the transformation of T'ang and Sung Taoist eccentrics during the Yuan dynasty', in Maxwell K. Hearn and Judith G. Smith (eds), *Arts of the Sung and Yuan*, New York, 213–25.

Jones, Mark 1998. 'The mobilisation of public opinion against the slave trade and slavery: popular abolitionism in national and

regional politics, 1787–1838', D.Phil dissertation, University of York.

Jones, Wendy 2006. *Grayson Perry: Portrait of the Artist as a Young Girl*, London.

Jones, Catrin and Chris Stephens (eds) 2020. *Grayson Perry: The Pre-Therapy Years*, London.

Judge, Joan 1996. *Print and Politics: 'Shibao' and the Culture of Reform in Late Qing China*, Stanford, California.

Kanazawa Yo 金沢陽 2015. 'Guanyu Yuan qinghua Zhaojun chusai tuguan de huati – yu Yuanqu "Po youmeng guyan Hangong qiu zaju" de bijiao yanjiu' 關於元青花昭君出塞圖罐的畫題 – 與元曲《破幽夢孤雁漢宮秋雜劇》的比較研究 (Comparison of the subject matter *Zhaojun Leaving the Pass Behind* on Yuan blue-and-white and the Yuan play *Autumn in the Han Palace*, in Shanghai Museum, vol. 2, (Chinese) 220–31 and (Japanese) 233–41.

Katz, Marshall P. and Robert Lehr 1996. *Palissy Ware: Nineteenth-Century French Ceramists from Avisseau to Renoleau*, 2nd edition, London.

Katz, Paul R. 1999. *Images of the Immortal: The Cult of Lu Dongbin at the Palace of Eternal Joy*, Honolulu, Hawaii.

Kayser, Petra 2006. 'The intellectual and the artisan: Wenzel Jamnitzer and Bernard Palissy uncover the secrets of nature', *Australian and New Zealand Journal of Art* 7(2), 45–61.

Kent, Richard K. 1994. 'Depictions of the Guardians of the Law: lohan painting in China', in Marsha Weidner (ed.), *Latter Days of the Law: Images of Chinese Buddhism, 850–1850*, Lawrence, Kansas, 183–213.

Kerr, Rose 2016. 'Chinese ivories: history and craft', in Rose Kerr, Phillip Allen and Ching-fei Shih (eds), *Chinese Ivory Carvings: The Sir Victor Sassoon Collection*, London, 10–16.

Kerr, Rose and Ingalill Jansson 2015. *Asian Ceramics in the Hallwyl Collection*, Stockholm.

Kerr, Rose and Luisa E. Mengoni 2011. *Chinese Export Ceramics*, London.

Keyes, Roger 1985. *The Art of Surimono: Privately Published Japanese Woodblock Prints and Books in the Chester Beatty Library, Dublin*, 2 vols, London.

Kilburn, Richard 1981. *Transitional Wares and Their Forerunners: An Exhibition Presented by the Oriental Ceramic Society of Hong Kong and the Urban Council, Hong Kong at the Hong Kong Museum of Art*, Hong Kong.

Kisch, Yves 1992. 'Une réapparition archéologique', in *Bernard Palissy: 1510–1590. L' écrivain, le réformé, le céramiste*, Albineana, Cahiers d'Aubigné 4, 183–6.

Kleeman, Terry F. 1994. *A God's Own Tale: The Book of Transformations of Wenchang, the Divine Lord of Zitong*, Albany, New York.

Klein, Jacky 2009. *Grayson Perry*, London.

Ko, Dorothy 1994. *Teachers of the Inner Chambers: Women and Culture in Seventeenth-Century China*, Stanford, California.

Kobayashi Fumiko 小林ふみ子 2008. 'Surimono to publicize poetic authority: Yomo no Magao and his pupils', in John T. Carpenter (ed.), *Reading Surimono: The Interplay of Text and Image in Japanese Prints*, Leiden, 46–53.

Kok, Daan 2017. 'Visualizing the classics: reading surimono and kyōka books as cultural and social history', PhD dissertation, Leiden University.

Kräftner, Johann, Claudia Lehner-Jobst and Andreina d'Agliano (eds) 2005. *Barocker Luxus Porzellan: die Manufakturen Du Paquier in Wien und Carlo Ginori in Florenz; (anlässlich der Ausstellung 'Barocker Luxus Porzellan. Die Manufakturen Du Paquier in Wien und Carlo Ginori in Florenz' im Liechtenstein-Museum, Wien, vom 10. November 2005 bis 29. Jänner 2006)*, Munich.

Krahl, Regina and Jessica Harrison-Hall 1994. *Ancient Chinese Trade Ceramics from the British Museum*, Taipei.

Krahl, Regina and Jessica Harrison-Hall 2009. *Chinese Ceramics: Highlights of the Sir Percival David Collection*, London.

Kris, Ernst, 1926. 'Der Stil "Rustique": die Verwendung des Naturabgusses bei Wenzel Jamnitzer und Bernard Palissy', *Jahrbuch der Kunsthistorischen Sammlungen in Wien* 1, 137–208.

Kube, Alfred N. 1976. *Italian Majolica XV–XVIII centuries: State Hermitage Collection*, ed. Olga E. Mikhailova and E.A. Lapkovskaya, Moscow.

Lai, Yu-chih 2019. 'Costuming the empire: a study on the production of tributary paintings at the Qianlong court in eighteenth-century China', in Tara Zanardi and Lynda Klich (eds), *Visual Typologies from the Early Modern to the Contemporary: Local Contexts and Global Practices*, New York, 90–103.

Lam, Peter Y. K., Monique Crick and Laure Schwartz-Arenales 2018. *A Millennium of Monochromes: From the Great Tang to the High Qing: The Baur and the Zhuyuetang Collections*, Milan.

Landau, David and Peter Parshall 1994. *The Renaissance Print: Art for the Connoisseur or the Common Man*, London.

Landsberger, Stefan. Undated. http://chineseposters.net/posters/e13-327.php (accessed 5 February 2019).

Lau, Christine 1993. 'Ceremonial monochrome wares of the Ming dynasty', in Rosemary Scott (ed.), *The Porcelains of Jingdezhen* (Colloquies on Art and Archaeology in Asia, no. 16), London, 83–100.

Lauder, Anne Varick 2004. *Musée du Louvre. Département des arts graphiques. Inventaire général des dessins italiens, tome VIII. Battista Franco*, Paris.

Lawner, Lynne 1984. *I Modi: nell'opera di Giulio Romano, Marcantonio Raimondi, Pietro Aretino e Jean-Frédéric-Maximilien de Waldeck*, Milan.

Leadbetter, Charles 1766. *The Royal Gauger, . . . The Sixth Edition . . . Now Augmented and Improved by Samuel Clark*, London.

Lee, Debbie 2017. *Slavery and the Romantic Imagination*, Philadelphia, Pennsylvania.

Lehuédé, Patrice, Jacques Castaing and Anne Bouquillon 2019. 'Le bore dans les glaçures des céramiques post-palisséennes', *Technè* 47, 116–25.

Leonardi, Corrado and Massimo Moretti 2002. *I Picchi maiolicari da Casteldurante a Roma*, Urbania.

Lessmann, Johanna 1976. 'Battista Franco disegnatore di maioliche', *Faenza* 62, 27–30.

Lessmann, Johanna 1979. *Herzog Anton Ulrich Museum Braunschweig, Italienische Majolika, Katalog der Sammlung*, Brunswick.

Lessmann, Johanna 2004. 'Bildfliesen von Francesco Xanto Avelli zur Geschichte Persiens', *Keramos* 186, 61–85.

Leung Hiu Sun, Michael (ed.) 2017. *Commissioned Landscapes: Blue & White and Enamelled Porcelain of the Seventeenth Century*, exh. cat., China Guardian Auctions, Beijing.

Leutrat, Estelle 2016. 'Feu honnorable homme Leonart Gaultier, vivant maistre graveur a Paris. Nouveaux documents sur l'estampe en France au début du XVIIe siècle', *Documents d'histoire parisienne* 18, 25–42.

Liberman Mintz, Sharon 2002. 'A Persian tale in Turkish garb: exotic imagery in eighteenth-century illustrated Esther scrolls', in Joseph Gutmann (ed.), *For Every Thing A Season: Proceedings of the Symposium on Jewish Ritual Art*, 13 September 2000, Cleveland, Ohio, 76–101.

Li Shaobin 李紹斌 2011. 'Yuandai qinghua yu Yuandai zaju' 元代青花與元代雜劇 (Yuan dynasty blue-and-white and Yuan dynasty variety plays), *Dongfang shoucang* 東方收藏 (Oriental Collection), no. 9, 20–3.

Little, Stephen 1990. 'Narrative themes and woodblock prints in the

decoration of seventeenth-century Chinese porcelains', in Michael Butler, Margaret Medley and Stephen Little (eds), *Seventeenth-century Chinese Porcelain from the Butler Family Collection*, Alexandria, Virginia, 21–32.

Little, Stephen 1981. *Chinese Ceramics of the Transitional Period, 1620–1681*. New York.

Little, Stephen and Shawn Eichman (eds) 2000. *Taoism and the Arts of China*, Chicago, Illinois.

Liu Li 劉麗 2008. *Yinshua gongyi sheji. Xiuding ban* 印刷工藝設計修訂版 (The Design Craft of Printmaking, revised edition), Wuhan.

Liu Yi 劉毅 2015. 'Yuan qinghua renwu tu'an tanxi' 元青花人物圖案探析 (Analysis of figural decoration on Yuan blue-and-white), in Shanghai Museum, vol. 2, 267–87.

Liverani, Francesco 1979. *Le maioliche della Galleria Estense di Modena*, Faenza.

Lomazzo, Gian Paolo 1585. *Idea del tempio della pittura di Gio. Paolo Lomazzo: pittore, nella quale egli discorre dell'origine, e fondamento delle cose contenute nel suo Trattato dell'arte della pittura, scoltura et architettura*, Milan.

Louvre des Antiquaires 1990. *Sur les pas de Palissy: exposition d'oeuvres de céramistes du XVIe siècle à nos jours*, exh. cat., Louvre des Antiquaires, Paris.

Lovell, Julia 2010. 'China's Conscience', *The Guardian*, published at https://www.theguardian.com/books/2010/jun/12/rereading-julia-lovell-lu-xun (accessed 6 February 2019).

Lü Chenglong 呂成龍 2017a. 'Mingdai yuyao ciqi – Jingdezhen chutu yu Gugong yuancang Hongzhi, Zhengde ciqi duibizhan' 明代御窯瓷器－景德鎮出土與故宮院藏弘治、正德瓷器對比展 (Porcelain of the Ming imperial kilns – Exhibition comparing Hongzhi and Zhengde porcelain excavated at Jingdezhen and those in the Palace Museum collection), *Shoucangjia* 收藏家 (Collectors), no. 11, 22–8.

Lü Chenglong 呂成龍 2017b. 'Mingdai Hongzhi, Zhengde chao Jingdezhen yuyao ciqi jian lun' 明代弘治、正德朝御窯瓷器簡論 (Brief discussion of imperial ceramics of the Hongzhi and Zhengde reigns of the Ming dynasty), *Gugong bowuyuan yuankan* 故宮博物院院刊 (Palace Museum Journal) 193(5), 121–63.

Lü Zhangshen 呂章申 (ed.) 2012. *Ci zhi yun: Da Ying bo wu guan, Yingguo guo li Weiduoliya yu Aibote bo wu guan cang ci qi jing pin* 瓷之韵: 大英博物馆, 英国国立维多利亚与艾伯特博物馆藏瓷器精品 (Passion for Porcelain: Masterpieces of Ceramics from the British Museum and the Victoria and Albert Museum), Beijing.

Lü Zhen 呂震 *et al.* 1428. 'Preface', in *Xuande ding yi pu* 宣德鼎彝譜 (Illustrated Collection of Tripods and Vessels from the Xuande Reign), e-*SKQS*.

Macdonald, Sean 2016. *Animation in China: History, Aesthetics, Media*, Abingdon.

Mackerras, Colin 1998. *Chinese Theater from its Origins to the Present Day*, Honolulu, Hawaii.

Mallet, John V.G. 1987a. 'Review of Wilson 1987' by Timothy Wilson, *Burlington Magazine* 129, 331–2.

Mallet, John V.G. 1987b. 'In Botega di Maestro Guido Durantino in Urbino', *Burlington Magazine* 129, 284–98.

Mallet, John V.G. 1988. 'Xanto: i suoi compagni e seguaci', in *Francesco Xanto Avelli da Rovigo. Atti del Convegno Internazionale di Studi 1980*, Rovigo, 67–108.

Mallet, John V.G. 2003. 'One artist or two? The painter of the so-called "Della Rovere" dishes and the painter of the Coalmine service', *Faenza* 89(1–6), 50–74.

Mallet, John V.G. 2004. 'Xanto and Gubbio: new thoughts and queries', *Keramos* 186, 37–60.

Mallet, John V.G. 2007a. *Xanto: Pottery-Painter, Poet, Man of the Italian Renaissance*, with contributions by Giovanna Hendel and Elisa Paola Sani, Wallace Collection, London.

Mallet, John V.G. 2007b. 'Nicola da Urbino and Francesco Xanto Avelli', *Faenza* 93, 199–250.

Mallet, John V.G. 2011. 'Transfer printing in Italy and England', *English Ceramic Circle Transaction* 22, 89–115.

Mallet, John V.G. 2012. 'Il decoro a riporto in Italia e Inghilterra', *Amici di Doccia, Quaderni* 6, 10–43.

Mandler, Peter 2006. *The English National Character: The History of an Idea from Edmund Burke to Tony Blair*, New Haven, Connecticut, and London.

Margolin, Sam 2002. '"And freedom to the slave": antislavery ceramics, 1787–1865', in Robert Hunter (ed.), *Ceramics in America*, Milwaukee, Wisconsin, 81–109.

Markley, Robert 2009. 'Anson at Canton, 1743: obligation, exchange, and ritual in Edward Page's "Secret History"', in Cynthia Klekar and Linda Ziokowski (eds), *The Gift in the Eighteenth Century*, New York, 215–33.

Marucci, Valerio and Antonio Marzo (eds) 1983. *Pasquinate romane del Cinquecento*, 2 vols, Rome.

Mazzotti, Valentina (ed.) 2019. *I restauri delle maioliche del Museo Correr di Venezia presso il MIC di Faenza*, Faenza.

McDermott, Joseph P. 1999. *State and Court Ritual in China*, Cambridge.

McDougall, Bonnie S. 1980. *Mao Zedong's 'Talks at the Yan'an Conference on Literature and Art': A Translation of the 1943 Text with Commentary*, *Michigan Monographs in Chinese Studies* 39, Ann Arbor, Michigan.

McDowall, Stephen 2013. 'The Shugborough dinner service and its significance for Sino-British history', *Journal for Eighteenth-Century Studies*, published at https://doi.org/10.1111/1754-0208.12034 (accessed 17 June 2019).

McKee, Daniel 2006. *Japanese Poetry Prints: Surimono from the Schoff Collection*, Ithaca, New York.

McKee, Daniel 2008. *Colored in the Year's New Light: Japanese Surimono from the Becker Collection*, Ithaca, New York.

McLaren, Anne E. 2005. 'Constructing new reading publics in Late Ming China', in Cynthia J. Brokaw and Kai-wing Chow (eds), *Printing and Book Culture in Late Imperial China*, Berkeley, Los Angeles, London, 152–83.

McNab, Jessie 1987. 'Palissy et son "école" dans les collections du Metropolitan Museum of Art de New York', *Revue de l'art* 78, 70–6.

Mee, Jon 2016. *Print, Publicity, and Popular Radicalism in the 1790s: The Laurel of Liberty*, Cambridge.

Meissner, Kurt 1970. *Japanese Woodblock Prints in Miniature: The Genre of Surimono*, London.

Midgley, Claire 1992. *Women Against Slavery: The British Campaigns, 1780–1870*, London.

Mirviss, Joan B. 2003. *Masterpieces of the Art of Surimono*, New York.

Mirviss, Joan B. and John T. Carpenter 1995. *The Frank Lloyd Wright Collection of Surimono*, New York.

Mirzoeff, Nicholas 1994. '"Seducing our eyes": gender, jurisprudence and visuality in Watteau', *The Eighteenth Century* 35(2), 135–54.

Moore, Andrew 1988. 'The Fountaine Collection of maiolica', *Burlington Magazine* 130, 435–47.

Morley, Henry 1852. *Palissy, the Potter: The Life of Bernard Palissy, of Saintes, his Labours and Discoveries in Art and Science; with an Outline of his Philosophical Doctrines and a Translation of Illustrative Selections from his Works*, London.

Motley, Will 2014. *Cohen & Cohen: Hit & Myth*, London.

Motley, Will 2017. *Cohen & Cohen: Take Two*, London.

Mulcahy Rosemarie 2002. 'Enea Vico's proposed Triumphs of Charles V', *Print Quarterly* 19, 331–40.

Müller-Scherf, Angelika 2016. 'Die Meissener Kinder à la Raphael und ihre Vorbilder', *Keramos* 234, 9–36.

Murck, Alfreda 2000. *Poetry and Painting in Song China: The Subtle Art of Dissent*, Cambridge, Massachusetts.

Murck, Alfreda 2009. 'Décor on Republican era tea wares', in E. Perry Link (ed.), *The Scholar's Mind: Essays in Honor of Frederick. W. Mote*, Hong Kong, 229–52.

Murray, Julia K. 2000. 'The evolution of pictorial hagiography in Chinese art: common themes and forms', *Arts Asiatiques* 55, 81–97.

Nicolai, Alexandre 1936. *La Famille d'Henri IV. A propos d'un plat de faïence polychrome de Nicholas et Mathurin Palissy. Extrait du Bulletin et Mémoires de la Société Archéologique de Bordeaux*, Tome XLIX, Bordeaux.

Norman, Alexander V.B. 1976. *Wallace Collection. Catalogue of Ceramics I: Pottery, Maiolica, Faience, Stoneware*, London.

O'Connell, Sheila 2010. 'O'Neale as a miniature painter and print designer', in Hanscombe, 130–63, appendix 186.

O'Connell, Sheila and Rosemary Baker 2011. 'Satirical prints by Jefferyes Hamett O'Neale', *Print Quarterly* 28(3), September, 338–43.

Oger, Danielle 2002. *Un bestiaire fantastique: Avisseau et la faïence de Tours (1840–1910)*, Paris.

Osnos, Evan 2013. 'Fact-checking a hero', published at https://www.newyorker.com/news/evan-osnos/fact-checking-a-chinese-hero (accessed 5 February 2019).

Ostier, Janette 1978. *Les objets tranquilles: natures mortes japonaises XVIIIe–XIXe siècles*, Paris.

Palissy, Bernard 1563. *Architecture et Ordonnance de la grotterustique*, La Rochelle.

Palissy, Bernard 1580. *Discours admirables de la nature des eaux et fontaines, tant naturelles qu'artificielles, des métaux, des sels et salines, des pierres, des terres, du feu et des émaux*, Paris.

Palissy, Bernard 1777. *Oeuvres de Bernard Palissy, revues sur les exemplaires de la Bibliothèque du Roi, avec des notes par MM. Faujas de Saint Fond et Gobet*, Paris.

Palissy, Bernard 1844. *Oeuvres complètes de Bernard Palissy*, Paris.

Palissy, Bernard 1880. *Les Oeuvres de Bernard Palissy avec une notice historique . . . par Anatole France*, Paris.

Palissy, Bernard 2010. *Oeuvres Complètes*, 2nd edition, ed. by Marie-Madeleine Fragonard, Paris.

Pang Laikwan 2007. *The Distorting Mirror: Visual Modernity in China*, Honolulu, Hawaii.

Paoli, Feliciano and John T. Spike (eds) 2019. *Francesco Maria Della Rovere di Tiziano. Le collezioni roveresche nel palazzo ducale di Casteldurante*, Urbino.

Paolinelli, Claudio 2019. 'Terra Pulchritudinis. La maiolica a decoro ornamentale nel ducato di Urbino nella prima metà del Cinquecento', in Paoli and Spike 2019, 81–103.

Patai, Raphael 2013. *Encyclopedia of Jewish Folklore and Traditions*, Armonk, New York.

Pecker, André 1958. 'Bourdaloues', *Cahiers de la céramique, du verre et des arts du feu* 11, 123–34.

Pennant, Thomas 1782. *The Journey from Chester to London*, London.

Perlès, Christophe (ed.) 2016. *Faire bonne figure*, Paris.

Perrin, Isabelle 2001. *Les techniques céramiques de Bernard Palissy*, 2 vols, thesis published on demand by 'Atelier national de reproduction des thèses' (ANRT).

Philadelphia Female Anti-Slavery Society 1833–8. Minutes, at Historical Society of Pennsylvania, published at https://digitallibrary.hsp.org/index.php/Detail/objects/14653 (accessed 26 May 2019).

Philadelphia Museum of Art 1916. *Exhibition of 'Fakes' and Reproductions, Pennsylvania Museum, Philadelphia*.

Pic, Marielle 2012. 'Un céramiste de légende: Palissy à Sèvres', *Sèvres* 21, 31–45.

Piccolpasso, Cipriano 1976. *Li tre libri dell'arte del vasaio*, ed. by Giovanni Conti, Florence.

Piccolpasso, Cipriano 1980. *The Three Books of the Potters' Art*, 2 vols, trans. and ed. by Ronald W. Lightbown and Alan Caiger-Smith, London.

Piot, Eugène 1842. *Histoire de la vie et des travaux de Bernard Palissy*, Paris.

Plaks, Andrew H. 1987. *The Four Masterworks of the Ming Novel*, Princeton, New Jersey.

Polizzi, Gilles 1992. 'L'intégration du modèle: le Poliphile et le discours du jardin dans la Recepte véritable', in *Bernard Palissy: 1510–1590. L'écrivain, le réformé, le céramiste*, Albineana, Cahiers d'Aubigné 4, 65–92.

Pollard, Alfred W. 1970. *Old Picture Books: With Other Essays on Bookish Subjects*, New York.

Prentice von Erdberg, Joan and Marvin C. Ross 1952. *Catalogue of the Italian Maiolica in the Walters Art Gallery*, Baltimore, Maryland.

Priestman, Geoffrey H. 2001. *An Illustrated Guide to Minton Printed Pottery 1796–1836*, Sheffield.

Pyhrr, Stuart 1998. *Heroic Armor of the Italian Renaissance: Filippo Negroli and his Contemporaries*, New York.

Qian Qianyi 錢謙益 1910. *Liechao shiji qianji* 列朝詩集乾集 (A Collection of Poems from the Different Reigns, *Qian* Collection), reprint, Shanghai.

Qian Qianyi 錢謙益 1991. *Liechao shiji xiaozhuan* 列朝詩集小傳 (Brief Biographies from a Collection of Poems from the Different Reigns), reprint, Taipei.

Quince, Eleanor 2010. 'The London/Paris, Paris/London design dialogue of the late eighteenth century', *Synergies Royaume-Uni et Irlande* 3, 47–58.

Rackham, Bernard 1940. *Victoria & Albert Museum: Catalogue of Italian Maiolica*, London. (re-issued with additions by John V.G. Mallet, 1977)

van Rappard-Boon, Charlotte and Lee Bruschke-Johnson 2000. *Surimono: Poetry and Image in Japanese Prints*, Leiden.

Ravanelli Guidotti, Carmen 1985. *Ceramiche occidentali del Museo Civico Medievale di Bologna*, Bologna.

Ravanelli Guidotti, Carmen, Valentina Mazzotti and Claudio Paolinelli 2019. *La Grazia dell'Arte. Collezione Grimaldi Fava. Maioliche*, Cinisello Balsamo.

Reilly, Robin 1989. *Wedgwood*. London.

Reilly, Robin 1992. *Josiah Wedgwood 1730–1795*, London.

Reynolds, Anne 2005. 'The papal court in exile: Clement VII in Orvieto, 1527–8', in Gouwens, and Reiss, 143–61.

Rochebrune, Marie-Laure de 2004. 'A propos des "suites de Palissy"', *Technè* 20, Terres cuites de la Renaissance, 84–92.

Rosen, Jean 2018. *La faïence en France du XIIIe au XIXe siècle: technique et histoire*, published at halshs-01973891 (accessed 16 June 2020).

Rosier, Bart 1990–1. 'The Victories of Charles V: a series of prints by Maarten Van Heemskerck, 1555–56', *Simiolus. Netherlands Quarterly for the History of Art* 20(1), 24–38.

Rousseau, Vincent 2019. 'État de la bibliographie depuis 2009', *Technè* 47, 140–2.

Rubens, Alfred 1981. *A History of Jewish Costume*, London.

Rubin, Patricia L 1995. *Giorgio Vasari: Art and History*, New Haven, Connecticut, and London.

Rucellai, Oliva, 2017. 'Carlo Ginori's armorial gifts between diplomacy and fashionable sociability', *Separata de Armas e Trofeos*, IX Serie, Tomo 19, 219–34.

Rucellai, Oliva, 2018. Catalogue entry in Balleri, d'Agliano and Lehner-Jobst, cat. 126, 428–9.

Rückert, Rainer 1966. *Meissener Porzellan, 1710–1810*, Munich.

Saito Kikutaro 斎藤菊太郎 1967. 'Gendai no sometsuke ko – Juyon-seiki chuyo no Genseika to Genkyoku' 元代染付考 – 十四世紀中葉の元青花と元曲 (Yuan blue-and-white in the mid-14th century and Yuan drama), *Kobijutsu* 古美術 (Quarterly Review of the Fine Arts), vol. 18, 24–51, and vol. 19, 59–74.

Salles, Jules 1855. *Étude sur la vie et les travaux de Bernard Palissy, précédée de quelques recherches sur l'histoire de l'art céramique*, Nîmes.

Sani, Elisa Paola 2010. Catalogue entry in Ausenda, Raffaella (ed.), *Le collezioni della Fondazione Banco di Sicilia. Le maioliche*, Cinisello Balsamo, 130–3.

Sani, Elisa Paola 2019. 'Il ritorno degli eroi. L'ideale classico delle maioliche istoriate al tempo di Francesco Maria I Della Rovere', in Paoli and Spike, 57–79.

Sanudo, Marino 1879–1903. *I diarii di Marino Sanuto [sic] (MCCCCXCVI–MDXXXIII) dall' autografo Marciano ital. cl. VII codd. CDXIX–CDLXXVII; pubblicati per cura di Rinaldo Fulin, Federico Stefani, Nicolò Barozzi, Guglielmo Berchet, Marco Allegri; auspice la R. Deputazione venta di storia patria. M. Diarii*, Venice.

Sargent, William R. 1991. *The Copeland Collection: Chinese and Japanese Ceramic Figures*, Salem, Massachusetts.

Sargent, William R. 2012. *Treasures of Chinese Export Ceramics from the Peabody Essex Museum*, New Haven, Connecticut, and London.

Scarce, Jennifer M. 2002. *Women's Costume of the Near and Middle East* (1st edition 1987), London.

Scheidemantel, Vivian J. 1968. 'An Italian majolica wine cooler', *Art Institute of Chicago: Museum Studies* 3, 42–62.

Schmidt, Steffi and Setsuko Kuwabara 桑原節子 1990. *Surimono: Kostbare japanische Farbholzschnitte aus dem Museum für Ostasiatische Kunst*, Berlin.

Scott, Paul 2012. *Ceramics and Print*, London.

Scott, Paul 2015. *Horizon: Transferware and Contemporary Ceramics*, Oslo.

Shanghai Museum 上海博物館 (ed.). 2015. *Youlan shencai: 2012 Shanghai Yuan qinghua guoji xueshu yantaohui lunwenji* 幽藍神采：2012上海元青花國際學術研討會論文集 (Splendors in Smalt: Art of Yuan Blue-and-white Porcelain Proceedings, Shanghai), 2 vols, Shanghai.

Shell, Hanna Rose 2004. 'Casting life, recasting experience: Bernard Palissy's occupation between maker and nature', *Configurations* 12(1), 1–40, *Project MUSE*.

Shih Ching-fei 2016. 'The new idea of ritual vessels in the early Ming dynasty: a third system?', in Craig Clunas, Jessica Harrison-Hall and Luk Yu-ping (eds), *Ming China: Courts and Contacts 1400–1450*, London, 113–21.

Slater, Graham 1999. 'English Delftware copies of La Fécondité pattern dishes attributed to Palissy', *English Ceramic Circle Transactions* 17(1), London, 47–64.

Slitine, F. 1997. 'Ceramique francaise de la Renaissance – sa redecouvert au XIXe siècle', *L'Objet d'art* 318, 57–69.

Smith, Adam 1790. *The Theory of Moral Sentiments, VI: Of the Character of Virtue Consisting of Three Sections*, London.

Smith, Alan 1970. *The Illustrated Guide to Liverpool Herculaneum Pottery, 1796–1840*, London.

Smith, Pamela 2004. *The Body of the Artisan: Art and Experience in the Scientific Revolution*, Chicago, Illinois, and London.

Smith, Pamela 2006. 'Art, science, and visual culture in early modern Europe', *Isis* 97(1), 83–100.

Smith, Pamela 2014. 'Between nature and art: casting from life in sixteenth-century Europe', in Elizabeth Hallam and Tim Ingold (eds), *Making and Growing: Anthropological Studies of Organisms and Artefacts*, Aldershot, 45–63.

Smith, Pamela, and Tonny Beentjes 2010. 'Nature and art, making and knowing: reconstructing sixteenth-century life-casting techniques', *Renaissance Quarterly* 63, 128–79.

Sotheby's 1974. *Catalogue of Fine Chinese Export Porcelain, Jades and Works of Art*, London, 5 March.

Sotheby's 2007. *Catalogo Asta*, Milan, 13 November.

Sotheby's 2019. *Property from the Collection of Nelson & Happy Rockefeller: A Collecting Legacy*, New York, 18 January.

Spallanzani, Marco 1978. *Ceramiche orientali a Firenze nel Rinascimento*, Florence.

Spallanzani, Marco 2009. '20 maggio 1797: la dispersione degli istoriati dei Medici', *Faenza* 95(1–6), 95–9.

von Spee, Clarissa (ed.) 2010. *The Printed Image in China: From the 8th to the 21st Centuries*, London.

Spero, Simon and John Sandon 1996. *Worcester Porcelain 1751–1790: The Zorensky Collection*, Woodbridge, Suffolk.

Steedman, Carolyn 2013. 'No body's place: on eighteenth-century kitchens', in Anne Massey and Penny Sparke (eds), *Biography, Identity and the Modern Interior*, Farnham, 11–22.

Syson, Luke and Dora Thornton 2001. *Objects of Virtue*, London.

Taillebois, Emile 1889. *L'Archéologie à l'Exposition*, Dax.

Tainturier, Alfred 1860. *Notice sur les faïences du XVIe siècle dites de Henri II suivie d'un catalogue contenant la description de toutes les pièces connues*, Paris.

Tainturier, Alfred 1863. *Les Terres émaillees de Bernard Palissy, inventeur des rustiques figulines; étude sur les travaux du maître et de ses continuateurs, suivie du catalogue de leur ôeuvre; ouvrage enrichi de planches et de gravures dans le texte*, Paris.

Talvacchia, Bette 1994. 'Professional advancement and the use of the erotic in the art of Francesco Xanto Avelli', *Sixteenth Century Journal* 25(1), 121–53.

Talvacchia, Bette 1999. *Taking Positions: On the Erotic in Renaissance Culture*, Princeton, New Jersey.

Tanner, Arleen and Grahame 2013. *Swansea's Cambrian Pottery Public & Private Commemorative Printed Wares*, published at https://www.transcollectorsclub.org/specinterest/Swansea%20Cambrian%20Pottery%20%20Printed%20Commemorative%20Wares%20Final%202.pdf (accessed 1 July 2020).

Tapp, Major William H. 1938. *Jefferyes Hamett O'Neale 1734–1801, Red Anchor Fable Painte, and Some Contemporaries*, London.

Taylor, Alice 2008. 'Selling abolitionism: the commercial, material, and social world of the Boston Antislavery Fair, 1834–1858', PhD dissertation, Western University, London, Ontario.

Taylor, Alice 2010. '"Fashion has extended her influence to the cause of humanity": the transatlantic female economy of the Boston Antislavery Bazaar', in Beverly Lemire (ed.), *The Force of Fashion in Politics and Society: Global Perspectives from Early Modern to Contemporary Times*, Burlington, Vermont, 115–42.

Teall, Gardner, 1919. 'Bernard Palissy, his wisdom and his wares', *House & Garden*, February 1919, 18–19.

Teitelman, S. Robert, Patricia A. Halfpenny and Ronald W. Fuchs II. 2010. *Success to America: Creamware for the American Market: Featuring the S. Robert Teitelman Collection at Winterthur*, Woodbridge, Suffolk.

Thom, Danielle 2015. 'Sawney's defence': anti-Catholicism, consumption and performance in 18th-century Britain', *V&A Online Journal* 7, Summer, published at http://www.vam.ac.uk/content/journals/research-journal/issue-no.-7-autumn-2015/

sawneys-defence-anti-catholicism,-consumption-and-performance-in-18th-century-britain/ (accessed 1 July 2020).

Thomas, Margaret 2003. *German Stoneware: The Catalogue of the Frank Thomas Collection*, London.

Thompson, Sarah E. 1991. 'The politics of Japanese prints', in Sarah E. Thompson and Harry D. Harootunian (eds), *Undercurrents in the Floating World: Censorship and Japanese Prints*, New York, 29–91.

Thornton, Dora 1999. 'An allegory of the Sack of Rome by Giulio da Urbino', *Apollo*, June, 11–18.

Thornton, Dora 2004. 'The use of Dürer prints as sources for Italian Renaissance maiolica', in Giulia Bartrum (ed.), *Albrecht Dürer and His Legacy: The Graphic Work of a Renaissance Artist*, London, 1–13.

Thornton, Dora 2007. 'Giulio da Urbino and his role as a copyist of Xanto', *Faenza* 93(4–6), 269–89.

Thornton, Dora and Timothy Wilson 2009. *Italian Renaissance Ceramics: A Catalogue of the British Museum Collection*, 2 vols, London.

Tien, Ju-k'ang (Tian Rukang) 1990. 'The decadence of Buddhist temples in Fukien in late Ming and early Ch'ing', in Vermeer, 83–100/1.

Tōkyō-to Edo Tōkyō Hakubutsukan 東京都江戸東京博物館 (ed.) 2013. *Hana hiraku: Edo no engei*『花開く江戸の園芸』(Flowers in Bloom: The Culture of Gardening in Edo), Tokyo.

Triolo, Julia C. 1996. 'The armorial maiolica of Francesco Xanto Avelli', PhD dissertation, Pennsylvania State University.

Tudor-Craig, Algernon 1925. *Armorial Porcelain of the Eighteenth Century*, London.

Turnau, Irena 1999. 'Jewish costume in sixteenth–eighteenth century Poland', in Jerzy Kruppé and Andrzej Pośpiech, *Omnia res mobilia: Polish Studies in Posthumous Inventories of Movable Property in the 16th–19th Century*, Warsaw, 281–90.

De Ulloa. Alfonso 1566. *Vita dell'Imperatore Carlo V*, Venice.

De Valdés, Alfonso 1952. *Alfonse de Valdés and the Sack of Rome*, trans. by John E. Longhurst, Albuquerque, New Mexico.

Vasari, Giorgio 1906. *Le opere di Giorgio Vasari*, ed. by Gaetano Milanesi, 9 vols, Florence.

Vaysettes, Jean-Louis and Lucy Vallauri 2012. *Montpellier, terre de faïences: potiers et faïenciers entre Moyen Âge et XVIIIe siècle*, Milan.

Verhoeven, Wil 2013. *Americomania and the French Revolution Debate in Britain, 1789–1802*, Cambridge.

Vermeer, Eduard B. (ed.) 1990. *Development and Decline of Fukien Province in the 17th and 18th Centuries*, Leiden.

Viennet, Christine 2010. *Bernard Palissy et ses suiveurs du XVIe siècle à nos jours: hymne à la nature*, Dijon.

Walvin, James 2005. 'British abolitionism, 1787–1838', in Anthony Tibbles, *Transatlantic Slavery: Against Human Dignity*, Liverpool, 83–91.

Wang Guangyao 王光堯 2011. *Mingdai gongting taoci shi* 明代宮廷陶瓷史 (History of Ceramics at the Ming Court), Beijing.

Wang Su 王肅 1991. *Kongzi jiayu* 孔子家語 (Family Sayings of Confucius), reprint, Zhengzhou shi.

Wang Tao 2018. 'Lost archaeology: from antiquity to plaything', in Tao Wang, *Mirroring China's Past: Emperors, Scholars and Their Bronzes*, Chicago, Illinois, 85–99.

Wang Yinong 王依農 2018. 'Xiong qi die li – Shiqi shiji zhuanbianqi ciqi duandai qianshu' 雄奇昳麗：十七世紀轉變期瓷器斷代淺述 (Grand and pretty: simple description of dynastic porcelains in the transitional period of the 17th century), *Shoucang* 收藏 (Collections), no. 8, 102–37.

Watson, John R. 2003. *Romanticism and War: A Study of British Romantic Period Writers and the Napoleonic Wars*, Basingstoke and New York.

Weidner, Marsha *et al.* 1988. *Views from Jade Terrace: Chinese Women Artists, 1300–1912*, Indianapolis, Indiana.

West, Stephen H. and Wilt L. Idema (eds) 1991. *The Moon and the Zither: The Story of the Western Wing*, Berkeley and Los Angeles, California.

Willcock, Sean 2013. 'A neutered beast? Representations of the sons of Tipu Sultan – "The Tiger of Mysore" – as hostages in the 1790s', *Journal for Eighteenth-Century Studies* 36(1), 121–47.

Williams, Glyn 1999. *The Prize of All the Oceans: The Triumph and Tragedy of Anson's Voyage Round the World*, London.

Williams-Wood, Cyril 1981. *English Transfer-printed Pottery and Porcelain: A History of Over-glaze Printing*, London.

Wilson, Timothy 1987. *Ceramic Art of the Italian Renaissance*, London.

Wilson, Timothy 1991. *Italian Renaissance Pottery. Papers Written in Association with a Colloquium at the British Museum*, London.

Wilson, Timothy 1999. '"Il papà delle antiche maioliche": C.D.E. Fortnum and the study of Italian maiolica', *Journal of the History of Collections* 11(2), 203–18.

Wilson, Timothy 2002. 'La maiolica a Castel Durante e ad Urbino fra il 1535 e il 1565: alcuni corredi stemmati', in Gian Carlo Bojani (ed.), *I Della Rovere nell'Italia delle corti, Atti del convegno di Urbania 1999, IV, Arte della maiolica*, Urbino, 125–65.

Wilson, Timothy 2004. 'The maiolica-painter Francesco Durantino: mobility and collaboration in Urbino "istoriato"', in Silvia Glaser (ed.), *Italienische Fayencen der Renaissance. Ihre Spuren in internationalen Museumssammlungen. Wissenschaftliche Beibände zum Anzeiger des germanischen Nationalmuseums*, Band 22, Nuremberg, 111–45.

Wilson, Timothy 2005. 'Iconografia sessuale nella ceramica rinascimentale. Un "intricamento" tra Leonardo ed Arcimboldo', *Ceramic Antica* 15(2), 10–44.

Wilson, Timothy 2016. *Maiolica. Italian Renaissance Ceramics in the Metropolitan Museum of Art*, New York.

Wilson, Timothy 2017. *Italian Maiolica and Europe: Medieval, Renaissance, and Later Italian Pottery in the Ashmolean Museum, Oxford, with Some Examples Illustrating the Spread of Tin-Glazed Pottery in Europe*, Oxford.

Wilson. Timothy 2018. *The Golden Age of Italian Maiolica-Painting. Catalogue of a Private Collection*, Turin.

Wood, Frank L 2014. *The World of British Stoneware: Its History, Manufacture and Wares*, Kibworth Beauchamp, Leicestershire.

Wu Dongmei 武冬梅 2009. 'Xing Cijing shufa yanjiu' 邢慈静書法研究 (Research into the calligraphy of Xing Cijing), MA thesis, Capital Normal University, Beijing.

Xin, Wenyuan 2017. 'Stories of Cizhou wares at the British Museum', *Arts of Asia* (November–December), 58–64.

Yan Jiayan 2011. 'A pioneer in raising issues against the Mmainstream – Lu Xun's "difference between literature and politics"', trans. by Raoul David Findeisen, published at https://fphil.uniba.sk/fileadmin/fif/katedry_pracoviska/kvas/SOS_10_2/01_40ayanjiayan-form120529.pdf, 283–90 (accessed 5 February 2019).

Yang, Richard F.S. 1972. *Four Plays of the Yuan Drama*, Taipei.

Yang Tingfu 楊廷福 and Yang Tongfu 楊同甫 2002. *Mingren shiming biecheng zihao suoyin* 明人室名別稱字號索引 (Index to the Studio and Alternative Names of Persons from the Ming Dynasty), Shanghai.

Yellin, Jean 1989. *Women and Sisters: The Antislavery Feminists in American Culture*, New Haven, Connecticut.

Yongle gong bi hua xuan ji 永樂宮壁畫選集 1958. Beijing.

Young, Hilary 1997. 'Views of Chelsea: a problematical print by Zachariah Boreman, and an unpublished drawing by J.H. O'Neale', *Transactions of the English Ceramic Circle* 16(2), 217–21.

Young, Hilary 1999. *English Porcelain, 1745–95: Its Makers, Design, Marketing and Consumption*, London.

Yu Yunyao 俞允堯 2005. 'Zhu Yuanzhang yangzi Mu Ying ji qi jiazu mu chutu hanjian wenwu' 朱元璋養子沐英及其家族墓出土罕見文物 (Rare artefacts excavated from the tombs of Zhu Yuanzhang's adopted son Mu Ying and his family), *Lishi yuekan* 歷史月刊 (Historical Monthly) 213, 18–21.

Yuan, Bingling 2002. 'Dehua white ceramics and their cultural significance', in John Ayers (ed.), *Blanc de Chine: Divine Images in Porcelain*, New York.

Zalamea, Patricia 2016. 'Inscribing the *paragone* in French Renaissance art: René Boyvin and Pierre Milan's engraving of the *Nymph of Fontainebleau*', *Word & Image* 32(3), 311–25.

Zang Maoxun 臧懋循 1966. *Yuan quxuan* 元曲選 (Selected Yuan Plays), Taipei.

Zhang, Fan Jeremy 2014. 'Jin-dynasty Pingyang and the rise of theatrical pictures', *Artibus Asiae* 74 (2), 337–80.

Zhang Pusheng 張浦生 and Huo Hua 霍華 2015. 'Hengkong chushi de Yuanmo Mingchu renwu tu qinghua qi' 橫空出世的元末明初人物圖青花器 (The sudden emergence of blue-and-white wares painted with figures in the late Yuan and early Ming), in Shanghai Museum, vol. 1, 49–60.

Zhao Zhongnan 趙中男 *et al.* 2010. *Mingdai gongting dianzhi shi* 明代宮廷典制史 (History of Decrees and Regulations at the Ming Court), 2 vols, Beijing.

Zhou Lili 周麗麗 2015. 'Guanyu Yuandai qinghua xiqu renwu gushi tu ciqi xingzhi de renshi' 關於元代青花戲曲人物故事圖瓷器性質的認識 (About the characteristics of images of opera figures and stories in Yuan blue-and-white), in Shanghai Museum, vol. 1, 109–30.

Contributors

Patricia F. Ferguson was Project Curator at the British Museum from 2017–20, focusing on European ceramics and print sources. Between 2006 and 2017, she was a consulting curator in the Asian and Ceramics Departments of the Victoria and Albert Museum. As Honorary Adviser on Ceramics to the National Trust, she published *Ceramics: 400 Years of British Collecting in 100 Masterpieces* (2016) and *Garnitures: Vase Sets from National Trust Houses* (2016).

Alessandro Biancalana was introduced to the world of porcelain through his work on the exhibition 'La manifattura toscana dei Ginori. Doccia 1737–1791', held in Pisa in 1998. Most recently he catalogued the European porcelains in the Museo Internazionale delle Ceramiche in Faenza and edited, *Guida alle porcellane europee del 18.-19. Secolo*, 2018.

Claire Blakey is Curator of 19th-century Decorative Arts at National Museums Scotland in Edinburgh. She has worked in museums across the UK, curating numerous exhibitions and publishing on topics including majolica, *maiolica*, the trade in Staffordshire pottery and East Asian ceramics.

Elaine Buck has an MA and a PhD from SOAS where she teaches courses on the art and archaeology of Medieval China and the Silk Road. Her PhD was on the Eight Immortals on Yuan and Ming ceramics.

Ronald W. Fuchs II is the Senior Curator of Ceramics at the Reeves Museum of Ceramics at Washington and Lee University in Lexington, Virginia. He is a graduate of the College of William and Mary and the Winterthur Program in Early American Culture at the University of Delaware.

Mary Ginsberg is an international banker turned art historian. She was editor and part-author of *Communist Posters* (2017), guest curator and catalogue author of *The Art of Influence: Asian Propaganda at the British Museum* (2013) and catalogue co-author of *Lu Xun's Legacy* for the Muban Educational Trust (2020). Her current project is a global study of folk art and its modern transformations.

Helen Glaister is an art historian specialising in Chinese ceramics and Decorative Arts. She began her career at the British Museum before moving to the V&A where she is the Course Director of the Arts of Asia Programme. Current research interests include Chinese export porcelain, collections history and cultural interactions between China and Europe during the long 18th century.

Catrin Jones is Chief Curator of the V&A Wedgwood Collection and Trustee at the Alex Moulton Charitable Trust. She has published widely on historic and contemporary applied arts. She was formerly Curator at the Holburne Museum, Bath, where she curated the major exhibition *Grayson Perry: The Pre-Therapy Years*, and edited the accompanying publication.

Rachel King is Curator of Renaissance Europe and the Waddesdon Bequest in the Department of Britain, Europe and Prehistory at the British Museum. She has worked in museums across the UK and in Germany, and published variously on the material culture of devotion, small scale statuary in amber, English alabasters, and other aspects of the collections in which she has worked.

Luk Yu-ping is Basil Gray Curator: Chinese Paintings, Prints and Central Asian Collection at the British Museum. Her previous publications have focused on the arts of empresses in Ming and Qing China. She is currently developing research related to the collection under her care.

Caroline McCaffrey-Howarth is an art historian specialising in European decorative arts, material culture and the histories of collecting. She gained her PhD at the University of Leeds in 2019. She is Curator of 17th and 18th-Century Ceramics and Glass at the V&A Museum and Tutor in History of Design for the V&A and Royal College of Art.

Sheila O'Connell was curator of British prints at the British Museum until retiring in 2015. She oversaw on-line cataloguing of 250,000 British prints and has published on related subjects, as well as organising several exhibitions: *The Popular Print in England* (1999), *London 1753* (2003), *Bonaparte and the British* (2015), and *Britain meets the World* (at the Palace Museum, Beijing, 2007).

Mary Redfern is Curator of the East Asian Collections at the Chester Beatty, Dublin. Prior to receiving her PhD from University of East Anglia in 2015, Redfern worked at the National Museum of Scotland (2009–2011) and the Victoria and Albert Museum (2008–2009). Redfern's research addresses the role of ceramics across the Edo-Meiji era transition, and print cultures of the Edo period.

Elisa Sani studied History of Art at the universities of Perugia and Siena. She started her curatorial career at the Wallace Collection in London and was later an assistant curator at the Victoria and Albert Museum. She is a Research Fellow at the Courtauld Gallery, working on the catalogue of the collection of ceramics from the early modern period.

Dora Thornton is the Curator of the Goldsmiths' Company Collection in London. She was formerly Curator of Renaissance Europe and Curator of the Waddesdon Bequest at the British Museum, 1990–2018. Publications include: (with Luke Syson), *Objects of Virtue, Art in Renaissance Italy* (2001); and (with Timothy Wilson) *Italian Renaissance Ceramics, A Catalogue of the British Museum's Collection* (2009).

Wenyuan Xin is the Project Curator for China 1800s in the Department of Asia, British Museum. Previously she was the Project Curator for Chinese ivories, The Sir Joseph Hotung Gallery and the exhibition *Ming: 50 years that changed China* at the British Museum.

Index